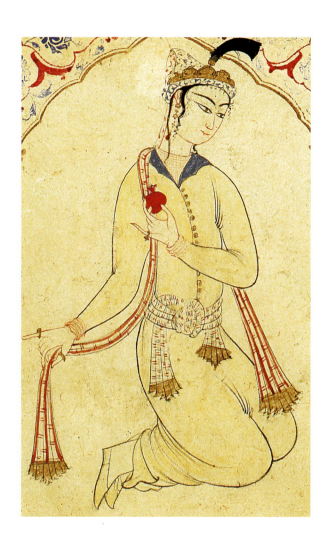

The Album of the
World Emperor

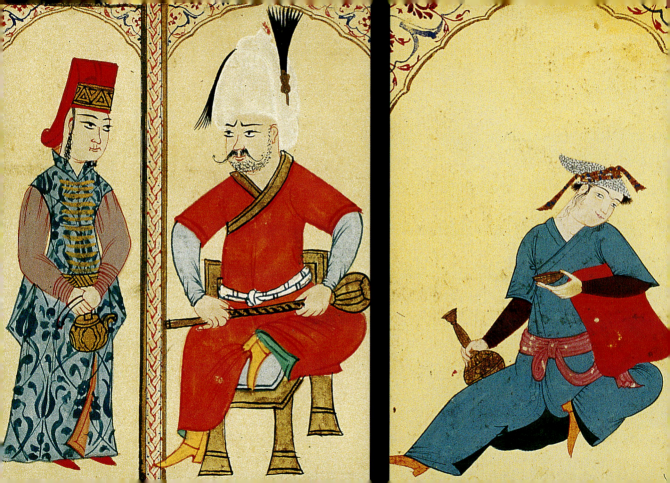

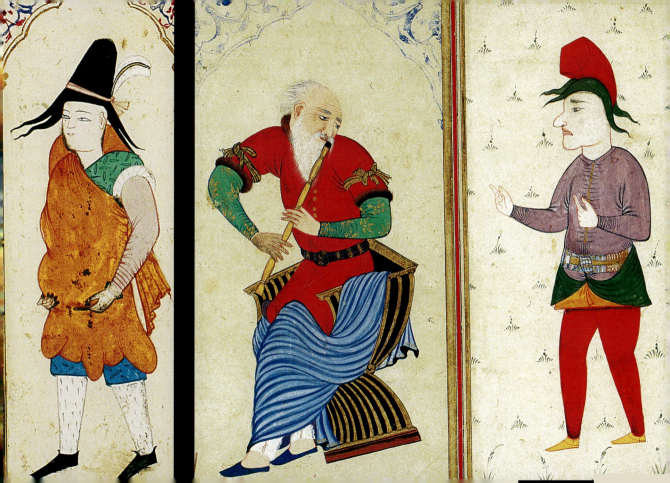

Copyright © 2019 by Princeton University Press
Published by Princeton University Press,
41 William Street, Princeton, New Jersey 08540
In the United Kingdom: Princeton University Press,
6 Oxford Street, Woodstock, Oxfordshire OX20 1TR
press.princeton.edu

JACKET ILLUSTRATIONS:
Album of the World Emperor, Topkapı Sarayı Müzesi
Kütüphanesi, B 408, photos: Hadiye Cangökçe.
Front: fol. 14a (detail); back: details of folios 21a,
5a, 22a, 9b, 30b, 30a, 15b, and 29a.
ILLUSTRATIONS IN FRONT MATTER:
p. i, detail of plate 46; pp. ii and iii, details of plates
21, 32, and 55; p. vi, detail of plate 58; p. xiii, detail
of plate 54.
ILLUSTRATIONS IN CHAPTER OPENERS:
p. xiv, detail of plate 1; p. 12, detail of plate 10; p. 32,
detail of plate 38; p. 60, detail of plate 18; p. 88,
detail of plate 62; p. 110, detail of plate 31; p. 130,
detail of plate 54.

All Rights Reserved
LCCN 2018946126
ISBN 978-0-691-18915-4
British Library Cataloging-in-Publication Data is
available

Designed by Jo Ellen Ackerman / Bessas & Ackerman
This book has been composed in Vesper Pro Light
and Veljovic
Printed on acid-free paper. ∞
Printed in Malaysia

10 9 8 7 6 5 4 3 2 1

For Daniel and Dilara,
the stars that
light up my world

Contents

Acknowledgments

I owe this book to two dear friends: Zeynep Çelik Atbaş, Curator of Manuscripts at the Topkapı Palace Museum Library, Istanbul, and Hadiye Cangökçe, the extraordinary photographer whose brilliant images made it possible to present the entire *Album of the World Emperor* in this volume. It was their idea, back in 2002, to photograph the entirety of the *Album* (Bağdat 408, as it is known in the Topkapı) as a way to allow me to study it, since it was too fragile for prolonged handling. My sustained, careful study of the folios was made possible by these photographs and through multiple visits to the Topkapı to examine the album. I am most thankful to Zeynep and the Topkapı Palace Museum Directorate and the Library for repeatedly welcoming me and for allowing me to study the *Album of the World Emperor*. I was able, as a result, to experience the album over time, with return visits akin to those enjoyed by early modern audiences at the Ottoman court, and had the luxury to focus on details and discuss them in scholarly gatherings, always learning from my interlocutors, and in time, coming to know the album intimately, drawing multiple lessons from it.

This book was mostly written in my peaceful office at the Institute for Advanced Study, Princeton, where I was a Hetty Goldman Member in 2016–17. I am most grateful to the Institute and to Yve-Alain Bois and Sabine Schmidtke for their support of my research, and to Kirstie Venanzi and Karen Downing of the IAS Library, as well as to Brett Savage, for their help in locating books, articles, and images. My IAS art history colleagues Roland Betancourt, Yu-chih Lai, Daniel Sherman, and Despina Stratigakos helped me refine my ideas and arguments. I thank them and especially Yve-Alain Bois for their intellectual companionship during a year of intensely pleasurable research and writing. Columba Stewart and Jane Hathaway were also invaluable interlocutors at the IAS, and Marian Zelazny watched over us all in the kindest way possible.

I have had many conversations about this book, about albums, and about the Ottomans with beloved friends and mentors Gülru Necipoğlu and David J. Roxburgh, whose wisdom and intellectual generosity I have relished for the past twenty years. Their questions, encouragement, and suggestions continue to inspire me and push me to be a better scholar. Sunil Sharma has been a most valuable intellectual companion, sharing ideas about painting and poetry, and saving me from many an egregious Persian mistake. András Riedlmayer was instrumental to my research on costume albums and European depictions of Ottomans. Nadine Orenstein and Jamie Gabbarelli shared their expertise on prints and helped me to feel more confident about my analysis of the album folios in the Metropolitan Museum of Art. A long conversation with Kaya Şahin clarified my thinking on Sultan Ahmed; Alicia Walker helped me find ways to imagine a community of calligraphers; and a criticism from Cemal Kafadar about how my reading of the prints was not grounded enough pushed me toward greater precision. Irvin Cemil Schick answered my desperate e-mails about calligraphy with incredible speed and good humor.

Çiğdem Kafescioğlu and David J. Roxburgh generously commented on the entire manuscript. Roland Betancourt, Yve-Alain Bois, Olga Bush, Yu-chih Lai, Aslı Niyazioğlu,

Kaya Şahin, Irvin Cemil Schick, Avinoam Shalem, and Despina Stratigakos have read earlier drafts of some chapters and provided invaluable feedback. I benefited from conversations with Shahab Ahmed, Walter Andrews, Hasan al-Ansari, Tülay Artan, Sussan Babaie, Kathryn Babayan, Serpil Bağcı, Charlie Barber, Raoul Birnbaum, Maurits van den Boogert, Antoine Borrut, Anastassiia Botchkareva, Glen Bowersock, David Brafman, Palmira Brummett, Zeynep Çelik Atbaş, Nicola Di Cosmo, Holly Edwards, Patrick Geary, Jane Hathaway, Robert Hillenbrand, Renata Holod, Christopher Jones, Cemal Kafadar, Thomas DaCosta Kaufmann, Ilham Khuri-Makdisi, Selim S. Kuru, Rudi Mathee, Eugenio Menegon, Mika Natif, Anastasios (Tom) Papademetriou, Ayşe Parla, Bruce Redford, Simon Rettig, Ünver Rüstem, Dana Sajdi, Daniel Sheffield, Priscilla Soucek, Femke Speelberg, Claudia Swan, Alicia Walker, Bronwen Wilson, Warren Woodfin, Ayşin Yoltar Yıldırım, and Michael Zell. Hyunjin Cho was a meticulous research assistant. My colleagues and department chairs at Boston University, Bruce Redford and Alice Tseng, have been extremely supportive of my research, and a Publication Production Grant from the Boston University Center for the Humanities helped offset some of the publication costs.

Early stages of my research were supported by the Peter Paul Career Development Professorship at Boston University and a residential fellowship from the Kunsthistorisches Institut, Florence. I presented aspects of the project at the Boston University Center for the Study of Asia Leisure and the State Workshop (2010); Historians of Islamic Art Biennial Symposium (2010); Boston University Scripture and the Arts Program (2011); University of Michigan, Center for European Studies (2011); "Gazing Otherwise: Modalities of Seeing" conference, Kunsthistorisches Institut-Max-Planck Institut, Florence (2012); Yale University, History of Art Department, Medieval and Renaissance Seminar (2012); University of Washington, Departments of Art History and Near Eastern Languages and Civilizations (2013); College Art Association Annual Conference, Chicago (2014); Kunsthistorisches Institut, Florence (2014); Renaissance and Early Modern Studies Graduate Group, Brown University (2015); Mediterranean Crossings Workshop, Yale University (2015); Getty Research Center Workshop on Prints and the Islamic World, Los Angeles (2016); New Studies in Islamic Painting Symposium, Northwestern University (2016); "The Ottomans and Entertainment" conference, Skilliter Center for Ottoman Studies, University of Cambridge (2016); Zentralinstitut für Kunstgeschichte, Munich (2016); Princeton University Near Eastern Studies Department (2017); and New York University, Daniel H. Silberberg Lecture Series (2018). My heartfelt thanks go to the participants and organizers at these events, and especially to Hannah Baader, Cristelle Baskins, Ebru Boyar, Palmira Brummett, Matteo Burioni, Olga Bush, Susan Dackerman, Kate Fleet, Finbarr Barry Flood, Dario Gaggio, Lara Harb, Megan Holmes, Deeana Klepper, Selim Kuru, Karla Malette, Alan Mikhail, Bilha Moor, Ulrich Pfisterer, Kishwar Rizvi, Avinoam Shalem, Daniel Sheffield, Francesca Trivellato, Max Weiss, and Gerhard Wolf for the invitations to share my work, and their comments and suggestions.

I thank the following curators, librarians, and staff for allowing me access to the materials in their care, for arranging photography, and giving me permission to publish images: Ladan Akbarnia, British Museum, London; Elaine Wright and Moya Carey, Chester Beatty Library, Dublin; Mary McWilliams, Harvard Art Museums, Cambridge,

MA; M. Nicolas Sainte-Fare Garnot and Mélanie Leboucher, Musée Jacquemart-André, Paris; Sheila Canby and Annick Des Roches, Metropolitan Museum of Art, New York; A. Yıldız, Y. Akçay, and P. Bezirci, Istanbul University Rare Book Library; Directorate of Manuscripts, Süleymaniye Library, Istanbul; Zeynep Çelik Atbaş, Ayşe Erdoğdu, Gülendam Nakipoğlu, and Esra Müyesseroğlu, Topkapı Palace Museum, Istanbul. Nancy Micklewright, Head of Public and Scholarly Engagement, Freer Gallery of Art and Arthur M. Sackler Gallery, Smithsonian Institution; and Gülru Necipoğlu, Aga Khan Professor of Islamic Art and Architecture, Harvard University, Director of the Aga Khan Program for Islamic Architecture, and editor of *Muqarnas: An Annual on Islamic Art and Architecture*, kindly gave me permission to use material from two articles I had previously published: "The Album of Ahmed I," *Ars Orientalis* 42 (2012): 127–38; and "The Gaze in the Album of Ahmed I," *Muqarnas* 32 (2015): 135–54.

I am most grateful to Michelle Komie at Princeton University Press for her enthusiastic support of this project from our very first meeting and to Pamela Weidman for her able assistance. I also wish to thank Sara Lerner at the Press and Beth Gianfagna of Log House Editorial Services for their careful work on the manuscript, and Steven Sears and his team for the beautiful design. The comments provided by the two anonymous reviewers for Princeton University Press struck the perfect balance between encouragement and criticism, and improved the final manuscript immensely. Any remaining mistakes, of course, are my own.

No words can adequately express my gratitude to my family. My parents and my sister's love and encouragement have supported me from afar when we could not be together. Going above and beyond the call of familial duty, they have provided child care, accompanied me to conferences, secured image permissions, found books, and communicated with libraries on my behalf. My husband Daniel's faith in me has sustained me through the writing process, and his love and encouragement gave me the strength to complete this book. He has patiently listened to me, gently pushed me to sharpen my arguments, and helped me be a clearer thinker and writer. My daughter, Dilara, brings endless amounts of joy into my life, making every day brighter and happier. She has practiced various magic spells so I could finish writing, and has been the sweetest little helper I could ask for.

Note on Transliteration and Abbreviations

Except in transliterated quotations and book titles, foreign terms that have entered standard English dictionaries (for example, "Mahdi," or "hadith") have been given in their anglicized forms. Less familiar terms are italicized only at their initial mention. Ottoman book titles have been given in full transliteration, and Ottoman names are spelled according to modern Turkish orthography. For transliterations from Persian and Ottoman Turkish, I have followed the system used by the *International Journal of Middle East Studies* (but used ḥ for ح and ğ for غ) except when the transliterations are quoted from a published source, in which case I have retained the published form. The Arabic alphabet, used for Arabic, Ottoman, and Persian, does not use punctuation, but I have chosen to do so for clarity in transcribed texts.

Abbreviations

BL	British Library
BM	British Museum
EI2	*Encyclopaedia of Islam*, 2nd ed., edited by P. J. Bearman, Th. Bianquis, C. E. Bosworth, E. van Donzel, W. P. Heinrichs, et al. Leiden: Brill, 1954–2005. Also available online by subscription.
IJMES	*International Journal of Middle East Studies*
IÜK	Istanbul Üniversitesi Nadir Eserler Kütüphanesi (Istanbul University Rare Book Library)
SYEK	Süleymaniye Yazma Eser Kütüphanesi (Süleymaniye Rare Book Library)
TDVIA	*Türkiye Diyanet Vakfı Islam Ansiklopedisi* [Turkish Foundation of Religious Affairs Encyclopedia of Islam]. 44 vols. Istanbul: Türkiye Diyanet Vakfı, 1988–2013.
TSMK	Topkapı Sarayı Müzesi Kütüphanesi (Topkapı Palace Museum Library)

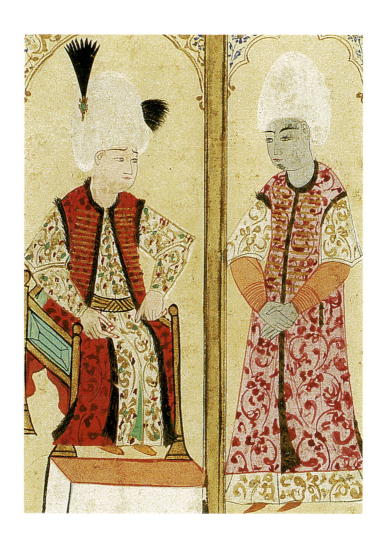

The Album of the
World Emperor

The *Album of the World Emperor*

One of the most intriguing albums in the vast collection of the Topkapı Palace Museum Library in Istanbul was compiled for the Ottoman sultan Ahmed I (r. 1603–17) by his courtier Kalender Paşa (d. 1616). All the folios of this album, including five that were later separated from it, are reproduced at the back of the volume you hold in your hands. They have been reproduced from back to front, following the proper orientation of books in the Arabic alphabet, which is written from right to left and was used for Ottoman Turkish as well as Persian. The album's title, *Album of the World Emperor Sultan Ahmed Khan (May God Perpetuate His Kingdom until Doomsday. Amen)*, inscribed in white over gold at the center of an elaborate illuminated heading on the first page (see folio 1b, plate 2), introduces some of the main concerns of the album maker and his patron: a claim to world rule, and the hope that Ahmed's reign will last until the end of the world.[1] The visual materials collected in the album and examined in this book further the album title's claims. Pointed as they are, however, these are not the only messages of the *Album of the World Emperor*, which is above all a multivalent object. The variety of materials in the album present Ahmed as a discerning collector and patron and allow him to lay claim to vast artistic traditions as a sign of imperial prowess. The sultan's control over the bustling metropolis from which he ruled, his pious inclinations, and his illustrious lineage are also advertised. The title of the *Album of the World Emperor* and its varied contents suggest that on some level it was understood to be a microcosm of the world over which the sultan ruled.[2] Just as the Ottoman Empire consisted of vast lands with multiethnic and multiconfessional subjects, and its language, Ottoman Turkish, made use of eastern and western Turkic languages, Persian, and Arabic, so the album contains styles and materials from diverse contexts. The stylistic and material multiplicity forms a visual corollary to the world-encompassing empire alluded to by the subject matter of the album's contents and title, and provides a play on the concept of the album as microcosm.[3]

The sheer variety of the album's contents supports these readings. The album currently has thirty-two folios of painting, calligraphy, and illumination. Paintings and drawings include examples of narrative scenes and imperial portraits, depictions of ethnic and social types, and the earliest examples of what might be called Ottoman genre paintings: tableaux depicting coffeehouse entertainments, bathhouse gatherings, amorous countryside escapades—and even a scene set in an insane asylum. Some of the ethnic and social types are by artists from Safavid Iran; others are Ottoman imitations of Persian paintings; a few evoke Mughal India; and some are Ottoman works similar to those produced for the costume books popular with contemporary European travelers. The multiple calligraphic examples, which mostly comprise Persian lyric poems, are by both Ottoman and Persian calligraphers. As if this variety were not dazzling enough, some pages subsequently separated from the album contain European prints of Christological and mythological subjects.

Although it has been more than fifteen years since David J. Roxburgh firmly demonstrated that albums are not just scrapbooks of random materials but rather deliberate constructions with specific narratives and meanings, the eclecticism in the *Album of the World Emperor* has thus far discouraged scholars from considering it as a discreet work of art.[4] That this album was meant to be understood as a unified although multivalent artwork and to serve as a guide to greater thoughts, whatever they may be, is made

evident in its seven-page preface, written by the album's maker, Kalender. He writes that the images in the album were meant to educate and inspire, especially during difficult times: "[I]f some instructive images from predecessors and successors are gazed upon and remembered, imagining and picturing to oneself the various sorts of chameleon designs, images of strange traces and marvelous shapes that occur with the passage and appearance of the celestial sphere will certainly cause the acquisition of the capital of the science of wisdom, will result in the perfection of the eye of learning by example, and will additionally console the felicitous person and troubled heart of the mighty sovereign by enlivening his mind and by pleasing his luminous inner self and his illuminated heart."[5]

The *Album of the World Emperor* is also an extraordinary visual feast demonstrating the skills of Kalender in not only choosing and juxtaposing artworks, but for creating striking compositions enhanced by his illumination and paper joinery, which are showcased right at the beginning of the album on folio 1a, consisting entirely of his work (see plate 1, and detail of plate 1 facing page 1). Thereafter, every page is a collage of sorts joining diverse materials in a unified but not seamless composition. On the contrary, the seams are highlighted by Kalender's handiwork: multicolored frames and margins that guide the viewer's eye and establish visual relationships between the materials. The varied origins of the collected artworks are emphasized by the way they are kept separate yet together by the frames, underlining the multiple styles and media comprising the album and pointing to the vast artistic traditions brought together under the sultan's gaze. The eclecticism that may have deterred previous scholars from finding meaning in the entirety of the album is the very quality that renders it meaningful. The striking visuals hold the viewers' interest over long periods of time and encourage sustained perusal as well as return visits—I have been thinking about it for nearly a decade with great pleasure, and it will be clear to readers that there is still more to learn from the *Album of the World Emperor*. This stunning album is reproduced in its entirety (including the doublure and binding) at the back of the present volume in order to simulate the full experience of viewing it. Readers can slowly turn the pages, compare different folios, move back and forth at their own pace, absorb the entirety of the album, and perhaps draw lessons not encompassed by the present study.

Study of the meaning and significance of this album is complicated by the fact that albums are not like books that have a beginning, middle, and end, with a linear narrative running through them. Rather, they are objects that encourage readers to flip back and forth, compare materials on different pages, and derive something new or different out of every encounter with the object. The *Album of the World Emperor* is no exception. Kalender's visual interventions encourage multiple traverses back and forth to compare pages and to trace potential narratives. And his preface, cited above, provides internal evidence that there is more than one way of enjoying an album. He mentions four modes in which the images were meant to be experienced: acquisition of wisdom, perfecting "the eye of learning by example" (in other words, both visual learning and connoisseurship), enlivening the mind, and giving pleasure to the inner self and the heart. The present study examines how the structure and contents of the *Album of the World Emperor* guide viewers toward these various forms of experience and interpretation.

The stylistic eclecticism of the *Album of the World Emperor* diverges significantly from the unified and imperial visual idiom previously developed by Ottoman artisans and courtiers in ceramics, textiles, architecture, and—eventually—illustrated manuscripts.[6] The sixteenth century was a period of self-definition and consolidation, after vast amounts of new territory had been conquered. The arts were an important component of the definition of Ottoman courtly identity. In addition to the visual sphere, a local imperial identity began to be expressed in literature and history written in Ottoman Turkish rather than Persian, and local inflections could be detected everywhere, in most aspects of cultural expression, from law to cuisine. However, the album's preface and contents demonstrate that Ottoman artists continued to experiment with new styles and subject matter and closely followed a variety of early modern artistic trends, from European costume books to Safavid single-page paintings to Mughal albums. While the effects of the first two are evident in the visual materials of the album, the latter is made obvious by the title, referring to the Ottoman sultan in terms also used at the Mughal court (*padishāh-i jahān*). Surely, Ahmed knew the regnal title of his contemporary, the Mughal emperor Jahangir ("world seizer," r. 1605–27), and his interest in painting and albums.[7] The album also includes at least two Mughal-inspired figures (see plates 32 and 51). While it is thus far impossible to demonstrate beyond a doubt Ottoman awareness of Mughal artistic production, the contents of the album, its title, and its principles of organization leave no doubt in my mind that Ahmed I's courtiers were not ignorant of album production at the courts of the Mughal rulers Akbar and Jahangir and the active role the Mughal manuscript studio played in crafting an idealized image for the Mughal emperor.[8]

The album thus points to the importance of viewing the artistic landscape of the early modern world as connected. The portability of prints, costume books, drawings, and calligraphic samples and the ease with which these materials crossed imperial and class boundaries is a crucial part of the story of the *Album of the World Emperor*: they made the eclecticism of the album possible.[9] The album's contents remind us of the existence of networks of collectors, patrons, and artists that were not necessarily delimited by imperial boundaries—Englishmen were collecting art in Istanbul; Ottomans were buying Safavid works of art or traveling to Isfahan to study calligraphy; and Safavid artists and calligraphers came to the Ottoman court.[10] The Ottoman and Safavid visual traditions grew out of a shared aesthetic past, and as is clear from this album, they were not entirely separate from each other even after a century of differentiation.

Cross-cultural exchange has been a topic of great interest to scholars in the fields of intellectual, religious, literary, economic, and art history in the past three decades. Various instances of Ottoman and Italian artistic interaction, in particular, have been studied, and the Mediterranean is now viewed as a zone of connectivity.[11] The Islamic world's trade and cultural connections with other parts of western Europe in the early modern period are well documented in recent studies.[12] Thus, the Ottoman court's wide-ranging collecting activities demonstrated in this album do not come as a surprise. They afford us the opportunity to examine in detail an instance of the interconnected globe we now understand the early modern world to have been. The evidence provided by the *Album of the World Emperor* suggests different modes of interacting with multiple aesthetic traditions, providing an alternative art historical model for those interested in cross-cultural exchange. In the Ottoman

case, such interactions had been ongoing since the fifteenth century, if not before.[13] There were a plethora of local models to consult that already derived from multiple visual modes.

Kalender the album maker, and his patron the sultan Ahmed I did consult these earlier models as they studied numerous examples from the vast collection in the Topkapı Palace treasury.[14] The album makes unmistakable references to older albums in the Topkapı, pointing to a conscious effort to define the album genre by replicating the types of materials collected in earlier examples.

Kalender and Ahmed modeled the *Album of the World Emperor* on early-sixteenth-century examples. The ensuing years, however, had produced very different materials in the Ottoman court. Illustrated works of Ottoman history, which were the main tools of imperial identity formation, with their self-consciously unified visual idiom, denied any dependence on foreign visual materials.[15] By contrast, in the *Album of the World Emperor*, the fresh models (be they European prints or single figures of urban types produced for an open-market, non-royal, local production, or Persian calligraphies) are incorporated into the album. The incorporation of European, Safavid, and non-courtly works alongside Ottoman courtly materials clearly based on such models in an imperial album carefully titled the *Album of the World Emperor* suggests that the album maker Kalender understood the Ottoman imperial style to now incorporate variety. The album is extraordinary for the extent to which it reveals a shift in Ottoman attitudes toward non-Ottoman and non-courtly artworks. The openness we witness in this album is reminiscent in some ways of the cosmopolitan court of Mehmed II, but it belongs to the early modern moment with its inclusion of the non-imperial and its attention to the urban context.[16] The openness in evidence here is an earlier manifestation of the *décloisonnement* attributed to eighteenth-century Istanbul by Shirine Hamadeh.[17]

This shift in attitude was partly a response to the vibrancy of urban life, new forms and spaces of entertainment in the city, and the broadened, more fluid art market that appears to have emerged toward the end of the sixteenth century, as far as we can tell from the visual and literary evidence.[18] New patrons appeared on the scene, and new subjects began to be explored in the paintings created in this period.[19] It must also be noted that the manuscripts and the albums created at this time point to the emergence of new ways of engaging with visual material and to shifts in image-text relationships in books as well as in albums.[20] This is not unrelated to the increasing use of independent images for entertainment and divination in the late sixteenth century.[21] These trends are directly relevant for the present study, because the sub-imperial materials collected in the *Album of the World Emperor* demonstrate significant overlaps between what was read and viewed in the palace and in the surrounding city. This newfound visual flexibility appears to be the result of a quest for a new way to visualize, just as the poetry of the period was seeking new forms of expression in the so-called new style (*şive-i taze / tarz-ı nev*).[22] The album at hand shows that precisely by looking at both older Islamic art forms and new materials from western Europe and from the urban context, the Ottoman court breathed new life into the arts. The simultaneous consideration of, and responses to, former models, and the articulation of novelties distinguishes this album from its precedents and connects it inextricably to the early modern moment.

The increase in album production and the accompanying openness to new forms of visuality are intimately connected to the social and economic developments of the

period, which included administrative, economic, monetary, legal, and cultural changes.[23] A market-oriented economy and increased social mobility brought people not from the military classes into the urban elite, resulting in the well-known growth of Ottoman cities in the period.[24] The city (as opposed to the court) became the locus of creative energy and the source of artistic inspiration.[25] The artistic changes discussed above are related to this influx of new consumers. Not only were these men rich enough to buy artworks, but they also brought a new sensibility to the market. They did not simply mimic courtly tastes; they instead brought other flavors to the court—hence the varied materials we find in the pages of the *Album of the World Emperor*. These social and artistic developments are not unique to the Ottoman Empire. The growth of cities and increased engagement in long-distance international trade were defining aspects of the age. A vibrant art market has long been posited for the Safavid capital Isfahan, and the presence of large numbers of European merchants, diplomats, and missionaries in the Safavid and Mughal empires has long attracted the attention of scholars.[26]

The album format (rather than the illustrated manuscript), allows for cross-cultural interaction to become visible, owing to its collection of various artworks. It is interesting to note that in addition to their newfound popularity in the Ottoman, Safavid, and Mughal empires, albums also became popular in seventeenth-century China, and that both the Ottoman and Japanese contexts also saw the rise of anthologies and personal collections of texts at this time.[27] This is not to suggest that these are connected phenomena, or that they are all the same, as surely the Chinese and Japanese literary and artistic histories are far different from the Ottoman or Safavid ones. But these parallels do beg the question of whether there is something about the early modern period that encouraged collections, juxtapositions, and excerpts. Perhaps the rise in popularity of these composite works is indicative of new attitudes toward historical materials, or are correlated with social changes. By the early modern period, there was a plethora of material in vernacular languages available to the new consuming publics. Add to this the interest in classifying and organizing demonstrated by costume albums and other intellectual products of the early modern period, and the rise of compilations no longer seems to be a mystery. Cemal Kafadar suggests that literary miscellanies and albums reflect emergent forms of urban entertainments and perhaps embody their form better than more classical long works.[28] They certainly seem connected to the invigorated urban context and with personalized, selective representation, an extension of the increased visibility of the individual author of creative works from the sixteenth century onward.[29]

The popularity of the album format, as well as the tightly connected world reflected in albums, inevitably brings up the issue of the early modern, a term that has now become almost standard in scholarship on the Ottoman Empire, but that is not without problems. Considering Ottoman history from the sixteenth century to the eighteenth as part of an early modern experience shared across Eurasia, indeed shaped by cross-cultural interaction, does offer interesting opportunities for fresh insights.[30] The "parallelisms" that helped Joseph Fletcher argue in 1985 for a shared early modern experience across the globe are still relevant for conceptualizing the period: population growth, a quickening tempo, the growth of "regional" cities and towns, the rise of the urban commercial classes, religious revival and missionary movements, rural unrest, and the

decline of nomadism.[31] Aspects of these can be found in the sixteenth- and seventeenth-century Ottoman Empire and form some of the background of the present study. Even more consequential was the emergent global trade network and increasing economic integration that Fletcher does not mention.[32] Valuable as it is to recognize the importance of the interconnectedness of the globe to the "early modern," it is also necessary to pay attention to the particularities of the Ottoman case so that we do not lose sight of its nuances and re-create a Eurocentric account.[33] In paying close attention to a specific source as I do in this study, I hope to strike just such a balance. The *Album of the World Emperor* is a local manifestation of the interconnected globe and is not a generic artwork that could have been made or appreciated anywhere in the early modern period. Rather, it is a very specific compilation anchored at the court of Ahmed I.[34]

Ahmed I and His Album

In the words of the late-seventeenth-century traveler Le Chevalier, when Ahmed I came to power, "the affairs of the Ottoman state were hopeless: internal war had destroyed the Asian provinces, women were the mistresses of the government, and the pashas had stopped being obedient."[35] This caricatured portrayal is similar to the stereotypical characterization of the post-Süleymanic Ottoman Empire in popular consciousness. The Frenchman's next sentence, however, reflects a perception that did not survive into the present: "In the middle of all these storms, a child came to power and dared to take the scepter, and the empire recovered its power."[36] The image of Ahmed I as a daring young ruler who asserted control over the empire and recovered its glory is created by the *Album of the World Emperor* and other literary, visual, and architectural products of Ahmed's court. The title of the album seems specifically designed to belie political setbacks and claims world dominance above all for Sultan Ahmed, similar in spirit to Le Chevalier's presentation of Ahmed in his travel writings.[37] We shall see in later chapters how these claims are visually advanced.

In order to understand what kind of an image is created for the ruler by his album, the first chapter presents an overview of Ahmed's reign. I pay particular attention to his admiration of his ancestors Selim I (r. 1512–20) and Süleyman (r. 1520–66) and his emulation of the Prophet Muhammad, both of which informed his behavior and are reflected in his poetry and library, also examined in the first chapter.[38] Ahmed ruled during a period of eschatological apprehension. The Islamic millennium, which corresponded to 1591–92 CE, had created significant anxiety and heightened expectations among believers and their rulers, leading in the Ottoman case to the presentation of a number of monarchs as messianic rulers. Erdem Çıpa, Cornell Fleischer, Barbara Flemming, and Kaya Şahin have convincingly shown that millenarian, messianic, and apocalyptic expectations surged during the reigns of Selim I and Süleyman I.[39] Millennial expectations affected the way Islamic rulers sought legitimacy in the early modern period. Many of them "styled themselves divine kings, millennial sovereigns, talismanic cosmocrators."[40] Ahmed came to the throne after the millennium had passed, yet eschatological anxieties still gave shape to political ideology. The album, I argue, eulogizes Ahmed as the Mahdi, "the Redeemer" who is expected by Islamic apocalyptic traditions to appear

before the end of the world as the last ruler. However, Ahmed's millennialism is rather different in flavor from that of his illustrious ancestors, who could claim multiple military victories before the much-anticipated millennium. Through a demonstration of intense devotion to the Prophet, which contained strong mystical elements, Ahmed's public persona laid emphasis on the connection between the Mahdi and the Prophet Muhammad. The overlaps between their names, Mahdi Muhammad, Prophet Muhammad, and Ahmed (which derives from the same Arabic root as Muhammad and was one of the names given to the Prophet) no doubt helped to foster this mapping. His claim was to the leadership of the Islamic world. The case of Ahmed I shows us that despite its persistent hold over the political imagination of rulers, the millennial image changed over time to accommodate new political realities.

Eschatological anxieties were no doubt related to the crystallization of religious identities across western Europe and the Islamic world starting in the sixteenth century. Among historians, this period has come to be referred to as the "age of confessionalization," implying both closer alliances between political and religious powers, and the concretization of differences between most creeds.[41] Taking their cue from Europeanists, Ottoman historians now view confessionalization as a useful heuristic for understanding the Ottoman state and society during the early modern period.[42] The tight embrace of Sunni Islam as state policy by the Ottoman dynasty in the sixteenth century very much influenced the kind of ruler Ahmed aspired to be, the Mahdi who would lead all Muslims. The *Album of the World Emperor* presents him as such. The full meanings of the album are revealed when we make space for religious, imperial, and aesthetic readings that are historically grounded in the specificities of the age.[43]

My analysis of Ahmed's artistic patronage in chapter 2 is intended to situate the *Album of the World Emperor* in a fuller context and demonstrates the consistency of various themes: an interest in eschatology and history coupled with fascination with the popular and the urban. These are expressed through a contemporary aesthetic, with an eye toward the demonstration of artistic discernment. This chapter, by examining Ahmed I's wider patronage of art and architecture, which have never been examined together, prepares the way for a detailed discussion of the album's contents.

The last four chapters focus on the album exclusively. Chapter 3 examines its aesthetic dimensions, paying particular attention to Kalender's tactics for moving the viewer through the album, and situates the contents of the album in the larger artistic context of the seventeenth century by considering literature and albums beyond the Ottoman court. Kalender's deliberate aesthetic interventions showcase the new tastes of seventeenth-century Ottomans. With visual quotations, references, and repetitions, Kalender encourages a kind of viewing he refers to as "the contemplative gaze" and privileges comparative looking. His masterful illuminations and paper joinery help to bring out relationships between artworks, direct the viewer's attention where he wants, and are nothing short of extraordinary visual creations. Kalender's calligraphic choices are examined in chapter 4, which tries to understand the significance of the exclusive use of the *nastaʿlīq* script for the poetic excerpts in the album. Generally associated in scholarly imagination with the Safavid court, the *nastaʿlīq* script was also, as is demonstrated by the *Album of the World Emperor*, very much adopted into the Ottoman canon

long before the eighteenth century, the date traditionally understood as the adoption of nastaʿlīq by Ottoman practitioners.

Perhaps the largest share of the album consists of urban imagery, which is explored in the fifth chapter in the context of social developments as well as Ahmed's personal interests. The colorful human geography in the album is enhanced by public entertainment scenes that demonstrate a growing interest in the urban context. This focus is partly a reaction to the rapid social changes happening throughout the empire in the seventeenth century, but that are most obvious in the social and cultural context of Istanbul. However, the images examined here also represent the palace's growing interest in the art and literature produced in the city, some of which was destined for European visitors. The final chapter takes up the European prints currently in the Metropolitan Museum of Art in New York that were originally, in my opinion, part of the *Album of the World Emperor*. These prints, with their Christological and mythological subject matter, force us to consider the album as a collection of the images of the last days and suggest Ahmed as the emperor to rule over the end times. Their eventual excision from the album makes the Sultan as Mahdi argument much more difficult to reconstruct, begging the question as to whether they were taken out so as to soften that point. We will probably never know.

Each chapter can be understood as a rotation of a kaleidoscope, providing a different view of this multivalent and complex artwork. In the following section, I would like to evoke for the reader what it would have been like to consult this album in the seventeenth century, providing, I hope, a window into its reception and an explanation for why the intellectual, religious, literary, and political background of Ahmed's court needs to be understood in order for the album to be appreciated in its full complexity.

Viewing the Album

The term used for albums in the Perso-Islamic world is *muraqqaʿ*, meaning "patched," such as a patched garment, and is used for albums to evoke their patchwork or collage-like character.[44] These bound collections of calligraphy, painting, and drawing were conceptualized in widely different ways but were usually meant to preserve and display previously loose materials.[45] The earliest extant albums date to the Timurid courts of the early fifteenth century, and their popularity as an art form increased in the second half of the sixteenth century. Over this period, album production seems increasingly to be considered a creative endeavor and not merely an act of collecting.[46] A number of albums were made in the sixteenth century that through their prefaces and contents told histories of art, connecting works to each other through a pedagogical chain, and in one case juxtaposing different traditions of depiction. These albums also contain prefaces that gesture toward explaining the rationale for the collection and juxtapositions within them, revealing the notions of art history and aesthetic principles embodied by albums. Yet a defined genre, with conventions of display and contents only appears to emerge during the later seventeenth and eighteenth centuries, in the Mughal and post-Safavid Iranian contexts.[47] Over time, albums took on a more sophisticated conceptual character that was expressed in their physical form. The *Album of the World Emperor* seems to call

for the dating of this phenomenon—the development of a well-defined album genre, or a certain consensus on what an album looks like—to be moved earlier, to the early seventeenth century.

Art historians have focused more of their efforts on Mughal and Safavid albums and their later counterparts than on Ottoman albums.[48] Although much work remains to be done, we learn from recent publications that album making at the Ottoman palace started during the reign of Mehmed II or his son, Bayezid II, soon after albums gained in popularity at the Timurid court, perhaps as a response to these.[49] In parallel fashion to Persian albums, Ottoman albums were originally courtly productions. In the late sixteenth century, non-courtly collectors emerged onto the cultural scene as album patrons.[50] By the eighteenth century, collecting and album making were widely shared Ottoman cultural pursuits.[51]

The earliest Ottoman album, known popularly as the *Baba Nakkaş Album*, contains calligraphies mostly from the court calligraphers of Mehmed II.[52] This appears to have been followed by two early-sixteenth-century albums, Topkapı H 2153 and H 2160, which were examined by Kalender and Ahmed and served as inspiration for the mixture of materials one finds in the *Album of the World Emperor*. Gülru Necipoğlu has recently attributed these albums to Ottoman production at the court of Selim I in the early sixteenth century and underlined the exotic nature of the materials collected and juxtaposed in them, suggesting that they demonstrate a meditation on aesthetic differences via symmetrically composed bifolios.[53] Albums from the reign of Süleyman demonstrate a decidedly Persianate aesthetic in their calligraphic contents but also help to trace the development of the Ottoman visual idiom, especially the *saz* style.[54] The same can be said of two albums made for his grandson Murad III and great-grandson Mehmed III.[55] Although Ottoman albums appear to always have contained non-Ottoman artworks, and therefore did not fit fully into the Ottoman visual idiom, they were not intended so much as imperial propaganda but rather highlighted the aesthetic discernment of their patrons above all else. Other works, such as illustrated histories, were the preferred mode of political legitimation and imperial image formation. Further research is required to understand these earlier albums better.

In addition to imperial Ottoman albums, the Topkapı treasury also contained a number of Persian albums that were either given as diplomatic gifts or collected as war booty. The *Album of the World Emperor* appears to consciously reference the history of Ottoman and Persian album making represented in the treasury in its preface and contents, to be explored in later chapters. It also, despite, or perhaps because of, its eclectic contents, presents a uniquely Ottoman album that diverges from its immediate predecessors at the same time as it responds to them. This suggests that Kalender was well aware of working within a tradition of album making.

Albums were viewed in literary gatherings (*majālis*; sing., *majlis*), where they (or books, or paintings, or calligraphic samples, or anthologies) would be the center of conversations and would be used as props in an oral intellectual exchange, providing opportunities to show off one's aesthetic discernment.[56] As we can tell from the way images are at times pasted onto album pages with different orientations, the audience would gather around the codex, sometimes moving around it, sometimes turning it. They would

undoubtedly have had conversations about what it was they were looking at and discuss the visual characteristics of the images, the qualities of the calligraphy, and the use of colors or different inks. Comparisons would almost certainly be made to works of art that were not in this album, perhaps referencing other albums. The *Album of the World Emperor* also contains what can be considered humorous or puzzling images. Humor is something one enjoys in the company of friends: it is a social experience.

By using unusual, exciting works of art, establishing ambiguous and changing visual relationships among works on a single page, evoking contemporaneous practices of comparison and imitation, and juxtaposing word and image to create fluid thematic and visual relationships among the folios, Kalender created an album that would yield multiple lessons to those who looked at it with the "scrutinizing gaze." His tactics appeal to the connoisseur's careful eye, reminding us that this album was intended for a limited audience of courtiers whose training and acculturation would have sensitized them to such aesthetic notions. As these connoisseurs leafed through the album, they would come to appreciate the visual play and the connections set up by Kalender, as well as to admire the precision of his paper joinery and illumination work. As they took stock of the full contents of the album, they would be dazzled by the wealth of materials, the variety of figures, and the diverse visual formulas that anchor these disparate works of art in the album. Dazzlement, or wonder, then would lead the viewers to a heightened state of consciousness where they could get to higher truths.

In order to fully grasp the meanings of an album, especially one as complex as the *Album of the World Emperor*, one would need to spend significant amounts of time with it.[57] The relationships across its pages take time to identify and understand, and multiple traverses seem necessary to retain the memory of its contents and recall images from different pages when viewing others. Yet quick glances at single openings also clearly bear fruit; Kalender has incorporated enough material on almost every page to serve as the center of an exchange between viewers assembled in a majlis. In other words, different audiences would have access to different levels of meaning. Those allowed to spend time with the precious object more than once or for longer periods would have access to the more sustained narratives and messages contained in the pages. These people would probably be the intimate companions of the sultan who were in his audience in a repeated fashion.

Zeynep Tarım Ertuğ writes that sultanic majālis—the contexts in which an album such as this one would be viewed—usually took place in one of the pavilions in the Topkapı Palace's gardens or in one of the small kiosks forming part of the inner palace grounds, either after the midday meal or following evening prayers.[58] The pavilion Ahmed I added to the Topkapı, with poetic verses still gracing its walls, was likely one of the contexts in which this album was examined.[59] One can also imagine this album being enjoyed at the countryside feasts that accompanied hunting expeditions that Ahmed was so fond of. Indeed, the many outdoor leisurely scenes in the album allude to just such a context.[60] Artists may have been in Ahmed's very large retinue on these trips. It is not at all far-fetched to imagine that they might have brought artworks with them, too. Alternatively, images created during such outings—as Ahmed's personal prayer leader and the chronicler of his reign, Mustafa Safi (d. 1616), verifies—would be

incorporated into albums such as this one, to be enjoyed later as mementos of those shared moments.[61] Musicians, storytellers, and other entertainers would also be present at these intimate gatherings. Poetry and album viewing were by definition social endeavors, done with company, however intimate. It is clear from the writings of late-sixteenth-century Ottoman intellectuals like Mustafa Âli that authors consciously wrote for a small, intimate audience that would not just be reading works in isolation but would be discussing them in gatherings.[62] Thus, the contents of the album would be viewed in juxtaposition to other poems and tales that would be shared in these circles, which also served as places for the elite to demonstrate, or perform, their elevated status by means of their responses to the artworks under discussion.[63]

Albums are decidedly multivalent objects that contain multiple readings. This derives partly from the contents of the album that were originally created for other contexts or as freestanding artworks. The juxtaposition of different texts and images on album pages often suggests relationships of meaning but does not fix those relationships, leaving open the possibility of multiple interpretations.[64] This is especially true of images that are not narrative, such as portraits or depictions of types, which are more open to interpretation. Such images make up the majority of the contents of the *Album of the World Emperor*. One might raise the question of whether the album holds together at all as a carrier of meaning. Kalender's careful work in organizing, joining, and illuminating the folios, the consistency of his aesthetic interventions, and the deliberate nature of his visual tactics certainly suggest that the *Album of the World Emperor* was an intentionally multivalent artwork compiled to communicate its messages to select audiences.

Sultan Ahmed I

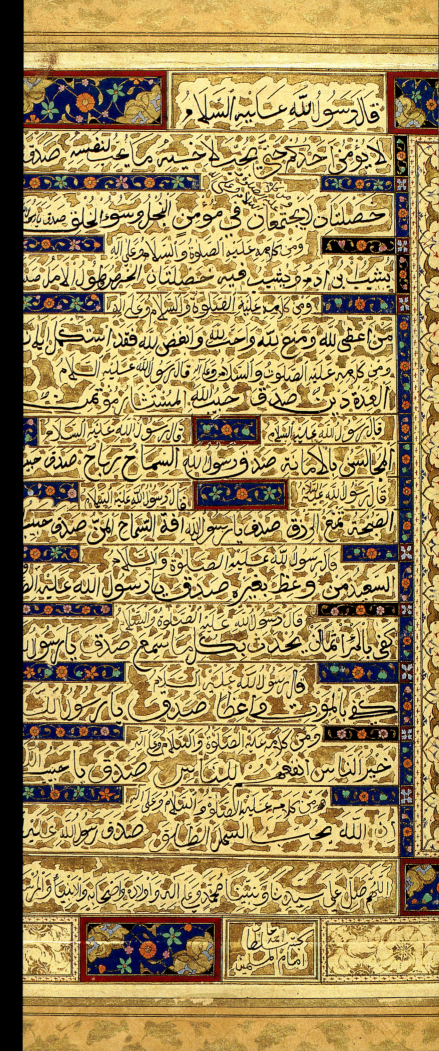

Prince Ahmed's father, Mehmed III, died rather unexpectedly in the Topkapı Palace on December 20, 1603. Ahmed was the elder of his two surviving sons, and since his younger brother was only four, he had no rivals for the throne. According to the historian Hasan Beyzade, who witnessed the event, on the morning of December 21, the deputy grand vizier, Kasım Pasha, received an imperial decree delivered by the chief eunuch of the harem, as the imperial council was preparing for a meeting. He could not read the handwriting, and could only work out the words "my father." This did not make sense to him, as the present sultan's father was long deceased. He asked Hasan Beyzade, who was also in attendance (and had a reputation for deciphering difficult texts), to read it for him. The note read: "You, Kasım Pasha! My father has gone by God's will and I have taken my seat on the throne. You had better keep the city in good order. Should sedition arise, I will behead you!"[1] This was the first instance in which an Ottoman sultan simply sat on the throne, all by himself, and claimed it as his own. Previous practice had almost always entailed keeping the death of the sultan a secret until the heir apparent could be alerted. The new sultan would then hasten to Istanbul from his provincial posting and claim the throne in a ceremony under the watchful eyes of the imperial council, who would be the first ones to congratulate him. Ahmed was the first sultan to simply emerge from the palace, never having been assigned a provincial post. It is tempting to view his sitting on the throne without waiting for the presence of the grand vizier or any other administrators as the capricious behavior of a child, which at the age of thirteen, Ahmed still was.[2] He had not even been circumcised yet. Beyzade's reference to the illegible handwriting might very well be a reminder of the sultan's youth. Ahmed's handwriting improved in legibility by the time he wrote out the page of hadith included in his album and discussed below, but he was certainly no calligrapher (see detail of plate 10 on page 12). That he appreciated good calligraphy, however, is one of the implicit claims of the *Album of the World Emperor*. His accession was not the only unusual aspect of Ahmed's rise to the throne; it only marked the extraordinary beginning.

Ahmed's note to Kasım Pasha reflected anxieties that were both specific to him and shared by his ancestors: at the accession of each sultan, the ties that bound the Ottoman state were loosened, all appointments had to be remade and confirmed, and commotion frequently broke out in the capital. Each accession called for the reestablishment of imperial order, and each sultan had to prove himself anew.[3] Those who came before Ahmed had earned their legitimacy on the battlefield, oftentimes fighting their brothers for the throne; had established households for themselves while serving as provincial governors; and had secured the allegiance of the military. This was not the case for Ahmed, which posed a significant challenge as he established himself on the throne. The young sultan chose two important ways to create an air of legitimacy and fashion an idealized image of himself. He looked first to Ottoman history and modeled his image on those of his renowned ancestors Selim I and Süleyman I, thereby seeking legitimacy in dynastic tradition.[4] He also turned to the example of the Prophet Muhammad and emulated his deeds to create an aura of piety and personal devotion that bordered on the mystical. The blending of these two sources of legitimacy, the Ottoman and the Sunni, had come to define ideal rulership by the end of the sixteenth century. The many advice books presented to Ahmed and examined later in this chapter provide insights as to why Ahmed turned to these past models.

Ahmed's Challenges

The first two decades of the seventeenth century were politically and militarily tumultuous. At Ahmed's accession, the Ottoman Empire was in the midst of war with the Habsburgs (1593–1606) and the Safavids (1603–12), and there were ongoing rebellions extending from Bursa to Aleppo known as the Celali rebellions. Numerous uprisings took place in Istanbul during the years before his accession, and in other urban centers (notably in Cairo in 1609) early in his reign.[5] Although the Habsburg war ended in 1606 with a treaty, this was no great victory. The Ottomans were allowed to keep the territories they had conquered, but they agreed to address the Habsburg emperor as "Emperor" and not simply king, according him equal status with the Ottoman ruler for the first time.[6]

The Ottoman-Safavid political competition was a defining factor during the reign of Ahmed I, as long-standing rivalries intensified between the two empires, which both claimed universal rulership and had been engaged in confessional competition for a century.[7] Wars lasted from 1603 to 1612, and again from 1615 to 1618, and did not end with victory.[8] By 1612, the Safavids had managed to gain back the territories they had lost in 1590. Ahmed had a formidable foe in the Safavid Shah ʿAbbas (r. 1587–1629), who sought to make alliances with European powers against the Ottomans and enriched his empire through investments in long-distance trade and exports. He fashioned a new standing army and made significant efforts to centralize and personally control the economy, the religious power structure, and the military.[9] ʿAbbas moved the capital to Isfahan, which he rebuilt to represent paradise on earth, enhancing his image as a messianic ruler. ʿAbbas's clerics formulated a particular Persianized Shiʿi framework of legitimacy for him, which helped him to assume the place of the Hidden Imam, known as the Mahdi in the Shiʿi tradition.[10] Like Ahmed, Shah ʿAbbas used artistic and architectural commissions to solidify this image.[11] As a result of the Ottoman-Safavid confessional rivalry and its related military clashes, numerous scholars from the border lands between the two empires, especially the Kurdish regions, moved into the Ottoman Empire, reinvigorating Ottoman intellectual life. Some of the strongest anti-Shiʿite polemics of the period were written by these Kurdish scholars.[12]

Simultaneous with the external challenges posed by the Safavids and the Habsburgs, population pressures in the countryside, changing economic balances resulting from the influx of silver from the Americas, and the accompanying sharp price increases resulted in the Celali revolts that shook up the Ottoman Empire from the 1590s onward.[13] The Celali rebellions were suppressed with brutal measures by Ahmed's deputies in 1609, but not without significant concessions and vast devastation in the countryside. The military engagements on the eastern, western, and internal fronts kept the administration and treasury preoccupied for most of Ahmed's reign. Despite all this military activity, there were no significant territorial gains or victories under Ahmed I, which meant that it was more difficult than ever to claim legitimacy or power as a ghazi, or warrior for the faith.

Rhoads Murphey hypothesizes that an "atmosphere of apocalyptic doom" must have hung over the Ottoman court during Ahmed's early years.[14] The apocalyptic mood must have been enhanced by a number of facts that at the time might have seemed to threaten the very viability of the House of Osman. The first Ottoman sultan not to have

been appointed as a provincial governor prior to acceding to the throne, Ahmed was unusually inexperienced. He was also the youngest—so young that he was circumcised after his accession to the throne.[15] He had no children yet and still needed to prove that he could ascertain the continuity of the Osman dynasty, which, for the first time since the Central Asian warlord Timur's devastating campaigns into Ottoman territory in the early fifteenth century, probably seemed on the verge of extinction.[16] This was also a period of plague and smallpox. Ahmed became very ill twice during the first two years of his reign. One plague outbreak between October 1607 and January 1608 killed thousands of people in the city, including members of the elite.[17] The wars, the rebellions, the dynastic succession issue, the frequent outbreaks of disease (not to mention economic problems) must have made for a nervous beginning to Ahmed's reign.

Not having served as a provincial governor, Ahmed did not have the opportunity to form a loyal household around himself that would then accompany him to the Topkapı and form the core of his administration. He found other means of gathering a loyal inner circle that would help him succeed as a ruler. Empowering palace insiders at court was one way in which the dynasty countered the power of the military elite and the religio-legal classes during the late sixteenth and the early seventeenth centuries.[18] During the first few years of his reign, Ahmed was under the guidance of his mother, Handan Sultan, and the royal tutor, Mustafa Efendi.[19] With their deaths in 1605 and 1608, the chief gardener, Derviş Agha (promoted as grand vizier in 1606, but then executed later that year), and the chief eunuch of the harem, Hacı Mustafa Agha (d. 1624), rose to prominence. The chief eunuch was an appointee of the sultan's mother. He had been a palace eunuch during the reigns of Murad III and Mehmed III but had been exiled to Egypt. He was recalled by Handan Sultan when Ahmed rose to the throne and was appointed as a *muṣāhib*, a companion to the sultan. He then became chief eunuch in late 1605, and was thereafter the sultan's agent in numerous arenas, including the commissioning of artistic projects and the promoting of artists. Hacı Mustafa Agha remained a prominent power broker at the Ottoman court throughout Ahmed's reign and beyond.[20] He was the most important patron of Kalender.

Despite his youth and inexperience, after about two years on the throne, Ahmed seems to have come into his own as ruler. As of 1605, he was holding regular meetings with his viziers, and around 1608 had established a personal hold over the business of rule. A gruesome assertion of his own will and demonstration of his haughty personality are the various decapitations Ahmed ordered during the first two or three years of his reign. Ottavio Bon, the Venetian ambassador to Ahmed's court, described him as "impressionable, hot-tempered, bloodthirsty and reckless."[21] The English ambassador Lello's report cites the killing of Kasım Pasha, Sarıkçı Mustafa Pasha, and Derviş Pasha on the sultan's orders—either by his hand, or in front of him—and the display of the bodies either outside the palace or outside the first courtyard, as proof of the cruelty and impetuousness of the sultan.[22] We can add to these the harsh measures his deputy Kuyucu Murad Pasha took to suppress the countryside rebellions.[23] These appear to be steps toward asserting power and performing retributive justice, perhaps deemed necessary because of the difficult circumstances in which Ahmed came to power.

The anxieties and upheavals recited here were accompanied by vibrant life in growing urban centers, new forms of socialization and creativity, and deepening commercial

ties between the Ottoman Empire and the world around it, which brought all sorts of goods and people into the capital city. Ahmed's reign was a time of increased economic engagement with Europe, which could be felt on the streets of Istanbul. Trading privileges for the English, the Venetians, and the French were renewed early in Ahmed's reign—the Venetians and the French in 1604, and the English in 1606. In 1610, the sultan finally decided to grant favor to the Dutch and allow them to trade under their own flag in Syria and in other parts of his empire.[24] In 1612, they were allowed to trade throughout the empire. Correlated with the expanding European trade network and confessional dynamics within Europe, this was a period of greater and more varied Christian presence in the Ottoman Empire, with the first Jesuit mission appearing in Istanbul in 1608, and other missionary groups entering the stage.[25]

The vibrancy of his capital seems to have inspired Ahmed to be as present as possible in the city. His reign is remarkable for the abundance of public ceremonies organized by the palace. This young monarch took every opportunity to stage a public celebration or parade, and in this way, he was similar to his renowned ancestor Sultan Süleyman, who took full advantage of the possibilities of ceremonial to stage performances of power and majesty for the populace, conveying the imperial agenda to local and foreign viewers alike.[26] The relatively reclusive lifestyles of the sultans between Süleyman and Ahmed, especially of Murad III, who ruled for twenty-one years and almost never left his palace, meant that when Ahmed appeared on the streets of Istanbul, it was once again a novel sight. A few examples will suffice to provide a sense of the variety and frequency of these public celebrations: On October 11, 1606, there was a celebration to mark the peace treaty with the Hungarians.[27] The Prophet Muhammad's birthday (*Mevlūd*) was introduced as a new public festival to be celebrated at the Sultan Ahmed Mosque, beginning in 1610, long before the building was completed in 1617. During 1611 and 1612, Ahmed's daughters Ayşe and Gevherhan were married to the courtiers Nasuh Pasha and Mehmed Pasha with great public pomp and circumstance.[28] Similar public ceremonies and processions were organized around Ahmed's departures for hunting trips in 1613 and 1614 and upon his return to the capital in 1612. The year 1613 also brought about a feast celebrating the circumcision of the sons of various viziers, celebrated on floats on the sea.[29] In 1617, the closing of the Sultan Ahmed Mosque's dome was celebrated with a procession from the Topkapı Palace and the raising of tents in front of the mosque, an entirely novel type of festivity.[30]

Certainly, the increased importance of the city and of urban populations, as well as the series of urban revolts that took place in Istanbul before Ahmed's reign, must have encouraged the sultan to assert his physical presence there.[31] The staged appearances were complemented by impromptu excursions out of the palace, which also suggests a personal interest in the life of the city. Ahmed's love of Istanbul is signaled in a ghazal he composed in praise of the city of Edirne. He writes that Edirne is such a priceless city, but still nothing in this world is a match for Istanbul, and although Edirne's quinces are good, they are not as good/beautiful as Istanbul's juicy peaches.[32] Notwithstanding the sexual undertones of the poem, the young sultan's preference for his capital city evident in these lines might also explain a desire to see the life of the city, and be present in it, whether for its peaches or other beauties on offer. During the first few years of his reign,

Ahmed often left the palace in the company of Derviş Pasha; together they inspected markets and streets, punished wrongdoers, sailed in the royal barge, and hunted.[33] Later on, he seems to have done so with his personal imam Safi Efendi and others, to participate in holiday prayers as a lay person, to carry out inspections, and to hear the views of his subjects on various matters.[34] Another way to be visually accessible was to participate in hunts outside the palace, which Ahmed frequently did. He staged elaborate hunts that lasted for weeks, which also included opportunities for feasting and reveling.[35] As a result of all these outings, Ahmed became a monarch who was much more visible than his immediate ancestors had been.

Crafting the Ideal Sultan: Lessons from Ottoman History

In political discourse and official historiography of the late sixteenth and the early seventeenth centuries, the Ottoman rulers' moral qualities and genealogy had come to dominate as legitimating factors over their military deeds. The emphasis on genealogy was correlated with contemporary political thought, in which the whole dynasty was characterized as being chosen by God.[36] Imperial rituals, such as the visitation of dynastic tombs at the accession of a new sultan, or the commemoration of past sultans through their royal caftans in the treasury, became outward expressions of this emphasis on the dynasty as a whole.[37] In parallel fashion, a strong notion of legacy and order had developed in imperial traditions and dominated the visualization of the Ottoman ruler in artworks.[38] The *Album of the World Emperor*, with its inclusion of the full series of Ottoman imperial portraits and the narrative images of the Ottomans' ancestors, continues the emphasis on the sultan's long line of royal ancestors. The visual evidence from the other works of the period, described in the next chapter, also points to this. The emphasis on ancestry was not limited to the visual realm: after his accession, Ahmed visited the tombs of his ancestors in Istanbul, beginning the process of inscribing himself into the Ottoman dynastic tradition.

As an extension of the Ottoman exceptionalist attitude that saw the Ottoman dynasty as chosen, Ottoman political writers came to increasingly idealize previous Ottoman rulers and to present them as examples to be emulated, replacing heroes of the ancient Perso-Islamic past, who had historically been the models of ideal rulers for Islamic monarchs.[39] Sultan Süleyman came to be exulted as a particularly apt model for the Ottoman rulers who came after him.[40] Ahmed too chose to emulate this great ancestor. He was certainly not the first to do so, but it was not until Ahmed's reign that such grand public gestures as the building of a mosque similar to the Süleymaniye (discussed in detail in the next chapter) or the issuing of a new law code closely modeled after one issued by Süleyman and aiming to revert some current practices back to the condition they had enjoyed during Süleyman's reign—were undertaken.[41] Just as Süleyman's architectural commissions, like the Süleymaniye mosque or his renovations of the Dome of the Rock, had played a large role in crafting his public image, so Ahmed harnessed the power of such patronage. The Sultan Ahmed Mosque is in many ways built to evoke the Süleymaniye and was the first sultanic mosque to be built in Istanbul since the Süleymaniye was completed in 1557.

According to the Venetian *bailo* (chief diplomat) Simone Contarini, Ahmed read all the histories of Süleyman and tried to imitate, even to surpass him in his actions. The Englishman Paul Rycaut wrote that many of Ahmed's officers hoped that he would start his reign by conquering Malta, as Süleyman had started by conquering Rhodes.[42] A comparison between Süleyman and Ahmed indeed seems to have been set up by those close to him. It is certainly a theme running through Ahmed's personal imam Safi Efendi's *Zübdetü't-tevārīḫ* (Quintessence of histories), a eulogistic account of Ahmed's sultanate.[43] Anecdotes from Hasan Beyzade's contemporaneous history and from the later seventeenth century *Seyāḥatnāme* (Book of travels) of Evliya Çelebi attest to the ongoing comparison made between Ahmed and Süleyman by influential contemporaries such as Üsküdarlı Aziz Mahmud Hüdai, one of the most powerful Sufi shaikhs of the time (and a man to whom Ahmed was devoted), and by shaikh al-Islam Sunullah Efendi.[44] Ahmed's efforts were recognized by those around him, who wanted to see the similarities between him and the great Süleyman.

Contemporaries also saw similarities between Ahmed and Selim I. Safi in *Zübdetü't-tevārīḫ* points to Selim's conquest of the two holy cities (Mecca and Medina) and his great victory against the Safavids as reasons for their similarity, and credits Shah ʿAbbas with the idea that Ahmed and Selim shared the same nature.[45] Ahmed renovated the sanctuaries in Mecca and Medina in 1611, which Safi interprets as symbolic re-conquests. War with the Safavids, whom Selim had defeated in a decisive victory in 1514, was a constant issue during Ahmed's reign. Moreover, Selim's reign was peppered with the suppression of Kızılbaş sympathizers—part of what gave him the epithet of "Grim." This was echoed in the suppression of Celali rebels, with whom Ahmed's lieutenant Kuyucu Murad Pasha dealt so decisively. Perhaps Ahmed's cruel decapitations discussed above also served to bring his image closer to that of Selim's, whose cruelty accentuated his image as a warrior. Sufficient parallels existed to make Selim an attractive model. The prevalence of the images of Selim in the *Album of the World Emperor* and in other artworks made for Ahmed discussed in the next chapter, along with Safi's underlining of the similarities between the two suggests that Selim was indeed one of Ahmed's models.

A cyclical view of Ottoman history and the understanding that rulers from different periods shared certain characteristics is already evident in late-sixteenth-century textual accounts and books of imperial portraiture.[46] Safi's comment (cleverly attributed to Ahmed's foe, Shah ʿAbbas) that Ahmed and Selim shared the same nature is a further reflection of such a view. However, Ahmed could not claim to imitate Süleyman or Selim's military victories. While there were a few around him who encouraged him to go to war, when the young sultan hastened to leave the palace for campaign, he was held back by those close to him on numerous occasions. Süleyman's image as a pious and just ruler and Selim's as defender of Sunni Islam were the most accessible to Ahmed. These were also attractive characteristics in the context of the seventeenth century, when rulers throughout Eurasia prioritized their confessional allegiances and when an image of religious leadership—oftentimes an apocalyptically tinged, messianic leadership—had become expected.[47] In this context, it will be useful to consider Ahmed's imitation of the Prophet Muhammad to see how he personalized messianic leadership.

Crafting the Ideal Sultan: Lessons from Islamic History

Today Ahmed I is remembered first and foremost as a pious ruler,[48] and we owe this characterization, above all, to Safi Efendi.[49] The first volume of Safi's *Zübdetü't-tevārīḫ* includes nine sections on sultanic virtues: "Justice," "Probity and Honesty," "Piety," "Reason and Intelligence," "Modesty and Humility," "Generosity and Magnanimity," "Charitable Building Program," "Bodily Vigor and Skills in Horsemanship and the Hunt," and finally, "Valor and Bravery." In addition to being the main subject of one section, Ahmed's piety is an undercurrent throughout the text. The building of the Sultan Ahmed Mosque is presented in the "Charitable Building Program" section, for example, as the most visible and public gesture of the sultan's piety.[50] In pages describing events such as outings or hunts, Safi emphasizes time and again how the sultan never missed a single prayer no matter where he was and how careful he was to pray with a congregation, even for the morning prayer, which Ottoman sultans had customarily performed in private. He repeatedly directs the discussion to piety.

The sultan's magnanimity is also described to support a pious image: Safi enumerates Ahmed's smaller acts of generosity, which went a long way toward improving the lives of his subjects.[51] In his discussion, Safi recounts the amount of money Ahmed spent on renovations at the Kaʿba, the jewels he sent there, and the kinds of treasures that were brought to Istanbul from the two holy cities during the renovations as proof of Ahmed's devotion to Mecca and Medina and of how seriously he took his role as the "Servant of the Two Holy Cities."[52] During Ahmed's reign, on special occasions, the fabric covering of the Kaʿba, which was usually produced in Cairo, began to be made in and sent from Istanbul, tying the ruler even more closely to the holy cities of Islam and strengthening his image as a pious sultan.[53]

The picture of piety that Safi paints places particular emphasis on the emulation of the Prophet Muhammad. He takes every possible opportunity to highlight the parallels between Sultan Ahmed and the Prophet.[54] Moreover, as Rhoads Murphey points out, Safi implies that Ahmed is the divinely appointed ruler (*al muayyad min ʿind Allah*) and the lord of the auspicious conjunction (*ṣāḥib-ḳirān*). He goes so far as to suggest that the ideal ruler should model his personal behavior on the *sunna* of the Prophet Muhammad and the example of his immediate successors, the four caliphs.[55] The myriad examples Safi gives of Ahmed doing so enhance his overall eulogy of the young sultan.

Safi's formulation of the ideal ruler was in tune with Ottoman state policies, which by the early seventeenth century had come to prioritize Sunni Islam. Ottoman Sunnitization was the result of a gradual process in which the religio-legal classes were empowered in Ottoman lands, becoming vocal participants in the determination of state policy and local administration.[56] An active building program of mosques and charitable complexes was sponsored by the elite to create physical spaces throughout the empire in which Sunni Islam could be practiced, taught, and spread. Built in a recognizable Ottoman architectural idiom, these buildings helped to mark Ottoman territories.[57] This was accompanied by the increased importance of piety and religious legitimacy in the conceptualization of the ideal Ottoman ruler.[58] In 1593–94, the court historian Talikizade listed the Ottoman sultans' adherence to Sunni Islam as the number one characteristic that rendered them superior to all others, suggesting that the Ottoman rulers' self-image

had evolved to privilege their religious roles. Second on Talikizade's list is the inclusion of Mecca and Medina in the Ottoman Empire, which gave the rulers the right to the title "Protector of the Two Noble Harams."[59]

The Sunni identity of the Ottoman dynasty was formulated in response to the appearance of their Shiʿi-Safavid competitors to the east and the intense rivalry between the Habsburgs and the Ottomans, both during the sixteenth century.[60] The incorporation of the Holy Lands of Islam into the empire in the early sixteenth century no doubt also encouraged a religious identity. Given the variety of ethnicities and languages now living in the Ottoman realm, Sunni identity might also be viewed as a unifying characteristic for large portions of the Ottoman population. Another factor that no doubt encouraged this development was the larger early modern context in which Islam and Christianity, and their respective subdivisions, came to be more sharply defined against each other as rulers started to collude with religious authorities on a more regular basis, bringing the state and the faith in an ever-closer relationship.[61]

The Ottoman ruler was certainly not without agency in the face of these general trends; therefore it is important to pay attention to the specifics of Ahmed's pious image. To a certain extent, the young sultan continued previous practice. His ancestors had cultivated differing religious roles, and he followed suit. The memory of Selim I in Ottoman historical consciousness was that of a "divinely invested messianic conqueror."[62] It was his conquest of Egypt that had put an end to the Abbasid caliphate and had given the Ottomans the right to that title. The Ottoman sultan as the caliph of God was an image refined throughout Süleyman's reign. While as early as 1525 he was hailed as the caliph of all Islam, he was later presented as a militarily configured renewer (Mahdi), but later in his reign, he came to be lauded for his piety and universal justice.[63] His renovations at the Dome of the Rock and in Jerusalem bear inscriptions that praise him as caliph of God and the second Solomon, and have strong eschatological undertones.[64] Political discourse during Süleyman's age increasingly had a Sufistic tinge, which also came to influence the notion of the ideal ruler.[65]

The Sufi emphasis in Ottoman political thought would only increase under Murad III, during whose reign devotion to the Prophet Muhammad became a central aspect of sultanic piety. Among the works created for Murad III, the *Siyer-i Nebī*, a six-volume illustrated biography of the Prophet Muhammad, was a concerted effort on Murad's part to engage in pious acts that would help identify him as the "renewer" (*müceddid*) of the faith for the new millennium.[66] Murad was a follower of the Halveti path, an order that had been closely associated with the Ottoman house since the early sixteenth century, and the most popular Sufi order in Istanbul, perhaps for its support of Sunni Islam against Shiʿi Iran during the sixteenth century.[67] Its members actively propagated what has been called state-Sunnism but at times came under suspicion and attack because of their roots in Iran.[68]

Emulating the Prophet Muhammad aligned with the Sufi concept of the "perfect man" (*insān-ı kāmil*), derived from the Qur'anic notions that God created man in his image, and that man is God's representative or deputy (caliph) in the world.[69] The Prophet Muhammad was deemed the "perfect man" by the influential medieval Andalusian mystic Ibn ʿArabi, who became the patron saint of the Ottoman house during the

sixteenth century and was fundamental to the teachings of most early modern Ottoman Sufis. Selim I built a tomb over Ibn ʿArabi's grave in Damascus soon after he conquered the city, and ʿArabi's *Fuṣūṣ al-ḥikam* (Bezels or pearls of wisdom) had been translated to Ottoman Turkish by Nev'i Efendi for Murad III a few decades earlier.[70] His writings, and especially the notion of the *insān-ı kāmil* were crucial for Ottoman political thinking on the sultanate and the caliphate during the sixteenth century.[71]

The mystical idea of the *insān-ı kāmil* as a model for the Ottoman ruler became evident in the visual realm during the reign of Murad III through works that brought into visual form ideas that were already present in the intellectual (if not visual) and architectural products of Süleyman's reign. It was used to praise Sultan Süleyman in the *Hünernāme* (Book of skills), and the *Zübdetü't-tevārīḫ* (Quintessence of histories, same title as Safi's work) eulogizes Murad III as the heir to the prophet Muhammad and the four caliphs.[72] Murad himself is likened to the *insān-ı kāmil* in the inscriptions to his Friday mosque in Manisa.[73] Whether as the "perfect man" or as the heir to the traditions of the Prophet Muhammad, by the end of the sixteenth century, the idealized image of the Ottoman sultan most certainly was a Sunni caliphal ruler with Sufi ideals and emphasis on the Prophet Muhammad. Thus Safi's assertion that the ideal ruler should model his behavior on the sunna of the Prophet Muhammad and the first four caliphs was a refinement of these earlier Ottoman religio-political ideals.

Like Murad III, Ahmed had close relationships with two particular Sufi shaikhs. Most famously, he was a devotee of Üsküdarlı Aziz Mahmud Hüdai, one of the founders of the Celveti order. Anecdotes abound in the hagiographic literature about how Ahmed washed Hüdai's feet and had his mother, Handan Sultan, pour water over them, and about how he would send gifts to Hüdai that were at times rejected.[74] Hüdai had been the "shaikh of the foundation" (*temel şeyḫi*) at the ground-laying ceremony of the Sultan Ahmed Mosque and was later appointed to preach there once a month.[75] He also presided over the extraordinary dome-closing ceremony that was held at the mosque.[76] Many of Ahmed's courtiers, including shaikh al-Islam Hocazade Esad Efendi and the commander of the navy and later grand vizier Halil Pasha, were devotees of this shaikh.[77] Esad Efendi's father, Hoca Sadeddin, the tutor of Murad III and shaikh al-Islam under Mehmed III, had also been a follower of Hüdai.[78] Hüdai used Ibn ʿArabi's Qur'anic exegesis, and based some of his own writings on Ibn ʿArabi, clearly drawing on many concepts developed by the earlier mystic, which would partly explain the emphasis on the Prophet Muhammad as the "perfect man."[79]

A second important adviser to Ahmed was the Halveti shaikh Ebülhayr Mecdeddin Abdülmecid, known as Sivasi Efendi, whom Ahmed went so far as to call "my father."[80] Like Hüdai, Sivasi had also been in palace circles before Ahmed's reign: he had been invited to come to Istanbul from his native Sivas by Mehmed III.[81] Ahmed commissioned Sivasi to write an exegesis on Jalal al Din Rumi's (1207–73) *Maṣnavī-i Maʿnavī* and also appointed him to the position of the first imam of the Sultan Ahmed Mosque.[82] While still in this position during the 1630s, Sivasi became a focus of public attacks by those who opposed the prominent role of Sufism in Ottoman public life.[83] The attacks on Sivasi were a part of emergent religious tensions that would become much more pronounced from the 1630s onward.[84]

Whether with his choice of Sufi shaikhs or in his devotion to the Prophet Muhammad, Sultan Ahmed followed established tradition. While the ideological and religio-political references to the Prophet, the Mahdi, the "perfect man," and the apocalypse had been part of the imperial imaginary since the early sixteenth century, leading up to and past the Islamic millennium, it was Ahmed I who brought some of their particularities to life. As the following will clarify, his concerted efforts to advertise his devotion to the Prophet and his emulation of the Prophet's deeds are unmatched in their intensity.

Ahmed's association with the Prophet Muhammad began to be demonstrated early in his reign, through his accession ceremonies. He was girded with a sword at the tomb of Ayyub al-Ansari, the warrior who is believed to have been a companion of Prophet Muhammad and who participated in the first Arab/Muslim siege of Constantinople. According to one of the many legends about him, Ayyub had agreed to raise the siege if he was allowed to pray in Hagia Sophia, because the Prophet had said that the great church would be a mosque one day. Ayyub was betrayed and killed after his prayers, and buried just outside the land walls of the city. His burial spot was auspiciously "discovered" immediately after Mehmed II conquered the city.[85] This renowned place became the burial ground of many Ottoman grandees from the fifteenth century onward and played a significant role in the Ottoman dynasty's inscription of its glory and presence onto the landscape of Islamicized Constantinople.[86] The inclusion of this site (Eyüp) in the accession ceremonies is a sign of the rising importance of Islam to the public image of the Ottoman ruler.

While we know from other sources that earlier sultans went to Ayyub's tomb as part of their accessions, the sword girding is not mentioned until the seventeenth century, after which point it is also often said to be performed by the chief mufti.[87] Ahmed I's sword-girding ceremony, which was the young sultan's first public ceremonial outing, took place on January 3, 1604.[88] The chief religious officer of the empire, Ebülmeyamin Mustafa Efendi, was the person to gird the ruler.[89] He was also the first person to pay his obeisance to the new sultan upon his accession, perhaps signaling a shift in the importance of the role of the mufti. Ahmed's father and grandfather had first been congratulated by viziers.[90]

According to Evliya Çelebi, the sword with which Ahmed was girded had belonged to the Prophet, but Safi simply calls it a "power-demonstrating sword."[91] In many other historical accounts, later sultans are said to be girded with the sword of the Prophet, but it is not clear with which sultan the tradition began.[92] Ahmed might well be the first. Lokman's *Zübdetü't-tevārīḫ* of 1583 describes a sword that was believed to have belonged to the Prophet, which was miraculously discovered during the reign of Murad III and presented to the ruler.[93] It is possible that this is the very sword that was used at Ahmed's accession, the reason for the later chroniclers' mention of such a sword. Ahmed's being girded by the chief religious officer of the empire, at this place associated with the period of the Prophet Muhammad, perhaps with the sword believed to have belonged to the Prophet, underscores the symbolic significance of the relics of the Prophet.

The sword of the Prophet is not the only relic that attracted Ahmed's interest. According to Evliya Çelebi, Ahmed had brought the stone footprints of the Prophet from the tomb of the Mamluk ruler Qaytbay in Cairo to his own mosque in Istanbul (after keeping them at Eyüp for a short while). The night before the inauguration of the

mosque, Ahmed dreamed that he was being accused of theft by Qaytbay in front of a court of prophets, and that the Prophet Muhammad advised him to return the footprints. The next morning Ahmed ordered the footprint returned to Qaytbay's tomb, on the advice of multiple religious leaders, including his shaikh al-Islam and his shaikh Aziz Mahmud Hüdai.[94] Qaytbay's appearance in Ahmed's dream is doubly significant because he built the Green Dome over the Prophet's tomb in Medina, a city in which Ahmed had also sponsored renovations.[95]

A third renowned relic of the Prophet Muhammad in Ottoman possession that received Ahmed's attention was the Prophet's cloak. The sultan built a shelf above the throne in the privy chamber for a silver box housing the cloak. Safi writes that Ahmed took the cloak of the Prophet with him everywhere he went.[96] Furthermore, Ahmed is also credited with the invention of a tradition of "visiting" the Prophet's cloak on the fifteenth day of the holy month of Ramadan. The cloak would be taken out of its box in the company of the sultan, the shaikh al-Islam, and Qur'an reciters, and its skirts would be slightly immersed in a bowl of water, which would then be diluted and drunk.[97] The cloak also made an appearance in Ahmed's father Mehmed III's Haçova battle in 1596, where the sultan was encouraged to wear it. It had been in Ottoman possession since the conquest of Egypt in 1517, when holy relics were brought to Istanbul by Selim I.[98]

Probably as a result of Ahmed's devotional acts, his contemporaries saw parallels between him and the Prophet. Taşköprizade Kemaleddin Efendi (d. 1621), a prominent statesman and scholar, praises him as "the mighty sultan who shares a name with His Highness Ahmed [i.e., the Prophet Muhammad] the Chosen" in the preface to a calligraphy album that Kalender prepared for the sultan around 1612 (TSMK H 2171, discussed in chapter 4).[99] Similarly, the account of the dome-closing ceremony for the Sultan Ahmed Mosque includes a praise poem (qaṣīda) eulogizing Ahmed: "To the resplendent pure soul of the Sultan of Creation [Muhammad] / As also to his companions and kinsmen, offer [you all] prayers and salutations. / Because, O Large-Hearted Sultan, you have modeled yourself on him, / You have truly executed the rule of holy law in the world."[100] This praise of Ahmed's modeling himself on Prophet Muhammad is followed by praise for his good deeds, citing the building of the Sultan Ahmed Mosque together with Ahmed's renovations at Mecca and Medina. The qasida describes these deeds in two couplets following the claim that Ahmed had modeled himself on the Prophet: "Above all, the Flourishing House [Kaʿba] and the city of God's Prophet [Medina] / Have been reanimated in your time, given honor and new life / May your good works find favor in the eyes of God Almighty / For your exquisite mosque has become a Paradise of Refuge in the world." These two couplets, however, not only suggest that Ahmed's renovations at Mecca and Medina gave new life to those places (just as, perhaps, he was giving new life to the Prophet's example) but that his mosque is counted along with them as a part of his "good works." Other contemporaries also likened the mosque to the Kaʿba.[101] Such commentary no doubt strengthened the image of Ahmed as the ideal pious ruler who follows the Prophet Muhammad's sunna.[102]

Ahmed's devotion to the Prophet Muhammad reverberated beyond court circles when the ruler chose to have the Prophet's birthday (mevlūd) celebrated at the Sultan Ahmed Mosque, a tradition that has persisted into the modern period.[103] The endowment

deed of the mosque earmarked funds for the recitation of the *Mevlūd* (Nativity) poem, ascertaining the continuity of this new tradition.[104] According to Safi, the *Mevlūd* was read at the mosque in 1610 in an elaborate ceremony, soon after construction began in 1609, suggesting a certain kind of urgency. Many dignitaries were invited, the mosque was perfumed with incense and flowers, and the great interest in the reading resulted in a large crowd congregating at the mosque, turning it into a very festive occasion.[105]

The mevlūd had been celebrated in Istanbul before, mainly during the reign of Murad III, but the public celebration had been forbidden by the shaikh al-Islam Sunullah Efendi in the year 1600, under Mehmed III, on the grounds that it was an innovation introduced after the time of Prophet Muhammad (*bidʿa*).[106] The celebration of Prophet Muhammad's birthday was closely associated with Sufi practices, which may have rendered it controversial. The first mevlūds in Arbela, at the beginning of the thirteenth century, were celebrated at a Sufi *khanqah*.[107] They have been recorded as far back as medieval Cairo, where they were fairly popular, attended by large crowds of people, and associated with Sufi practices.[108] Its support by Murad III and reinstatement by Ahmed might also be linked with the Sufi sympathies of these two rulers. The mevlūd ceremony, at the same time, was fraught with tension, and had historically been criticized by those with more orthodox tendencies as an unacceptable innovation.[109]

Ahmed was keenly interested in emulating the Prophet in his daily life. A clear example relates to the sultan's renovations of the Hagia Sophia. Among other repairs, the dome was re-leaded, and the building was whitewashed inside and out. The figural mosaics inside the prayer hall, which had been visible until then, were thus covered over—with two exceptions: the seraphim in the pendentives and the image of the Virgin and Child in the apse. Gülru Necipoğlu suggests that these may have been left untouched because their iconographies were acceptable from an Islamic point of view, and she astutely argues that in leaving Virgin Mary above the apse, Ahmed may have intended to emulate the Prophet Muhammad's actions, who according to tradition had removed all the figural images from the Kaʿba, except an icon of the Virgin and Child.[110] Ahmed similarly respected and preserved the Virgin and Child in a previously non-Islamic sanctuary. The fact that Ahmed later ordered renovations at the Kaʿba gave him another opportunity to follow the Prophet's steps.

An intensely personal demonstration of Ahmed's modeling his behavior on the sunna of the Prophet is incorporated in the *Album of the World Emperor*. Sultan Ahmed has written several hadith, or sayings, by the Prophet Muhammad, in a shaky and uneven handwriting that presents a jarring contrast to the elegant consistency and perfect proportions of the calligraphic samples in the rest of the album (see plate 10). The Prophet's sayings chosen for replication are like aphorisms, with similar moral messages:

> 1/ The Messenger of God, upon him be peace, said
> 2/ "None of you believes until he desires for his brother what he desires for himself," the Beloved of God spoke truly
> 3/ And from his discourse, may peace and blessings be upon him and upon his family
> 4/ "Two qualities are not found together in the one who believes: stinginess and bad morals." It is true O Messenger of God

And at the end of the page, Ahmed has written:

> 22/ "The best of men is the one among them who is kindest to people," it is true, O Beloved of God!
> 23/ And from his discourse, may peace and blessings be upon him and upon his family
> 24/ "Truly, God loves open-handed generosity," it is true, O Messenger of God.
> 25/ God bless our master and Prophet Muhammad and his family and his children and his companions and the prophets and the messengers! Praise be to God, Lord of the Worlds!
> 26/ written by Sultan Ahmad Khan, Imam of the Muslims."[111]

The sultan's repetitious writing evokes an attempt to internalize the words of the Prophet Muhammad and embody the lessons conveyed by this most exemplary of men. The little phrases in between the prophet's sayings, the exclamations like: "It is true, oh Beloved of God!" give a liturgical character to the page. We can imagine Ahmed writing these out, saying them to himself over and over again as he practiced his calligraphy. By starting the album with this page, Kalender gives a private act of devotion public proportions in a very deliberate fashion. The multiple steps that led to the page in front of us make this abundantly clear: the text was written by Ahmed, selected by Kalender or Ahmed (that part is unclear) probably after a conversation between the two, illuminated and bound into the album by Kalender, and then viewed by Ahmed and his companions. Kalender's illumination around the text might be seen as a devotional act unto itself, this time to his ruler, as he painstakingly illuminates the handwriting of Ahmed, contemplating its details, and through it his moral character. In Perso-Islamic calligraphic lore, there was a general understanding that the morality of a calligrapher was reflected in his writing, that the writing was a trace of the calligrapher's nature, with an indexical relationship to him.[112] This notion is particularly palpable in Timurid and Safavid writings about calligraphy, but was equally present in the Ottoman sphere.[113] By containing the traces of Ahmed's hand, writing out moral lessons from the Prophet Muhammad, the page bears witness, in other words, to Ahmed's moral character.

The lessons from the Prophet range from the practical (14/ "Sleeping late in the morning obstructs livelihood." It is true, O Messenger of God!)—which might be related to the fact that Ahmed was so young when he came to the throne (thirteen) and only twenty-four or so when this album was made for him—to the more spiritual ("He who gives for God and withholds for God; he who loves for God and hates for God, his faith becomes complete"). There are also statements that might be interpreted as more specifically related to this album ("A promise is a debt." The Beloved of God spoke the truth. "The one who is asked for counsel is given a trust." 11/ The Messenger of God, upon him be peace, said. 12/ "Gatherings are a trust." The Messenger of God spoke truly. "Generosity is gain." The Beloved of God spoke truly.) An album such as this one would be viewed in a gathering, which, according to Ahmed's writing, is a trust. And his generosity (which according to his handwriting again, is "gain") is expected by Kalender, of course, in exchange for preparing the album for him, but also by those whose gifts and artworks are incorporated into the album, according to Kalender's preface.[114] Thus Ahmed could seek the guidance of the prophet in almost any area.

Ahmed's signature at the end of the page "Sultan Ahmed Khan, Imam of the Muslims" is a particularly important clue for understanding his sense of identity. The term "sultan" suggests delegated authority from God, a traditional title for Muslim rulers in use since at least the Seljuq period of the eleventh century and consistently used by Ottoman rulers after the conquest of Constantinople.[115] The title "khan" is Central Asian in origin, one that the Ottoman Turks adopted as well. The use of these two simply puts Ahmed in line with his Ottoman ancestors and are not remarkable in themselves beyond carrying the gravity of dynastic tradition. The next phrase, however, Imam of the Muslims (imām al-müslimīn) is not one usually found in Ottoman titles.[116] It is undoubtedly related to rivalry with the Safavids, as the Safavid shahs claimed to be representatives of the Hidden Imam, or Mahdi, while he was in occultation, and "imam" was one of the titles they used. The signature appears as a challenge to Safavid claims. Similarly, the building of Ahmed's monumental Friday mosque in Istanbul can also be seen as a challenge, with its inscriptions emphasizing communal prayer, like the Süleymaniye before it, which was also built during a period of military engagement with the Safavids. Shah ʿAbbas responded to Ahmed's architectural challenge by building the first Safavid Friday mosque in Isfahan, despite Shiʿi hesitation about Friday prayer in the absence of the Hidden Imam.[117] Its inscriptions cursing the four caliphs, and in a roundabout but clear fashion, the Ottomans as their ultimate Sunni Muslim rivals, underline the pointedly competitive nature of the building. The two mosques were built almost simultaneously, Ahmed's starting in 1609 and ʿAbbas's in 1611.

The term is also significant purely within the Ottoman context and relates to changing notions of the ideal ruler. Its use here by Ahmed suggests a renewed interest in a religious leadership role and a new understanding of the sultanate. "Imam" was understood in Ottoman political thought to indicate the sultan as the vicegerent of God and implied spiritual superiority and being chosen by God.[118] When juxtaposed with the contents of Ahmed's handwriting on the same page, the title Imam of the Muslims points the way toward a fashioning of Ahmed as a prophet-ruler. While this comes close to the notion of the Mahdi/redeemer that was integral to the constellation of politico-religious thought of the time, it was nevertheless a departure. Ahmed was a ruler closely modeled on the Prophet Muhammad, one that embodied Sufi ideals and personally, intimately enlivened the role.

The Sultan's Books

Ahmed's youth and inexperience, and the difficult circumstances in which the empire found itself were probably reason enough for the sultan and his advisers to turn to models from the past. One other impetus was provided by the advice books with moral lessons that were presented to Ahmed. The authors of these reform treatises sought to find the reasons for the perceived decline and suggested solutions through political advice, often counseling the ruler to renew the emphasis on either religious or legal traditions.[119] Such books decrying the current state of affairs had been written since the second half of the sixteenth century, as a response to the social and political upheavals of the period, but the large number presented to Ahmed suggests there was more doubt about the

strength of his rule than ever before. His eagerness to go on campaign was probably also to counter such doubts. Perhaps Ahmed's young brother Mustafa's life was spared because of the doubts about Ahmed's possibilities for success, and Mustafa provided insurance against the demise of the dynasty. The doubt, in turn, would encourage Ahmed to prove otherwise, by emulating the deeds of great men before him.

A number of the books presented to Ahmed were translations of Timurid works of morals and ethics.[120] The Timurids, especially their last ruler, Sultan Husayn (r. 1469–1506), had long served as a courtly ideal for the Ottomans. Many Timurid works, illustrated and not, are in the Topkapı Palace library and elsewhere in Ottoman collections.[121] Safi Efendi writes that one day Ahmed asked for some books to be brought to him from the treasury, and his advisers explained their contents for him. He wanted to have the story of Jamal and Jalal (an allegorical chivalrous love story with mystical emphasis) translated, probably because it was written for Sultan Husayn, and also because it contained anecdotes about good rulership from which Ahmed liked to draw lessons.[122] His chief falconer, Hafız Ahmed Pasha, suggested Mustafa Safi Efendi for this task.[123] Safi took one year to translate the Persian original into Ottoman Turkish, and he was done by October 1608.[124] This was Safi's first assignment from Ahmed, after which the two became very close.

Another project that resulted in the translation of a Timurid book on morals was spearheaded by Hocazade Abdülaziz, the third son of Hoca Sadeddin, the prominent tutor and adviser of Murad III, and shaikh al-Islam under Mehmed III. Abdülaziz translated Husayn Vaʿiz-i Kashifi's *Akhlāq-i Muḥsinī* for Ahmed, under the title *Aḫlāḳ-ı Ṣulṭān Aḥmedī* (The morals of Sultan Ahmed), in 1612.[125] *Akhlāq-i Muḥsinī* is dedicated to Sultan Husayn but mainly addresses his son Abu al-Muhsin Mirza (d. 1507). Kashifi and Nasir al-Tusi, on whose work *Akhlāq-i Muḥsinī* is modeled, both point to the maintenance of balance in society, made possible by the application of justice by the ruler. Many copies of Kashifi's *Akhlāq-i Muḥsinī* survive all over the Islamic world, including in Istanbul libraries. It was a much-appreciated work in the Ottoman context.[126] Ahmed's desire to have the book translated and the inclusion of his name in the new title suggests that its moral lessons were deemed particularly important or salient by the young ruler (or by his advisers, who no doubt helped him craft his public image). The book's emphasis on balance and justice is particularly relevant to unpacking the meanings of the *Album of the World Emperor*, and its significance will become clearer in chapter 5, when I discuss the images of urban types from the album. Likewise, the continuing admiration of the Timurid court also explains the choice of calligraphic styles in the album, explored in chapter 4.

Contemporary political resonances were equally or perhaps more important than Timurid ideals among the books presented to Ahmed, which contained contemporary studies on princely conduct and moralia. Ayn-ı ʿAli devoted a reform treatise to him that is a practical guide to how different portions of the state should function.[127] Bostanzade Yahya Efendi presented his *Mirʿātüʾl-Aḫlāḳ* (The mirror of morals).[128] Upon Ahmed I's orders, his Halveti shaikh Abdülmecid Sivasi, consulting fifty-seven different sources, also composed a book on morals that contains advice for the ruler, *Leṭāʾifüʾl-ezhār ve lezāʾizüʾl-esmār* (The charms of flowers and the delights of fruits).[129]

Important among these books for explaining current political ideologies and the role of the sultan is the anonymous *Gencīne-i ʿAdālet* (The treasury of justice), also dedicated

to Ahmed I. According to Baki Tezcan, one of its central morals is the controversial principle of "enjoining good and forbidding evil" (*al-amr bi'l-maʿrūf wa'l-nahy ʿan al-munkar*), because the book concludes with an entire chapter dedicated to this topic. The book presents "the rectification of society" as a form of holy war, "implying a new conception of the ghazi, or the holy warrior, as a champion of enjoining good and forbidding evil."[130] *The Treasury of Justice* also equates the sultan with the caliph, a role presented as inclusive of the tasks of prophet and scholar. According to this treatise, the sultan should concurrently be caliph, prophet, and scholar in order to enjoin good and forbid evil—ideals that seem in keeping with Ahmed's attempts to emulate the Prophet Muhammad and follow his actions.

Ahmed's books demonstrate a vast variety of literary tastes and give us a snapshot of literary interests that existed simultaneously and that are echoed in the varied contents of the *Album of the World Emperor*. Ahmed's tastes ranged from the moralistic to the entertaining, even bawdy. His eclectic tastes are exemplified by a manuscript discussed by Maurits van den Boogert: a collection of stories in rhymed prose by Ahmed's contemporary, the poet Zarifi. He dedicated the book, which includes not only anecdotes about Nasruddin Hoca but also some pornographic elements, to Sultan Ahmed.[131] At the same time, Veysi's *Hābname* (Book of dreams) was also dedicated to Ahmed; it contains historical and didactic tales, as well as stories from religious history, like the *Qiṣaṣ al-ʿAnbiyāʾ* (Stories of the prophets).[132] These two works suggest that the ruler was not immune to the increasing popularity of prose tales in the urban contexts of the empire and that followed current literary trends.

Indeed, Ahmed seems to have enjoyed prose tales told by entertainers known as *meddah* (storyteller, entertainer). The meddah Medhi, the translator of the *Shāhnāma* for Ahmed's son Osman II, had been at the palace since the reign of Murad III.[133] He also wrote books for Ahmed I, even though they do not survive.[134] Medhi's rising star is partially explained by the fact that the powerful chief eunuch, Hacı Mustafa Agha, was his patron; however, the taste for popular tales in court circles must also be a factor in his success. The close connection between court and popular life and literature in the seventeenth century is also conveyed by the fact that an anecdote from the life of Yemişçi Hasan Pasha, one of Ahmed's grand viziers, became the subject of a tale told by meddahs later in the century. Similarly, the protagonist of seventeenth-century and later popular tales, Tıflī Efendi, was a *Shāhnāma* reciter at the court of Murad IV.[135] The poet Nadiri, whose anthology is analyzed in the next chapter, has made notations in a book of Cenani's (d. 1595) tales (first written for Murad III, a ruler known for his love of unusual and entertaining stories), including a chronogram recording the date of his hunting trip with Ahmed I.[136] In other words, Nadiri must have been reading them to Ahmed I to entertain him during such outings.[137]

It might be productive to think of Ahmed's books in a manner similar to David Roxburgh's analysis of the library of the Timurid prince Baysunghur. The many books on morals and good government that Baysunghur collected, rather than simply having didactic function, helped foster an image of the prince as a just and wise ruler.[138] No doubt there is an element of this in Ahmed's books, as well. They helped him to not only *be* pious and just, but to also advertise himself as such to those around him—his

advisers, confidantes, and members of his court. The contents of the sultan's library would be known to the intimate circle around him, who would participate in the readings and discussion of these works in small group settings. The variety of the books echoes the variety of the literary tastes of the era and the kinds of materials that would be discussed in majlis settings, where albums would also be enjoyed.

Ahmed's *Dīvān*

The collected poems of Sultan Ahmed reveal much about this young ruler and his concerns; they corroborate his pious image but at the same time remind us that piety was only one dimension of a complex character. The sultan's poetry also offers multiple clues for understanding the contents of the *Album of the World Emperor*. Ahmed wrote poetry under the pen name of Baḫtī, "of good fortune." According to Safi, Baḫtī referred to Ahmed's good fortune in reaching the throne and the date of his accession.[139] The numerical values of the letters in *baḫtī* add up to 1012 (1603), the year of his accession.[140] The unexpected deaths of his two elder brothers opened the path to his claiming the throne. Consequently, Ahmed felt that his sultanate was ordained by God, as is fitting with contemporaneous Ottoman notions of legitimacy:

> When it was not in my mind, You bestowed a *devlet* on me, this *Bahtî*.
> I thus put my personal affairs, my whole fears, in your hands, my God![141]

Ahmed's *Dīvān* is a short manuscript of only twenty-three folios. It begins with poems of a religious nature that echo the traditional order of such anthologies, with eulogies to God and the Prophet Muhammad. It also contains two poems that praise the birthday of the prophet and the *Mevlūd* poem that is customarily read during the celebrations. The first of these poems makes much of the fact that in that year the birthday coincided with Nevruz, first day of spring celebrations.[142] There are also poems that celebrate the month of Ramadan, and the Eid religious holiday.

Ahmed's poems reveal a pious belief that all things are due to God. The very first poem in the *Dīvān* says that he wants to follow the path of Muhammad, and thanks God for his fortune. The second one praises the virtues of reciting the name of God. While these take up standard themes in Persian lyric poetry, and indeed in preface writing in the Islamic context in general, they gain further meaning when accompanied by later poems where Ahmed promises that he will work for God in spreading justice.[143] In a later poem, he thanks God for the good news about the defeat of the Kızılbaş, and asks God for help in other military struggles against the "non-Believers" in Hungary, and against the Celali rebels.[144]

Poems dedicated to Ayyub al-Ansari and Mawlana Jalal al-Din Rumi highlight Ahmed's Sufi inclinations. The former celebrates Ayyub as the man who first sowed the seed of Islam in the land of Rum, says he has always been a companion to the rulers of the House of Osman, and asks him to be so for Ahmed, too. The poem also alludes to Ahmed's visiting the tomb of Ayyub and asks him for his help.[145] The poem on Rumi mentions reading his *Maṣnavī-i Maʿnavī* (Spiritual couplets), an extensive mystical poem

in the *maṣnavī* (rhyming couplets) Persian poetic format, while watching a *semāʿ* (lit., "listening," commemorating God by whirling) ceremony, and it concludes with the couplet, "Baḫtī is the slave of that Majesty Mawlana / He is the sultan of the ages on the throne of meaning."[146] These are the only people, other than the Prophet Muhammad and his own father, to whom he dedicated poems in his *Dīvān*.

A link between Ayyub and the Prophet Muhammad, and Ahmed's interest in both, is also evident in the special viewing windows Ahmed ordered, in 1613, on a new wall surrounding the tomb of Ayyub in Istanbul. The verses inscribed on the windows are the very same Arabic verses written above the viewing windows at the tomb of the Prophet in Medina.[147] Thus beyond simply sponsoring renovations at Ayyub's tomb and thereby linking his name in perpetuity to the early-Islamic hero, Ahmed also highlighted the connection between Ayyub and the Prophet Muhammad, a connection that was undoubtedly meant to extend to himself. Enhancing this connection is the fact that Ahmed's chief eunuch, Hacı Mustafa Agha, was eventually buried next to Ayyub's tomb.

Two depictions in the *Album of the World Emperor* relate directly to these poems (see plate 20). One is a picture of Shams-i Tabrizi, the beloved of Mawlana Jalal al-Din Rumi, an extremely important figure for the Mevlevi order. He is identified in the inscription above his image. To his right is Ayyub al-Ansari. The anonymous Persian poem accompanying the images on this folio speaks of longing and separation. Ahmed's own poetry is not in the album, but there are significant overlaps in the subject matter contained by both. Common themes are encapsulated by Ahmed's verses describing enjoying the gardens in Üsküdar, being in a beautiful pavilion and enjoying the landscape and the sea in front of his eyes.[148] These relate to the many images of outdoor entertainment to be found in the album (see, for example, plates 27, 31, 55).

Ahmed's literary preferences and skills are demonstrated in a response poem he wrote to a work by Zekeriyazade Yahya Efendi (of later fame as Şeyhülislam Yahya Efendi), one of the towering figures of Ottoman poetry and the military judge for Anatolia and Rumelia on different occasions during Ahmed's reign. The response poem adds three lines to each couplet of Yahya's poem. This demonstrates Ahmed's knowledge of and active involvement with the literary scene of his time.[149] Although Ahmed's own poems do not show special talent, they do remind us of his interest in the literary arts, and they form an important link between the *Album of the World Emperor*, which contains many Persian poems, and literary trends at the early-seventeenth-century Ottoman court. The response to Yahya Efendi also brings to mind Ahmed's patronage of other contemporary poets, among them Nadiri, and Nef'i, considered to be the forerunners of a new style of poetry with Indian influences that would become all the rage in the seventeenth century.[150] Although Ahmed himself is not considered a sufficiently important poet to ever be discussed by literary historians in the context of the new style, the fact that he refers to contemporary situations in his poetry and that he explicitly draws on his own life, whether it is a visit to a special pavilion in the palace or a garden in Üsküdar or the success of his armies, does align him with this new wave of poetry. Ahmed's openness to new literary tastes, as made evident by his patronage and by his own poetry, will be important to bear in mind when we consider the new aesthetics embodied by his album. His interest in poetry is also reflected in the dedication of Riyazi

Mehmed Efendi's treatise on Ottoman poets to Ahmed in 1609, which suggests that the author hoped Ahmed would be interested, and given the evidence provided here, this was not an impossible hope, but rather an educated guess.[151]

A striking scene is described in Safi's account of the ground-laying ceremony of the Sultan Ahmed Mosque. In an unusual gesture, Ahmed descended into the foundation and, with a silver spade, began digging. Safi describes the sweat that collected on the sultan's young forehead as a result of his hard work.[152] The sultan's physical exertion mimics in many ways his painstaking copying of the Prophet's hadith. Through these, the Ottoman ruler appears involved and accessible, and religion and religious leadership become personal and deliberate undertakings.

This is reflected in the *Album of the World Emperor*, which is a response to the political events of the period, caters to its patron's interests, and contributes to the creation of a public persona for the sultan, starting with those most close to him. After the introduction, the album proper begins with Ahmed's copying of the hadith, and the facing folio includes selections from the Araf and Baqara suras, further hadith, and a saying of 'Ali (see plates 10, 11). The selection from the Araf concerns those who ignore the signs sent by God and is an admonishment against doing so.[153] The Baqara (1–5) follows, establishing the Qur'an ("This is the book about which there is no doubt, a guidance for those conscious of God")[154] as the guide for believers—saying that those who follow the Qur'an, who believe in what was revealed to the Prophet Muhammad and to other prophets before him, and who are certain of the hereafter will be successful. Together, these two Qur'anic excerpts mentioning a book as guidance, the importance of signs, and the importance of believing in the revelation of the Prophet Muhammad and in the hereafter, provide guidance about how to interpret the album. It too is a book meant to guide, and it gives priority to faith and tradition. The following folios include images of the Ottomans' ancestors as well as the portraits of Ottoman rulers, reminding us of the centrality of Ottoman tradition to Ahmed's legitimacy. After this assertion of his emulation of the Prophet and the centrality of Sunni Islam and the Ottoman tradition to his legitimacy, follow, in a somewhat mixed order, examples of calligraphy, single figures, urban scenes, and images of hunting, feasts, and prints—reminding us that the album has more to say beyond eulogizing Ahmed and that it links with his interests as reflected in his poetry, his books, and his enthusiasm for the city of Istanbul. The multiple messages of the album come to life within the contexts of religious and political competition, performance, urban growth, international trade, war, rebellion, and eschatological apprehension.

Sultan Ahmed's
Artistic Patronage

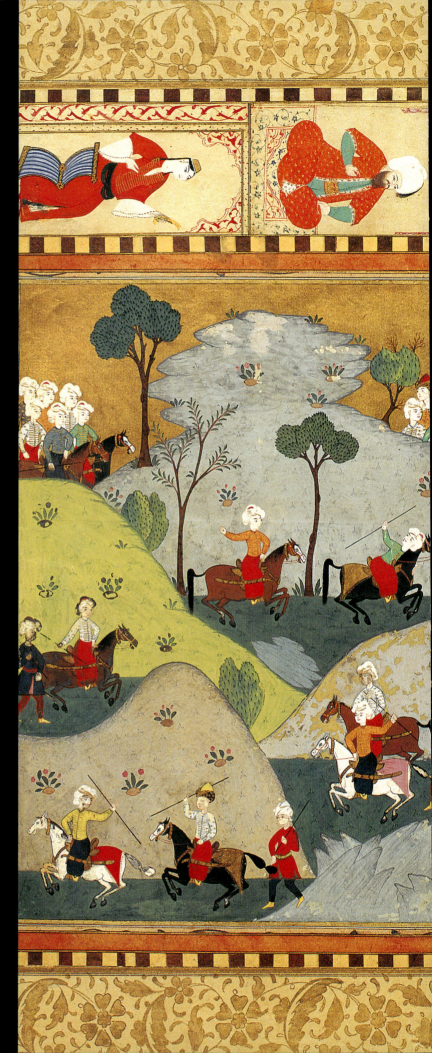

The artistic and cultural outputs of the early-seventeenth-century Ottoman palace attest to a new aesthetic taking root in almost all aspects of cultural production, from poetry to architecture. Accompanying this new aesthetic was an intensifying focus on religious and occult themes, in keeping with both Ahmed's interests and also with the new Ottoman understanding of the ideal ruler, as outlined in the previous chapter. The artistic projects Ahmed sponsored, and those that were created at or near the palace with varying degrees of involvement by the ruler, all attest to these two developments. The first section of this chapter examines the major achievement of Ahmed's reign, the Sultan Ahmed Mosque, and the second section examines the illustrated works of the period in order to offer a sketch of the artistic landscape in which the *Album of the World Emperor* was created.

The Sultan Ahmed Mosque

Certainly the grandest expression of Ahmed's patronage of the arts is his commissioning of a mosque in Istanbul in the second half of his reign (fig. 1). Although it is often derided in modern scholarship, the Sultan Ahmed Mosque (Ahmediyye) was much admired by its contemporaries and embodied a new aesthetic that placed emphasis on the mosque's lavish interior decoration, articulated exterior, and sumptuous furnishings.[1] The mosque is built in a style that—while evoking the classical forms of sixteenth-century Ottoman architecture with its cascading domes, pencil-shaped minarets (of which it has six, more than any other mosque in the empire, save the sanctuary around the Kaʿba), and arcaded courtyard—also deliberately departs from it, especially in its elongated forms and its decorative aspects. The inside is covered entirely in Iznik tiles, hence its popular name, the Blue Mosque.

The Sultan Ahmed Mosque was understood to demonstrate the sultan's gaining control of his empire, as well as his piety.[2] The economic problems, which were also closely connected to the Celali revolts, made the construction of such a mosque controversial. Ahmed had no great military victories that would provide income to support the construction and upkeep of such an undertaking.[3] It was customary to finance imperial mosques with war booty, and not doing so further strained the already straitened imperial budget.[4] Resistance against the project was certainly great enough to have been noted by European observers. Grelot, in 1683, observes that there is not one mosque

> more irregularly built than this. . . . The Grand Signors are forbidden to undertake this task until they have won from the infidels cities, provinces, or kingdoms sufficient to defray the excessive charges of such magnificent piles. Though Sultan Ahmed had not by any conquest extended the boundaries of the empire, [he] resolved to build a mosque to the end he might eternize his name, since his achievements did not suffice to recommend him to posterity. And though the Mufti, the Mollas, the Chaiks [*sic*] and other doctors of law laid before him the sin of undertaking to erect such a costly fabrick, since he had never been in any other combats . . . nevertheless he gave little heed to their admonitions, but carried on the work with a vigor answerable to his resolution.[5]

Grelot emphasizes Ahmed's strength of conviction, which is demonstrated by his going against the admonitions of the religious officials (such as the chief religious officer of

Fig. 1. Sultan Ahmed Mosque, Istanbul.

the empire at the time, shaikh al-islam Hocazade Mehmed Efendi) and is corroborated by Safi's efforts to prove the necessity of the mosque by insisting that it would have a large congregation.[6]

Ahmed's choice to push forward a controversial project suggests that it was of great significance to him. Certainly the mosque could be interpreted as asserting his own will, but the politico-religious symbolism of the project is also significant. Cafer Efendi, in his biography of the mosque's architect, Mehmed Agha, blends such symbolism into his description of the mosque as an edifice to the suppression of the Celali rebellion:

> And the rebels went to hell because they did not pray.
> Your entire country, cleansed with their blood, became pure.
> Therefore they gave you the name Bloody Sovereign in honor of this.
> When, along with your majesty, they saw your success and faith and sword,
> Bans and kings and unbelievers prostrated themselves before you.[7]

This was no simple military victory. Cafer Efendi casts the rebellion, which was not a religious one, into sectarian terms when he accuses the rebels of not praying and thereby creates a link between them and the Shi'i rivals of Ahmed. The suppression of this rebellion then becomes proof of his piety and championing of Sunni Islam, which in turn is emblematized in the building of a Friday mosque, enabling the Sunni practice of communal Friday prayer. In this way, Ahmed and his mosque are shown to further the Sunnitization of Ottoman territories, much in the same way as did the many Friday mosques supported by the ruling elite that were built throughout Ottoman territories during the sixteenth century.[8]

The juxtaposition of the Ahmediyye with the unfinished mosque of Safiye Sultan in Eminönü similarly underlines the ruler's piety and justice.[9] The construction of the mosque sponsored by Ahmed's influential grandmother, Safiye Sultan, had been halted suddenly when she was moved to the Old Palace at Ahmed's accession.[10] Contemporary and modern sources interpret her removal to the Old Palace as a sign of Ahmed's establishing control over the affairs of state.[11] Hers was a controversial project with an aura of despotism attached to it, because it was built in a contested area of the city on forcibly claimed land that had belonged to Karaite Jews.[12] Moreover, Safiye Sultan's power was resented by urban and military groups so much so that it had resulted in an urban rebellion in 1603. When Ahmed desired to have a mosque constructed, he first considered completing the one started by Safiye Sultan, then decided against it, ostensibly because the At Meydanı (Hippodrome) was a larger, more festive place.[13] The rejection of Safiye Sultan's mosque allowed Ahmed to appear even more pious and just in the eyes of his contemporaries, since his mosque was built on property he bought legally rather than confiscate.[14]

The careful placement of the Ahmediyye on the Hippodrome establishes a strong visual relationship to the Byzantine patriarchal cathedral Hagia Sophia, which had been converted into a mosque soon after the city's conquest in 1453. Just before the start of construction for his own mosque in 1609, Ahmed ordered repairs to the Hagia Sophia, so the ancient monument was very much on his mind as the Ahmediyye was built.[15] The elongated proportions and articulated facade and side elevations of the Sultan Ahmed Mosque represent a further move away from the massive exterior of the Hagia Sophia, already eschewed in the Ottoman chief architect Sinan's sixteenth-century mosques.[16] The interior decoration of the Ahmediyye also appears to respond to the Hagia Sophia. The inscriptions on the mihrab wall of the Sultan Ahmed Mosque allude to the Virgin Mary and contain the word "mihrab," which at first glance may seem to be the reason they were chosen. Nuha N. Khoury, who has studied the inscriptions, finds a more convincing explanation, however, stating that these verses were not used in Ottoman mihrabs until the fall of Constantinople in 1453 and that they imply an iconographic parallel to the Byzantine model of placing images of the Virgin Mary and the Christ Child in church apses. The Mary verse (3:37) became popular during the reign of Süleyman. However, the use of two verses relating to Mary's story (3:37 and 3:39) is witnessed for the first time in this mosque and moves beyond the Byzantine or the prior Ottoman model. The emphasis on the Virgin Mary might be a deliberate allusion to the Hagia Sophia, where her representation was still in full view, allowed to remain visible, as discussed in the previous chapter, perhaps in emulation of the Prophet's treatment of the Marian icon in the Kaʿba.[17] The relationship between the two monuments was noted by many early modern viewers. To cite just one, Dimitri Cantemir observed at the turn of the eighteenth century that Ahmed had undertaken the construction of his mosque in order to compete with the Hagia Sophia.[18] In some ways, this competition is reminiscent of the visual dialogue between the Dome of the Rock and the Church of the Holy Sepulcher in Jerusalem, which would have been known to Sultan Süleyman, who renovated the Dome of the Rock and rebuilt the walls of Jerusalem.[19] One wonders if similar motives drove the two Ottoman sultans.

There are striking similarities between the Ahmediyye and the Süleymaniye, and this is no coincidence.[20] Mehmed Agha, the architect of Ahmed's mosque, had studied

with Sinan, the Süleymaniye's architect.[21] The mosque that Mehmed Agha built adopts elevations similar to those of the Süleymaniye, with its protruding side arcades over ablution fountains and its entrance facade of centrally placed cascading domes above an even arcade of slightly pointed arches. According to its architect Sinan's own words, the Süleymaniye was intended as an answer to the perceived challenge of the Hagia Sophia.[22] Sinan consciously repeated the domical superstructure of the Byzantine church in the Süleymaniye. The Ahmediyye, in turn, responded to the Hagia Sophia with its inscription program and its placement, and to the Süleymaniye with its architectural features.

Another similarity lies in the foundation inscriptions of the two monuments. That of the Sultan Ahmed Mosque, just above the main entrance, underlines the sultan's piety and his role as the patron of Sunni Islam. The profession of faith, including the Prophethood of Muhammad and two Qur'anic selections (4:103 and 2:238) emphasizing communal worship, precede Ahmed's name and titles. The inscription emulates the phrasing of the Süleymaniye's foundation inscription by giving the name, titles, and lineage of the sultan and stating that the mosque was built as a pious deed. The similarity of the two foundation inscriptions is highlighted by comparison with those of other imperial mosques, such as that of Mehmed II, which stresses Mehmed's role as conqueror, or those of the Selimiye and the Şehzade Mosques, which also lack a similar emphasis on ritual prayer. Ahmed and Süleyman are presented in these inscriptions as those who make communal prayer possible, a pointed message both in terms of the Islam-Christianity competition outlined via the Hagia Sophia, and in the context of Ottoman-Safavid / Sunni-Shiʿi rivalry.[23] The Süleymaniye and the Ahmediyye were both built during periods of heightened tension between the Safavids and the Ottomans, and they embody the dynamics of religious competition that marked the age.

Despite the similarity of its facade, its cascading domes, and its foundation inscription to the Süleymaniye, and despite—indeed, because of—its emulation of the classical architectural synthesis perfected by Sinan, the Sultan Ahmed Mosque has been constructed to look as light as possible. The Ahmediyye elaborates on the more playful facade articulation of later Sinan mosques, possibly owing to similar pressures to stand out in the dense urban context.[24] With its more sculpted silhouette, its walls dissolved into windows, and its vertically elongated proportions, this mosque is the outcome of a new aesthetic.[25]

The aesthetic preferences of the seventeenth century emphasize decoration (and location) above all else.[26] Seventeenth-century authors evoke the senses of sight, smell, touch, and hearing as they describe the mosque as a paradisiacal metaphor, mainly on the basis of its decorative features.[27] The floral tiles decorating its walls merge in these descriptions with the sound of the nightingales that could be heard through the mihrab wall windows opening onto a garden, the smell of the flowers therein wafting into the mosque, the flower smells mixing with the incense aroma, and the sounds of the birds merging with the prayers of the faithful inside. The lights illuminating the interior of the mosque blend with the light flowing in from the windows.

The inscription program of the mosque alludes to paradise, suggesting the seventeenth-century viewers' reception was indeed the intended one. In addition to its decoration and fenestration, the location of the mosque—overlooking the Bosporus,

with its gardens and courtyard opening onto the large public piazza of the Atmeydanı—also helped the mosque to be viewed as a paradisiac spot. Cafer Efendi refers to its location thus: "O God, what a charming excursion spot is this pure place! / Surrounding it is the promenade of the face of the sea." Earlier in the same treatise, he writes: "The noble mosque and pleasant sanctuary are an excursion spot such that there is no other place of comparable vastness in the world."[28] With its encouragement of public gatherings, both at ceremonial events and on a more quotidian basis; the novel, multisensory experiences it offered visitors; and its decorative emphasis on the afterlife, the mosque echoes many of the concerns we find in the *Album of the World Emperor*.

Although the most prominent, the mosque was not the only architectural commission of the sultan. He and his courtiers had a number of mansions and pleasure pavilions built along the shores of the Bosporus.[29] He also renovated the Edirne Palace for use during his hunting parties, and a pavilion bearing his name was added to the Topkapı Palace as well. It is decorated with floral scrollwork and plenty of inscriptions, one of which dates to 1608–9. The contents of the inscriptions range from pious texts to odes to the sultan, and some of the greatest poets of his reign are represented here, providing further proof of his patronage of poets and personal engagement with literature.[30]

The emphasis on a new aesthetic in Ahmed's architectural patronage is also present in contemporaneous illustrated books and albums. Like the mosque, these were made to not only please the sultan through their aesthetic merit and the specific ways in which they praised him, but also to project a certain revised image of the Ottoman ruler. Like the sultan's pleasure pavilions, they demonstrate an interest in contemporary literature; like the sultan's nonillustrated books discussed in the previous chapter, they attest to an interest in the everyday and the urban as well as the religious.

The Sultan's Illustrated Books

KALEIDOSCOPIC TEXTS AND POWERFUL IMAGES

When considered together, the illustrated manuscripts from Ahmed I's court highlight changing aesthetic preferences and manuscript production methods that are correlated with the rising popularity of albums. The first point they demonstrate is a shifting relationship between words and images in manuscripts, such that the images become the main drivers of narrative, and the texts are often compilations of shorter pieces, either anthologies, collected stories or poems, or a collection of different texts on similar themes, rather than books with a single linear narrative running through them. They also demonstrate an evident interest in the occult and in apocalyptic narratives, rather than Ottoman history (which had been the focus of previous rulers). Both tendencies have their roots in the late sixteenth century but become amplified at the court of Ahmed I.

The fragmentary or anthology-like nature of the texts compiled for illustration are best demonstrated by two transitional works that have their germination in the court of Mehmed III but appear to have been finished during the early years of Ahmed's reign: the *Dīvān* (Poetic anthology) of Nadiri, and *Vaḳāʾiʿ-i ʿAlī Pāşā* (The chronicle of Ali Pasha).[31] The bridging of the two reigns by these books is an important reminder that

artistic landscapes do not shift overnight just because there is a new sultan on the throne. The importance of the agency of authors, artists, and workshop supervisors, many of whom continue in their posts from one reign to the next, becomes evident in this continuity. The power brokers and courtiers around the sultan, some of whom are also legacies of earlier periods, are often instrumental in determining the contents of illustrated works. Their longevity in positions of power results in a certain continuity in artistic traditions.

The *Dīvān* is a collection of praise poetry by Nadiri, but it functions in many ways as a history text, as the illustrations in it depict specific events. The detailed preface lavishes praises on the chief palace eunuch of Mehmed III, Gazanfer Agha, suggesting it was begun before the eunuch's death in 1603. However, the contents of the rest of the *Dīvān* point to a later date of completion, in the early years of Ahmed I's reign. There are poems praising Gazanfer, Murad III, Mehmed III, Ahmed I, and various officers who served at the court during the reigns of all three rulers.[32] Narrative illustrations featuring the recipients of the poems are interspersed with the lyric poetry, but unlike earlier illustrated manuscripts, where the images would be inserted next to the very words they illustrate, here the poetry does not always relate to the events presented in the images, even if it praises the people in them.

The image of Ahmed I in the manuscript is inserted in the midst of a poem that mentions his arrival in Edirne, "turning fall into spring" (fig. 2). The artist depicts just such a trip and makes sure the viewer identifies Edirne by including the image of the Selimiye Mosque, with its famously large single dome and four minarets, which is the most recognizable monument of the city.[33] Readers of the manuscript are asked to draw upon their knowledge of the event from other sources—contemporary accounts of Ahmed I's hunting trips to Edirne in 1605 and 1612 or knowledge of the architectural features of Edirne's famous mosque—to locate the image they are looking at. The beardless depiction of Ahmed allows viewers to date the trip back to 1605, as Zeren Tanındı has done in her analysis of the manuscript.[34] Word and image work in tandem here, but image is not subordinate to word; it rather acts independently, provides more specificity, and is the main carrier of the story. The verbal component, which is praise poetry, functions as embellishment to the visual account of an event, reversing the way words and images work in earlier illustrated manuscripts. The *Dīvān* is also unusual in comparison with other illustrated *Dīvān*s from Islamic book culture, where the images are rarely (if ever) of specific historical events, as they are here, but instead reflect courtly pastimes and preoccupations such as hunting, reading poetry, or enjoying the countryside in the company of intimates, with generic or idealized rather than identifiable figures. They do not illustrate specific occasions so much as courtly ideals.[35] In the *Dīvān* of Nadiri, a gathering of poems functions as a historical account, demonstrating a preference for texts that are kaleidoscopic in nature, like albums and textual miscellanies, as discussed in the introduction.

The author Nadiri is an interesting figure with tight links to the Naqshbandi Sufi order, a flourishing legal career, and also with secure and lasting patronage at the court—after Ahmed's death, he worked for Ahmed's successor, Osman II, and was asked to compose a chronicle of his one military campaign. His association with Hoca Sadeddin, whose student he had been, might well have secured his success at the palace during

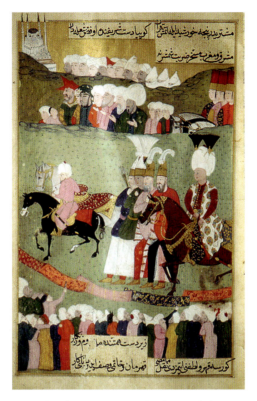

Fig. 2. Ahmed I in Edirne. *Dīvān* of Nadiri. Istanbul, ca. 1603–17. Topkapı Sarayı Müzesi Kütüphanesi, Istanbul, H 889, fol. 10a.

the seventeenth century, as Sadeddin's sons served as chief religious officers with great power throughout the first quarter of the seventeenth century. While the judge of Istanbul, during the early years of the reign of Ahmed I, Nadiri made clean copies of fifty or so books in his possession, and gifted these to the palace library. He was one of Ahmed's hunting companions, and his notes in a copy of the storyteller Cenani's tales that dates one of the Edirne hunts to 1612–13 have been discussed in the previous chapter.[36] Nadiri was also a calligrapher, and he copied a fifty-volume Qur'an commentary by the thirteenth-century scholar Baydawi on Ahmed's orders. The partially completed work includes Nadiri's own notes in the margins.[37]

The *Vaḳāʿī-i ʿAlī Pāşā*, likewise, is not a linear narrative. It revolves around the figure of Ali Pasha, who was appointed governor of Egypt by Mehmed III, and later as grand vizier, while he was still in Egypt. As Ali Pasha traveled to Istanbul to fill his new position, Mehmed III died. Ahmed nonetheless confirmed his appointment. He was thus the last grand vizier of Mehmed III, and the first of Ahmed I. The first half of the book recounts Ali Pasha's appointment as governor and narrates his time in Egypt, but it is organized thematically rather than chronologically and is interspersed with descriptions of Egypt. The second half consists of various types of poems (*qaṣīda, ghazal, tārīḫ, qiṭaʿ, tarjiʿ-band*), most but not all of which are dedicated to Ali Pasha. Some praise other contemporaries, others are related to Egypt, and some Arabic poems are by local poets who must have been under Ali Pasha's protection. The first half of the book was written by Kelami, a chancery scribe instructed by Mehmed III to write Ali Pasha's biography. The

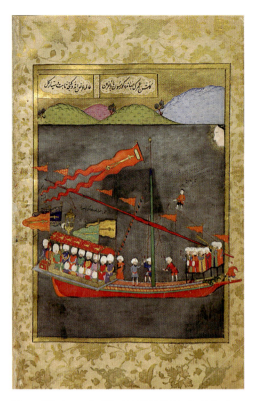

Fig. 3. Ali Pasha on the Nile. *Vaḳāʿī-i ʿAlī Pāşā* by Kelami. Istanbul, ca. 1603–17. Türkiye Yazma Eserler Kurumu Başkanlığı, Süleymaniye Yazma Eser Kütüphanesi, Istanbul. Halet Efendi 612, fol. 24b.

poems in the second half were collected by him upon the order of Ali Pasha.[38] Thus the author of the first half is the collector/compiler of the second half, an act similar to Kalender's when he was choosing materials for albums.

Another parallel between the Ali Pasha manuscript and albums is the fact that its images were produced separately and pasted into the book later. These pages are thicker than the rest of the manuscript as a result.[39] This aggregative approach to bookmaking, evident in both the verbal and the visual portions of the book, renders it much closer to an album in spirit than an illustrated manuscript. The paintings, poems, and anecdotes come together in a looser fashion than does the material in sixteenth-century illustrated histories (where the relationship between word and image is tight), thereby creating a collage that lends itself to multiple readings, not unlike an album.[40]

Vaḳāʿī-i ʿAlī Pāşā praises the moral qualities of Ali Pasha as a leader/governor rather than depicting his military activities. It praises his justice, fair sense of rule, and pious leadership, qualities that were sought in leading men of the late sixteenth and early seventeenth centuries, a far cry from the militarized heroes of the mid-sixteenth century. In the images, Ali Pasha is shown in various ceremonies that surround his appointment, but he is also depicted sailing on the Nile (the plentiful waters of which were understood to attest to just rule) (fig. 3), punishing rebels, praying with the community, and wandering out at night in disguise in order to see how his constituents were really doing.[41]

The strengthened role of images in driving the narrative, and the fragmenting of a single, continuous narrative into sections—oftentimes poetic sections that do not have

a unified structure—are important characteristics of the arts of the book in the seventeenth century. That this trend does not end with the reign of Ahmed I is demonstrated by Tülün Değirmenci's assertion that Nadiri's *Şehnāme*, the account of Osman II's Hotin campaign, is a similarly impressionistic work that is also, in its verbal and visual narrative, broken down into its constituent bits. In its structure Nadiri's *Şehnāme* resembles a poetic anthology rather than a narrative work.[42]

Another collated work from Ahmed's court is *Tuḥfetü'l-mülūk ve's-selāṭīn* (Gift of kings and sultans), an Ottoman translation of an Arabic text, dated to around 1610 on the basis of internal evidence.[43] The book contains the sultan's seal on its opening folio, and he is also identified in the circular ex-libris; it is therefore more closely associated with Ahmed's person than either the *Dīvān* or the *Vaḳāʿ i-i ʿAlī Pāşā*. The book consists of three treatises: on horses and their treatment, horsemanship, and on hunting. Given what we know of Ahmed's love of hunting—so much so that he was criticized by contemporaries for his passion—it seems a fitting book to have dedicated to him.[44] A section of the work is a book of counsel for rulers, and this too aligns with Ahmed's interests, or at least the contents of other books prepared for him, discussed above.[45] The *Tuḥfetü'l-mülūk* also demonstrates a loose image-text relationship by including images for which there are no textual counterparts, especially images of warriors demonstrating combat positions, highlighting the potential of the hunt as military preparation.[46]

Tülay Artan interprets the entertainment scenes here as part of a visual argument made by the producers of the book that hunting was not simply about excess and joy, as its detractors would have it, but that it also teaches lessons about good rule (fig. 4).[47] A similar argument is made by Safi in the "Sultanic Justice" section of *Zübdetü't- tevārīḥ*, where he defensively writes that the hunt has three uses: one is carrying out God's will and

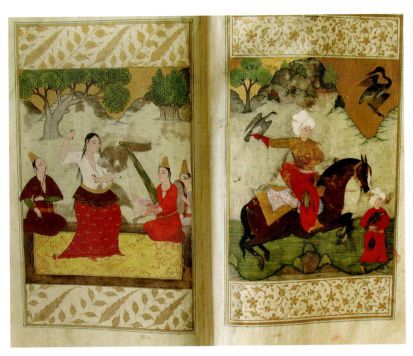

Fig. 4. Musical entertainment and hunting. *Tuḥfetü'l-mülūk ve's-selāṭīn*, anonymous. Istanbul, ca. 1610. Topkapı Sarayı Müzesi Kütüphanesi, Istanbul. H 415, 240b–241a.

designs, the second is "striking fear into the hearts" of enemies by appearing near the borders of the empire, and the third is acquiring direct knowledge about the affairs of the empire by conversing with locals.[48] Safi's book also has a separate section dedicated to the hunt, where it is portrayed as the perfect exercise for training not just in war but in rule.[49] Hunting scenes from the *Album of the World Emperor*, depicting princely figures engaged in heroic acts and graceful games of marksmanship seem to carry similar messages (see plates 33, 38, 47). The composition of plate 38 (see detail on page 32), in particular, echoes the *Tuḥfetü'l-mülūk* by juxtaposing a ruler and a female courtier with a hunt scene below.

Through discussions of the hunt, the author also gives the ruler some suggestions as to how a hunter should conduct himself and to what use he should put his hunting pleasures. In other words, the manuscript is a justification and a mirror for princes rolled into one. Artan suggests Hafız Ahmed Pasha, Ahmed I's son-in-law and grand vizier, as a possible patron for this manuscript, partly because, having also served as chief falconer, he would have been closely involved in the hunts that are praised in such lavish terms by the manuscript.[50] Additionally, he was the patron of a sumptuously illustrated Turkish translation of the *Shāhnāma*.

The translated *Shāhnāma* was begun in 1616, at the same time that two illustrated copies of Hoca Sadeddin's dynastic history of the Ottoman house, *Tācü't-tevārīḫ* (The crown of chronicles), were produced. Given their continuous narrative and historical subject matter, these three books are different in character from those we have examined thus far. They illustrate the importance of patronage networks and highlight the ongoing significance of genealogy and tradition to seventeenth-century Ottoman notions of rule.

One of the two illustrated *Tācü't-tevārīḫ* copies contains portraits of the sultans only, and the other has fourteen narrative illustrations.[51] The copy with narrative illustrations is dated to Rebiyülevvel 1025 (March 1616), and was copied by the court scribe Ibrahim b. Mustafa. The paintings mimic the historical images in the courtly visual idiom developed in the late sixteenth century for the official court historian Lokman's imperial histories, perhaps deliberately archaizing for this historical manuscript. An unusual aspect of the illustration depicting Murad II here, as noted by Serpil Bağcı et al., is the inclusion of a courtly lady, the consort of Murad II, Hatice Halime Sultan, in one of the images (fig. 5). As they do, I too would attribute this to the seventeenth-century popularity of genre scenes with female and male figures.[52] Many such images are included in the *Album of the World Emperor*.

It is interesting that the *Tācü't-tevārīḫ*, composed in 1574 and covering only the period prior to the death of Selim I in 1520, had never been illustrated before, despite being a well-known work consulted by historians and written by such a powerful courtier. One explanation for its illustration is the importance of its author Sadeddin's legacy at the court of Ahmed I.[53] Ahmed's favorite in his early reign, Derviş Pasha, was closely connected to Hoca Sadeddin's family. He petitioned to appoint Sadeddin's two youngest sons, Esad and Abdülaziz, as the chief military judges of Rumelia and Anatolia in 1606.[54] In the same year, Ebülmeyamin Mustafa Efendi, a protégé of Hoca Sadeddin, was reappointed as shaikh al-Islam. From June 1608 until his death in July 1615, Sadeddin's eldest son Hocazade Mehmed Efendi held the position of chief mufti. His brother Esad was appointed when Mehmed died. According to Baki Tezcan, the two brothers often acted

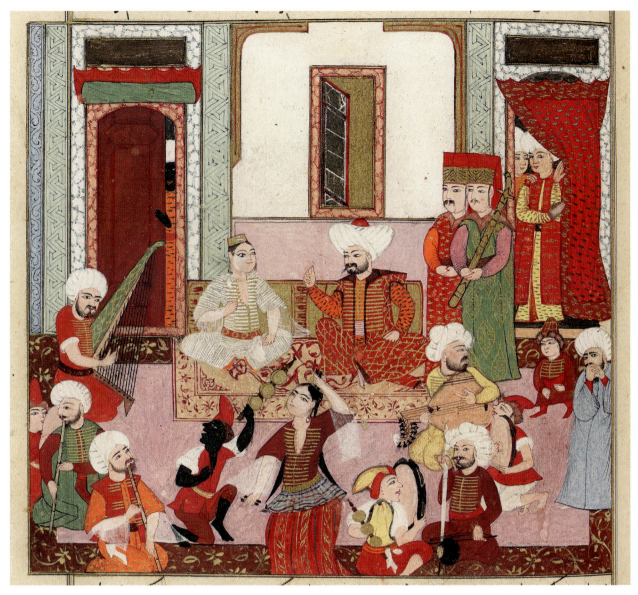

Fig. 5. Murad II and Hatice Halime Sultan being entertained. *Tācü't-tevārīḫ*, by Hoca Sadeddin. Istanbul, 1616. Musée Jacquemart-André, Paris. D262, fol. 138a.

against the interests of the imperial family, demonstrating a significant amount of independence and exercising their political clout.[55] Therefore it is no surprise that in this period where no other histories were illustrated, two copies of Hoca Sadeddin's history of the Ottoman Empire, *Tācü't-tevārīḫ*, were produced with lavish paintings. Shaikh al-Islam Esad Efendi was in office during the years 1615–22 and 1623–25, which cover the production period of the illustrated copies. One of the copies includes an image of the reigning Ahmed and was likely made for the ruler.

If the power of Sadeddin's sons is one explanation for why the *Tācü't-tevārīḫ* was illustrated at this time, another is the emphasis on Selim I as the Lord of the Auspicious Conjunction. The *Tācü't-tevārīḫ* begins with a poem by Sadeddin talking about how close his father, Hasan Can, was to Sultan Selim I, and how his father knew all of Selim's secrets and anecdotes. The poem is intended to both authenticate the information

included in the book and to show its special nature, implying that it includes material otherwise not known or knowable.[56] The verses are also a reminder that the current shaykh al-Islam Esad Efendi was the third generation in his family who had served the Ottoman ruler at such close proximity and high position. More important for my purposes, an illustrated account of Ottoman history that began with this reminder of Selim I's era and that culminated with Selim I's reign—indeed, written with special knowledge of his affairs—would have helped to foster the image of Ahmed as a follower of Selim I. The characterization of Selim I as the Lord of the Auspicious Conjunction is also highlighted in the next manuscript I will examine, where his memory is even more closely intertwined with eschatological anxiety.

THE OCCULT: *TERCÜME-İ MİFTĀḤ-I CİFRÜ'L-CĀMİ'*

The *Miftāḥ-ı cifrü'l-cāmi'* (Key to comprehensive prognostication) was originally an Arabic text (one of the languages used at court and in legal and religious contexts) written by Abd al-Rahman al-Bistami of Antioch (d. ca. 1455).[57] Bistami was active around the Ottoman court and was an authority on both occult cosmology and the science of letters, which allowed him to write about the end times and predict the events leading up to the apocalypse.[58] This is expounded at length in the *Miftāḥ*, which combines Mamluk apocalypses and prophetic works attributed to Ibn 'Arabi to describe signs of the approach of the day of resurrection, and makes other relevant prognostications.[59] Cornell Fleischer labeled it long ago as the "urtext of Ottoman dynastic eschatology."[60] While the prophetic aims and divinatory iconography of the *Miftāḥ-ı cifrü'l-cāmi'* might not seem in keeping with Sunni orthodoxy, such divinatory sciences were very much a part of the fabric of courtly life in the Islamic world of the early modern period.[61]

The text was translated into Ottoman Turkish from the original Arabic at the court of Ahmed's father, Mehmed III, and acquired a new title, *Tercüme-i* [The translation of] *miftāḥ-ı cifrü'l-cāmi'* (figs. 6, 7, 8). The Ottoman translation was an illustrated, expanded, and updated text that also commented on the fact that Bistami's predictions for the end of the first millennium did not come true.[62] Despite this caveat, the *Miftāḥ* retained its hold over the Ottoman elite and continued to provide an eschatological role for the Ottoman ruler that bolstered his legitimacy. This explains why it was illustrated a second time for Ahmed I (see figs. 12–21). Ahmed's copy of the *Miftāḥ-ı cifrü'l-cāmi'* was simply the latest manifestation of an Ottoman courtly interest in eschatology and the occult that had been present at the court since the fifteenth century (if not earlier).[63]

Bistami's works were read in courtly circles throughout the sixteenth century, gaining further traction during the reign of Süleyman.[64] Fleischer's discussion of a late-sixteenth-century Ottoman astrological manual now in Florence demonstrates the prevalence of astrology at the palace and reminds us of the shared astrological culture in Mediterranean courts of the early modern period. Astrology and prophecy are, of course, overlapping fields of expertise. Fleischer describes an Ottoman astrological compendium from the period of Süleyman, which contains "a discussion of the astrological signs of the imminent destruction of the Islamic state and predominance of Christian power throughout the world," in addition to a treatise on the rules governing astrological practice and notes by the imperial astrologer. This same manuscript contains treatises by

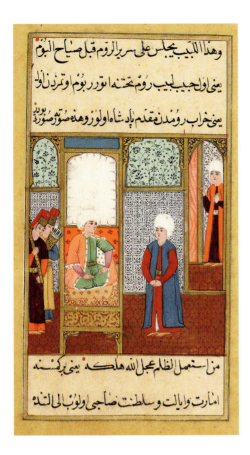

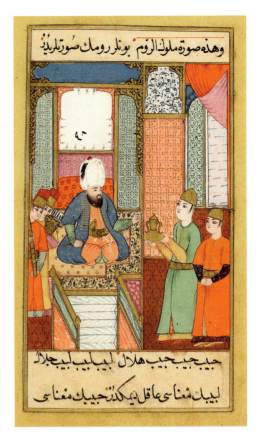

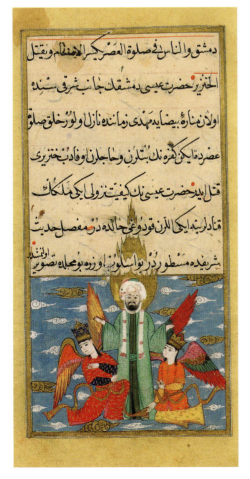

Fig. 6. The Mahdi enthroned. *Miftāḥ-ı cifrü'l-cāmiʿ*, translated by Şerifi. Istanbul, ca. 1600. Topkapı Sarayı Müzesi Kütüphanesi, Istanbul. B 373, fol. 320b.

Fig. 7. Sultan of Rum. *Miftāḥ-ı cifrü'l-cāmiʿ*, translated by Şerifi. Istanbul, ca. 1600. Topkapı Sarayı Müzesi Kütüphanesi, Istanbul. B 373, fol. 393b.

Fig. 8. Descent of Jesus. *Miftāḥ-ı cifrü'l-cāmiʿ*, translated by Şerifi. Istanbul, ca. 1600. Topkapı Sarayı Müzesi Kütüphanesi, Istanbul. B 373, fol. 219a.

various Muslim and Christian astrologers.[65] There is proof here that not only court scribes and other personnel (including a court astrologer) were keenly aware of and interested in the occult sciences, but that these interests were shared across religious and socioeconomic lines. Khaled El-Rouayheb has recently demonstrated that although astrology does not appear to be as well-supported in the seventeenth century Ottoman Empire, its sister science, astronomy, certainly was.[66]

The evidence of illustrated and luxury manuscripts from the reigns of Murad III, Mehmed III, and Ahmed I shows that eschatological and occult concerns were little abated after the Islamic millennium of 1591–92, despite the passing of the urgency after the millennium. Murad III's interest in the occult is made most explicit in his well-documented interest in dream interpretation. The letters exchanged between him and his Halveti shaikh implicitly fashion him as a messianic figure.[67] Two illustrated copies of the *Maṭāliʿ al-saʿāda wa manābiʿ al-siyāda* (The ascension of propitious stars and the sources of sovereignty), an expanded Ottoman translation of the late-fourteenth-century *Kitāb al Bulhān* (The book of wonders) prepared for Murad's two daughters, and the original *Miftāḥ* in Arabic prepared for illustration during his reign—although not finished—also strengthen our knowledge of his interests.[68]

Many of the works prepared for Murad, when examined with an eye toward the occult and prophecy, reveal such undertones: the imperial portrait book (*Şemāʿilnāme*) of 1579 (fig. 9), for example, depended on the science of physiognomy, and in its implication that the physical appearance of a ruler explains events in his reign also suggested that the fate of the ruler can at least partially be foretold from his appearance.[69] Similarly, the universal history-cum-genealogy *Zübdetüʾt-tevārīḫ* (fig. 10) by the court historian Lokman also betrays a cyclical worldview, where the Ottoman rulers are connected to figures from Islamic history and a link is fashioned between the Prophet Muhammad and Murad III.[70] When discussing Murad III, Bağcı rightfully points to the building of the observatory in Galata during his reign as a result of his interest in astrology and the many miracles performed by the Prophet Muhammad in the *Siyer-i Nebī* as further demonstrations of occult concerns.[71] The visual evidence thus suggests that beyond the emulation of the Prophet Muhammad and Sufi tendencies, there was an acute interest in occult teachings at the court of Murad III.

When we turn to Mehmed III's short reign, the translation of the *Miftāḥ-ı cifrüʾl-cāmiʿ* stands out, but we might also consider the two surviving *Aḥvāl-i ḳiyāmet* (Circumstances of the day of resurrection) manuscripts from the turn of the century (fig. 11). They were prepared either during Mehmed III's or Ahmed I's reign and are painted in a style very similar to Ahmed I's *Miftāḥ* manuscript, probably by the same artist.[72] An additional group of manuscripts with links to this interest in the natural and occult sciences are the *ʿAjāʾib al Makhlūqāt* (Wonders of Creation), which were illustrated in greater numbers during the reigns of Murad III and Mehmed III.[73] In particular, one *Wonders of Creation* manuscript dated to circa 1595 has illustrations in the style of Nakkaş Hasan, who continued to be an important court artist and administrator under Ahmed I.

To return to the *Miftāḥ-ı cifrüʾl-cāmiʿ*, it is significant that the order to translate the work from Arabic into Ottoman Turkish was given by Mehmed III's chief eunuch, Gazanfer Agha, and that this effort resulted in an illustrated copy (see figs. 6, 7,

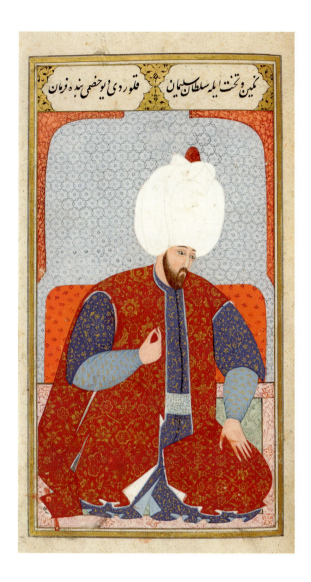

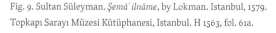

Fig. 9. Sultan Süleyman. *Şemā'ilnāme*, by Lokman. Istanbul, 1579. Topkapı Sarayı Müzesi Kütüphanesi, Istanbul. H 1563, fol. 61a.

Fig. 10. Sultan Murad III. *Zübdetü't-tevārīḫ*, by Lokman. Istanbul, 1583. Türk ve Islam Eserleri Müzesi, Istanbul. 1973, fol. 88b.

Fig. 11. Israfil blowing the trumpet of resurrection. *Aḥvāl-i ḳiyāmet*, anonymous. Istanbul, ca. 1600. Süleymaniye Yazma Eser Kütüphanesi, Istanbul. Hafid Efendi, 139, fol. 22a.

8). Gazanfer was a close associate of Hoca Sadeddin (the author of the *Tācü't-tevārīḫ* discussed above*)*, whose political and intellectual legacy was felt throughout the reign of Ahmed I. The translator of the *Miftāḥ*, Şerifi, was a professor at the madrasa established by Gazanfer Agha and was only one of a number of students of Hoca Sadeddin who were later employed or supported by Gazanfer Agha. The translation, illustration, and re-illustration of the manuscript points to the persistence of the intellectual and artistic networks of the sixteenth-century Ottoman court into the seventeenth century. It is also a reminder that these networks were often responsible for guiding intellectual pursuits at court and that the individual sultans were parts of these networks, and not lone actors.

During the early years of Süleyman's reign, the original *Miftāḥ* had been used to present him as the Mahdi.[74] Its translated and illustrated versions for Mehmed III and Ahmed I do the same thing for them, this time visually.[75] The two illustrated copies have almost identical painting programs. They both provide a visual argument that the House of Osman is the last dynasty to rule before the end times, and they equate the reigning Ottoman monarch with the Mahdi. This argument is made primarily by mapping events from Ottoman history onto the events of the apocalypse. Verbally, various hadith, verses, and signs are interpreted as pointing to the House of Osman, who then populate the images. Instructions for painters written on the blank pages of an unfinished Arabic copy prepared for Murad III demonstrate that this was the intention of the illustrated version from the very beginning. The painters' instructions ask for Sultan Süleyman and Ibrahim Pasha to be illustrated in one spot, and in another they indicate "that the last conqueror of Egypt is to be represented by an enthroned Selim."[76]

The signs of the apocalypse, according to Islamic popular understanding as demonstrated in the *Miftāḥ* and elsewhere, include military clashes (often with Christians); the destruction of the Kaʿba; various calamities; the appearance of the Mahdi (fig. 12; see also fig. 6); the appearance of Jesus (as separate from the Mahdi, fig. 13; see also fig. 8); the loosening of morals with the prevalence of pleasure-seeking sinners (fig. 14); the appearance of Gog, Magog, and the Antichrist; and the rise of the sun from the west.[77] Events from Ottoman history are located in the last portion of the book. The identical painting program of the two manuscripts places clear emphasis on Selim I, particularly his battles with the Mamluks, his conquest of Egypt and Syria, and his victory over the Safavids (figs. 15, 16). The conquest of Constantinople by Mehmed II is also of obvious interest to the makers of the manuscript, since so many of the events foretelling the apocalypse are expected to happen in Constantinople. The rulers associated elsewhere with prophecy, the auspicious conjunction, or the Mahdi—in other words, Mehmed II, Selim I, and Süleyman I (fig. 17)—feature as the heroes of the *Miftāḥ*, bringing the Ottoman past to bear on the future.

The group portraits of the Ottoman rulers (fig. 18) come after a section that lists positive moral qualities in people, without any textual link to Ottoman sultans. But the translator's comment, referring to the original fifteenth-century Arabic (written by Bistami for the Ottoman ruler Murad II), reads as follows: "The author, after writing these words, illustrated eleven people. And he made a marginal notation saying here are their images, such that they are drawn from the House of Osman. God is the one that knows best what the author's intention was."[78] In other words, the images of the rulers are there

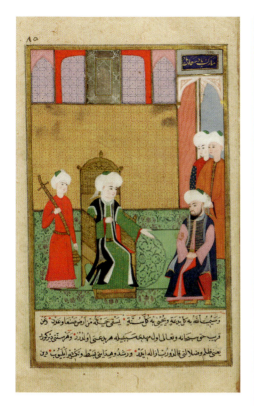

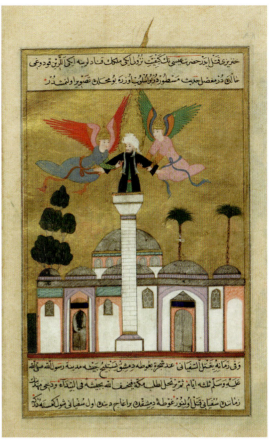

Fig. 12. Mahdi enthroned. *Miftāḥ-ı cifrü'l-cāmiʿ*, translated by Şerifi. Istanbul, ca. 1603–17. Istanbul Üniversitesi Nadir Eserler Kütüphanesi, Istanbul. T 6624, fol. 85a.

Fig. 13. Descent of Jesus. *Miftāḥ-ı cifrü'l-cāmiʿ*, translated by Şerifi. Istanbul, ca. 1603–17. Istanbul Üniversitesi Nadir Eserler Kütüphanesi, Istanbul. T 6624, fol. 89b.

Fig. 14. Sinners enjoying a picnic after the warm apocalyptic wind. *Miftāḥ-ı cifrü'l-cāmiʿ*, translated by Şerifi. Istanbul, ca. 1603–17. Istanbul Üniversitesi Nadir Eserler Kütüphanesi, Istanbul. T 6624, fol. 100b.

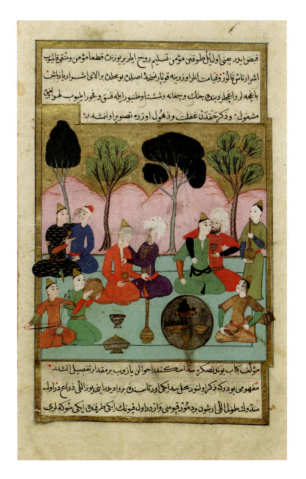

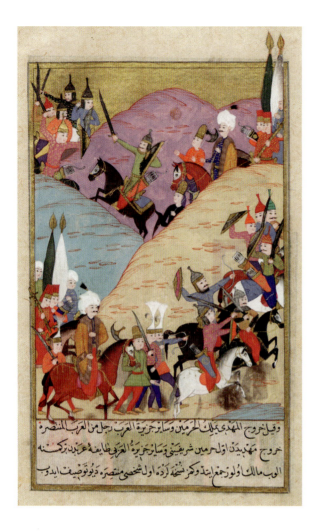

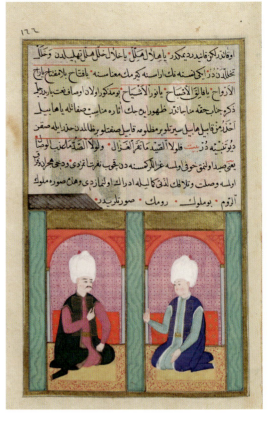

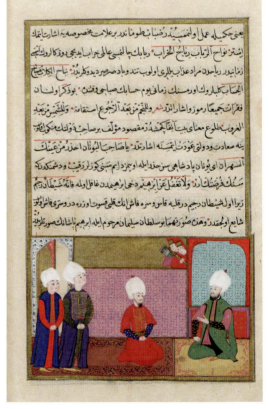

Fig. 15. Sultan Selim I in battle. *Miftāḥ-ı cifrü'l-cāmiʿ*, translated by Şerifi. Istanbul, ca. 1603–17. Istanbul Üniversitesi Nadir Eserler Kütüphanesi, Istanbul. T 6624, fol. 133b.

Fig. 16. Selim I and the young ruler of Rum, Ahmed. *Miftāḥ-ı cifrü'l-cāmiʿ*, translated by Şerifi. Istanbul, ca. 1603–17. Istanbul Üniversitesi Nadir Eserler Kütüphanesi, Istanbul. T 6624, fol. 166a.

Fig. 17. Sultan Süleyman and his grand vizier Ibrahim Pasha. *Miftāḥ-ı cifrü'l-cāmiʿ*, translated by Şerifi. Istanbul, ca. 1603–17. Istanbul Üniversitesi Nadir Eserler Kütüphanesi, Istanbul. T 6624, fol. 159b.

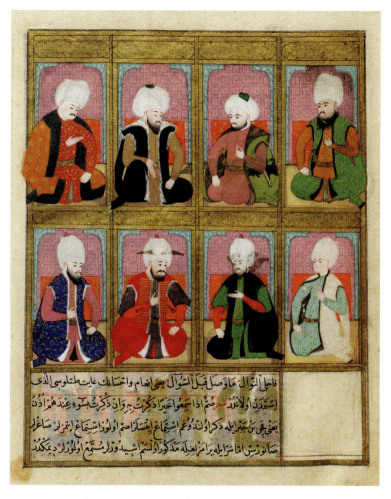

Fig. 18. Ottoman sultans. *Miftāḥ-ı cifrü'l-cāmi'*, translated by Şerifi. Istanbul, ca. 1603–17.
Istanbul Üniversitesi Nadir Eserler Kütüphanesi, Istanbul. T 6624, fol. 163b.

to illustrate good moral qualities, which means that they embody these qualities. The
visual contents of the manuscript deliberately connect the events described in the book
with the Ottoman dynasty.

While the connection established between the Ottoman dynasty and the apoca-
lypse takes the whole House of Osman as its focus, there are images in the two illustrated
manuscripts that relate the book not only to the dynasty but to the specific ruler for
whom each illustrated copy was made. The *Miftāḥ* made for Mehmed III presents the
ruler of Rum with Mehmed III's physiognomy, including his squarish full beard, his
hefty body, and his historically accurate clothes, throne, and attendants (see fig. 7). The
copy made for Ahmed, however, presents the ruler of Rum as a young Ahmed (fig. 19),
corresponding to the depiction of Ahmed I in the group portrait of Ottoman rulers
included in the same manuscript (see fig. 12 for Mahdi and fig. 18 for Ahmed and his
ancestors). Each manuscript thus presents its own patron as the last ruler before the end
times. Even the conqueror of Egypt in Ahmed's manuscript looks more like Ahmed than
Selim I (the actual Ottoman ruler who conquered Egypt), with a beardless young face
instead of Selim's idiosyncratic moustache, a consistent iconographic feature in almost
all imperial Ottoman manuscripts depicting Selim I (fig. 20). Additionally, in Ahmed's

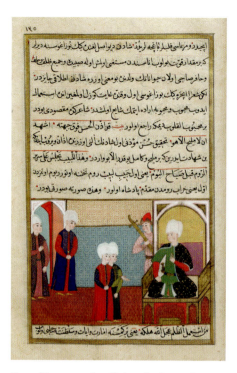

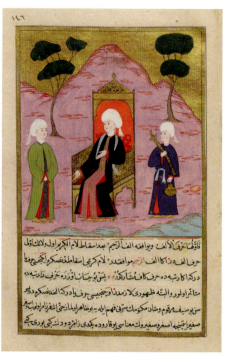

Fig. 19. The person who will sit on the throne of Rum. *Miftāḥ-ı cifrü'l-cāmi*ʿ, translated by Şerifi. Istanbul, ca. 1603–17. Istanbul Üniversitesi Nadir Eserler Kütüphanesi, Istanbul. T 6624, fol. 135a.

Fig. 20. The person who will rule over Cairo. *Miftāḥ-ı cifrü'l-cāmi*ʿ, translated by Şerifi. Istanbul, ca. 1603–17. Istanbul Üniversitesi Nadir Eserler Kütüphanesi, Istanbul. T 6624, fol. 146a.

copy, the rulers of Rum on folios 166a and 166b also include one figure who represents Selim I (again with the moustache and no beard) and three young men. The one sitting across from Selim on 166a (see fig. 16) is particularly reminiscent of Ahmed's image on folio 163b of the same book (see fig. 18). The juxtaposition of Selim I and Ahmed I evokes Safi's comments about how the two rulers share the same nature.[79] A clear apocalyptic iconography had been created for Selim I, which explains why he features heavily in this work, and the connection implied between him and Ahmed helps to catapult Ahmed onto the same apocalyptic stage.

The visual parallels created inside the manuscript are strengthened by the frontispiece to Ahmed's volume (fig. 21), which is, however, a later addition. Currently, the front binding and the first three folios are separated from the rest of the volume as a result of damage. Moreover, there are two illuminated headings (fols. 2b and 3b) that start the text, one in the separated portion, and one still bound in the book. This also shows that the first three folios were originally intended for another book. However, the image is consistent in style with the rest of the manuscript, which even without it points to Ahmed as the Mahdi as described above. The frontispiece shows the young Sultan Ahmed enthroned in the second courtyard of the Topkapı Palace at his accession ceremony. This frontispiece image, which is not called for by the text, intimately links the contents of the *Miftāḥ* with Ahmed. Laying claim to the contents of a book via a frontispiece image is an old tradition within Perso-Islamic book arts. Among the many examples that come to mind are the images of the fifteenth-century Timurid prince and bibliophile Baysunghur that were appended to the beginnings of his copies of *Kalila wa*

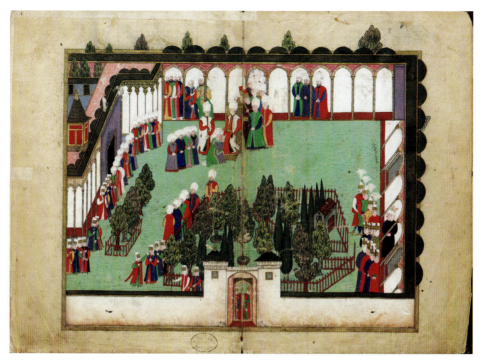

Fig. 21. Frontispiece, Ahmed I enthroned. *Miftāḥ-ı cifrü'l-cāmi'*, translated by Şerifi. Istanbul, ca. 1603–17. Istanbul Üniversitesi Nadir Eserler Kütüphanesi, Istanbul. T 6624, fols. 1b–2a.

Dimna (1429) and the *Shāhnāma* (1430), immediately calling to mind parallels between the ideals upheld by the books and their owner pictured in the beginning.

The illustrated versions of the *Miftāḥ* demonstrate that the occult was a quiet and fluid presence at the Ottoman court that became more evident when one looked with eyes attuned to seeing it—given its nature, this is only to be expected. The persistence of an eschatological ideal and role for the reigning Ottoman sultan, necessitated by political theory, the confessional competition, and the heightened early modern interest in millennial rulership is made explicit by these manuscripts, but it is also to be found among works prepared for Ahmed by Kalender.

THE OCCULT: *THE FĀLNĀME*

The *Fālnāme* (Book of omens), by its very nature as a device of prophecy, is further proof of occult interests at Ahmed's court.[80] Ahmed's *Fālnāme* is one of four surviving monumental manuscripts created at the end of the sixteenth and beginning of the seventeenth centuries. Assembled by Kalender in 1614–16, simultaneously with the *Album of the World Emperor*, the *Fālnāme* is a book with images and text for prognostication that participates in the long-standing and popular practice of bibliomancy (the consultation of special books for auguries or signs) practiced throughout the Islamic world, despite the fact that it was strongly condemned by some.[81] Bibliomancy certainly forms a part of occult knowledge, and consequently the *Fālnāme* should be seen as an expression of an existent Ottoman courtly interest in the occult, one that has led to the creation of such works as the *Miftāḥ-ı cifrü'l-cāmi'*, discussed above. The practice of bibliomancy at the

Ottoman court is attested by a Qur'an by Şeyh Hamdullah prepared for Bayezid II that includes a *fāl* table at its end, to help with using the Qur'an for prognostication.[82] Bağcı also points to the *Rāznāme* (Book of secrets), dedicated to Murad III and presented again to Mehmed III, which includes anecdotes on the practice of prognostication among the Istanbul elite.[83] Persistent Ottoman interest in seeing the future through books is evident from the existence of calendars with predictions such as one prepared for Selim I, still in palace collections.[84] Other sources, namely, Evliya Çelebi's account of fortune-tellers in the bazaar, describe the use of pictures for divination.[85] Ahmed's *Fālnāme*, in other words, is a novel manuscript, but for a long-standing practice.

The *Fālnāme* functions as an album does; where images drive the narrative, viewers need knowledge beyond the book in order to make sense of its images, which in turn help interpret the augury.[86] The images include topics such as Adam and Eve, paradise, hell, the Virgin Mary and Child Jesus (fig. 22), Dajjal (the Antichrist), the Beast of the Earth, Alexander the Great, Mars (see fig. 45), Hippocrates (see fig. 46), Ali, and other figures from Islamic and Abrahamic tales. In other words, apocalyptic and religious concerns are well represented here.[87] The book is used by opening it to a random page in order to help answer a specific question. Each opening consists of an image of an omen on the right and its accompanying text on the left. The text begins with a declaration of what the omen is, along with a short poem about it, then proceeds to answer the various possible questions, such as whether this is a good omen for going to war, for entering into a profession, building a house, and so forth. The text was written by Kalender, clearly based on other examples, but it is not simply a translation of an existing text; it is an original creation. He must have thus had to become (or already be) knowledgeable in the interpretation of omens in order to compose it. The images were not specifically created for this project, but gathered by Kalender from among existing paintings, as he explains in the preface. The images chosen might have been used for prognostication beforehand, while they were still unbound single sheets, as we know some images were, and they were perhaps chosen for their efficacy. The addition of the text, Bağcı tells us, eliminated the need for someone else to interpret them, allowing the sultan to act as both augury seeker and seer, which perhaps suggested he had the power of prophecy.[88]

Most of the images are dated by Farhad and Bağcı to the 1570s or 1580s on stylistic grounds, and they are related both stylistically and by subject matter to the other three surviving *Fālnāma*s from this period, which are in the Persian language. The genre points to close ties, or porous borders, between these neighboring artistic traditions and strengthens my assertion that Ahmed's eschatological aspirations were closely linked with internal dynamics of the Islamic world, and in particular with competition with the Safavids. The porosity of borders also entails the sharing of ideas and open competition on aesthetic as well as ideological grounds. It must also be borne in mind that one of the Persian *Fālnāma*s in the Topkapı treasury, although we do not know when it got there, is currently housed right next to Ahmed's *Fālnāme*; they even have consecutive manuscript numbers H (*Hazine*, "treasury") 1702 and H 1703.

In subject matter, the paintings relate to books on the lives of prophets (see, for example, fig. 22, depicting Mary and the Infant Jesus), to Zodiac imagery, and to the sixteenth-century Ottoman universal history *Zübdetü't-tevārīḫ*, with its images of

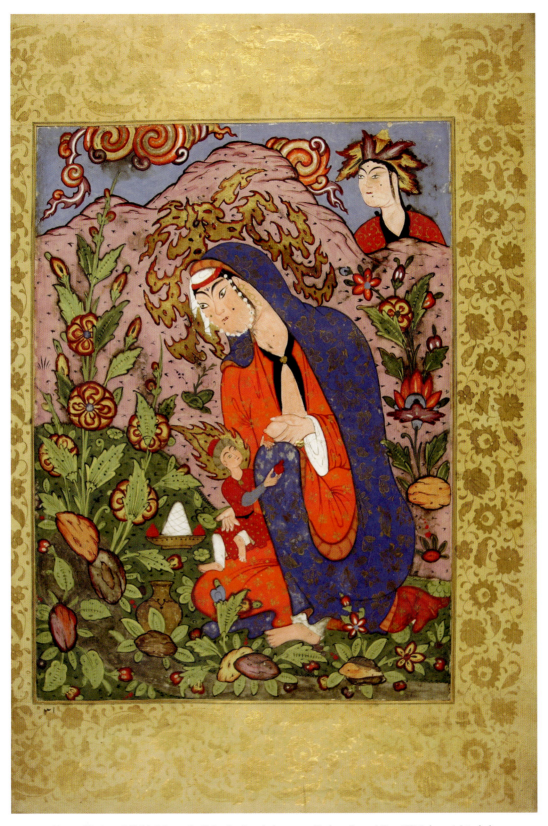

Fig. 22. Virgin and Child. *Fālnāme*, by Kalender. Istanbul, 1614–16. Topkapı Sarayı Müzesi Kütüphanesi, Istanbul. H 1703, fol. 32b.

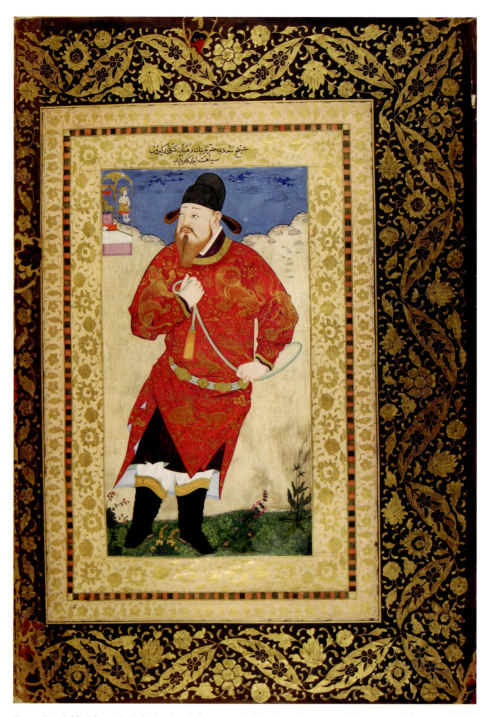

Fig. 23. Poet Saʿdi. *Fālnāme*, by Kalender. Istanbul, 1614–16. Topkapı Sarayı Müzesi Kütüphanesi, Istanbul. H 1703, fol. 6b.

Abrahamic prophets, Alexander the Great, and figures from Islamic history.[89] As with the other *Fālnāma* manuscripts, there are quite a few images of ʿAli, but contrary to current expectations, this would not have been considered unorthodox or unusual by an early modern Sunni viewer for whom ʿAli was a member of the household of the Prophet Muhammad, and was consequently revered.[90]

The first painting in the manuscript (fig. 23), however, is an unusual one, showing, as Bağcı points out, both engagement with the treasured earlier albums in the Topkapı and

with Ahmed's concerns about the role of images. The painting is by the Ottoman artist Nakşi, who contributed to a number of courtly manuscripts at the end of the sixteenth and the early part of the seventeenth century. It is possible, though by no means certain, that he is responsible for some images in B 408 as well. The *Fālnāme* image is of the classical Persian poet Saʿdi (d. 1292) dressed as a Chinese monk. It relates to an anecdote from Saʿdi's *Būstān* (Orchard) in which the poet hides in a Chinese temple to discover the secret behind a moving idol, which turns out to be a monk hiding behind a curtain, pulling a rope, as if moving a marionette. Most of the painting is taken up by Saʿdi in a sumptuous red tunic, holding a rope. His pose and dress are modeled on an image of two fifteenth-century Chinese grooms, of which three copies are incorporated (fig. 24) into two different earlier albums in the Topkapı treasury. One of these albums, H 2153, has notations by Ahmed I, including his name and the date 1025/1616.[91] The topic of idolatry taken up by this image is one that was close to Ahmed's heart. A well-known anecdote about him concerns his destruction of a musical clock that featured an organ, which had been given by the English to Mehmed III, because he viewed the moving statues on it as idols that must be destroyed.[92]

Another painting in Ahmed's *Fālnāme*, made at the Ottoman court by Nakkaş Hasan, shows Adam and Eve. This image is common in both the *Aḥvāl-i ḳiyāmet* (Signs

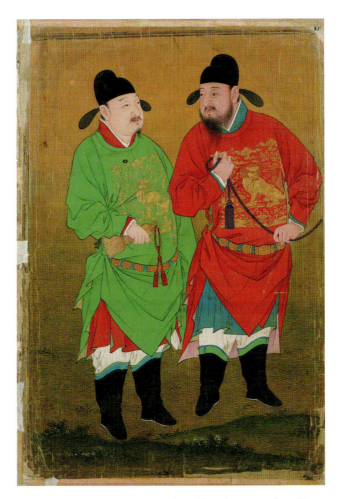

Fig. 24. Chinese grooms. Anonymous. China, fifteenth century. Album folio: probably Istanbul, early sixteenth century. Topkapı Sarayı Müzesi Kütüphanesi, Istanbul. H2153, fol. 123b.

of the apocalypse) manuscripts, the *Zübdetü't-tevārīḫ*, and the *Enbiyānāme* (Book of prophets, volume 1 of the *Şehnāme-i ʿāl-i Osmān* [Book of kings of the house of Osman], a universal history from the reign of Süleyman), although visualized very differently. It is not a novel image in either subject matter or style, but it is important as a counterpoint to the image by Nakşi, as it demonstrates the existence of very different painting styles at the court of Ahmed I, a multiplicity evinced in the *Album of the World Emperor Sultan Ahmed Khan* as well. It also reminds us of the important positions artists had come to occupy at the Ottoman court. The painter Nakkaş Hasan, like Kalender, was a long-serving bureaucrat and military officer as well as an artist, and he was appointed as vizier to the imperial council in 1605.[93]

The foregoing survey of Ahmed's artistic patronage demonstrates that an interest in the occult and the end times was one of his major preoccupations. The visual evidence provided by the *Miftāḥ*, the *Fālnāme*, and the *Album of the World Emperor Sultan Ahmed Khan*, coupled with the emphasis on Ahmed's piety and emulation of the Prophet in the written sources, suggests that a new kind of messianic image was being fashioned for Ahmed. By the early seventeenth century, the idea of the Mahdi was no longer as novel as it had been during the mid-sixteenth century, but it was still current and was updated through works such as the *Miftāḥ* to accommodate historical changes. A new image of the Ottoman ruler had formed in the intervening years, one that accorded with the historical reality of an Ottoman sovereign who controlled the holy cities of Islam, who could claim the title of caliph, and who no longer led his army on campaign (but went hunting instead). The new Mahdi derived legitimacy from his bloodline, the Ottoman dynasty whose ascendancy had been foreseen in texts such as the *Miftāḥ* and been proven by their control of the holy and historic lands of Islam, by their just rule of law, and their inheritance of the legacy of the Prophet Muhammad as caliphs. Produced after the sixteenth century (and soon after the Islamic millennium) when these kinds of arguments about the Ottoman house as divinely ordained, and Ottoman rulers as *insān-ı kāmil* had already been made, these manuscripts build on existent notions but visualize them for the first time and allow us to form a clearer image of the ideal ruler during the reign of Ahmed I.

If the first commonality between Ahmed's books is their visualization of a refined eschatological ideal for the Ottoman ruler, the second characteristic uniting them is an engagement with the contents of the Topkapı treasury. The *Miftāḥ* translation was made based on three earlier copies of the text in the imperial coffers, including one with illustrations.[94] Ahmed's copy seems to build directly on his father's version, which would also have been deposited in the treasury. The *Fālnāme*, for its part, drew on both earlier albums in the Topkapı collections—in this case both fifteenth- and sixteenth-century Persian and Ottoman albums that contained two versions of a painting on silk of fifteenth-century Chinese grooms (this one from H 2153, fol. 123b; see fig. 24), and also earlier Persian paintings.

Third, all of these books, in terms of their word-image relationships, are a step removed from the illustrated chronicles of the sixteenth century. The verbal contents of the books in question are themselves collections. The images in them carry much more of the narrative than does the text, or at least have independent functions from the text.

The text in the *Fālnāme*, for example, relates mostly to the answers to the questions. The images, though, give us details about the story of the figures illustrated therein, so that we may recognize them and learn from their stories. This collected, piecemeal approach to the book is also one, of course, that dominates in the album. A similar approach is also displayed in the literary miscellanies that began to appear in greater and greater numbers in the seventeenth century. These developments point to the emergence of a new conception of the book, or how books and collections related to each other: collecting texts, collecting images, collecting poetry. The *Album of the World Emperor* appeared in this context, fully belonging to the moment.

Owing to the varied nature of the materials within them, albums construct multiple readings and come alive through intertextual/intervisual reading. This also means that the lessons revealed by the *Album of the World Emperor Sultan Ahmed Khan* are highly dependent on what viewers bring to the reading. Given what we know of the intellectual atmosphere at Ahmed I's court, as well as the sultan's literary, religious, political, and intellectual leanings, it is possible to suggest a number of interpretations that may have appealed to Ahmed and his courtiers. The rest of this book seeks to draw out some of these readings.

Kalender and the Album

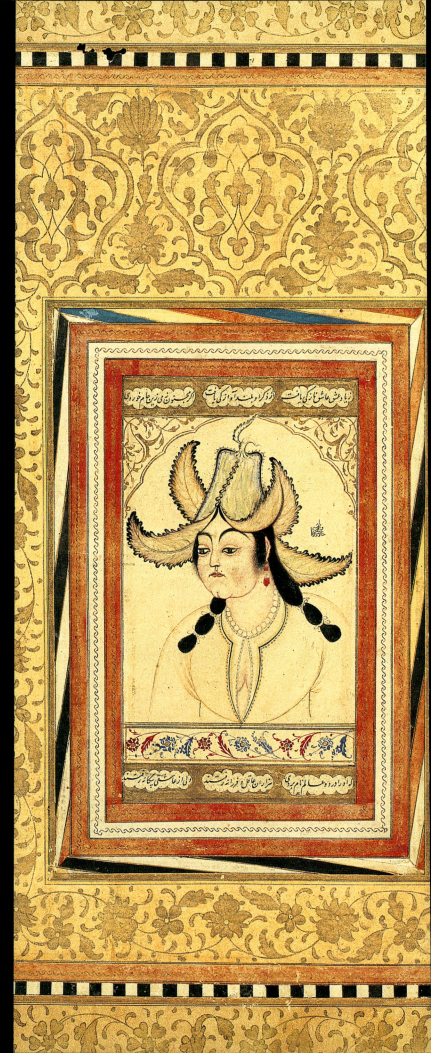

As important as the personality and patronage of Sultan Ahmed I are for understanding the meanings and purposes of the *Album of the World Emperor*, certainly the figure of Kalender also looms large in this story. Unusually for an artisan from the early modern Islamic world, we know a significant amount about his life.[1] Kalender held the post of *şehremini* (urban superintendent) in the early months of 1609, becoming a secretary-treasurer of the second rank in March 1609. He was appointed to supervise the construction of Ahmed I's mosque in November–December 1609. In 1612, he was appointed as senior secretary-treasurer.[2] Two years later, he became a vizier in the Imperial Council, and he died another two years after that in 1616.[3] Kalender's steady rise through Ottoman bureaucracy was probably made possible by the patronage of the chief harem eunuch, Hacı Mustafa Agha, who orchestrated his appointment as the building supervisor to the Sultan Ahmed Mosque. The significance of this position is evident from the central place Kalender had in the ground-laying ceremony. When Ahmed appeared at the construction site to put down the foundation stones of the mihrab wall with his own hands, the stones were in a box gifted by Kalender.[4] His fast and consistent rise through the ranks indicates that Kalender was more than a superb artist of paper joinery: he was a tastemaker and no doubt a politically powerful figure, well-entrenched in the networks of power at the palace.

All of this is borne out by a eulogy to Kalender by the contemporaneous Ottoman historian Mustafa Âli, from his treatise on calligraphers and other artists of the book, *Menā-kab-ı Hünerverān* (*Epic Deeds of Artists*). In an epilogue added to the 1599 copy, Âli writes:

> This distinguished *vassal* [paper joiner] was a man of talent; he had no match among his skillful peers
>
> In every composition where he joined together paper of all colors, a rainbow appeared on the face of the page
>
> No one could possibly detect the seams, even the most visionary eyes would think it a single piece
>
> When he joined paper and leather, not a word, not a sound from those who could split a hair into forty
>
> That perfect Creator decorated him with the art of *halkâr* [illumination with gold pigment], *zerefşân* [gold sprinkling], and the affixing of *pervâz* and *cedvel* [margins and frames] to the works
>
> Like the sweet sherbet of union for heartbroken lovers, he brings withered paper back to life with his remedies
>
> Should they say, "and who is he?" and doubt his fame, come, O pen, and write down your answer with this couplet:
>
> That mine of talent that they call Usher Kalender, do not wonder if the Crescent Moon—a ring on his ear!—becomes his slave
>
> The illumination he has made around the margins, full of knots, every one of them binds a knot around the feet of mind
>
> No one possessed so many calligraphic compositions, no one expended so much on artistic talent.[5]

Âli highlights Kalender's extraordinary skills in the various arts of album making, which are in evidence on the folios of the *Album of the World Emperor*. His characteristic

compositions of colored strips of paper that frame almost every page, the elegant gold illuminations that grace the margins of the folios, the paper joinery that turns distinct pieces of paper into exquisite single compositions are indeed wonder-inspiring. A later viewer of the *Album of the World Emperor* inscribed *vaṣṣāle-i nādire* (rare specimen of paper joinery) in the margins of a number of folios, suggesting that Âli was not alone in his appreciation of Kalender's handiwork.[6] Kalender's collection of calligraphy is also important to Âli, and to us, as some pieces from it clearly ended up in the sultan's albums. His possible belonging to a Sufi order is hinted at by the reference to the crescent moon being a ring on his ear.

In his preface to the *Album of the World Emperor*, Kalender writes that the sultan "brought together all the leaves of pictures and calligraphies and sent them to this humble servant." Kalender then "expended crafts unseen and marvels unheard of" and joined them together in an album.[7] Kalender emphasizes the visual aspect of his work by saying that when "those with acute perception and sagacious people of insight" look at the album with the scrutinizing gaze, they will see "the four corners and the facing one are all in harmony with and conforming to each other, be it in color or in size and length and width."[8] Kalender's task was not simply creating frames for a set collection; rather, the curation and organization of the pieces on the album folios depict specific choices and preferences. His interventions guide viewers through the album and shape the experience of these individual works of art—they are no longer individual pieces, in fact, but work within networks of relationships established or highlighted by Kalender. The album also showcases Kalender as a connoisseur, a refined courtier who could appreciate and suggest relationships among paintings, drawings, and calligraphies from disparate sources. In a courtly context where increasing numbers of the ruling elite engaged in the visual arts, indeed where this was almost expected, the *Album of the World Emperor* allowed Kalender to perform his elite status and showed Ahmed to be a connoisseur and a wise patron.[9] Let's look at Kalender's visual tactics to see how he achieved this.

Making the Album: Inducing Contemplative Vision

In the preface to the *Album of the World Emperor*, Kalender writes the following about the works of art in the Topkapı Palace: "Those matchless pearls of crafted marvels, the personages of precious words and best of the features of depicted things, which are in the flawless palace and heavenly castle . . . seduced the hearts of world rule and [astonished and excited] the natures of the people of the heart with their beguiling beauty."[10] Kalender describes the effects of the "matchless pearls of crafted marvels" with the words "seduced," "astonished," and "excited" (*firīfte, alüfte,* and *āşüfte*).[11] In the next section, he writes about the power of images to educate and inspire, especially during difficult times: they "will certainly cause the acquisition of the capital of the science of wisdom, will result in the perfection of the eye of learning by example, and will additionally console the felicitous person and troubled heart of the mighty sovereign by enlivening his mind and by pleasing his luminous inner self and his illuminated heart."[12] The next sentence, beginning with the word "consequently" (*binā'en 'alā*), tells us the sultan wanted these materials to be collected in an album. Because works of art, those

seductive, astonishing, and exciting things that enlivened the spirit of the sultan and gave pleasure to him, could teach and inspire people, the sultan asked Kalender to organize some in an album format. The visual relationships among paintings, calligraphies, and drawings, carefully arranged on specific pages, could perhaps guide viewers to conclusions they may not have drawn by looking at the individual works of art. Aesthetic pleasure and learning are intimately linked in Kalender's understanding.

The idea that aesthetic perception could lead to edification was not unique to Kalender's preface. Gülru Necipoğlu has argued that the "intimate connection between sight and insight" was a prevalent notion in medieval and early modern Perso-Islamic sources.[13] We might understand Kalender's organization and embellishment of the materials in the album as an aid to the "scrutinizing gaze" (imʿān-i naẓar). His interventions were intended to guide viewers to a higher level of understanding by encouraging them to gaze with contemplation—a level of understanding they might not reach by themselves if they were simply perusing these artworks individually or in a haphazard fashion. What Kalender was doing, in other words, was very much in line with what Necipoğlu has identified in the context of architectural ornamentation as "the willful complication of vision by intricately decorated surfaces . . . [as] a calculated way of inducing contemplative vision," similar to what has been argued about the architectural ornamentation of the Alhambra or the Aljaferia palaces in Spain.[14]

In the introduction to the *Album of the World Emperor*, Kalender suggests that viewers of the album need to look with care, in a reflective fashion, so that pleasurable viewing can lead to learning. A similarly explicit link between aesthetic pleasure and learning is also made in the popular medieval book of fables *Kalīla wa Dimna* (Kalila and Dimna), which is further proof that Kalender's ideas about the arts drew on earlier Islamic notions of aesthetics.[15] Kalender writes that the sultan wanted the materials in the album to be arranged "with respect to each one's relationship to each other" (*her birisinin biri birisine münāsebeti ile tertīb olunup*). He repeats the phrase "each one's relationship to each other" when he writes that he joined paintings (*taṣvīrāt*) and calligraphic panels (*muḳaṭṭaʿāt*), pasted them onto colored papers, and turned them into an album.[16] He presents his organization of the album as guided by aesthetic concerns that can be appreciated by those who know how to look: "it is not unknown or hidden to those with acute perception and sagacious people of insight that by looking at each one of them with a scrutinizing gaze [*imʿān-ı naẓar*], if attention is paid, God willing, the four corners and the facing one are all in harmony with and conforming to each other, be it in color or in size and length and width."[17] Kalender's description of his own interventions here brings his work into the realm of artistic skill. Each folio was a careful composition in which he matched examples of calligraphy with paintings or illumination. His parameters were both mechanical, focusing on size, proportion, and the fit of edges, and stylistic, as is evidenced by the display of stylistically similar pieces in proximity to each other and his illuminations that further unified the individual pieces. He suggests here that these works were chosen primarily for their visual characteristics: the style of depiction, the calligraphic script, and the size and appearance of the sheets. However, upon examining the album carefully, it becomes evident that content, provenance, and authorship (especially for the calligraphies) also guided his choices.

Kalender's illumination and paper joinery skills are evident in the visual play created by the multiple frames, the dazzling contrast between subtly illuminated margins and rulings of psychedelic strips of color, the different backgrounds of marbled paper, and the careful detail work added to many of the images thus unified on the pages of the album. Yet within the visual variety of colored papers, stenciled frames, gilding, marbling, and geometric colored strips, there is clear order and hierarchy on the pages as well. This organized spectacle seems to guide the gaze so that the eye derives maximum pleasure and information from each page. The visual qualities of the works, when properly displayed, and when gazed at with care, would help the viewers to move from pleasure to learning. Kalender's role, in short, was powerful, for his album making brought these works to their full potential.

One of Kalender's tactics was to dazzle the eye with plenty. Although this appears to be a departure from mid- to late-sixteenth-century Ottoman and Safavid albums, which contain fewer works of art per page, the earlier albums in the Topkapı collections H 2153 (see figs. 24, 30, 31) and H 2160, which contain Ahmed's notations, do present folios as similarly crowded as those in the *Album of the World Emperor*. Like folios from these earlier albums, Kalender's layouts astonish the viewer by overwhelming the eye with multiplicity. This response is achieved not only through the sheer number of objects on a single page but also through the variety of works of art contained in the album as a whole. Yet within that variety there are also repetitions that contribute to the overwhelming effect by appearing to multiply the artworks. Identical figures are repeated with minute differences of pose or garments (see plates 21, 23, 54). Moreover, Kalender has included a vast variety of types from various ethnic and social backgrounds, infusing the album with yet another kind of multiplicity. Whether repeating or contrasting figures, their numbers serve to astonish the viewer.

The relationships established among the elements on a single page is another important tool. Kalender has constructed relationships across frames that are purely predicated on the visual, as exemplified by folios 11a and 27b (see plates 21, 54). These, like the word-image relationships examined in the next chapter, suggest loose narratives. Depicted here are types of officials and servants one would find in the Ottoman palace. Yet instead of being organized into discrete pages as they were in costume albums prepared for visitors to Istanbul at the time (examined in chapter 5), these images are organized in such a way as to suggest narrative scenes. Their compositions repeat the placement of figures in audience scenes from history books, but here the scenes have been broken down into their constituent pieces: the different figures, separated by frames. The ruler is placed at the upper right, in a place of compositional authority, as he often was in narrative paintings. The courtiers then are organized in a loose circular composition with the sultan at its apex. The sultan converses with a eunuch in one and a servant of the privy chamber in the other. The figures, which at first appear to be distinct depictions simply pasted onto the same page, are clearly in communication with each other, creating a loose narrative about an unspecified moment in the Ottoman court. As the eye moves across the pages of the album, it lingers further on those that hint at a narrative, perhaps encouraging the viewers to consider their own role. If there were a courtly narrative to be gleaned from these images, certainly the original viewers of the album would have been able to do so: they

were, after all, courtiers themselves. This elusive narrative, in turn, helps to give order to the dazzling array of images and calligraphies in the album.

These folios also illustrate the most important of Kalender's visual tactics: comparison. The two figures on the left column of plate 23 are a case in point: both seem to be watching a pair of lovers to the right on the same rows. They are wearing almost identical clothes but are in slightly different poses. The images challenge the eye to spot the differences. Mainly, however, the eye is invited to go back and forth, to compare and scrutinize. Kalender could easily have provided different young male figures for the two rows: the couples on the right, after all, are different. The repetition immediately triggers the comparative gaze and forces viewers to look carefully. The same comparative gesture is suggested by other folios. The two female figures on the left side of folio 15a, for example, are almost identical, except for the fact that one has her belt unfastened (see plate 29). The slight difference in color between the tunics (one blue, one green) and the opposite directions they are facing encourage the eye to move back and forth, spotting the differences and similarities. The same can be said for the figures in red, rendered in different sizes, in the lower row of this page and the upper row of the facing folio (see plate 28). When considered together with Kalender's repeated statement in the preface that he organized the contents "with respect to each one's relationship to each other" (*her birisinin biri birisine münāsebeti ile tertīb olunup*),[18] it becomes clear that viewers are being asked to identify the relationships among the images. Kalender writes that when the artworks in the album are viewed with attention to detail and looked on with the "scrutinizing gaze," these relationships become obvious. The comparison, then, is meant to encourage the scrutinizing gaze and also becomes obvious by means of it. The viewer emerges edified, having thought beyond the individual works of art, beyond the aesthetic properties of the page, to something greater.

The two folios of palace-related figures discussed above (see plates 21, 54) similarly come to life when viewed with the comparative gaze, and the relationships among the figures on them become evident in the comparison. That a discrete composition is being repeated becomes obvious only when viewing the two pages in tandem. Currently, these two folios are placed in different parts of the album, but the similarities between them are so remarkable that when viewers come upon the second page, they immediately remember the first one. It is tempting to suggest that in the original order of the album these two pages were placed closer together, but at present this is not possible to demonstrate. Both folios have four figures in their upper row and three in the lower, separated by simple frames. Their frames, borders, and margins mimic each other. Each folio has one figure in the lower row that has been depicted against a different background color and enclosed by a more elaborate frame than the others. The poses of the sultans in the upper row mirror each other, and they are placed in the same spot on both pages—second figure from the right in the upper row.

With such strong invitations to compare the two compositions, one wonders if a deeper similarity is being suggested here between the courts of two Ottoman sultans. In this case the scrutinizing gaze encourages us to identify the rulers being depicted, since the differences between them suggest a certain kind of specificity. When considered in tandem (and compared with other portraits of the two sultans), the portraits are

identifiable as Selim I in plate 54 and Ahmed I in plate 21. Ahmed's possible modeling on Selim, discussed in the first chapter, increases the possibility that this was a comparison Kalender wanted us to make between the two rulers. Thus, the visual comparison leads the viewer to a greater truth, and eulogizes Sultan Ahmed by likening him to his great ancestor Selim.

Another strong incentive to identify the rulers portrayed on these two folios is provided by the other portraits of Ottoman rulers in the album. The serial format in which these are presented incites the comparative gaze immediately. Currently one folio at the beginning contains the portraits of four sultans (see plate 13), and folio 32, no longer bound but still collated with the album, contains eight others, four on each side (see plates 63, 64). It is quite likely that originally these folios were bound together, as they would have continued an existing tradition in Ottoman book arts of picturing all the sultans of the dynasty in a series.[19] Such series by their very nature encourage a comparative gaze. Necipoğlu first drew attention to the process of viewing imperial portrait series. She argued that viewers were encouraged to make connections between rulers of the same name and to move back and forth across the series, spotting similarities and differences between them. She demonstrated that the comparative act helped to create a group identity for the rulers and laid the emphasis on the entire dynasty.[20] Elsewhere, I have made a similar point, focusing on the seriality of the imperial portraits in the *Şemāʾilnāme* (Book of dispositions) and their emphasis on order and repetition.[21] Here I simply want to point out that these portraits are intended to evoke a comparison, and, indeed, they make sense only in a comparative context. As such, they attest to the importance of the scrutinizing gaze in the workings of the album. Scrutiny reveals their individual and shared characteristics, creating both a corporate identity for the group and ascribing a distinct identity to each ruler, which is deepened by their serial presentation.

The calligraphic samples in the album, all of the same script (nastaʿlīq), also attest to a comparative framework. These will be the focus of the next chapter, but here I want to consider the design principles of some of the calligraphy folios. On folio 31, for example, we see the work of two different calligraphers gracing the opposite sides of the same folio, arranged in a similar page layout, again prompting an assessment (see plates 61, 62). The illumination on the two sides is almost, but not quite, identical. Both have an outer border of pale rose with gold floral pattern, and just inside this border is a checkered color-block pattern of two colors—brown and cream on one, rose and cream on the other, with blue corners in one and pink in the other. Moving inward, both folios contain an illuminated ground with a tripartite design. While the "a" side has one whole and two half cartouches, and the "b" side has three whole cartouches, the rhythm they create is identical. Their color schemes of gold and white are perfect reversals of each other. Both have a smaller inner border of three strips, one of which is again a checkered pattern, but not in the same order or with the same colors. At the center of both pages are calligraphic panels with almost identical compositions. The size and style of the script, the angle at which the verses are placed, and the framing of the verses are perhaps the most important common elements. Again, an extremely similar illumination surrounds the poetry, with triangular blank spaces filled with floral designs and the lower left corner of each frame occupied by a signature. The color scheme, too, is very close, but not identical.

At first glance, the two pages seem to have the same design. Upon closer examination, the eye begins to spot the differences, and viewers remain interested. This arrangement can be interpreted as Kalender's decision to bring aesthetic unity to a group of disparate works of art, yet the subtle differences he introduces and his choice not to make the illumination identical but rather to provide variations on a theme enhance the comparative glance. This is correlated in many ways with the importance of comparative judgment in the practice and appreciation of calligraphy, an art that particularly interested Kalender.[22]

Another way in which Kalender induced the scrutinizing gaze was by creating thematically related compositions across two-page openings. Their current physical state suggests that these folios belonged together in the original album. The maroon border around folio 17b extends across the album's gutter to the inner border of folio 18a, joining these two with certainty (see plates 34, 35). From this pairing, we can see that the border colors did not need to be the same in a single opening; indeed, the matching of a lighter and a darker margin was used elsewhere. The gold floral motif on the border, however, is similar enough on the two pages to be considered a match. Similarly, the ruling, which in this case consists of diagonal strips of colored papers, is, while not identical, closely related in its tones and hues in the two facing pages. The borders have similar proportions and widths. Folios 21b–22a, which also retain traces of the original binding and were originally together as they are now, display similar qualities in their margins and overall conception (see plates 42, 43).

The contents of both pairings are distinct from each other. In the case of folios 17b–18a, there are paintings on one side and calligraphy on the other (see plates 34, 35). But they have been arranged into frames that approximate each other in size. They are thematically related to each other, very much in the same vein of the earlier folios discussed here. The paintings on folio 18a exemplify two kinds of love—acceptable, demure homo-socialization in the bath scene above contrasts with carnal love gone mad in the image below.[23] That they are the opposite sides of the same coin becomes obvious only by comparison. Of the three poetic samples on the facing page, one discusses unrequited love, a second is about a beauty who plays with his curls, and the last one curses those who do not want the beloved's happiness.

Folio 22a contains a relatively small single page of text removed from a manuscript (see plate 43). The space it occupies has been expanded through extensive illumination and the use of different colored papers; in fact, a whole composition has been orchestrated so that it matches the dimensions of the center portion of the facing folio (fol. 21b). That folio, in turn, contains six discrete pieces of writing, four calligraphic specimens (qiṭaʿ), and one poetic anthology page that has been split down the middle to fit into the available space on the right side (see plate 42). Together, these facing folios contain calligraphies by the three calligraphers identified by name in the introduction as representing the highest level of achievement in their art: Mir ʿAli, Nur ʿAli, and Shah Mahmud Nishapuri (see plates 42, 43). The reason for bringing them together is therefore obvious. Kalender has worked hard to create balanced compositions on both sides of the opening so that the margins could be of similar width and the center of the page of comparable dimensions on both sides. Creative placement and illumination bring visual unity to the pages.

We can conclude from these pairings that Kalender's modus operandi involved creating double-page compositions that held together aesthetically as well as thematically—whether that theme is work by famous calligraphers or meditations on different kinds of love. Openings of two pages held together visually and often worked in unison to create meaning, building on the motions of the eye as the gaze is directed by Kalender's illumination and ordering of artworks. No two pages are identical, however, and the illumination is varied enough to create visual interest and keep the mind comparing, as the eyes move back and forth.

The album contains a large number of folios that have relevant works of art and closely related compositions and illumination on both sides. The two sides would be matched with facing pages that would also, in all likelihood, relate visually and in terms of content—for example, the two sides of folios 31 and 32 (see plates 61–64). I discussed folio 31 above in detail. Folio 32 contains sultanic portraits on both sides with identical composition but borders of different colors. Furthermore, both the internal organization and the framing of this folio match the appearance of folio 7a, featuring the first four rulers of the House of Osman (see plate 13). Together these portraits add up to twelve, the correct number of Ottoman sultans, culminating with Murad III, the last one portrayed in the series. Originally these sultanic portraits would have been in the same part of the album. Similarly, folio 31 has affinities with other pages earlier in the album and may have been placed with them (see plates 61, 62).[24] The consistent aesthetics of Kalender's framing strengthens the link between these pages.

Kalender's tactics on the level of the individual folios or pairings—that is, the dazzling of the eye with plenty, the establishment of relationships across frames, the suggestion of narrative, and the encouragement of the comparative gaze—are complemented by his overall curating decisions. While it is not possible to recreate the exact form of the album at the time of its presentation to Ahmed, we can be pretty confident that in its rough outlines, the album was not too different from how it appears today—with the notable exception of the European materials that were removed, probably sometime in the late nineteenth century, and which are examined in the final chapter of this book. The album has lost some folios, but it retains its original binding.

The album in its original form most likely had different sections that contained thematically related artworks. These sections had similar aesthetic qualities as well, as is evident from the consistent aesthetics of facing folios and backing sides. Kalender began the album with the introduction and the pious folios containing the hadith and selections from the Qur'an. He then moved on to Ottoman history, presenting their ancient ancestors first, then the House of Osman. After this came semi-narrative folios with palace figures, as well as the large-scale portrait of Mehmed II (see plates 21, 30, 54). Among these earlier folios would also be the images of Shams-i Tabrizi and Ayyub al-Ansari. Once the album was thus anchored in Islamic and Ottoman history, the following images of urban types, beautiful beloveds, and entertainment and hunting scenes were interspersed with thematically related poetry copied by masters of nastaʿlīq. Thus, like a book, the album opened with praise of the maker (in the introduction), the Prophet, and the patron (who would be praised through his ancestry), and moved on to the larger topic of Ahmed's claim to be the emperor of the world (a world

that consisted of varieties of people reflecting local notions of diversity, including Ottoman "others" such as Persians and Europeans) with reminders of the last days (sinners, the return of Jesus) interspersed, as this had become the Ottoman eulogistic narrative with the *Miftāḥ*.

Although most material of similar theme is still together, creating a sense of overall order, two folios currently at the back of the album are clearly related to earlier materials. Folio 28 (see plates 55, 56) contains a scene from a historical manuscript regarding the Ottomans' ancestors that is linked with folios 6b, 7b, and 8a (see plates 12, 14, 15). Folio 32 (see plates 63, 64) contains the eight sultanic portraits that belong with folio 7a (see plate 13). Moreover, a number of folios, including 31 and 32, are no longer bound in the album but are loosely placed in it. Despite the mixed order of the last section of the album, codicological analysis with particular attention to the illumination shows that most folios are still in their original order.

Such an organization of relevant materials in different parts of an album is evidenced in other albums from the Islamic world, especially eighteenth-century albums. Anastassiia Botchkareva views a similar arrangement in the St. Petersburg album as evidence of connoisseurship.[25] We could easily say the same of Kalender's choices. Indeed, when considered in tandem with the comparative mode, the groupings of multiple similar things most certainly evokes connoisseurial habits already attested in the album by other means.

The comparative framework determined the way not only Ottomans but other participants in Perso-Islamic visual culture often viewed paintings and calligraphy, especially in the context of albums or other compilations.[26] Visual comparison of artworks is closely related to the social contexts of viewing in which these works are appreciated, for they are gestures that belong to the realm of connoisseurship. The connoisseurship aspect also explains the movement of the gaze across the pages and back, comparing things that are not necessarily next to each other. Such a viewing would require an excellent visual memory and a storehouse of preexisting forms to draw on with every new encounter. An important aspect of the connoisseurial gaze was the issue of style, to which I now turn.

Style

An album by its very nature brings together artworks from multiple sources. The album maker might choose to focus on material from a single historical and/or geographical context, a single artist, or, as is the case here, draw on multiple aesthetic traditions. The variety of styles gathered in the album by Kalender would have resulted in a disjointed artwork had it not been for his careful manipulation of layouts, unifying illumination, and consistent paper joinery evident in the frames. The end result is celebratory of multiplicity, yet constitutes a coherent whole that is anchored in the Ottoman courtly context of the early seventeenth century.

Five illustrations of the same size prepared for a history of the Ottomans' ancestors represent Ottoman historical style in the album (see plates 12, 14, 15, 56). Their sparse backgrounds in pastel colors, the poses and the depiction of human figures, the

compositions against single or double hills, and the inclusion of small lakes and water canals are strongly reminiscent of the paintings in the first volume of the *Hünernāme* (Book of skills, Topkapı Palace Museum Library, H. 1523), an Ottoman dynastic history dating to the 1580s. These pages are probably from a similar book produced by the court historian's office around the same time, and extracted here into the album, either because the book was damaged, or more likely, never completed.

The titles above the images on folio 6b both begin with the phrase "Of the ancestors of the House of Osman" and name two of the Ottomans' Oghuz ancestors, Yalvaç Beg and Kurtarı Beg (see plate 12). The ancestors named on the surrounding folios are Sunghur, Çemendur, and Tugrul, all of whom are part of the same genealogy, Ahmed I's illustrious ancestors.[27] Ahmed's immediate ancestors, the Ottoman sultans that came before him, are represented through their portraits, both in serial format and individually dispersed among the folios. Both with their subject matter and their style, these portraits and the historical narrative scenes firmly localize the album in the Ottoman court (see plates 13, 16, 19, 21, 30, 38, 54, 63, 64).

Some of the single figures in the album are indistinguishable from those in costume albums sold to foreign visitors to Istanbul, which constitutes a local but non-courtly aesthetic. A particularly instructive example is *The Habits of the Grand Signor's Court*, made in Istanbul circa 1620 for an unidentified British traveler and now in the British Museum.[28] It contains 124 paintings, including portraits of sultans and high-ranking officials and images of various figures representing a variety of ethnic, social, and occupational groups (figs. 25, 26; see also figs. 38, 39, 40). There are overlaps not only in terms of subject matter with multiple figures in the *Album of the World Emperor*, but also style and execution. Their shared characteristics include simplified, pared-down aesthetics; figures with bellies slanting forward, wide swaying hips, narrow shoulders, skirts slightly open near the hem as if a slight breeze is blowing, a center hair-part (in the women's hair), pale, rounded faces with protruding chins, and large, almond-shaped eyes. Similar colors and equivalent amounts of expensive materials such as gold are used, implying that the paintings in the album and the costume book are made by artists of similar skills and means.

Paintings consumed by the market and those consumed by the palace are generally assumed to be separate in the Ottoman context, but this album shows that this is far from the case. A theory first put forward by Metin And argues for the existence of a group of artists in Istanbul working solely in the marketplace called "bazaar artists."[29] However, as can be seen here, paintings in costume books such as the *Habits of the Grand Signor's Court* are indistinguishable from works in imperial collections. This is not only true of the *Album of the World Emperor*, but also of Ahmed I's hunting treatise, *Tuḥfetü'l-mülūk ve's-selāṭīn* (see fig. 4), or his copy of the *Miftāḥ* (see figs. 12–21). All are painted in the same new figural style of the seventeenth century, just as in the *Habits of the Grand Signor's Court*.

Another style represented in the album is that of the renowned Ottoman artist Ahmed Nakşi, found in other manuscripts of the period such as the *Dīvān* of Nadiri (see fig. 2). Especially close comparisons are the humorous figures in the album, such as the masked figures in the entertainment scenes, the single figure in the lower right corner of plate 53, or the man with exaggerated features in the upper left corner of plate 55.[30] Nakşi is an artist known for his "eclectic" style, borrowing ideas both from Safavid and western European

Fig. 25. Mevlana Hünkar. *The Habits of the Grand Signor's Court*, anonymous, fol. 91b. Istanbul, ca. 1620. British Museum, London. 1928,0323,0.46.80.

Fig. 26. *Uçkuru elinde* (Her belt in her hands). *The Habits of the Grand Signor's Court*, anonymous, fol. 117b. Istanbul, ca. 1620. British Museum, London. 1928,0323,0.46.105.

painting, echoing the sensibilities of Ahmed I's album in many ways.[31] Tülay Artan finds close affinities between Ahmed Nakşi and one of the artists featured in the *Tuḥfetü'l-mülūk ve's-selāṭīn*. She also finds similarities between the *Tuḥfetü'l-mülūk ve's-selāṭīn* and the artists working on Hafiz Ahmed Pasha's *Shāhnāma*. Both artists, she argues, worked in Istanbul in close proximity to the imperial manuscript workshop.[32]

There is, in other words, a certain level of consistency in the material prepared for Ahmed I, suggesting that what we find in this album is not simply material collected from the city, but might very well be produced by artists who worked on other projects for the sultan. The assumption that all the Ottoman single figures of the early seventeenth century are produced by "bazaar artists" would imply that in this period the number of artists working regularly for the imperial scriptorium would fall. If paintings were being collected from outsiders, then there would not be much need to retain palace artists. The available numbers, however, do not support such a scenario. There does not seem to have been a sudden decline in the numbers of artists drawing regular salaries from the palace.[33]

The similarity between paintings consumed by the city and those by the palace points to a shared visual culture between the two that is also attested in the written sources. Mustafa Âli's *Epic Deeds of Artists*, for example, has numerous references to art collectors. This prose account of the lives and works of calligraphers, decoupage artists, painters, limners, book repairers, and binders from a vast geographical area, including

the Safavid and Ottoman empires, was mainly intended as a guide to connoisseurs and collectors, suggesting that there was a sizable community of art patrons.[34] In it, Âli liberally criticizes dealers who flood the market with fakes and low-quality works, as well as collectors and album makers who spend much money on worthless albums, and who are too ignorant to know the value (or worthlessness) of the specimens in their collections and albums.[35] Similarly, sources recount an anecdote about the Safavid artist Sadiqi Beg gifting a line drawing to a poet friend with the words: "Merchants buy each page of my work for three *tomans*. They take them to Hindustan. Don't sell them any cheaper!"[36]

In addition to verbal accounts of the broadening art market, various manuscript projects in the last quarter of the sixteenth century already reveal the involvement of members of the bureaucratic-military class and imperial household servants as patrons and artists. Artists, whether associated with the palace or not, worked on projects commissioned by non-imperial patrons.[37] The rise in album production and single-page paintings in the early seventeenth century, in both Ottoman and Safavid contexts, is connected with the emergence of urban patrons.[38] The collecting of single-page paintings and drawings was indeed an activity shared across the wealthy urban classes and across Ottoman-Safavid borders.

This is further corroborated by two illustrated anthologies of poetry and one album from the period, probably produced for non-imperial patrons, which display very similar tendencies, stylistically and content-wise, to the *Album of the World Emperor*.[39] The album T 439 in the Chester Beatty Library, Dublin, which seems to have been put together in Istanbul around the same time as the *Album of the World Emperor*, includes the image of a peri (fairy) on folio 11a (fig. 27), almost identical to that on folio 9b of Ahmed I's album (see plate 18 and detail on page 60). The calligraphies in T 439 include works by Fahri, Malik Daylami, and Shah Mahmud Nishapuri, just like the examples in the albums of Ahmed I. The overlaps are striking, even though some of the Ottoman figures in the Dublin album are simpler, with less brilliant colors and fewer details than those in Ahmed's album. Some, however, are of the same quality. There is a Safavid figure on folio 12a of the Dublin album (fig. 28) that comes very close to one repeated (with different colors and orientations) in the *Album of the World Emperor* (see plates 36, 54). The Dublin figure is labeled, "This is the student of Hoca Hafiz, the son of a prince from Shiraz."[40] Ahmed's album, in turn, includes a seated, turbaned figure leaning his head on his hand (see plate 16) that is almost identical to a single figure in the Harvard Art Museum collections (fig. 29), which has the same composition as the depiction of Mevlana Hünkar in the *Habits of the Grand Signor's Court* (see fig. 25). The Harvard version identifies the figure as Hafiz of Shiraz.[41] These two Safavid (or Safavid-inspired) figures then, the son of the prince from Shiraz and Hafiz, his teacher, are to be found in multiple copies in multiple Ottoman albums. Another intriguing example of overlap is the flute player from the *Album of the World Emperor*, which mimics a Persian painting not in the album (see plate 55).[42] The Persian model, however, seems to be based on a European figure.

In addition to the material that dovetails with urban production and collecting, the *Album of the World Emperor* contains a few images that are decidedly Safavid in style, whether they are Ottoman copies or Safavid originals. Most of these are single figures, but some are drawings of narrative scenes. Many are displayed along with local types and some are

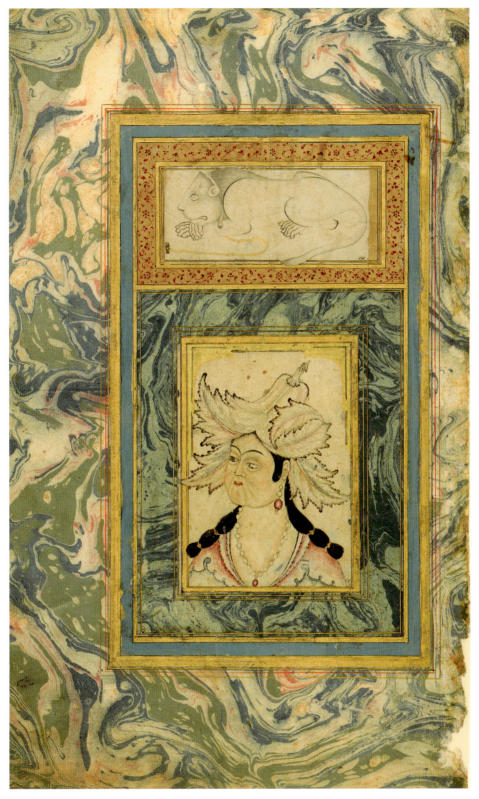

Fig. 27. Peri. Anonymous. Istanbul, ca. 1620. Chester Beatty Library, Dublin. T 439, fol. 11a.

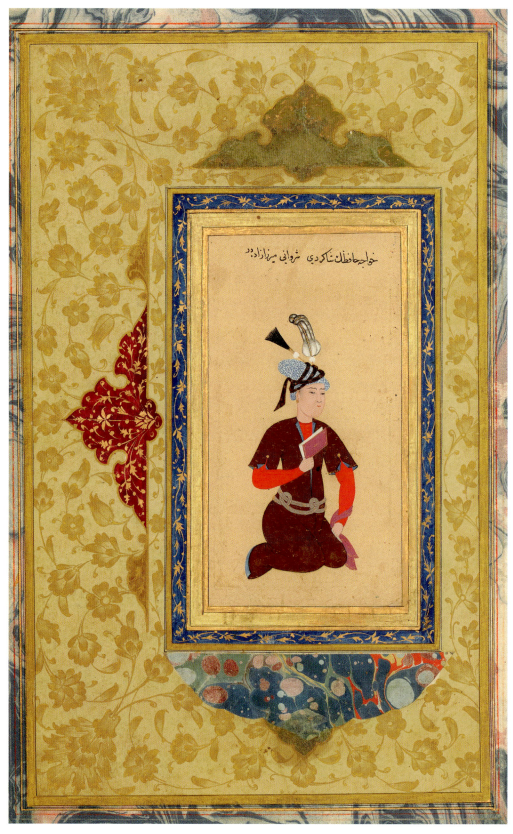

Fig. 28. Student of Hoca Hafiz. Anonymous. Isfahan or Istanbul, ca. 1610. Chester Beatty Library, Dublin. T 439, fol. 12a.

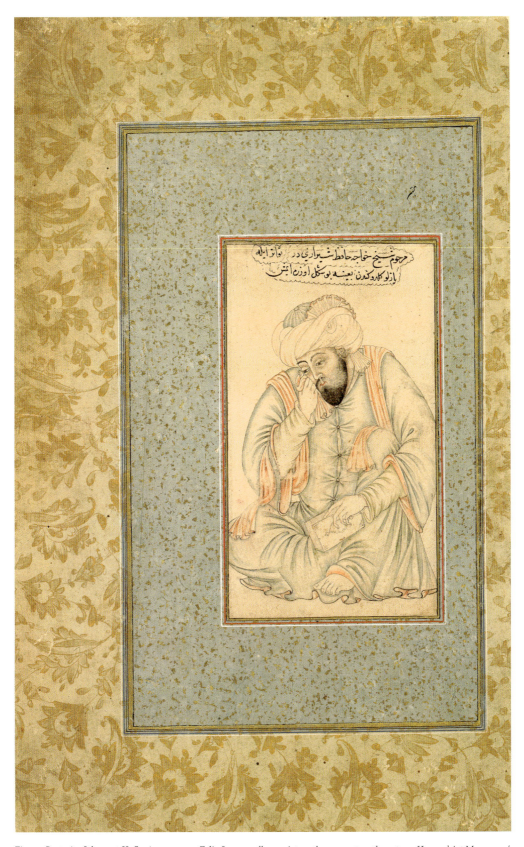

Fig. 29. Portrait of the poet Hafiz. Anonymous. Folio from an album, sixteenth or seventeenth century. Harvard Art Museums / Arthur M. Sackler Museum, The Edwin Binney 3rd Collection of Turkish Art at the Harvard Art Museums, Cambridge, Massachusetts. 1985.241.

juxtaposed with poetry (see plates 23, 28, 32, 36, 41, 46, 48, 49, 50, 51, 54, 55).[43] There is one figure on horseback on folio 17a attributed on stylistic grounds to Karbala.[44] Beyond Safavid materials, the album contains fifteenth-century Turkman and Timurid drawings, and a composite image whose upper half, forming the background, might be linked with Mughal interpretations of European prints (see plates 39, 46). A number of single figures mimic Mughal originals (see plates 32, 51). The mixture of Ottoman copies (which are difficult to distinguish from originals as style is their main indication of origin) along with authentic Persian artworks points to a serious concern with diversifying the styles represented in the album.

And finally, there are the European prints, which form the focus of the last chapter of the present study (see plates 65–72). They also come from different geographies and are in a range of styles, but they too are incorporated into the album's overall aesthetics by Kalender's arrangement, illumination, and paper joinery.

The stylistic contents of the album point in a number of different directions. As is made clear by the overlaps between this album and others examined, the market situation was fluid; artists produced for multiple patrons, at different levels, and collectors, whether in the palace or the city, collected material from different sources. Artists had access to similar models, were copying from each other, and participating in a visual culture that cannot be simply separated into "Ottoman" or "Safavid," "courtly" or "popular" groups.

The album explicitly demonstrates links between the Ottoman and both Persian and western European visual traditions, which marks a change from the sixteenth-century artistic landscape. At least in works of imperial propaganda such as the illustrated histories, even when Ottoman artists were inspired by other visual traditions, the resultant artworks were in a distinctly local imperial idiom.[45] In the *Album of the World Emperor*, by contrast, European and Persian artworks are carefully incorporated into a work of imperial propaganda as a sign of the Ottoman ruler's capacities as collector and ruler. The Persian and European materials are treated differently: the European materials are kept on pages by themselves (which is why they were so easy to extract afterward), accompanied only by other prints, but the Persian materials are displayed along with the local, pointing to the porous aesthetic borders between the two empires.

In both his geographic and chronological explorations, aesthetics were the primary concern for Kalender. Thus the multiplicity of styles represented in the album is deliberate and meaningful. However, the contents of the pieces he selected (figures from various backgrounds, Ottoman history, a variety of activities such as hunting, feasting, and entertainments) also contribute to the multiple readings the album offers. Kalender, like his contemporaries who were engaged in painting, poetry, and architecture, was clearly interested in exploring new sources of imagery as well as style. This openness and search for new sources, all the while privileging the local, is a strong trend in the literature of the period, which undoubtedly informed the album's production and consumption.

Albums and Literature: Parallel Forms and Contents

One of the most fascinating and challenging aspects of studying albums is the extent to which they assume and indeed *depend on* knowledge of poetry, painting, and calligraphy beyond the confines of the physical object itself. By demanding an intertextual reading,

they test the refinement of those examining the album, providing an arena for showing off one's knowledge of literature and the arts in the literary and elite gatherings where albums were perused.[46] The interactions among poets, calligraphers, and painter-decorators in early modern Islamic courts and the high degree of literary education and poetic knowledge among artists of the book are well documented and explain to a certain degree the intertextual nature of albums.[47]

The primary referent of albums was the literary sphere, in particular poetry, but also, beginning at around the same time as Ahmed's album, prose tales.[48] To understand the *Album of the World Emperor* fully, one must understand the contours of the contemporaneous Ottoman literary sphere. That the album was consumed in a literature-aware setting (to say the very least) is attested by the use of the term "people of the heart" (*ehl-i dil*) by Kalender in the introduction, when referring to the audience of the album. *Ehl-i dil* is a term one finds in lyric poetry referring to friends who participate in literary gatherings, and "who accept the rules of the emotional (mystical) interpretation and the party activity."[49]

An important development in the literary sphere of the period was the prevalence of the miscellany (*mecmūʿa*). I find it useful to think of miscellanies as the literary equivalent of albums. Containing portions of popular works, miscellanies were often used as mnemonic devices, to remind one of certain poems or narratives. They were highly personalized, unique selections.[50] We can assign a similar role to albums, too, gathering together materials that were enjoyed during literary majālis and presenting them in a convenient format. They served both to remind of gatherings past, but also of course served as aesthetic materials to be appreciated. One reason for thinking of the two as related is the fact that during the seventeenth century, the number of albums and the number of mecmūʿas created both increased significantly—so much so that Cemal Kafadar has proposed that mecmūʿas embodied the ethos of the seventeenth century better than any other literary genre. Mecmūʿas encouraged the appearance of local or vernacular dialects, expressions, and topics in written literature.[51] The *Album of the World Emperor* also participates in the inclusion of the visually local in-between the covers of books, and might profitably be viewed as a bridge, just as mecmūʿas were, between the local and the imperial.

The comparative impulse, which determined how the album was made and used, was a strong component of the literary culture of the early modern Islamic world, especially in the realm of poetry, which provided aesthetic criteria for the other arts. Necipoğlu has already demonstrated how the poetic comparative impulse displayed by the practice of writing response poems (*naẓīre*) can be used to understand architectural history.[52] It is even more appropriate to consider the literary device of the naẓīre in the case of an album of painting and calligraphy in which the calligraphic fragments are poetic selections. Naẓīre poems respond to earlier works by offering either praise or criticism, often with the intent of showcasing the responding poet's literary skills. They would either refer to or parallel earlier poems by repeating the theme or the rhyme scheme, thus retaining some aspect of the earlier poem, but they were new, different creations.[53] Indeed, Ottoman poets and authors of poets' biographies considered slavish imitation and substitutive translation to be inferior practices, and naẓīres needed to have originality in order to be appreciated.[54]

Response poems were collected in miscellanies beginning in the fifteenth century and became most prevalent in the seventeenth.[55] One notable example is a naẓīre collection created by a servant of Süleyman I but copied and expanded during the reign of Ahmed I. It includes poems by Ahmed himself, both response poems and independent poems.[56] The increased popularity of such compilations corresponds to the century in which Ahmed I's album was prepared.

Some translations of Persian poetry into Ottoman are also considered to be naẓīre-type responses. Such poetry was of fundamental importance for incorporating the wider Persianate literary world into the Ottoman cultural sphere: Ottoman poets would write naẓīre to Persian poems in exactly the same way as they would to Ottoman poems. Indeed sixteenth-century Ottoman poets considered Ottoman poetry proper to begin with the response poems of Ahmed Pasha (d. 1496) to the poetry of the Timurid poet and statesman ʿAli Shir Nava'i (d. 1501).[57] The term "naẓīre" had a parallel musical usage during the seventeenth century, pointing to the centrality of this concept to Ottoman culture.[58]

Ottoman poets repeatedly rewrote or updated older texts during the seventeenth century. Examples range from the rewriting by Cevri (d. 1654) of the *Selīmnāme* (Book of Selim) and other texts using more Persian and Arabic words than the original, to the *Ḥamse* (Quintet) of ʿAtai (d. 1635), which consists of five maṯnavīs that feature Istanbul and its inhabitants.[59] Both the recasting of earlier texts in accordance with contemporary linguistic preferences and the composition of a new *Ḥamse* are ways of responding to older works.[60] As such, they invite or, indeed, depend on, comparison in order to be fully appreciated. The contents of the *Album of the World Emperor* show that imitation was not limited to the literary and musical arts but also had its place in the visual sphere. By incorporating the images of men and women dressed in almost identical costumes and in poses that are difficult to distinguish from each other, the album gestures toward the idea of imitation. The images can be seen as responses to each other and to others not in the album. Kalender too was looking at earlier albums and can be said to be producing a response album.

In addition to the popularity of response works and the prevalence of collections, the literature of the early seventeenth century was increasingly urban and quotidian in reference (as opposed to princely and legendary). From prose and oral stories such as *Tıfli Hikayeleri* (The stories of Tıfli) about a courtier of the mid-seventeenth century, to the poetic genre of "city thriller" (*şehrengiz*), which will be discussed in more detail in chapter 5 in connection with the images of the single figures in the album, literary production of the period was concerned with the local and the everyday, rather than abstract ideals.[61] The *Ḥamse* of ʿAtai, composed between 1617 and 1627, is an excellent example of the localization emphasized by literary historians about the poetry of this period. It also demonstrates the simplification in language that is understood to characterize the period. Naturally, as poets turned to their own experiences and the world around them, they introduced local vocabularies into their writing.[62] Paralleling "localization" trends in verse literature, original, localized stories began to appear in prose literature, too, during the seventeenth century, just a few decades after the first original (as opposed to translated) prose tales in Ottoman Turkish were written.[63] Vestiges of prose tales about

urban love affairs and adventures that became more widely circulated at this time can be seen in the imagery in the album.

The rise of the local is also an aspect of the "new style" (şīve-i tāze or tāzehgū ʾī), which emphasizes originality and is said to characterize Ottoman poetry starting with the poet Nef'i (1572–1635), during the period under examination here.[64] In this new kind of poetry, the imagination became even more significant as a source of stories and motifs, as poets sought desperately for new tropes and unexplored metaphors, and Sufistic themes came to the fore.[65] This new style was later referred to as the "Indian style" (sebk-i hindī), as it is also known in Persian poetry of the period. Although the content of the "new/Indian style" was local, the form itself came from the Persian realm. Thus, like the album genre itself, the "new style" uses a Persian form to produce new local meanings.

It must be clear by now that it is not only the thematic and content-related links within the literature of the period that help us to understand the meanings of the album better, but also that the aesthetic preferences seen in prose and verse literature are noticeable as well in the style of the images and indeed the conception of the entire album. What is more, the structure and language of the poetry of the period is also echoed in the structure of the pages and the visual style of the imagery in the album. The literary contents of the album appear to be drawn from older literature rather than the contemporary moment (owing to the nature of the calligraphic tradition, to be discussed in the next chapter), but its visual contents are certainly inspired by the contemporary literary moment. In an interesting reversal, the literary content, which consists of calligraphic specimens, is appreciated for its visual characteristics (the calligraphy), and the visual is appreciated through reference to literature.

Engaging with the Topkapı Treasury

The search for fresh content from contemporary literature or the urban context and the experimentation with new and multiple styles exemplified in the *Album of the World Emperor* were accompanied by a reverence for earlier examples. Similar to the Sultan Ahmed Mosque, whose architecture continues the classical Ottoman aesthetic while departing from it in pointed ways, so the album, and indeed Kalender's methodology, glances backward and forward simultaneously, encapsulating in this way an early modern sensibility: the articulation of novelty in juxtaposition with the historical.

The treasury of the Topkapı palace, with its extraordinary album and manuscript collection, was an important source of inspiration for Kalender.[66] Over the course of the sixteenth century, Ottomans had amassed a significant collection of the arts of the book, including Artuqid, Ilkhanid, Mamluk, Aqqoyunlu, Qaraqoyunlu, Timurid, and Safavid works. A large portion of the Persian-language materials was incorporated as a result of Selim I's raid of Tabriz and its library in 1514. The conquests of Cairo and Baghdad had brought in significant Arabic-language materials. Most relevant for our purposes is the famed collection of albums in the Topkapı treasury that grew in numbers throughout the sixteenth century. In addition to conquest and war booty, competitive gifts from Safavid rulers and dignitaries to their Ottoman counterparts were a significant source

for albums. One of the most renowned albums from the Safavid context, the album of Shah Tahmasp made in the middle decades of the sixteenth century, was given to the Ottomans as a gift in 1576.[67]

The overall rhythm of Kalender's preface leaves no doubt that it is based on Safavid models.[68] Like a number of sixteenth-century Safavid album prefaces, it begins with praise of God as creator and inventor (*mubdiʿ* and *mūcīd*) of beautiful and artful things. Next comes praise for the Prophet and the four caliphs, and then the sultan, his love of beautiful things, and the beauty contained in his collections. Kalender then moves on to the value of images, and how they are great sources of learning. He says that calligraphers and artists of the past have produced beautiful things, some of which were given to the sultan as gifts, and that the sultan wanted these to be arranged in an album. When the sultan asked him, he says, to prepare an album out of this selection, he was delighted to obey. Then he describes how he put things together and finishes the preface with blessings on the ruler and prayers for him. This pattern of praising God's creation in a metaphor appropriate to the contents of the book, then praising Muhammad and the four caliphs or ʿAli in similar terms, usually followed by the current ruler and/or the patron, is a rather common one for books from the Islamic world.[69] What sets the album prefaces apart from other books is the consistent use of writing, album, and wonder metaphors when praising God's creation.[70]

Kalender follows Persian examples when he describes how hard he worked on the album, when he gives credit to his patron in its creation by saying he selected the pieces, when he states he hopes Ahmed will like the album, and also when he talks of other viewers, men of discretion and taste who will examine it with the "scrutinizing gaze" (*imʿān-i naẓar*). Kalender's use of Persian models for his preface is not unprecedented. The preface written by Cenderecizade Mehmed for the album he put together for Murad III in 1572 is also closely modeled on Persian prototypes. In fact, the beginning of Cenderecizade's preface copies a Timurid preface preserved in a Safavid album in the Ottoman treasury.[71]

Kalender uses other themes common to Persian album prefaces. An important one is the notion that albums pointed to their makers with their contents at the same time as they mirrored Creation, and its idealized form, paradise.[72] Kalender's description of his meticulous work in putting the album together and his repeated hopes that the sultan will be pleased easily suggest that he too understands the album as reflecting on him as a person. At the same time, his description of his work on the album as "expend[ing] insofar as possible, crafts unseen and marvels unheard of," and his description of the contents of the album as "matchless pearls of crafted marvels" creates a connection between the wonders of things created by God and those created by artists, calligraphers, and album makers like himself.[73]

Other parallels concern the imagined viewers of the albums. The primary projected viewer is, of course, the ruler/patron, both in Kalender's and in Safavid prefaces. As the owner of the objects contained within the album, the sultan also participates in its production. Kalender describes how Ahmed gave him the pieces to be included in the album, giving his patron credit for the aesthetic choices made.[74] Similarly, in the preface of the Shah Tahmasp album, which was in Ottoman collections at the time, the album maker Shah Quli Khalifa gives credit for the album to Tahmasp by writing,

"Consequently, an album was arranged and decorated in response to the judgment of the world embellisher," whom we are expected to understand is Tahmasp.[75] And just as Shah Quli wishes that the album will "continually be the object of your [Tahmasp's] gaze,"[76] so Kalender hopes that Ahmed will like what he sees when he "occasionally casts his peerless gaze upon it [the album]."[77]

Other projected viewers for Kalender, again mimicking Safavid album prefaces, include men with perception and aesthetic understanding. The Safavid album compiler Mir Sayyid Ahmad (also a calligrapher whose work is included on folio 17b) alludes to the "lords of vision" who will be examining his album, while Dust Muhammad, the compiler of the Safavid prince Bahram Mirza's famous album, says the album will be subjected to "the gaze of those possessed of sight/vision and visual/mental perception."[78] Likewise, Kalender asserts that if "those with acute perception and sagacious people of insight" examine his work "with a scrutinizing gaze" (im'ān-i naẓar) they will be able to appreciate what he has done.[79] Just as Persian albums were enjoyed by small groups of elite viewers, so the same thing is intimated to be true of the viewers of Ahmed's album, both as evinced by the above statement, and also by Kalender's reference to the "people of the heart" (ehl-i dil) as having been "seduced" by the "crafted marvels" included in the album.[80]

Roxburgh writes that Persian albums of the fifteenth and sixteenth centuries reveal a "theorization of artistic process as something fundamentally tied to precedent."[81] That is clearly in evidence here, too, not only in the preface or the individual contents, but in the entire conceptualization. If painters looked at earlier paintings for inspiration, and calligraphers at older calligraphic samples, then here too the album maker is looking at past album makers and making his choices accordingly.

We have concrete evidence of Ahmed's perusal of two albums in the Topkapı treasury, because he wrote in them. These are H 2153 and H 2160, two of the famous "Topkapı Albums." H 2153 probably took its final (or close to final) form during the reign of Selim I, soon after he raided Tabriz and brought numerous artworks and artisans to Istanbul.[82] The materials from Tabriz, according to Necipoğlu, were put together with others collected in Istanbul, including Italian Renaissance engravings and Europeanizing painted portraits.[83] The album also contains Chinese and Mongol paintings, some on silk, and a group of works often referred to as the work of Muhammad Siyah Qalam, showing nomads and demons in narrative scenes whose story line is not clear to us today.[84] Ahmed's inscription in H 2153 comprises an attribution and a marginal poem in Ottoman Turkish (perhaps one he composed himself?), both on folio 87b (fig. 30). The poem has been partially cut, but as far as I could read it, has Sufistic undertones and compares the wise to the ignorant, saying the wise one does not care too much about this world (. . . dünyā eylemez ʿāḳil olan / . . . meger kim cahilü nādān olan). He also signed his name and gave the date of 1025 (1616 CE).

In the other early-sixteenth-century album, H 2160, in a text dated Dhu'l-Qada 1024 (November 1615), Ahmed wrote a few lines, perhaps of hadith, relating to the Prophet Muhammad.[85] He also wrote attributions on multiple pages, which attest to his connoisseurial approach, which is of course embodied by the entirety of the album and more specifically in the comparative gaze that is evident in its organization. It is this

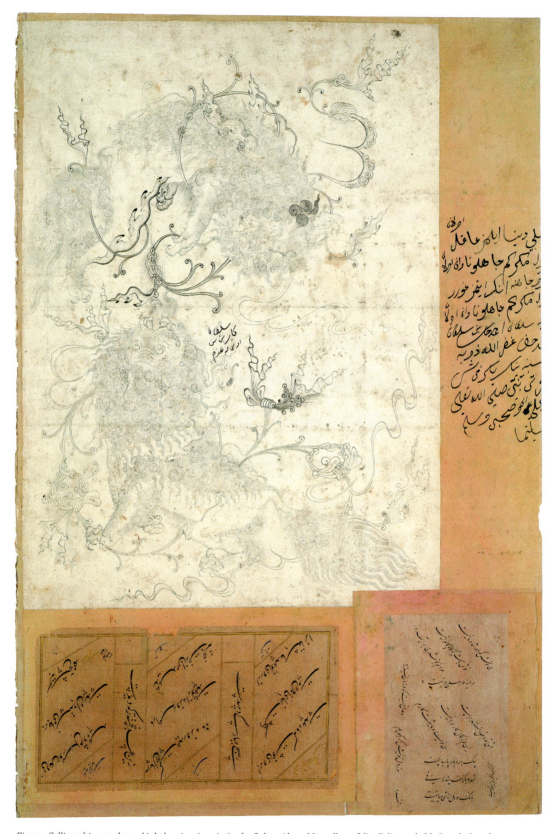

Fig. 30. Calligraphic samples and ink drawing; inscription by Sultan Ahmed I on album folio. Folio: probably Istanbul, early sixteenth century. Inscription: Sultan Ahmed I, Istanbul, 1616. Topkapı Sarayı Müzesi Kütüphanesi, Istanbul. H 2153, fol. 87b.

same connoisseurial attitude that explains the organization of the European prints in such a comparative fashion on the folios from the *Album of the World Emperor* that are now in New York.

Ahmed and Kalender's familiarity with the earlier albums is also corroborated by the visual quotation of a Chinese groom (an image repeated on folios 123b and 150a of H 2153) in the *Fālnāme*, there identified as the Persian poet Saʿdi (see figs. 23, 24).[86] The Chinese grooms were also copied in a Safavid album, H 2154, that is in the Ottoman treasury. This well-known album prepared by Dust Muhammad for the Safavid prince Bahram Mirza in 1544 presents a deliberate comparison between Persian, Chinese, and Frankish painting styles, presenting the Persian style as superior to the other two.[87] That Ahmed and Kalender were also looking at the Bahram Mirza album (H 2154) is obvious from the flow of Kalender's preface, which evokes that of Dust Muhammad's for the earlier album. Some of the drawings in Ahmed's album appear to be Persian in origin, or at least copying Persianate (perhaps early-Safavid) examples like those found in the Bahram Mirza album.[88] The Persian calligraphers represented in Ahmed's album are also found in H 2154. This overlap suggests both a shared cultural sphere with the Safavid court and also a deliberate reference to the Safavid and the earlier Ottoman albums. In either case, the reference is to earlier albums kept in the Ottoman treasury, thus albums considered to be part of the Ottoman cultural heritage. These comparisons clearly show that Kalender was engaging in the practice of nonverbal art history.

Yet another link between the *Album of the World Emperor* and the earlier Topkapı albums is the inclusion of a full-page portrait of Mehmed II (see plate 30). Julian Raby considers this portrait to be the work of "an Ottoman artist influenced by a European approach to delineation and modeling" and notes similarities between this portrait of Mehmed II and the one included on folio 145b of the earlier album H 2153 (fig. 31), suggesting they were both based on drawings by Costanzo da Ferrara and executed around 1479–81. Raby also links the Freer Gallery's *Seated Artist* (fig. 32) with the portrait of Mehmed II on folio 145b of H 2153, by suggesting they were executed by the same artist, Sinan Beg.[89] These portraits of Mehmed II were created in the late 1470s and the 1480s, an earlier moment in Ottoman art history when Ottoman artists were looking at European artworks and exploring different aesthetic styles.[90]

Raby further suggests that the face and the costume of Mehmed II in the *Album of the World Emperor* might be by different hands, the face dating from the reign of Mehmed II and the costume perhaps done when the portrait was included in Ahmed's album.[91] The collar of the costume of Mehmed II in B 408 is inspired, directly or indirectly, by a related image, the *Seated Scribe* (fig. 33), which was once in Dust Muhammad's album H 2154.[92] The *Seated Scribe* was later in F. R. Martin's hands, the same person who sold the Bellini Album, currently in the Metropolitan Museum and containing the European prints from the *Album of the World Emperor* as well as other folios from H 2154 and other Topkapı albums, to the Kevorkian Collection earlier in the twentieth century. The Bellini Album, in turn, was called that because the *Seated Scribe*, attributed to Gentile Bellini, was once in it, or at least Martin claimed as much. The Bellini Album includes folios from four related albums (B 408; H 2154; H 2153 or 2160; and H 2171, Ahmed's calligraphy album), which is quite striking. What is more to the point here is that the artist who

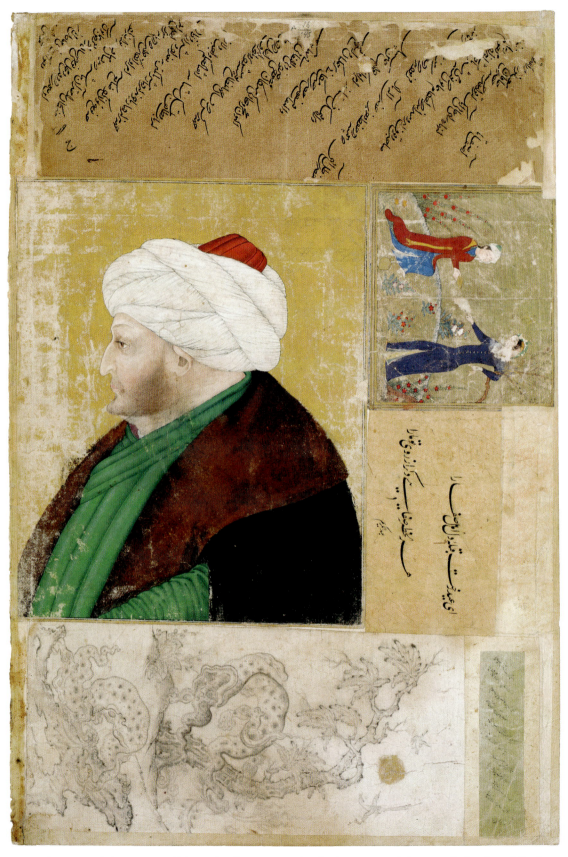

Fig. 31. Album page including a portrait of Sultan Mehmed II. Portrait attributed to Sinan Beg. Istanbul, ca. 1480. Topkapı Sarayı Müzesi Kütüphanesi, Istanbul. H 2153, fol. 145b.

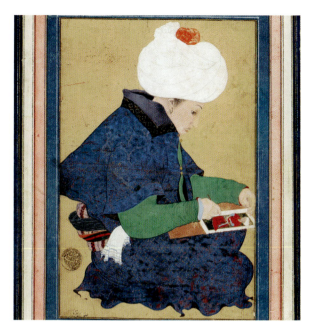

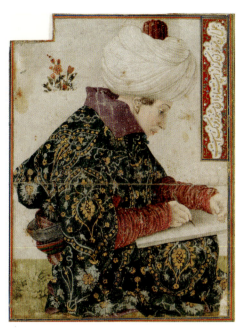

Fig. 32. *Seated Artist*. Attributed to Sinan Beg. Istanbul, ca. 1480. Freer Gallery of Art, Smithsonian Institution, Washington, DC. Purchase—Charles Lang Freer Endowment, F 1932.28.

Fig. 33. *Seated Scribe*. Gentile Bellini. Istanbul, 1479–81. Isabella Stewart Gardner Museum, Boston. P15e8.

worked on the portrait of Mehmed II in the *Album of the World Emperor* was probably looking at the *Seated Scribe* as he did so, since this was once in the Dust Muhammad Album (H 2154) and therefore in the Topkapı.

The relationships between the portrait of Mehmed II in the *Album of the World Emperor*, and that in H 2153, the Bellini *Scribe* (once in H 2154), and the Freer *Seated Artist*, are proof of the multilayered links between the albums in question and the cross-pollination that was rendered possible by having access to a library like the Topkapı treasury in the early seventeenth century. Kalender had the art of the world at his fingertips and derived inspiration from this wealth as he prepared his masterpiece for his sultan.

It is tempting to suggest that the mix of materials in H 2153, with their inclusion of Persian as well as European artworks, were an important model for the similar mixture of Ottoman, Persian, and European materials in the *Album of the World Emperor*. It may also have served as an organizational model, since it too contains multiple elements on each page, and many of them are in different orientations (see figs. 30, 31). This is a quality that one finds sometimes in later sixteenth-century examples, but is most pronounced in H 2153 and in the *Album of the World Emperor*. Moreover, if H 2153 was indeed prepared at Selim I's court, and if this was remembered during the early seventeenth century, it may have been even more attractive for Ahmed as a model, given his particular regard for Selim I. And for Ahmed's courtiers, if they were indeed trying to create an image of Ahmed as Mahdi, as Selim had been viewed, then the album would have been particularly enticing as a model too.

However, Kalender's albums for Ahmed do not sustain the same methodical comparison that H 2153 or H 2154, the Dust Muhammad album, do. Neither do the stylistic

explorations focus on the "seven modes of painting" explored by earlier Safavid albums.[93] There are no Chinese works, either. This might certainly be due to the fact that China was further away from the seventeenth-century Ottoman cultural consciousness than it would have been for the sixteenth-century Safavid one, or the fifteenth-century context of both Iran and the Ottoman Empire. Europe, in the meantime, had loomed larger in the cultural sphere in the ensuing years, replacing China in the cultural imagination as the source of wondrous images.[94] This is likely because of decreased contact with Chinese art and increased access to European materials as a result of trade connections. The Ottomans' sense of their place in the world, and their political competition with Christianity no doubt also fueled this. The *Album of the World Emperor* can be understood to reference the two neighboring cultural spheres of Iran and Europe that were contributing to Ottoman aesthetics, presented in the album as a self-consciously heterogeneous visual culture.

Kalender's organization and illumination of the album creates an aesthetically unified object out of its disparate materials. At the same time, he also makes an aesthetic statement through his album-making choices. By framing artworks from disparate places and times with contemporary, Ottoman illumination, he lays claim to the materials and asserts that the aesthetics of the present moment (amply represented in the artworks included in the album) are superior to that of previous moments or different places.[95] The illumination also, by unifying these disparate pieces, suggests that they are comparable to each other, hence worthy of the connoisseur's gaze. And given that not all the artworks are of the highest quality (especially the European works), by enveloping them in this cloak of imperial ownership and adding to their value with his exquisite illumination, he elevates some of the popular material into the royal realm. The hybridity evident in the aesthetics of this album was not an anomaly in the Ottoman context. Mustafa Âli's pronouncements on the origins of the people of Rum, that is, the inhabitants of the lands controlled by the Ottomans, demonstrates the awareness and appreciation of hybridity in the late-sixteenth-century Ottoman worldview:

> Those varied peoples and different types of Rumis living in the glorious days of the Ottoman dynasty, who are not [generically] separate from those tribes of Turks and Tatars . . . are a select community and pure, pleasing people who, just as they are distinguished in the origins of their state, are singled out for their piety, cleanliness, and faith. Apart from this, most of the inhabitants of Rum are of confused ethnic origins. Among its notables there are few whose lineage does not go back to a convert to Islam . . . either on their father's or their mother's side, the genealogy is traced to a filthy infidel. It is as if two different species of fruitbearing tree mingled and mated, with leaves and fruit; and the fruit of this union was large and filled with liquid, like a princely pearl. The best qualities of the progenitors were then manifested and gave distinction, either in physical beauty or in spiritual wisdom.[96]

The Album of the World Emperor seems to map this theory of ethnogenesis onto art making and style, retaining even the condescending attitude evident in Âli's reference to "filthy infidels."

Roxburgh reminds us that sixteenth-century Safavid albums do not constitute a "coherent genre category," but that they are inherently flexible and susceptible to "different permutations of personal, art historical, and biographical inscription."[97] In her excellent study of eighteenth-century Persianate albums, Botchkareva makes the important point that in contrast to the sixteenth-century situation outlined by Roxburgh, seventeenth- and eighteenth-century albums display a very clear sense of genre through a "strict codification of format."[98] These later albums usually have one work centered on each page (a few examples with four exist) and large borders that dominate the contents. Their openings alternate between calligraphy and depiction, not mounting the two on the same page. Although they display a pronounced interest in European artworks, these albums in general have a narrower range of content, calligraphy by a select few calligraphers, and depictions of a few themes only. Their contents also move away from the historical narratives of artistic tradition displayed in sixteenth-century albums to a focus on aesthetic discourses about depiction.[99] The *Album of the World Emperor* also displays some of the characteristics of the later albums Botchkareva writes about, but there are important differences, too. Kalender inundates the folios with many artworks, his selection of calligraphers is much broader than that of the Safavid and Mughal albums of the period, and there is greater variety in the figural materials. Yet, Kalender's engagement with the earlier albums in the Topkapı hints at a nascent sense of genre, also evident in these later albums. His repetition of the categories of materials he finds in earlier albums, as well as his echoing of the prefaces of earlier albums, are clear marks of this. His interest in European visual material and his connoisseurial emphasis on a comparative gaze approach the focus of contemporaneous Safavid and Mughal albums, suggesting, perhaps, an awareness of imperial album production in these centers, too. Like the later albums, Kalender's choices attest to a certain cultural cosmopolitanism and collecting abilities on a global scale, however anchored his album is in the Ottoman court. The calligraphies, single figures, and prints in the album provide strong evidence of this expansive view, and it is to these that I now turn.

Calligraphy in the Album

The calligraphic samples in the *Album of the World Emperor*, the focus of this chapter, mainly consist of qiṭaʿ (calligraphic specimens) written in the nastaʿlīq (Turkish: *nestalik*) script. Nastaʿlīq originated in late-fourteenth-century Iran, and in the sixteenth century, the most renowned nastaʿlīq masters were closely associated with the Safavid court.[1] The qiṭaʿ in the *Album of the World Emperor* are in the slanted format associated with Iran and are almost exclusively poetry in the Persian language. By virtue of their language, their selected script nastaʿlīq, and their overall composition, they read at first glance as Persian. The choice of nastaʿlīq as the calligraphic focus of the album was a deliberate and meaningful choice by Kalender. Just as the style of imperial portraits or historical manuscripts carried associations that were desirable, so calligraphic scripts had particular meanings. That the use of a specific script might have political meaning in and of itself is an argument shared by Yasser Tabbaa, Irene Bierman, and Irvin Cemil Schick.[2]

Among scholars today, nastaʿlīq is considered exclusively as a Safavid script during the sixteenth and seventeenth centuries.[3] However, many of the nastaʿlīq works in the *Album of the World Emperor* were produced by calligraphers at or close to the Ottoman court. In my view, nastaʿlīq was not perceived as a Safavid form by early modern Ottomans but was instead associated with the Timurid artistic tradition. The nastaʿlīq samples in the album do not reflect a fresh idiom, as do the single figures or the genre scenes discussed in the next chapter, nor do they espouse a uniquely Ottoman aesthetic, as in the imperial portraits or the pages from a historical account of the Ottomans' ancestors. Instead, they follow the calligraphic aesthetic associated with the Timurid court in Herat. Kalender's exclusive use of nastaʿlīq in the album signals a continuity of practice with the Timurid calligraphic tradition. Both the Ottomans and the Safavids had claims to the Timurid cultural heritage, and the cultivation of nastaʿlīq appears to be one way in which they could both assert their inheritance.

Ottoman artists' use of an aesthetic tradition shared across the Perso-Islamic world, even after the development of their own imperial styles, is due partly to the particularities of the calligraphic medium and partly to the changed nature of artistic patronage, collecting, and the art market in the seventeenth century, as discussed in chapter 3 and below. The album contains work by a strikingly large number of local nastaʿlīq masters, along with those who hailed from Iran, which is extraordinary, since most albums from the period tend to exclusively display works by artists of the Timurid or Safavid courts. Seventeenth- and eighteenth-century Mughal albums, for example, exclusively contain signed nastaʿlīq pieces by Timurid and Safavid calligraphers and no contemporary local work, and Safavid albums do not showcase Ottoman or Mughal calligraphies.[4] The divergent ways in which the early modern empires of the Islamic world made selective use of a shared aesthetic, each other's visual idioms, and other (especially western European) artistic traditions, as exemplified in this album, provide us with divergent models through which we can understand connected imperial and cultural history.[5] Artists and collectors in the Ottoman, Safavid, and Mughal empires understood their cultural legacies and delineated their artistic genealogies in multiple, sometimes contradictory ways.

Calligraphy as a whole was far from immune to Ottomanization.[6] During the course of the sixteenth century, a distinctly Ottoman school of calligraphy, represented especially by the work of Şeyh Hamdullah (d. 1520) was developed. Hamdullah, who had

been active at the court of Bayezid II (r. 1481–1512), and his followers found new ways of refining the six canonical calligraphic scripts, especially *thuluth* and *naskh*.[7] The sixteenth-century calligrapher Ahmed Karahisari (d. 1566), while basing his style on the Abbasid calligraphic tradition, was highly appreciated at the court of Sultan Süleyman.[8] A much-lauded Qur'an begun by Ahmed Karahisari during Süleyman's reign was later finished by his student and slave Hasan Çelebi and was illuminated at the end of the century by Nakkaş Hasan Pasha. It was endowed to the collection of Holy Relics in the Topkapı Palace at the end of the seventeenth century, demonstrating the high regard in which it was held a hundred years after its completion.[9] Imperial manuscripts such as this Qur'an and other religious and historical texts used the Ottomanized scripts of naskh and thuluth in tandem with Ottoman styles of painting *and* illumination. To be sure, Ottoman Qur'an scribes also continued to use the *muḥaqqaq* and *rayḥānī* scripts, which had become standard with the exquisite Qur'an manuscripts of thirteenth-century Baghdad and later Cairo.[10] Only when the Persian language was used in verse, as it was in some historical and literary texts like the *Süleymānnāme* or the *Şehnāme-i Selim Ḫān*, did Ottoman scribes turn to nastaʿlīq, suggesting that the script was chosen in those instances because of its aesthetic appropriateness for the Persian language, and perhaps for the association of the *Shāhnāma* form with its Persian origins.

Architectural inscriptions also developed a distinctly Ottoman flair in the sixteenth century. Hasan Çelebi was responsible for designing the inscriptions in many of Sinan's most important mosques, contributing to the formation of an Ottoman architectural decorative idiom.[11] The calligraphic styles chosen for adoption and localization by the Ottomans were the six canonical scripts, however, and not nastaʿlīq. In the Ottoman lands, a local nastaʿlīq idiom, which diverged from the Persianate tradition, was not developed until the eighteenth century.[12]

The distinctiveness of Kalender's choice to include only nastaʿlīq calligraphies in the *Album of the World Emperor* is made evident by a comparison with the calligraphy album he prepared for the sultan (H 2171) in 1612 that is described briefly later in this chapter.[13] The preface of H 2171 tells us it was prepared to show Kalender's "expertise in the science of geometry and his skill in building" and was presented to the sultan in thanks for his appointment of Kalender as building supervisor to the Sultan Ahmed Mosque.[14] The earlier album includes the other scripts as well as nastaʿlīq; it has pages from Qur'ans, multiple samples of hadith, as well as Persian and Ottoman Turkish poetic fragments, possibly from Kalender's own collection.[15] In it, Persian is not the only language, lyric poetry is not the only verbal content, and nastaʿlīq is not the only script. The *Album of the World Emperor*, by contrast, overwhelmingly contains poetic fragments or pages from poetic texts, all in nastaʿlīq, and all in Persian (except for a single poem in Arabic).[16] Thus both in content and in script, the calligraphy samples in the two albums are quite distinct from each other and point to a careful process of deliberation about the contents of the albums. Why, then, when other Ottomanized calligraphic scripts were available and collected in other albums, and at a time when book artists were in the habit of creating masterpieces that were identifiably in an Ottoman visual idiom, did Kalender choose exclusively nastaʿlīq pieces to include in the *Album of the World Emperor*?

The inclusion of Persian calligraphy in an Ottoman album is not unusual in itself, but these tend to be by Safavid or Timurid calligraphers.[17] It is well known that Safavid works, or works produced in Safavid lands, were appreciated by Ottoman courtiers. The Ottoman-Safavid wars of 1578–90 created a context for the acquisition of Safavid artworks by Ottoman grandees, and we also know that there was a vibrant art market in Shiraz during the second half of the sixteenth century, where Ottoman courtiers procured many luxury volumes.[18] Earlier albums, such as one prepared around 1560 for Sultan Süleyman that features the calligraphies of Shah Mahmud Nishapuri, include plenty of Persian material.[19] The album of Murad III from 1572, while including drawings by Ottoman court artists, clearly privileges calligraphy from fifteenth- and sixteenth-century Persian calligraphers.[20] The nastaʿlīq samples in these albums are surrounded by Ottoman illuminations of bold florals, which bring aesthetic unity to the materials they frame and locate them firmly in the Ottoman context, indeed marking the final product, the album itself, as Ottoman.

Aimée Froom attributes the Persian materials in the album of Murad III to the difference between private and public patronage, and to an enduring taste for the exotic, interpreting the Persian materials as foreign. She suggests that illustrated histories, like architecture and textiles, were for public enjoyment, whereas albums were for private viewing.[21] But like the illustrated histories, albums were viewed in group settings at court and were kept in the treasury. They were not necessarily more private than manuscripts, and it would be a mistake to brush aside the meaning of the Persian materials in them as a collector's whim for the exotic.

The album of Mehmed III, itself also full of Persian artworks and Ottoman paintings that mimic Persian examples, and even Safavid margins, is a case in point. The juxtaposition of these Persianate materials with the Ottoman verbal content that preserves documents from the Ottoman-Safavid wars creates an impression of comparison and rivalry. In this case, Ottoman ownership of Safavid materials appears as a discourse of domination.[22] The album supports Gülru Necipoğlu's recent suggestion that political and religious rivalry between the Ottomans and Safavids during the middle of the sixteenth century was the leading cause of the differing visual idioms adopted by the two empires.[23] Prepared soon after the Safavids had given multiple albums and artworks as gifts to the Ottomans, the album of Mehmed III is entangled in a discourse of imperial rivalry.

Kalender's inclusion of so many nastaʿlīq qiṭaʿ signed by calligraphers of the Ottoman lands is a first. Perhaps even more surprising than the inclusion of Ottoman nastaʿlīq in an imperial context is the question of why this did not happen earlier. The following analysis of the calligraphers represented in the *Album of the World Emperor* shows that the Ottoman and the Persian calligraphic worlds, especially for nastaʿlīq, could not be separated from each other, and consequently, there is nothing "exotic" about Persian nastaʿlīq.[24] Rather, the predominance of local practitioners of nastaʿlīq in the album suggests its deliberate appropriation into the imperial canon. As we understand from the album and from contemporaneous art historical writing, the associations of the nastaʿlīq script were distinct from those of the other calligraphic hands, the six canonical scripts. The consistent use of only the one script in this album versus multiple ones in H 2171 also suggests the emergence of a notion of different album genres and what they were meant

to convey. It is indicative of a certain understanding of the history of album making and lays claim to a specific legacy, as will be detailed below. The question of genre and the art historical nature of Kalender's choices are closely correlated with his engagement with the earlier Topkapı albums discussed in the previous chapter.

Calligraphers Renowned in the Lands of Rum and Ajam

Kalender informs us in the preface that the album includes works by "past calligraphers . . . known in the lands of *Rum* and *Ajam*, who have reached the level of Mir ʿAli, Shah Mahmud, Nur ʿAli."[25] He mentions two geographies that clearly matter: Rum, which mostly refers to Ottoman lands; and Ajam, which stands for Iran and beyond, the Persianate world. At the same time that he sets up a binary, he does not actually refer to Rumi and Ajami calligraphers; rather, he refers to those *known* in both geographies, which is the most important part of the world from his standpoint. In other words, for Kalender, these are the premier calligraphers in the world, and their reputation (that they are renowned in Rum and Ajam) is more important than their origins. His use of the two geographic terms does suggest that there are two different spheres of reception, and the calligraphers represented in the album are indicative of the highest echelons of those collected in the lands of Rum.[26]

The identity of the three calligraphers he lists is significant for understanding his choices: these are the only three important enough to name, so they must then signal the kernel of his artistic program. Mir ʿAli of Herat (d. 1543) was one of the leading calligraphers of nastaʿlīq in Iran, and his work was extremely popular among collectors in the Ottoman, Safavid, Uzbek, and Mughal contexts. His career bridged the Timurid and the Safavid periods, and his qiṭaʿs were plentiful on the Ottoman market.[27] Shah Mahmud Nishapuri (d. 1564–65), a calligrapher closely affiliated with the Safavid court, had also long been admired by Ottoman connoisseurs, as is evident by the album containing his works presented to Sultan Süleyman.[28] Nur ʿAli, on the other hand, was active in Ottoman lands.[29] According to an Ottoman biographical dictionary from the eighteenth century, he died in 1615 and was buried in Istanbul. After having studied with masters from Anatolia, he obtained his calligraphy diploma from Mahmud Shihabi, who in turn had been a contemporary of Mir ʿAli, and had been carted off to Bukhara by the Uzbeks, along with Mir ʿAli.[30] Nur ʿAli is not mentioned in Safavid sources, nor does his work seem to have been collected in Safavid or Mughal albums, giving credence to the possibility that he is indeed a Rumi calligrapher and not an Ajami one.[31] He was clearly viewed as Rumi in the eighteenth century, because Müstakimzade refers to him as Nur ʿAli-yi Rumi.[32] Kalender thus singles out two Ajamis and one Rumi in his preface, but the Rumi calligrapher traces his pedagogic genealogy to nastaʿlīq masters from Ajam. This already points to the difficulty of separating Ottoman and Safavid spheres in calligraphy, at least in nastaʿlīq. If a calligrapher hails from and lives in the Ottoman Empire, but writes in a Persian style and is trained by a Persian teacher, does he qualify as a Rumi or Ajami calligrapher?

The most renowned calligraphers in the album, Mir ʿAli Haravi, Shah Mahmud Nishapuri, Mir Sayyid Ahmad (d. 1578–79), Shah Muhammad al Mashhadi (active ca. 1560), and Malik Daylami (d. 1561–62), were all active in the first half of the sixteenth

century, and their artistic genealogies go back to Mir ʿAli Tabrizi, the late-fourteenth- / early-fifteenth-century calligrapher credited with the "invention" of nastaʿlīq.[33] Their singularities are highlighted by the compositions Kalender has created around their works. For example, the small page by Shah Mahmud Nishapuri, much appreciated at the Ottoman court, has an extraordinary composition around it on folio 22a (see plate 43). Nishapuri's text is from a small manuscript, and Kalender's illumination creates a large composition around it, filling the entire album folio. Above the page of delicate calligraphy is a roundel with concentric circles of different colors, and on either side of the calligraphy are four smaller roundels, the two at the bottom identical with each other, having dark blue backgrounds and gold florals, the upper two incorporating gold florals over a white background, contrasting like night and day. The combination of the concentric circles with the alternating slanted color strips that frame the entire composition creates a destabilizing effect that echoes the elusive meanings of the poetic content of the calligraphy, the first page of Saʿdi's *Būstān*, one of the classics of Persian literature.[34]

The works of Rumi masters are also displayed with great attention, and often by themselves at the center of a composition that has been built up around the calligraphy. The calligraphies gracing both sides of folio 31 are a case in point (see plates 61, 62). One of these is by Nur ʿAli, and the other is signed Derviş Receb-i Rumi. Nur ʿAli is represented by two works in the album, both of which are written on a pink ground, a visual unifier (see plates 42, 62, and a detail of plate 62 on page 88). There are four signed works by Receb (the most by any one calligrapher in the album), each prominently displayed. Three of Receb's calligraphies appear by themselves on the folio, and one shares the page with a sample by another Rumi calligrapher, Mevlevi-yi Rumi (see plates 22, 52, 61, and 44). Derviş Receb is not written about by art historians, but his affiliation with the Ottoman sphere is made evident by his use of "Rum" in his signatures (see plates 52, 61). His title, Derviş, puts him in good company in the early seventeenth century.[35] Two prominent calligraphers and a court storyteller of Osman II's reign also carry the title Derviş, suggesting the strong presence of Sufis in the artistic life of the palace at this time.[36] The history of Ottoman calligraphy is indeed peppered with calligraphers affiliated with specific Sufi orders. Şeyh Hamdullah was affiliated with the Khalwatiyya order in Amasya, and his son Mustafa Dede's name also points to a similar affiliation.[37] Moreover, Mevlevi and Bektashi shrines were important places of artistic production and patronage in the Ottoman and the Safavid worlds.[38] A possible connection between Derviş Receb and the Mevlevi order is strengthened by the juxtaposition of his work with that of Mevlevi-yi Rumi.[39]

In addition to Nur ʿAli, Derviş Receb, and Mevlevi-yi Rumi, the album contains the work of three other calligraphers active in Ottoman lands. The most prominent among them is Qutb al-Din Yazdi (see plate 34). Qutb al-Din hailed from Yazd, a city in Iran, but had migrated to Baghdad, a city that was passed back and forth between the Safavids and the Ottomans in the sixteenth and seventeenth centuries and became an interesting artistic milieu, a cultural hybrid caught between the two empires.[40] He was also the author of a treatise on calligraphy. When living in Baghdad in 1585–86 while composing his *Epic Deeds of Artists*, Mustafa Âli had consulted with Qutb al-Din, and also used Qutb al-Din's treatise on calligraphy as a model. One wonders if the juxtaposition of Qutb al-Din with Mir Sayyid Ahmad on this folio is meant to remind the viewer that as well as being

calligraphers, both were authors (or at least copyists) of texts on calligraphy.[41] Âli tells us about Qutb al-Din's teachers, who include "the Turkish Maqsud ʿAli" (which does not refer to an Ottoman but a Central Asian Turk, the Safavid Malik Daylami) and the Iraqi Muizz al-Din, and in the final analysis he claims that Qutb al-Din is from Iraq, a geographic rather than a dynastic designation.[42] Qutb al-Din's career challenges neat lines of distinction between an Ottoman and a Persian realm of calligraphers.

Similarly, Katib al Sultani (imperial secretary) Amir Muhammad Amin of Tirmiz, signed his qiṭaʿ in Persian "for the sake of Kalender Efendi" (*Bejehat-e Kalender Efendi*) (see plate 24). While the mention of Kalender clearly locates him at the Ottoman court, he is from the Central Asian city of Tirmiz. According to Âli, he also studied with Qutb al-Din's teacher, the Iraqi Muizz al-Din, and also stayed in Baghdad for a while before moving to Istanbul in 1588–89, twenty-five years before this album was compiled.[43] To complicate things further still, Qutb al-Din and Tirmizi's teacher Mir Muizz came to the Ottoman palace sometime after 1582, along with Ilchi Ibrahim, the Safavid ambassador and calligrapher, and found employment under sultan Murad III.[44]

The sixth calligrapher active in Ottoman lands is again unknown to modern scholars: he signs his name Sıdki (see plate 25).[45] Sıdki's page is dedicated, in Persian, to "his highness the great and honored kedhuda," and dated AH 1000.[46] Although we do not know the identity of this *kethüda* (steward or master), he must be an Ottoman and not a Safavid courtier, because the term was not used in the Safavid court, despite its prevalence in provincial administration.[47] Kalender chose to place Sıdki's panel in the same opening as Tirmizi's, juxtaposing two works dedicated to Ottoman courtiers. Both panels are actually dedicated to people who had occupied the rank of kethüda: Kalender was appointed as the kapı kethüdası (official representative of a provincial governor at the court, "court steward") in Rajab 1008 (January 1600).[48] Sıdki's work is dated earlier than Kalender's appointment but may have been given to him later, especially since it is facing another work dedicated to Kalender. The content of both panels is praise poetry with tinges of Sufism, referring to the "people of wisdom" and "friends [of God]." Tirmizi's writing praises Kalender as the "light of the eye of the heart of the people of wisdom" and prays for him.[49] Sıdki's panel praises the pleasant nature of the kethüda, says that his essence is the proof of his qualities, and wishes that his "beloved be a prophet and his supporter a friend [sufi]."[50] This example tells us that the calligraphers' social relationships were important to Kalender and factored into their reception and consequent presentation in the album.

Many of the calligraphers included in the album are related to each other through a pedagogical genealogy, which makes it harder for them to be grouped under dynastic headings. Mustafa Âli tells us that in addition to sharing a teacher with Tirmizi, Qutb al-Din also studied with Malik Daylami (see plate 26), who was in turn the teacher of Muhammad Mashhadi (see plates 19, 39). Malik Daylami, for his part, learned nastaʿlīq from Mir ʿAli (see plate 42). Qutb al-Din is also said to have learned from Mir ʿAli. Amir Muizz al Din, the teacher of Tirmizi and Qutb al-Din, trained with Mir Hibatullah of Kashan, who just like Shah Mahmud Nishapuri studied with Sultan ʿAli Mashhadi.[51] Pedagogical relationships do not seem to drive Kalender's organization: the works of a teacher are not juxtaposed with or immediately followed by a student's work, but they may well have determined his choices of what to include. These figures were part of an

international network, similar to academics today, and learned from each other's work or went to study with each other across political borders. Many Rumi calligraphers were trained by Ajami calligraphers, and a number of Safavid artists and calligraphers came to the Ottoman court during the sixteenth century.⁵² Their connections remind us of the impossibility of drawing impervious borders between early modern Islamic courts.⁵³

Not surprising given their shared pedagogy, the Rumi calligraphers in the album are almost indistinguishable from their Ajami counterparts on the basis of their calligraphy. But the presentation of their calligraphies with similar illumination (see plates 22 [Receb], 24 [Tirmizi], 52 [Receb], 61 [Receb], 62 [Nur ʿAli]) suggests that they are perceived as a group, and they are visually set apart by Kalender, unified into a distinct group through illumination and page layout. The panels by Sıdki (see plate 25), Daylami (see plate 26), and Nishapuri (see plate 43) are also presented as single images, but they are given different margins and frames, and are thus not put in the same group as the others.

The Rumi folios unified by Kalender's compositions (see plates 22, 24, 52, 61, 62) feature a vertical central panel, with one or two inner borders of pure pale color or gold illumination followed by a frame featuring Kalender's characteristic paper joinery of alternating color squares, rendered in one case (see plate 24) in leather, not paper. These consistent central elements are then followed by an inner margin of gold floral design that is wider at the top than on the other three sides. The gold designs on the upper bands of the inner margins repeat variations on three patterns of alternating serrated leaves or rosettes, or cartouches combining leaves and flowers. The other three sides have smaller-scale floral patterns. These are followed by a second frame of alternating colors and a final outer margin of a repeating floral design, simpler and thinner in the gutter and more developed, with larger floral elements, on the other three sides.

These repeating patterns encourage the eye to compare and identify the differences, engaging in contemplative gazing that Kalender describes in his introduction and as I detailed in the previous chapter. When comparing the work of the two Rumi calligraphers on either side of folio 31 (see plates 61, 62), for example, one sees that the rhythm and the placement and spacing of letters is slightly different in the two hands. Nur ʿAli's calligraphy, on the right, incorporates more space between the letters and is more horizontally elongated, whereas Dervish Receb-i Rumi's writing is more stacked and crowded. This difference is closely correlated with the different letters and their order and combinations, the links and the letters that do not link in the chosen texts. The varying thickness in the lines of the two samples is a result of pens of differing thickness being used.⁵⁴ The poem on folio 31a (see plate 61) is a love and praise poem that begins with the line "may the torch of your love be lit," and continues in that mode: "may the hearts and souls of your lovers burn. . . ." The opposite side also contains a poem complaining of not having the beloved's esteem.

What is perhaps surprising is that the calligraphy of Mir ʿAli, so beloved among collectors, does not receive special treatment. Rather than having individual compositions created around them, the only two samples of his calligraphy in the album are on the same folio, which they also share with one panel by Nur ʿAli: a qiṭaʿ without signature that talks, however, of love and yearning in terms of painting and calligraphy, and a page extracted from a *Dīvān* or an anthology, split down the middle and pasted in (see

plate 42).[55] The lower left panel by Mir ʿAli is from the *Dīvān* of Amir Khusraw Dihlavi. Here Kalender seems to be encouraging us to compare the calligraphy and the poetry on the page and to see the similarities and the differences between Nur ʿAli's hand and Mir ʿAli's. The relationship between the calligraphies and poetry suggests a continuity between the practice of Mir ʿAli and Nur ʿAli.

Continuity between Ajami and Rumi calligraphers is indicated with even greater emphasis in plate 44. The sample on the left of the folio is a cutout calligraphy by Mevlevi-yi Rumi, as we understand from the signature at the bottom of the panel, following the two horizontal lines of poetry. But directly above these lines, at the bottom of the diagonally written section is the signature Faqir ʿAli. What is presented is a cutout copy, by Mevlevi-yi Rumi, of a calligraphy sample by Mir ʿAli. His inclusion of the signature of the original calligrapher continues a long-standing practice in which calligraphers would copy the work of renowned masters and then add their own signatures to those of the masters. This was standard practice in training and signaled a certain degree of artistic maturity.[56] This example renders the original in a different medium (not in ink but cut paper), which is extremely unusual, signaling the extraordinary talent of Mevlevi-yi Rumi. The signing of his name as "*qāṭʿahu*" (cut by) is also unusual.[57] Other cutout works by Fahri of Bursa, for example, are not signed this way.

Learning from calligraphic samples was one of the standard means of calligraphic training, but here the artist seems to have gone beyond that to repurposing an earlier work of art, quoting it, and creating a new masterpiece that includes and surpasses the original.[58] The contents of the calligraphy emphasize the continuity between Nur ʿAli and Mevlevi-yi Rumi. The three couplets of poetry included in the diagonal lines and the straight ones are also all from the same *maṣnavī*, *Ṣifāt al-ʿāshiqīn*, by Hilali Chaghatai.[59] Just as the cutout calligraphy by Mevlevi-yi Rumi responds to the form of the calligraphy by Mir ʿAli, so the words he chooses to replicate respond to the content of the earlier calligraphy. Not only is he able to identify the lines whose authorship is not indicated, he is signaling a continuity of practice between himself and the calligrapher of the first two couplets by extending his work and copying the next couplet from the same poem.[60]

Continuity between Ajami and Rumi calligraphers was possible because calligraphy samples by great Ajami masters were available to Ottoman calligraphers among the immense number of Safavid albums and single-page calligraphies in the treasury collections at the Topkapı. Among the many instances in which the Safavids presented books and calligraphies to the Ottomans, an especially rich group was given in 1576. In addition to the single sheets of calligraphy enumerated by the Venetian *bailo* in his description of these gifts, the Shah Tahmasp album was probably also gifted at this time. Many manuscripts and an album were given by the Safavid shah in 1582, for the celebration of the circumcision of the then prince Mehmed. Another Safavid gift album is described in glowing terms by the Ottoman chronicler Seyyid Lokman when recounting the arrival of the Safavid prince Haydar Mirza in Istanbul in 1590.[61] We also know that calligraphy samples were available on the open market, and in fact the trade in these was vibrant enough to have tempted calligraphers to create and sell fakes.[62]

Plate 39 juxtaposes two pieces of Ottoman chancery writing with a Timurid preparatory drawing of an enthronement scene and Safavid drawing of a courtier on

horseback in the lower row, which have shorthand notations on them suggesting instructions to painters about colors. Also included is a page from a poetic anthology. In this folio, I would surmise, Kalender alludes to the contents of what Roxburgh has termed the "Timurid workshop album" (TSMK H 2152) reminding his viewers of the large numbers of practitioners in the scribal service and elsewhere in the palace, whose labor is preserved among the pages of albums such as this. A similar attitude is evident in plate 36, where again Persian drawings and paintings are juxtaposed with a page from an anthology, most likely the same manuscript as used in plate 39.

Both calligraphers themselves and their works moved among early modern Islamic courts, forming a trans-imperial network of patrons and practitioners. Painter-designers were also part of this network, and the inclusion by Kalender of Safavid figures in the album is proof of his interest in such associations, as discussed in the previous chapter. Kalender through this album makes a strong case for the local practitioners of nastaʿlīq as deserving members of a group spread across imperial and chronological boundaries, connected intimately to the Timurid court and its album-making practices.

Sultan Ahmed's Calligraphy Album: A Comparison

The choices that Kalender made in the *Album of the World Emperor* become even more evident when we consider the other album he prepared for Ahmed I, the calligraphy album he presented in 1612 (TSMK H 2171). The calligraphy album has a lot more variety in terms of both verbal contents and calligraphic styles. It begins with fourteen Qur'anic folios (and a text on calligraphy on folio 9a), followed by three pages of pure illumination. The preface comes next, and takes up six folios. Beginning with folio 24 are calligraphy samples in multiple scripts, making up the rest of the seventy-four-folio album.[63] Facing pages after the preface are designed in a careful visual relation to one another, inviting the viewer to compare them.[64]

The varied scripts in H 2171 are presented within extraordinarily refined and complicated frames and borders. Perhaps because there are no images for visual competition, the illumination and paper joinery really come to the fore and showcase Kalender's skills in geometry and design, as the album was meant to do. Folios 1a, 1b, which begin the album; 14a, 14b–15a, 15b, which separate the Qur'anic text from the preface; and 73 a–b, which end the album are pure illumination and paper joinery (figs. 34, 35). Acting as intermediary spaces, akin to contemporary books where the author's voice might become more pronounced in the *sebeb-i telīf* (the reason for writing) section, which usually appears in the beginning, or the way a calligrapher might identify himself in the colophon, these framing pages allow Kalender to come forward with his art. On these folios, colored strips of paper are formed into sunburst designs or lacelike pointed medallions that rival in intricacy the illuminated medallions of Timurid manuscripts renowned for their refinement. But the aesthetic here is decidedly different from the Timurid one: the relative sizes of the various motifs are altered, the choice of flowers accords with Ottoman preferences, and a deliberately local aesthetic is presented. The gold floral designs that illuminate the borders and the complex patterns of colored squares that are joined for the frames create dazzling compositions that have been appreciated by

Fig. 34. Illumination. Kalender. Istanbul, 1612. Topkapı Sarayı Müzesi Kütüphanesi, Istanbul. H 2171, fol. 1a.

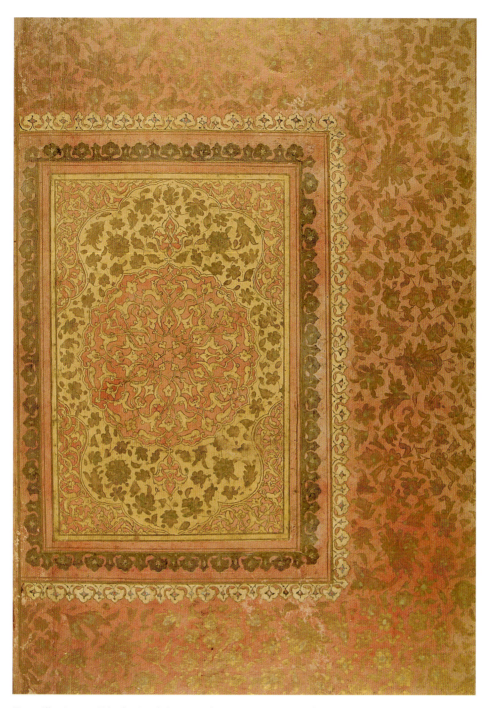

Fig. 35. Illumination. Kalender. Istanbul, 1612. Topkapı Sarayı Müzesi Kütüphanesi, Istanbul. H 2171, fol. 14b.

viewers ever since. That paper joinery was a particularly admired art at Ahmed's court is made evident by a paper cutout version of Saʿdi's *Gulestān*, presented to the sultan by the renowned cutout calligrapher Fahri of Bursa, whose works are also included in H 2171.[65] Coupled with Ahmed's clear interest in the work of Kalender, this might signal a preference on the part of the sultan for works in paper (rather than works *on* paper).[66]

The preface of H 2171, which is not written by Kalender but rather by Taşköprizade Kemaleddin Efendi, a prominent scholar of the period, singles out three aspects of the album to be praised, and in doing so provides insight as to how we should view the album:

> It has become a beautiful book of praiseworthy style such that if one gazes at the canonical rules embodied in its calligraphies, it furnishes information on the artistry of past masters, as a book of artifice and beauty. And if one gazes at the subtlety of its designs and pictures, it is as if it were a beloved who is adorned with variously embroidered garments and is decorated and jeweled with heart-attracting gems. The art of joining exhibited therein is a work that astonishes the eye, and everyone who sees it says, "How did he bring to his mind such a design; a hundred thousand praises for the master of that art," and heaps upon it a thousand bravos.[67]

The first thing we are to learn from the album is about the artistry of past masters, that is, the history of the art of calligraphy. The calligraphies, in turn, have been chosen to embody the canonical rules. They are conduits to something beyond themselves, not just examples of beautiful things, but informative about the rules/canons and the history of the art of calligraphy. Once again, a link is forged between aesthetic pleasure and learning.

There are significant correspondences between Mustafa Âli's *Menākab-ı Hünerverān* (*Epic Deeds of Artists*) and the contents of Kalender's calligraphy album. The calligraphers represented in the album range among the Timurid, Turkman, Safavid, and Ottoman courts. Qutb al-Din Muhammad Yazdi and ʿAbdallah Kırımi (d. 1590), for example, were shared favorites, as is made evident by Âli's writing and Kalender's presentation of them in his album.[68] The insistent inclusion of calligraphers active in Ottoman lands like Yazdi (fols. 26a, 33a, 38a, 55a); Kırımi (fols. 24a, 25b, 29b, 60b); Şeyh Hamdullah (fol. 29a); Derviş Muhammad b. Mustafa Dede b. Hamd Allah (fol. 49a, 73a [descendant of Şeyh Hamdullah]); Ahmed Karahisari (45b); and Fahri of Bursa (fols. 33a, 33b, 38a, 44a, 54b, 55a, 63a) alongside Persian calligraphers Mir ʿAli, Shah Mahmud, and Malik al Daylami, localizes the album in the Ottoman court but also demonstrates a shared cultural landscape. The Persian calligraphers are well represented in the Persian albums at the Topkapı, which Kalender was clearly drawing on, but the Ottoman ones are his inclusions, demonstrating the preference of Ottoman collectors, as they are also reflected in Âli's treatise. The history of the art of calligraphy as told in this album is very much one that incorporates the local tradition.

To return to the above selection from the preface: the "designs and pictures" of the album, namely, Kalender's handiwork in illumination, are praised for their beauty, akin to a literary beloved adorned with embroidery and jewels (see figs. 34, 35). Kalender's illumination, then, is the adornment and the decoration of the album, the aesthetic hook that entices the viewer to look at the contents, which in turn are revealing about the rules and history of calligraphy. The paper joinery is praised separately in the next

sentence, which implies that the "designs and pictures" refer to the illumination only. The paper joinery gets the most superlative praise, as it is the aspect that "astonishes the eye," which leads viewers beyond what is on the page to higher truths. The two albums by Kalender and their prefaces demonstrate very similar approaches to the visual arts and the reasons behind collecting and displaying them. At the same time, the differences between them, namely, the kind of calligraphy collected in each, the contents of the calligraphy, and the differences in illumination, point to Kalender's deliberation for each project and force us to take seriously the choices that he made.

The Timurid Connection

When we turn to Ottoman art historical writing of the period to probe the Rumi-Ajami relationship in calligraphy, our most important, and in this case, most relevant source is Mustafa Âli's *Epic Deeds of Artists*, already discussed briefly in chapter 3.[69] Âli's treatise provides us with a unique contemporary account of calligraphers who were active and popular in Ottoman lands in the late sixteenth century and their relationships with the broader history of Islamic calligraphy.[70]

The landscape of collectors that Âli alludes to in his *Epic Deeds* also suggests a fluid context for the exchange of calligraphy. He writes in the introduction that "calligraphic works of all styles are in high demand, and above all, the world's men of fine affairs are joyful as they have in their possession the qiṭaʿs of Mir ʿAli and Sultan ʿAli of Mashhad." He then writes about how much money Ottoman grandees spent on calligraphy samples and the preparation of albums, pointing to a vibrant market as the reason that he wrote his treatise in the first place: so that these artworks may be better appreciated by their collectors.[71] The Ottoman nastaʿlīq tradition is impossible to disentangle from the Safavid one, both on the production and the collection side.

While Necipoğlu has identified a competitive outlook in the *Epic Deeds*, pitting the Rumi and the Ajami calligraphers against each other, this is not the only operative theme in the treatise.[72] Âli highlights the distinctiveness of Rumi calligraphers, all the while chiding them for not always following the old masters closely enough.[73] Of the five chapters in Âli's treatise, four begin with Persian calligraphers and add the Rumis at the end. One chapter, however, that on nastaʿlīq, does not include any Ottoman calligraphers, or at least does not identify any as Rumi. Neither does he identify any as Ajami. He simply lists the cities they came from, and if they are affiliated with a ruler, he says so. Although Âli points to two cultural spheres, as in Kalender's introduction, the artists in them are closely intertwined with each other, participating in the same artistic genealogy. It seems that the practitioners of nastaʿlīq, at least, were not considered by either Âli or by Kalender as constituting rivalrous Ottoman and Safavid traditions.

Instead, in Âli's eyes, nastaʿlīq is most closely linked with the Timurids. His nastaʿlīq chapter begins with a eulogy to the court of Baysunghur, where nastaʿlīq is understood to have flourished. While one might expect him to begin discussing nastaʿlīq with Mir ʿAli Tabrizi, to whom the script is attributed, he begins instead with the Timurid Prince Baysunghur and his prized calligrapher, Jafar of Tabriz, "a pupil of Monla Abdullah, son of Mir ʿAli of Tabriz."[74] It is clear from the flow of the chapter that

Âli viewed nasta'līq as very much linked with the Timurids (he also showers lavish praises on Sultan Husayn and his courtiers), which he and many other Ottoman contemporaries admired as the zenith of cultural production. Thus the cultural associations of the script are not with the Safavid or Ottoman present moment, and its appreciation is not linked with the political entity the calligrapher or the viewers are living under, but rather with its historical context of flourishing. In different ways both the Ottoman and the Safavid artistic traditions built on and prized the Timurid legacy, even if they privileged different aspects of the Timurid cultural achievement. The Mughals too were fond of Mir ʿAli precisely for his link with the Timurid court in Herat, and the Mughal penchant for Persian art and artists also is very closely associated with their desire to connect with (or continue) the Timurid legacy.[75]

Beyond their style and authorship, the poetic contents of the calligraphy samples also, at times, present a link with the Timurid context. Folio 22b (see plate 44), for example, which I have already discussed, juxtaposes poetry by Hilali and Jami, both of whom were in the poetic circle of the last Timurid ruler, Sultan Husayn. Copied now by Rumi calligraphers Mevlevi-yi Rumi and Derviş Receb, these Timurid lines demonstrate the intimate knowledge of Timurid culture at the Ottoman court and among Ottoman calligraphers. As discussed above, Mevlevi-yi Rumi presents himself as an inheritor of Mir ʿAli's legacy by copying a qiṭaʿ by him and continuing the poetry in his own hand. In this case, both the form and the content of the calligraphy are from the Timurid court.

The Timurid associations of nasta'līq, coupled with the calligraphic culture of the period, which included training by studying earlier samples or traveling across political boundaries in search of training or patronage, meant that the dynastic differentiation we find in other visual arts after the middle of the sixteenth century is simply not there in nasta'līq. What is odd, however, is that the methods of training, the search for patronage, and even the Timurid resonance is mostly true of other visual arts, certainly of painting, where a very identifiable Ottoman idiom did develop. Perhaps the practitioners of nasta'līq were more interested in preserving a connection to the Timurid court than other artists. Another possibility is that calligraphers traveled and had more access to older samples outside of court patronage than other artists of the book did. Certainly the popularity of calligraphy among collectors was not matched by that of painting. The only other cultural form that was as widespread as calligraphy was poetry, the very content of the nasta'līq pieces. Many of the poems in the album are by renowned classical Persian poets like Jami, Hilali, and Saʿdi, and others are probably by contemporary poets or by the calligraphers themselves, as was the case in Mughal and Safavid albums of the period.[76] Yet we know that a new style of poetry was preferred among Ottoman literary circles at the time the *Album of the World Emperor* was made. Clearly, the various media of artistic expression did not follow the same trajectories.

Album Genres

The question that still remains is why Kalender chose nasta'līq as the predominant script for this album. Âli again provides us with a clue. His nasta'līq section clearly attributes the flourishing of all the arts that go into album making to the court of Baysunghur. The first

paragraph is devoted to praising Baysunghur, and ends with this: "It is even accounted that, in his prosperous time, forty talented calligraphers in his service gathered in a school and paradise-like workshop, a joyous place famed like heaven, which would make a picture gallery envious."⁷⁷ The second paragraph praises Jafar, the head of the workshop, and his colleagues. It ends with the declaration that "*nastaʿlīq*, gold sprinkling (*zer-efşan*), book repair [paper joinery] (*vaṣṣālī*),⁷⁸ illustration (*taṣāvir*), illumination (*teẕhīb*), and decoration (*muḥassenāt*) [all] emerged from that time onward."⁷⁹ Âli is saying in no uncertain terms that the building blocks of album making can be traced back to his workshop. And he lists nastaʿlīq along with the other arts that constitute album making, suggesting that nastaʿlīq is more closely linked with the Timurid tradition of album making than any other script. Although he does not mention album making explicitly, he names all the arts integral to it. The exquisite albums, anthologies and manuscripts prepared for Baysunghur—including Baysunghur's calligraphy album—were in Ottoman hands at the time.⁸⁰ These and other Persianate albums in the Ottoman treasury very obviously served as Kalender's models, not only for their contents but also their prefaces, as discussed in the previous chapter.

Kalender's introduction to the *Album of the World Emperor* is unique, however, in its emphasis on the visual. In comparison with other album prefaces, where Creation is linked with calligraphy by the use of metaphors involving writing, likening the sky to an album, and emphasizing the word of God, the first lines of Kalender's preface describe God as "the originator of strange marvels and inventor of amazing crafts" (*mubdiʿ-i bedāyiʿ-i garībetüʾl-āsār ve mūcid-i ṣanāyiʿ-i ʿacibetüʾl-etvār*), his act of creation as "knead[ing] and fashion[ing] the four elements" (*taḥmīr ü taṣvīr*), and emphasizes Adam at the end of the section praising God's creation, putting the emphasis on the human figure.⁸¹ The term *taṣvīr*, translated by Thackston as "fashioned," is also used to mean "depict," or "depiction." With this word choice, Kalender is clearly putting the emphasis on depiction and the wonders of the visual. From here, he moves on to describe how the sultan appreciates beauty and wisdom, and how the palace is full of awe-inspiring, beautiful, "resplendent" works of art, which have won the hearts of the courtiers and the sultan.⁸² Every time the mirror of existence is observed by those with penetrating eyes, Kalender begins, it shows designs and figures, but it gets rusty because of daily occurrences. In these useless days (*eyyām-ı nāfercām*), he says, if one contemplates some respectable figures (*ṣuver-i muʿteber*) and sights of good example (*seyir-i pür ʿibr*), which are demonstrated by numerous kinds of colorful designs, these will be the source of great learning and they will ornament the eye of experience.⁸³ In essence, the preface works as a defense of images.

While similar imagery can be found in Safavid prefaces, it is rarely activated to this degree.⁸⁴ By presenting images as means to something else, Kalender suggests that they are not simply admired for their beauty, but that beauty is employed in the service of something greater—wisdom. The depictions become particularly important, we understand, when the "mirror of existence" is rusty, because the images are then the only way of demonstrating the "respectable figures," and the "sights of good example" from which one can learn. The use of the mirror motif alludes to contemporary notions of the creative process, which understood the forms that the eye perceived to be stored in the artist's humor, which was thought to be a polished surface.⁸⁵ The mirror motif appears

in other album prefaces as a metaphor or intermediary for visual perception and depiction, and it is also a Sufi metaphor for self-improvement: polishing the heart so that it can reflect God's creation.[86] With his word choices, Kalender specifically argues for the value of art as a vehicle for sensual and cognitive renewal: what one cannot get from the mirror of existence during uncertain times, one can learn from paintings. Kalender thus presents us with a contemporary courtly Ottoman view on the significance of art as mysterious and powerful, but ultimately useful. Kalender's preface constitutes a strong and explicit statement about the value of depiction.

The question then arises: what is the role of calligraphy in an album that explicitly privileges figural depiction? The fact that Mustafa Âli lists nastaʿlīq along with the other book arts that flourished at the court of Baysunghur does suggest that it was associated with the origins of album making. Beyond its Timurid associations, is nastaʿlīq understood to have a closer relationship to visual materials than other scripts? Calligraphic albums without figural art, like H 2171 or Baysunghur's calligraphy album, showcase multiple calligraphic scripts and sample multiple kinds and languages of texts. The three languages of the Ottoman court, Persian, Arabic, and Ottoman, have very different appearances when written down, even though they use the same Arabic alphabet. The different scripts were clearly deemed more aesthetically appropriate for the three languages, and furthermore, they became associated with the contexts in which those languages appear.[87]

Early modern albums with images such as the present one (or the albums of Murad III and Mehmed III) contain mainly nastaʿlīq. On some level, the connection between the visual materials and the nastaʿlīq samples has to do with the content of the nastaʿlīq samples, which tends to be Persian poetry. The curious case of the album of Mehmed III is the exception that proves the rule. In that album, various prose texts in Ottoman are also written in nastaʿlīq. However, these are not previously existent calligraphic samples that have been collected, but rather texts copied directly onto the pages of the album. Their content rather than their form seems to be their primary significance, and nastaʿlīq is used probably because it had become associated with the mixed album genre containing calligraphy and images. We can thus add cultural associations to content as the reasons why nastaʿlīq was used in albums containing images.

The lyric poetry embodied by the calligraphy in the *Album of the World Emperor* is particularly well-suited to the images of beautiful youths that populate its pages, both in the entertainment and leisure scenes and in the single-figure studies.[88] This is well exemplified by the poetry in plate 22 and the images across from it in plate 23. The Persian translates as:

It is the Night of Qadr and the book of Separation is finished
Peace [greetings] until the break of dawn
I do not want to repent from drinking [carousing]
Even if she [he] were to harm me through abandonment or stone [stoning].[89] Signed:
Dervish Rajab *ghafara Allahu taʿālā dhunubahu wa satara ʿuyubahu.*

We can almost hear the young man in the top right corner of the facing page read this poem to the youth facing him, as their eyes are locked on each other, one holding a

poetry book, the other playing his lute in accompaniment. The themes of longing and separation are also apt for the two figures in the lower part of the page, one handing a cup of wine to the other. Various themes are evoked by the poem—distance, separation, drunkenness, and even the Night of Qadr, which is when the Qur'an is believed to have first been revealed to the Prophet Muhammad. Readers might visualize a scene, perhaps fill in the blanks in their mind's eye, but these few lines are far from telling us a story in its entirety. There is a narrative evoked here that is rather different from that in prose works; in maṣnavī-form, long-verse works such as the *Shāhnāma*; or in the Ottoman histories written and illustrated during the sixteenth century. And evoking, yet not specifying, a narrative is not at all unusual for lyric poetry. The contents of this poem are quite similar in nature to the other poetic selections provided in the album, especially in the qiṭaʿ format like this one. Whether it was this very page that always faced plate 23, or another, similar example, the structure of the poem and its evocative yet opaque character would be the same.

The facing page shows six male figures, organized across two rows, each painted inside a discrete frame (see plate 23). Their juxtaposition, especially the two in the upper right and the two in the lower right, hint at a certain kind of communication between them, suggesting, but not fully presenting, a narrative. Both the poetry and the images, owing to their suggestion of narrative, give the sense of being parts of larger wholes that exist beyond the covers of the album. Their partial or incomplete nature is echoed in both word and image. The lack of a background, hindering us from identifying a context and fully imagining a story, ensures that these images remain on the same suggestive but opaque platform as the poetry. Thus, visually, the images have the same kind of structure as the poem. As the gaze moves from right page to left page, it is impossible not to notice the poem, or song, that the youth in the upper right image is reading to the young man facing him across the divide of the thin frame that separates them. The man to his left is holding his musical instrument, perhaps putting to music the poetry that his companion is reciting. The two figures are also bound together by the similarity of their costumes. The lower couple presents an even stronger image of communication, because the wine cup offered by the cupbearer (*saki*) pictured on the right actually traverses the frame toward the hunter to whom he is offering it. The tree behind the cupbearer also spills over the frame that seemingly divides the figures, thus helping to unify the composition further. The intended recipient of the wine cup has one hand on his side, carrying what seem to be arrows, and his other hand is raised in front of his chest in what can be interpreted as a gesture of communication. This hand helps to direct the gaze of the viewer back to the cupbearer on the right, strengthening the link and communication between the two figures. In both rows, then, Kalender has created images of amorous communication of the kind one finds in the lyric poetry of the period, as is exemplified by the poem on the facing page.

The third figure, on the left-hand side of both rows, is repeated, and this strengthens the link between the images and a poetic reading. This figure may be considered the representation of the rival (*rakib*), that is present in the background story of many Ottoman lyric poems.[90] His presence enhances the poetic narrative even further and encourages us to consider the relationships depicted by the images in the context of lyric poetry.

The rival figure who, as his posture and glance suggest, is listening to the poem and witnessing the encounter between the lovers, might also serve to remind the viewers of what they are doing—observing the relationships depicted on the pages of the album, reading the poetry, and looking at the images. As such, the rival figure helps us to situate more concretely the gaze of the viewer that Kalender is manipulating.

A similar relationship between the poetic contents and the visual is evident in plate 27. Here the panel signed *ketebehu* (written by) *Meḥemmed Āmīn al kātib al Mekki al Harevi* reads:

> Bravo! The fresh rose petal is embarrassed before you
> Sweetness has borrowed sugar from you
> Every night I remember your lovely face
> Roses and tulips bloom in the bed because of you[91]

The poetry praises the beloved as so beautiful he or she puts the fresh rose petal to shame, possibly causing its red color, as it blushes in embarrassment, and so sweet that sweetness has borrowed sugar from him or her. And of course, the poet, the lover, constantly thinks of the beloved's face, the face that inspires flowers to bloom. While it is clear we have a kind of love story here, we have no narrative for the story, no context, no information about identities, only love and praise. The images below also clearly send a message of love and praise. While the passionate embrace of the amorous couple on the left could easily provide the context for such words, the female gathering in the center image, where a book is being read, might also suggest these lines being verbalized, as one woman reads to the other. Or, perhaps, the viewer of the album would be inclined to say these lines to a beauty such as the one dancing in the right-hand image. These images are also, to be sure, related to each other stylistically, thus enhancing their thematic links. The ambiguous, or perhaps generic, nature of the love story hinted at by the poem finds equally ambiguous visual expression in these paintings.

This and other ghazals like it that are included in the album would be just the type of literature that would be read in garden settings such as the central image. Gardens were the sites of poetic gatherings both in the palace and among the elite of Istanbul.[92] This is also exactly the kind of context in which an album such as the one containing these artworks would be consulted. One difference would be, of course that Ottoman as well as Persian poems would be recited at Ahmed's gatherings; perhaps he would be sharing his own poetry with his courtiers and poets at such gatherings.

However usual it may have been for nastaʿlīq to be used in copying lyric poetry, and however appropriate lyric poetry might be for inclusion in a pictorial album, the qiṭaʿ here are not simply bearers of text. The importance of their visual aspect is underscored by the fact that there are a few pages in the album from poetic anthologies that have been cut down the middle and placed on the folios as visual specimens (see plates 38, 42). The way they are cut splits the couplets of the poetry in such a way as to inhibit a comfortable reading. If the poetic content was the primary object of importance, surely these pages would not have been split in this way. The notion of contextual literacy, whereby the cut selections would serve as reminders of poems that the audience would

know by heart already, might be at work here, but if that was their sole purpose, why include the rest of the poetic selection elsewhere on the page? Most important, Kalender's introduction mentions the calligraphers included in the album, but he does not say a word about the poems.

Irvin C. Schick reminds us that Islamic calligraphy is seldom purely decorative, and that the medium often adds to the message.[93] Similarly, in a letter to the master calligrapher Sultan ʿAli Mashhadi, the Timurid ruler Sultan Husayn chides the calligrapher for introducing mistakes into his poetry, because such mistakes destroy the poems. Sultan Husayn's words leave no doubt that the poetry is inseparable from its visual representation through calligraphy.[94] Form and content are inseparable in the album, too, as demonstrated by various examples, but perhaps most pointedly, by the Mir ʿAli / Mevlevi-yi Rumi qiṭaʿ discussed above. That qiṭaʿ on folio 22b is meant to be viewed and admired as much for Mevlevi-yi Rumi's impeccable cutout image of Mir ʿAli's calligraphy as it is for the contents of Hilali's poetry, functioning simultaneously as the completion of a partial poem and the continuation of an artistic tradition (see plate 44). Further, the sample can be seen as the locus of multiple performances. Its execution is a performance of calligraphic skill, its inclusion in Ahmed's album is a performance of the refined knowledge of the astute collector, and its juxtaposition with the piece by Derviş Receb and the visual composition created around them is yet another aesthetic performance by Kalender. The context of its viewing, a majlis gathering where it would be viewed and read out loud, and where its visual and poetic virtues would be discussed, is the site of yet another performance.

The calligraphic samples in the album demonstrate multiple kinds of relationships with the visual materials. They are rarely, if ever, "discrete, closed domains in and of themselves," to borrow a phrase from Irene Winter.[95] The meanings of the samples here, like the official ancient Near Eastern texts that Winter writes about, are constituted by their verbal contents; the images, texts, and illumination surrounding them; the script in which they are executed; and the skill with which they are written. The qiṭaʿ format and the slanting angles of the nastaʿlīq might be viewed as visually appropriate to the swaying bodies of the young men and women incorporated into the album and discussed in the next chapter. The compositions created by Kalender around the calligraphies and discussed above bring them to life in varied ways. A striking example is the psychedelic composition created around the small page by Shah Mahmud Nishapuri on folio 22a, making the wonder-inspiring calligraphy that copies out the wonder-inspiring words of Sa'di into the center of a wonder-inspiring visual composition by Kalender (see plate 43).

A further example of the interrelation of the calligraphic and the pictorial contents of the album is demonstrated by the sample by Shah Muhammad Mashhadi in plate 19. The qiṭaʿ contains the word *silsile* (chain), which in the Ottoman context had come to refer to Ottoman genealogies with imperial portraits. The relationship between that word and the imperial portrait we see here might well be the reason why Kalender chose this example of Mashhadi over others to include here. A seemingly simple relationship between the content of the calligraphy and its form is thus established, where the two enhance the value of each other because of the larger context into which they are placed. In a non-Ottoman context, Mashhadi's qiṭaʿ might not be associated with an imperial

portrait, and in a qiṭaʿ by a lesser calligrapher, the word *silsile* might not be sufficient reason for inclusion into an imperial album.⁹⁶

A very different kind of relationship between form and content is to be found in the one pictorial calligraphy from the album (see plate 73). This beautifully illuminated calligraphy in the shape of a peacock on a folio since severed from the album reads:

> Beautiful as a houri, of angelic character, of auspicious omen, envy of the perfect ones, parrot of sweet tongue and sweet speech, peacock of the garden of . . . the lofty decree, sultan of the sultans of the world, fortunate and august, Khaqan of the Shahs, Dara of the time, Faridun of the age, hero of the world [text vice versa], champion of earth and time, sultan of the sultans of the family of Othman ibn Sultan Ghazi Khan . . . may God extend the days of his [happiness ?] to the day of [judgment ?].⁹⁷

Bringing together Persian mythology (Faridun, Dara) with a newly developed Ottoman script, *dīvānī*, as the rest of the calligraphic samples in the album, this glorious peacock points to the fact that the appropriation of Persianate terms and forms was an Ottoman practice through and through, and did not cast any doubt on the potency of the Ottoman imperial style. It functions both verbally and visually to praise the ruler, referred to as the "peacock of the garden of . . . the lofty decree."⁹⁸ This simultaneous image and word works as a counterpoint for the other calligraphies in the album. It is one of the very few writings here that are not nastaʿlīq, but is in an Ottoman chancery script (dīvānī) that had recently evolved away from its Persian predecessors—and in this iteration is still quite close to the Persian original. Its verbal contents derive directly out of Persian mythology but are used to praise the Ottoman sultan. The peacock encourages us to wonder at the sultan that its tail describes at the same time as we wonder at the calligraphic style that gives shape to the description of the sultan.

To sum up, Kalender chose nastaʿlīq samples for this album partly because the image is privileged here, and the contents of the calligraphy are meant to enhance the images. The most appropriate content was love poetry, and many of these are written as qiṭaʿ in nastaʿlīq. But notice that the samples do not include Ottoman Turkish ghazals, which were the current literature of the time. Consequently, it is possible to speak of an archaism where the nastaʿlīq links back with the Timurid court, that glorious context of poetry, majālis, and the visual arts, the place of germination for the album genre. Just as Richard Ettinghausen has argued for the Kufic script, and Yasser Tabbaa for the development of cursive Qur'anic styles in tenth-century Baghdad, and Irene Bierman for the use of Kufic in Fatimid Egypt, and Irvin Schick for the use of Kufic in nineteenth-century Istanbul, nastaʿlīq too had sociocultural associations: it reminded Ottoman viewers of the aesthetic refinement of the Timurid court.⁹⁹

The present album, by recontextualizing Persian pieces and juxtaposing them with Ottoman ones, comfortably incorporating the nastaʿlīq style and Persian poetry with Ottoman historical scenes and sultanic portraits, seems to simultaneously signal difference and continuity. The Persianate cultural heritage is not simply presented as "other"; rather, it is claimed as a part of the Ottoman artistic genealogy. Just as the portraits of Ottoman

rulers are linked with rulers of the past, so the works of Ottoman calligraphers are linked with past masters. In this way, the album is a reminder to qualify our notions of an Ottoman imperial style and its separation from the Persian cultural sphere.

It is important to note here that long before the eighteenth century, when modern scholars tell us an Ottoman style developed in nastaʿlīq (or taliq, as Ottomanists usually call it), Ottoman calligraphers were already appreciated for their nastaʿlīq qiṭaʿ at court. Local masters Nur ʿAli, Derviş Receb-i Rumi, Mevlevi-yi Rumi, Katib al Sultani Amir Muhammad Amin of Tirmiz, and Qutb al-Din Yazdi should be incorporated into the current account of Ottoman nastaʿlīq. It clearly did not all start with the Bukharan Derviş Abdi-yi Mevlevi studying with Mir Imad al Hasani in Isfahan as is the impression one gets from the scholarship.[100] Rather, Imad's contemporaries represented in this album, who in turn had learned from the same masters as Imad, such as his teacher Malik Daylami, also represented in the album, must also be remembered when recounting this history.

The City and the World in the Album

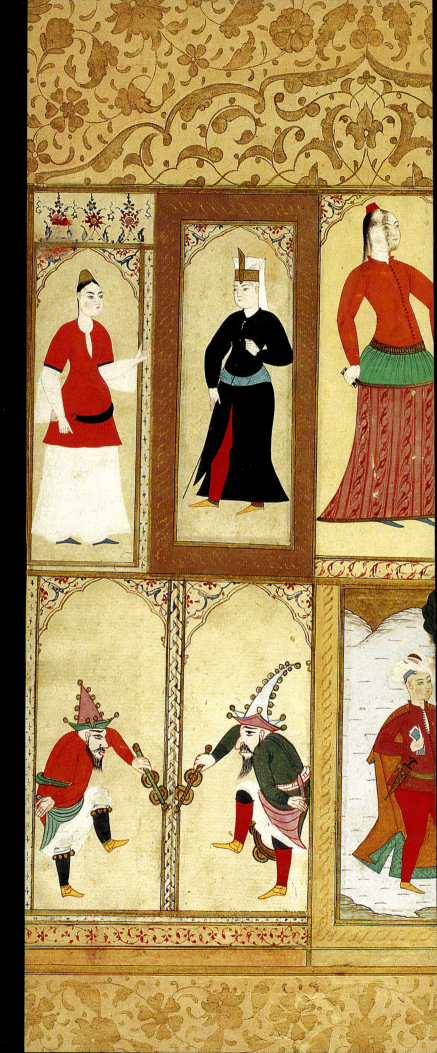

One of the most striking characteristics of the artworks in the *Album of the World Emperor* is their unusual subject matter. The genre paintings seen in such large numbers and for the first time—at least in the Ottoman context—are a prime example. Also unusual is the vast variety of the social backgrounds of the individual figures depicted on the album's pages. It is populated by many more ethnic types, members of different professions, and various officers of the court than one finds in early-seventeenth-century Safavid or Mughal albums, or the costume books made for Europeans to be discussed below. Indeed, the astonishment evoked by the variety of types here is not altogether different from the astonishment that aims to praise the ʿajāʾib (wonders) of creation and thus of God.[1] In addition to their inherent reference to the varieties of humans created by God, the album's images also draw out astonishment at the multiplicity of individuals in the Ottoman Empire, especially on the streets of Istanbul, indirectly praising the sultan who presides over this bewildering mass of people.[2] As the "scrutinizing gaze" wanders over the strange and wondrous figures, the viewer inevitably ponders the wonders of this world and the wealth of the empire that encompasses them.

That a city's significance could derive from its population is an idea held both by European and Ottoman writers of the early modern period. In a study of Spanish urban depictions, Richard Kagan points to Giovanni Botero's 1588 essay "On the Greatness of Cities," according to which "a city's grandeur depended primarily on the number and importance of its inhabitants."[3] Urban depictions can be roughly grouped under two headings, "chorographic" views, which take the city's physical contents, streets, buildings, and monuments as its focus, and the "communicentric" views that take as their subject certain communities in the city.[4] Chorographic views differed greatly as their artists experimented with varying ways of representing the world around them on paper, alternately privileging visual resemblance and measurements or factual information.[5] The album at hand falls into the first category of "chorographic," but in a surprising turn, it takes as the identifying character of the city its multiethnic, multiconfessional, and large population rather than its famed monuments.

Ownership of a majestic city like Istanbul is number six on Talikizade's 1593–94 list of the Ottoman dynasty's superior characteristics. His description of Istanbul undergirds the claim to be a world empire: "No other city could claim its fame and its location at the confluence of the two seas where ships from the east and west continually loaded and unloaded merchandise." Number eight on the list is "the prosperity of lands and the riches of the subjects" followed by number nine: "'The diverse collection of communities' living peacefully under their multiconfessional empire; no other sultanate possessed a capital assembling such a variety of religions and races."[6] The many portraitlike depictions of urban types and the genre scenes here give us a clear sense of the "variety of religions and races" in Istanbul—a metropolis estimated to have a population of about four hundred thousand people in the sixteenth century.[7] Here are dancing women, scholars, soldiers, wandering ascetics, handsome dandies, and courtly types but also foreigners like Europeans and Persians. Indeed, we learn from the French traveler Jean Thévenot, who passed through Istanbul in the 1650s, that inhabitants of the city were quite used to seeing foreigners.[8]

The multiplicities represented here, the populations depicted in varied artistic styles, are in some ways prefigured by a unique map of Istanbul from the 1580s (fig. 36),

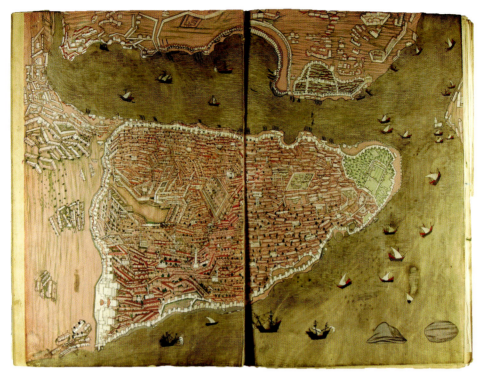

Fig. 36. Map of Istanbul. *Hünernāme*, by Lokman. Istanbul, 1584. Topkapı Sarayı Müzesi Kütüphanesi, Istanbul. H 1523, fols. 158b–159a.

eloquently analyzed by Çiğdem Kafescioğlu, who suggests that the view provided by the map builds on multiple modes of depiction culled together from disparate sources, including European cartographic views. The multiplicities and chaos of the early modern city are also evoked in an ode by Mustafa Âli that Kafescioğlu cites and discusses:

> I say Istanbul's a sea of people of the gaze
> Its populace abundant, a sea of all types

The map in question, which is incorporated into an official history depicting an orderly and monolithic Ottoman state, represents multiple viewpoints by its use of multiple perspectives. Kafescioğlu suggests that in the end, as representations of Istanbul, maps gave way to narrative depictions of urbanites in historical manuscripts.[9] The single figures and urban entertainment scenes in the *Album of the World Emperor* are further developments of such narrative images, but through them the album continues to incorporate multiple viewpoints, providing a pluralistic city-view.

Among the multiplicities evoked by the *Album of the World Emperor* are contrasting ways of seeing the city. In order to understand this better, one needs to remember that in the early years after its conquest, Istanbul evoked rather contradictory reactions, and images of the city during the fifteenth century were fluid. Those who were among the elite and supportive of Mehmed II's policies viewed the conquest as a positive development and described the city as beautiful and resplendent in poetry and prose, praising it as a "heavenly abode."[10] Those who were marginalized and disenfranchised by Mehmed's centralizing policies had negative reactions to the city and saw in it signs of

impending doom and omens of the apocalypse.[11] The popular image of Istanbul became more fixed during the sixteenth century as the city was reconstructed. More positive views, such as those put forward by Talikizade, came to dominate the written record.[12] The conquest of the city continued to be viewed as a portent of the end times throughout the sixteenth century, and, as is made evident by the *Album of the World Emperor*, into the seventeenth.[13] However, the conflicting reactions to Istanbul originally drew on the *Miftāḥ-ı cifrü'l-cāmiʿ*, presented to Mehmed II's father before its conquest. According to Islamic eschatology as represented in the *Miftāḥ*, many of the events leading up to the apocalypse were going to take place in Istanbul. The continuing popularity of that text suggests that the multiple, even opposite, conceptions of the city persisted to some degree. The images discussed in this chapter likewise evoke the "heavenly" aspects of the city along with its negative image, an anxiety-inducing metropolis over which the sultan needs to establish control. The urban image evoked in the album refers simultaneously to the pride and joy of the empire, and the end of the world.

Precedents, Models

The urban types depicted in the album are reminiscent of the many sixteenth- and seventeenth-century European costume books, which depicted "Oriental" types in regional costumes, or the Town Criers prints, which depicted street types from various European cities.[14] During the seventeenth century, the Ottomans began to make such books as well. The *Album of the World Emperor* is viewed as a forerunner of later seventeenth-century Ottoman costume books inspired by the European examples.[15] The basic idea of portraying different types of people, identifiable as representatives of certain social classes, ethnic groups, or professions is common to both.

Costume was deemed to be of singular importance in giving order to society in both the Ottoman and the European contexts, as is evident from the many attempts at controlling what people wore. For example, Ottoman imperial orders from 1568 and 1577 (the latter proclaimed by town criers sent through the city) determined the colors and materials worn by non-Muslim subjects of the empire.[16] The imperial council decreed in 1597 that "people were not to dress extravagantly, as they were at present doing, nor to dress above their station."[17] Sumptuary laws were often ignored, but their mere presence implies the perceived power and significance of costume in ordering society.[18] That clothes signaled social, ethnic, or religious identity is also proven by the fact that "Franks" were allowed to wear Muslim clothes when going through dangerous areas, to pass as Muslim.[19] European visitors to the empire, such as the Habsburg envoy Gerlach in the late 1580s, emphasize the importance Ottomans placed on "making displays with their outward appearances." Gerlach also notes the importance men placed on their wives' appearance as testament to their wealth.[20] Palmira Brummett refers to an anecdote recited by Evliya, in which Murad IV's courtier Kahvecizade would mimic in costume and speech the Polish, Czech, French, or Russian envoys that came to court while he was serving as translator: he would dress as a foreigner in order to better interpret.[21] In Europe, too, nationality or geographic origin, position in society, profession, status, income, and one's civil state were all signaled by costume.[22] Given this shared

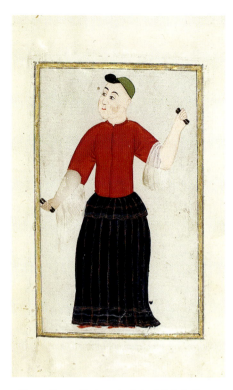

Fig. 37. Dancer. Costume book, by Csöbör Balázs.
Istanbul, 1570. Herzog August Bibliothek
Wolfenbüttel. Cod. Guelf. 206 Blank., fol. 15v.

understanding of the classifying potential of costume, it is no surprise that both Otto-
mans and western Europeans made costume books.

Despite the compositional similarity of multiple figures with different costumes
arranged in individual frames, stylistically speaking, of course, western European
printed costume books are a long way from the album we are considering. But an inter-
mediary is provided by a costume book prepared for a Hungarian nobleman in Constan-
tinople in 1570, by Csöbör Balázs, a Hungarian servant in the employ of an Ottoman
courtier. It contains images painted in the Ottoman style for a European audience (fig.
37).²³ These images remind us that the function of illustrating various types could be
fulfilled in different stylistic idioms, and Ottoman painting could be just as informative
as French or German prints. The artist Balázs, given his painting style, might have
worked in an Ottoman workshop, and he was certainly familiar with Ottoman painting.
That he would use the local idiom to present various "types" to his Hungarian patron
suggests that these figures were understood as generic types in the Ottoman context.

Indeed, costume books were often created by local Ottoman artists, as Pietro della
Valle, who visited Istanbul in 1614–15, also attests: "When I return to Rome I shall bring
a book of colored figures, which I have already commissioned, in which all the diverse
clothes of every sort, both of the men and of the women of this city, will be drawn from
life, and even if they are not depicted skillfully, but as best the Turks know how, being
simply painters of pots, all the same the clothes will be shown in a lifelike way, and as
such I believe that they will be looked at with delight in Italy."²⁴ Originally created for

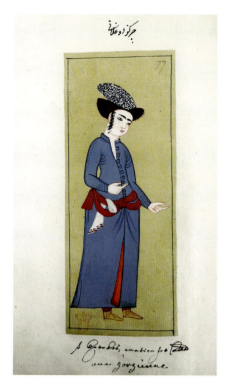

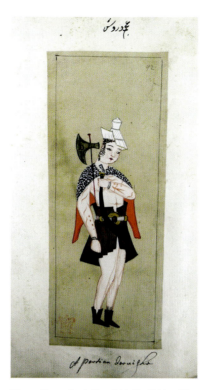

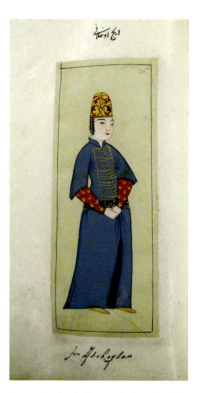

Fig. 38. *Çerkes oğlanı* (Circassian boy). *The Habits of the Grand Signor's Court*, anonymous, fol. 87b. Istanbul, ca. 1620. British Museum, London. 1928,0323,0.46.77.

Fig. 39. *ʿAcem derviş* (Dervish). *The Habits of the Grand Signor's Court*, anonymous, fol. 103b. Istanbul, ca. 1620. British Museum, London. 1928,0323,0.46.92.

Fig. 40. *İç oğlanı* (Palace page). *The Habits of the Grand Signor's Court*, anonymous, fol. 30b. Istanbul, ca. 1620. British Museum, London. 1928,0323,0.46.25.

European travelers, in the seventeenth century, Ottoman costume books were also made for Ottoman audiences.[25]

The Habits of the Grand Signor's Court, discussed briefly in chapter 3, was made by such local artists (see figs. 25, 26).[26] It has inscriptions in Ottoman, English, and French, implying that it was not made for a specific client, and the artists assumed that it may have been bought by an Ottoman patron. Or perhaps it was first owned by an Ottoman collector. There are significant correspondences between this book and the *Album of the World Emperor*, beyond the shared style that I have already discussed. The images lack a background or context, or any other clues about those depicted. Instead, the figures are classified through their costumes only, as with earlier European costume books. Moreover, there are overlaps between many of the images. Compare, for example, the images of Circassian boy (*çerkes oğlanı*) and Persian dervish (*ʿacem derviş*) in the *Habits of the Grand Signor's Court* with folio 14b of the album (figs. 38, 39, and see plate 28). The figure in the top right corner of the album folio is wearing the exact same clothes as the dervish in the *Habits of the Grand Signor's Court* and even has the same stance. He is depicted in reverse, raising questions about possible pouncing from a shared model. The Circassian boy's hat, tresses, yellow boots, and blue costume with belt are repeated in the lower left corner of the same folio. Likewise, the figure labeled "her belt in her hands" (*uçkuru elinde*) from the *Habits of the Grand Signor's Court* (see fig. 26) is repeated on folio 15a of the album (see plate 29), and the two figures identified in the *Habits of the Grand Signor's Court* as "palace page" (*iç oğlanı*) (fig. 40) and "Mevlana Hünkar" (discussed in chapter 3, see fig. 25) appear on

folio 8b of the album (see plate 16). Mevlana Hünkar, furthermore, is the same personage identified as Hoca Hafiz in a copy at the Harvard Art Museum (see fig. 29). All of these figures are depicted with similar colors, poses, and attributes. The close relationship between an imperial album and a book produced for the art market shows not only that Ottoman courtiers were fully aware of popular artistic trends among western Europeans and urban collectors, but they were open to experimenting with them.

The immense popularity of costume books in early modern Europe, beyond those depicting Ottoman types, has been attributed in the scholarship to a desire to order and make sense of an expanding world. The presentation of a large number of types together in a costume book encouraged comparisons between people of different backgrounds, based solely on their clothes. The costumes, in turn, came to be recognized as markers of alterity. It was not what one's skin or eyes looked like that set "nations" apart in sixteenth-century imagination; it was what they wore and how they conducted themselves.[27] The large numbers of figures in such works encourages the comparative process, and one begins to pay attention to the small differences between the figures, which are mainly in their costumes. A similar process is at play in the *Album of the World Emperor*. Here too, for the first time in an Ottoman album, a rather large number of figures are incorporated on the same page, in very similar poses. The uniform presentation draws attention to the minute differences and encourages a comparison.

Album viewing in social settings lent itself especially well to this kind of comparison. Casting a comparative gaze at the variously clad figures in the album doubtless was a source of entertainment and a way to demonstrate one's elite status. The importance of proving one's refinement by showing discernment in the arts was a common staple of early modern court life in the Islamic world.[28] Even more pertinent to an analysis of this album is a game that Mustafa Âli brags about inventing. In this game, which was meant to test "refinement of character," "a group of sophisticates" go to a bathhouse and try to guess the professions of the bathers by their physiognomies alone. "After they have entered the bath itself, then one does not know who the men are that come to the bath, that is, what their clothes are or what they have done in life." Whoever guesses the most correctly is the most refined person in the group. Refinement is thus defined by mastery of the science of physiognomy. The absence of clothing in the bathhouse was an exciting challenge. If one could guess the social identity of, as Âli classifies them, a porter, water carrier, judge, or professor, or a "penniless man from the common people," in this difficult circumstance, then one's exceptional refinement was proven beyond doubt.[29] Identity here is very closely bound with one's station in life, which was extremely important in a stratified society like the Ottoman one. The fact that guessing a person's social identity could be a sign of refinement provides a potential clue as to how the images in this album might have been understood or employed. Given the presence of this kind of "parlor game" one can well imagine others that might also have been played.[30] Moreover, the exaggerated facial features of some of the figures in the album suggest just such a context of entertainment and play, reminiscent of Karagöz shadow play types, which present ethno-linguistic, communal, and occupational identities through satire (see plates 23, 31, 53, 55).[31]

While costume books prepared for European buyers served as one source of inspiration, clearly the other model was Safavid art from Iran. That Kalender used earlier

Persian albums as models has already been discussed. In Safavid Iran at the turn of the century, single-page paintings depicting various types were among the most popular works of art produced for the court and for a broader clientele. Almost at the same time as the album we are looking at, Safavid artists also turned their attention from courtly types to urban figures of various classes and ethnicities.[32] Many of the figures in this album are clearly copies of Safavid originals, as discussed in chapter 3.

However, the single figures here also need to be considered in the context of the urban art market also discussed in chapter 3. After all, the *Habits of the Grand Signor's Court* and others like it contain images produced by artists in the city of Istanbul. The similarities in style, execution, and material quality, such as the use of gold, between the commercially available art and the imperial album (as well as other artworks made for Ahmed I) suggest the involvement of similar artists. The urban art market is also the likely source of at least some of the Safavid single figures incorporated into the *Album of the World Emperor*.

Beyond its interest in the art produced for the city, the court must also have had knowledge of the interpretive framework in which these images could be understood, which for the early modern Islamic world meant the literary imagination. Recent studies suggest that the literary worlds of the court and the city were not far removed from each other.[33] It appears from this album that their visual universes were getting closer, too.

Urban and Literary Context

Simply pointing to possible sources of inspiration like the Safavid and the European does not in itself explain the presence or function of so many urban types in the album. The use of a foreign genre like the costume album or adoption of the Persian penchant for single figure studies was possible, or desirable, of course, because the forms and format resonated with contemporary Ottoman sensibilities. In this case, the multiple figures tap into a growing fascination with things urban, and especially with the city of Istanbul. Such a focus on the urban pervaded the early modern world, and the Ottomans, with their impressive capital as well as other important urban centers such as Edirne, Bursa, and Aleppo, were not immune to this.[34] In her analysis of the 1580 *Hünernāme* map of Istanbul, for example, Kafescioğlu suggests that the map privileges a viewpoint from within the city, as opposed to the bird's-eye view that would embody the heavenly and the royal view seen in earlier depictions of the city.[35] Similarly, the illustrated account of a 1582 Ottoman imperial festival, the *Sūrnāme*, depicts a wide array of urban types as it records the parades by the guilds of the city, an urban celebration that lasted more than fifty days.[36] The urban perspective was becoming increasingly important.

The poetry in the album of Ahmed I alludes to an urban context, but through recourse to classical Persian poetry, where the references are not specific or localized. An example from plate 48 is a case in point:

> Your open eyes, I want that they
> Kill me, sometimes from mannerism, sometimes from coquettishness
> I buy whatever the friend is selling

Half coquettishly, with 100 000 prayers
Cruelty and wretchedness from the beloved
Are better than a thousand riches and blandishments[37]

With the phrase "I buy whatever the friend is selling," the poem evokes the bazaar set-ting, a common trope in Persian lyric poetry, but also the actual context in which real beloveds would most often be spotted. The paintings on the folio enliven such a context by bringing us people one might find in the bazaars of a bustling city. They feature a Persian and a European type, identifiable by their costumes. The young man to their left has the same outfit identified as "Circassian" in the *Habits of the Grand Signor's Court* (see fig. 38). The bearded man above him wears the costume of a merchant or shopkeeper, and across from him is a *çelebi*, a gentleman, as identified in the *Habits of the Grand Signor's Court*. Altogether, this variety is reminiscent of a crowded urban market area like the one alluded to in the poem above.

Images in albums do not necessarily illustrate texts in the same album but often have as their referents a literary consciousness, a shared literary corpus, or collective memory.[38] The literature of the late sixteenth and early seventeenth centuries is charac-terized by a sensibility toward the city and toward earthly love.[39] The figures discussed here are in tune with the lyric poetry of the period and provide images of beloved types that are lauded in contemporary literature, even though such literature is not included in the album.

Literary attention to the present moment and the local context goes back to the fifteenth century, when Ottoman poets began to incorporate the names of beloveds in their poems.[40] Soon thereafter, in the early sixteenth century, the poetic form known as the city thriller (*şehrengīz*) emerged on the Ottoman literary scene and retained its popu-larity in the seventeenth century.[41] Şehrengiz are works that eulogize the beauties of a city, which mostly means the beautiful boys and girls/women that are the city's inhabit-ants, and they provide a particularly apt literary parallel to the figures in the *Album of the World Emperor*.[42] In the same way that the figures in the poetry come to stand in for the town that is being lauded, the figures in the album come to represent the city of Istanbul—itself the subject matter of many a şehrengiz.

The visual language of the urban figures in the album parallels the verbal lan-guage of the şehrengiz.[43] Of the Ottoman şehrengiz, J. Stewart Robinson writes, "the *şehrengiz* . . . offer[s] a more topical and less idealistic form of entertainment by making a familiar locale and a set of immediately recognizable characters, most likely fictitious but believable, the focus of their poems." Emphasizing the erotic entertainment aspect of these works, Robinson associates the şehrengiz with the "Simple Turkish" (*Türki-yi basit*) movement and claims that their language is simpler than that of other poems of the time, addressing a wider audience.[44] The simplicity of some of the figures illustrated in the album, and the fact that they are not idealized courtly figures, but rather idiosyn-cratic urban ones brings them closer to the spirit of the şehrengiz.

Additionally, the poetic characterizations are vague and can easily apply to any boy or girl with the same name and profession in any and all towns.[45] Like the beauties in the şehrengiz, the figures in the album are visually vague in terms of their individuality but

not in terms of their social status, and they are rendered with the same ethos of direct simplicity as the language of the poetry. By the sheer variety of their costumes, these figures are localized to an Ottoman urban context—indeed, to Istanbul simply because of its size and varieties of peoples—just as the şehrengiz are localized to specific towns. The paintings visually enumerate the different figures, as the poetry does verbally. As such, they suggest that the album functions as a mnemonic device, which is not an unusual way of thinking of albums or manuscript illustrations in the Islamic world.

The Ottomans were not alone in producing şehrengiz; examples abound from the Safavid and Mughal empires.[46] In all three contexts, the poems are distinguished by a high degree of realism, or probably more accurately, the reality effect.[47] These figures contain elements of the real, but were never intended to be, nor should they now be seen as, a mere mirror to the streets of the city. They are very much representations, depicted with sufficient detail and nuance for us to imagine as possibly real. They allude to urban life and new urban groups, but they are not cataloging an actual variety, rather a symbolic or allegorical one. Names contribute to the reality effect, and when we turn to the British Museum versions of these types, we see that they are all labeled with names for the types and are visual descriptions of everyday costumes and individual characteristics, again elements that contribute to the reality effect.[48]

While in Ottoman lyric poetry beloveds are usually not distinguished as boys or girls, the şehrengiz is more explicit in this regard and generally focuses on boys (or very young men).[49] One sixteenth-century example by the poet Azizi is devoted exclusively to women. Comparing Azizi's types to those in the album is quite instructive as to the similarities between them (see plates 28, 29, 31 [detail on page 110], 49, 50, 51, 53). Azizi writes: "One of the brides [nigar] is Alem, the daughter of the tailor. People are crazy about her / Her beauty is a sun that decorates the universe / her crescent decorated face is a brilliant moon, there is none like her, she is a heart-stealing beauty, and she is unkind like the Sufis of the world." Another description refers to the chicken seller's daughter Ayşe, or the brilliant sun called the Little Moon (Hurşid-i Enver Küçük Kamer).[50] Similarly, the Ottoman inscription over the images in the Habits of the Grand Signor's Court give the impression that they are referring to stock characters in well-known urban tales, or figures one would encounter in shadow plays that appear at this time. That there is some kind of literary link is beyond doubt.[51] Tülün Değirmenci calls these figures "women who are known by their names, famous with their tales," and suggests that they are mostly prostitutes.[52]

Another parallel between the poetry and the visual rendering of these urban beauties is in the structure of the composition. Just as the poetry sets up a hint of narrative and suggests a relationship of admiration and lust between the tailor's daughter or the Little Moon and the poet (or the reader, who identifies with the poet as he recites the poetry), so the images are juxtaposed in such a way in Kalender's album to suggest relationships (see plate 23, for example, with two pairs of lovers on the right, and their "rival" or an onlooker watching from the left column).[53] These are relationships between the figures on the page, but also between the viewer and the figures. This is rather different from the European costume albums that present Ottoman types one by one without a framing narrative suggestion. Indeed, the composition, and the relationships set up by it, underlines the difference between an aptly named costume book, where the emphasis is on the outfit, and the

Album of the World Emperor, where the emphasis is on the people. The interpretive framework here, emphasized by the visual relationships, suggests that the present album goes beyond showing costumes to showing people. If the individual figures are inspired by costume books or Safavid single figures, the way they are brought together has clear hallmarks of contemporary literary culture and is unique to this album.

Genre Scenes

The rise in popularity of şehrengiz indicates interest in the changing urban contexts of the early modern period. Istanbul, for example, grew immensely in population as rural populations abandoned their lands and fled the violence in the countryside brought on by the Celali rebellions.[54] In addition to (and indeed related to) urban growth, there was also a significant amount of urban unrest and rebellion that preoccupied the state and the residents of the city during the late sixteenth and seventeenth centuries, including a minor revolt in early 1606 that was quickly quashed by Ahmed.[55]

A vast number of people had to be accommodated in the existent fabric of the city, which had to stretch and change in order to fit in the newcomers. Kafadar identifies three important areas of change in the early modern Ottoman city, which all seem relevant to the understanding of the urban imagery in this album: "(1) new levels and forms of urbanization accompanying the rise of a new bourgeoisie or a Burgertum; (2) increasing use of the night-time for socializing, entertainment and labor as part of emerging new regimes of temporality that redefined the spheres of work and leisure; (3) the rise of new forms of entertainment or performative arts, primarily of Karagöz shadow theatre and meddah story-telling performances."[56]

If the single figures in the album attest to the variety of the people in Ahmed's capital city, the genre images depict the new social activities of these new groups (see plates 35, 37, 40, 45). Both can be understood to serve as a guide to the new, changing city. New people and new activities are showcased here, brought into the palace for the sultan's perusal. Here we see depictions of the new bourgeoisie identified by Kafadar, some of them using the nighttime for a new form of public entertainment, others using private or public outdoor spaces. Altogether, these images attest to the proliferation of new public spaces in the city.

One of these spaces is the coffeehouse, an institution that first appeared in Cairo and Istanbul during the first half of the sixteenth century and became ubiquitous in the Ottoman Empire by the end of the century.[57] By turns "domestic spaces, places of business and leisure, an extension of the street or market, a venue of entertainment, a space of courtship, an arena of communication, a place in which to read and a realm of distraction,"[58] coffeehouses were built in such a way as to enable the inhabitants to look out onto the street, and passersby could peer in, too.[59] Ottoman coffeehouses in particular provided space outside the home for men to socialize, and their open architecture suggests that part of the attraction was the ability to see and be seen; one could gaze at the real-life versions of the beauties depicted in the album or described in the poetry.[60]

Coffeehouses served as places where one could enjoy nocturnal entertainments, as in the two entertainment scenes at the bottom of plate 37 and the top of plate 45.[61]

Another possibility is a tavern. Taverns, inasmuch as they were institutions that served wine, were not supposed to be frequented by Muslims, but they clearly were.[62] Until the late sixteenth century they were mostly institutions for the sale of wine rather than places where one would stay to consume wine. But just previous to the period we are considering here, they became places of gathering, and their numbers rose during the seventeenth century.[63]

While the patrons do not hold any coffee or wine cups, and the background is not distinct enough for us to place it in a physical location (except to note the tile patterns indicative of an indoor setting), the activities depicted in these two plates are exactly those that would occur in a coffeehouse or a tavern at night. The large group of men, gathered in the presence of candles, are being entertained by musicians and dancers, or players, with grotesque masks on their faces. The large size of the group suggests a public venue.[64] The spectators have amused expressions on their faces, and are all seated in calm, contained poses. They point to what they see, indicating wonder, amusement, and conversation. But their upper-body gestures contrast significantly with the comical movements of the players/dancers in the center. These men stomp their feet, raise their buttocks in exaggerated motion, and turn their heads and arms in unlikely directions. Their gestures match their oversized hats and comical masks with caricaturized features.

Perhaps what we see here are visualizations of what Âli describes as "sanguine youths and possessors of power who are wine worshippers, woman chasers, and boy lovers, who come to the tavern, some with their beloveds. They eat, drink, and when evening falls, return to their private dwellings." He later lists their professions as "businessmen, artisans, and government officials."[65] In front of our eyes then, is a portrait of this broad clientele, the slightly different costumes and facial hair of the men helping to distinguish between them. The omission of a background further focuses our attention on them.[66] The men playing music and dancing (or performing) at the center are dressed more simply, but the spectators include quite a few figures with gold detailing in the front of their clothes. It is clear though that we are not looking at the social elites, who would be wearing textiles with floral details, more complex weaves, and gold and silver detailing throughout. Class or social distinctions between the performers and the audience was also common to literary gatherings.[67]

Alan Mikhail makes a convincing case, using Mustafa Âli's description of the "indigents and the poor people" who frequent coffeehouses, that these were places for the lower classes to gather, as the elite had spaces within their homes for socializing.[68] Who were these lower classes? And how are they reflected in the images before us? I suspect in this case Âli is talking about a group known as "the city boys" (şehir oğlanları), who appear as a distinct group in late-sixteenth-century texts.[69] According to Marinos Sariyannis, city boys "fill[ed] the gap between the illiterate mob and the quasi anti-nomian members of the lower military and judicial elite."[70] The group had links with both lower and upper classes, and there were even poets among them. In his *Tables of Delicacies*, Âli describes them as "infamous liars who gossip all day in coffee houses with *sipahis* and janissaries and get entangled with hooligans in taverns."[71] While in the late sixteenth century city boys appear to refer to specific urban social and socioeconomic groups, by the mid-seventeenth century the term came to refer to a character type.[72] The two

images demonstrate a clear interest in these new urban types and their entertainments and social lives.

By contrast with these somewhat exotic, lower-class, but still acceptable entertainments, however, the image in the lower half of plate 45 seems to focus on the dangers of the overconsumption of wine. Here we find four men in various states of drunkenness in the countryside. One is kneeling on the ground, but his head has fallen forward, and he is probably passed out. Another is splayed out on the ground in full dress, except that his turban has fallen off his head. This figure provides a link with the upper image, since in that entertainment scene there are also two figures who have taken off their turbans. But theirs are neatly placed in front of them, the right way up, and furthermore, the small cap that serves as the base of the turban is still on their heads. Theirs is controlled relaxation, but in the image below, things have gotten out of control. Another contrast between the two images are the two cats. The cat in the upper image is white, and quietly sitting, watching. The black cat below, however, has started to eat his masters' food: there is no one sober enough to attend to the food or control the cat.

Perhaps most out of control is the amorous couple on the right. These two men have discarded their pants and turbans, and are caressing each other, with their genitalia in full view. That this scene is not considered appropriate is evidenced by the servants on the left side of the painting: one of them is biting his finger in surprise, the other has raised both hands to his cheeks in exaggerated wonder. A third is gesticulating forcefully, and a fourth is trying to wake up the fully-clad drunken man.

In the top half of plate 37 we have a male-female couple who are dressed as if members of urban upper-middle classes, and who seem to be the exact opposite, in terms of propriety, of these countryside (or park) revelers. They are surrounded by attendants in a garden setting.[73] Literary gatherings in garden settings were the ultimate context in which poetry, especially the kind of lyric poetry one finds in this (and in many) album(s), would be enjoyed. This image, as well as other garden scenes in the album where wine and conversation, and at times a book, seem to be enjoyed, refers to the immediate context of the album's viewing and gives visual context to the literature included in the album.[74] Additionally, early modern Istanbul boasted of gardens and parks as settings for leisure.[75] Thus the park/garden setting is also an aspect of urban life in this period.

A fountain with two ducks is gurgling in the top half of plate 37, and in the background are cypress trees and spring blossoms with pairs of birds gracing their branches. The couple are being entertained by women playing music, fanning them, and attending to their comfort. Judging by the chairs and the fountain, this is probably a garden attached to an upper-class home.[76] The young man's costume corresponds to that of a *çelebizāde* or *sipāhizāde*, as labeled in the *Habits of the Grand Signor's Court*. His female companion is dressed like a *ḫatuncuk* (a middle-class woman) or perhaps *nigār* (a higher-class bride/wife).[77] These are representatives of the new and distinct social and political actors referred to as urbanites (*şehirliler*) in sixteenth-century sources.[78] The new urbanites include the city boys but also, as seen here, wealthier and more stable groups.

The juxtaposition of this rather tame private entertainment scene with a more crude public entertainment, a comedic dance with male performers wearing masks on their faces, stomping the ground, and generally being buffoons with uncoordinated

movements seems to pit new urban groups—the riffraff—to use Kafadar's term, with the wealthier urban classes, hinting at some of the rifts in the urbanite population.[79] Certainly this image is intended to provide a stark contrast with the other three on these folios, thereby allowing for an exercise in comparison, a grounds for discussion of acceptable and unacceptable forms of sociability among the urban classes.

Another example of this kind of moral or social comparison juxtaposes a bath scene with young men swimming, bathing, and cleaning each other, with a scene from an insane asylum below (see plate 35). In the upper image, the young men embrace each other in the bath pool in an intimate fashion, converse in pairs, and groom each other. There is a sense of camaraderie as well as youth, intimacy as well as playfulness. It must be noted however, that this is probably not a bathhouse in Istanbul, as plunge pools were not approved by the Hanafi rite.[80] All the same, the festive mood helps us visualize one of the physical contexts in which men socialized intimately. One is reminded of the Molla's baths mentioned by the poet Sa'yi: "Do the pure born still flow like water towards Molla's baths? / For truly it is the very lifeblood of pleasure," he says, longing for Istanbul. The pleasure he writes of, of course, is not just bathing, but the opportunity to observe attractive young men.[81] The customers and bath boys certainly seem to be appreciating the view in this painting.

The panel below, however, contrasts with the joviality of this healthy socialization. Here we see three inmates in an asylum, all chained by their necks to keep them under control, and two restrained by their feet. These men are attacking their caretakers, with arms raised mid-strike. Two of them also have their genitalia visible, as an outward sign of madness. Madness is also signaled by the exaggerated physical features of the men: the one on the right has a large mouth and nose, his teeth visible in a caricaturized grimace; the others have unkempt hair and large, rough features that are a far cry from the bowlike eyebrows and rosebud lips of poetic beloveds or the youths at the bath. The sexual organs are also part of this depiction of the grotesque. Indeed, the exposed genitalia become signifiers of madness. And that reminds us that there is an integral connection between this painting and the bath scene above it. What might be erotic in the upper image becomes grotesque in the lower one. Could it be that the images foster the same belief as that discussed by Deli Birader in his *Dāfi'ü'l-gumūm ve Rāfi'ü'l-humūm*: namely, that being on the receiving end of sexual intercourse with a young boy will drive one mad?[82]

We know from classical poetry, too, that love often drives one mad. Majnun (whose name means "mad," "insane"), the protagonist of the medieval Islamic romance *Layla and Majnun*, is a perfect example. The madness of these men in the asylum seems intimately connected to sex, because of their exposed genitalia and the juxtaposition with the upper image. This sexualization of madness is perhaps a reminder that amorous relations are best kept within the bounds of decorum. In the bath scene, where we might expect it, we do not see any private parts, because here relations are being performed according to a certain script, within socially recognized norms. In the asylum, however, inappropriate, lewd behavior is on display. That we are to take the asylum scene as a depiction of the grotesque is also signaled by the figures watching from the window. Their fine features, small eyes and mouths, their fingers gingerly raised to their lips in surprise also provide an internal contrast within the image. As such, the asylum painting

characterizes the bathhouse image as demure: here the youths have elegant bodies, features, and gestures. They dive, swim, and play gracefully. The opposition provided by these two images helps to set the course straight; the viewer makes no mistake about acceptable socialization and love, and the carnal gone wild. Plate 35, in other words, sets up an opposition between different types of male behavior. Both feature undressed figures—those undressed for social cleanliness, and those undressed out of sheer madness. One group is enjoying love as it should be enjoyed; the other is mad and sexualized. One is elegant; the other, grotesque. In fact, the oppositions here are reminiscent of the notion of grotesque realism put forward by Mikhail Bakhtin in his analysis of Rabelais's work and hints at the underworld of elegant elite entertainments.[83]

When we turn to the poetry on the facing page, we find three separate pieces of paper pasted together (see plate 34). One, a page from a small manuscript, talks of unrequited love, the poet using the first-person voice to proclaim that he wants to bring a rose up close to his face, despite its thorns. The other two are calligraphic examples in nastaʿlīq by Qutb al-Din Yazdi and Mir Sayyid Ahmad, discussed in the previous chapter. Mir Sayyid Ahmad's, on the right, describes a beauty who plays with his curls, and the other curses those who do not want the beloved's happiness:

> May he who does not want your happiness be sad.
> May he who does not want you prosperous be destroyed.
> May your victory be the wish of all hearts.
> Whatever you want from God, may it become your daily sustenance[84]

All three poems can easily be reconciled with the painting showing the young men bathing. For there in the bath we can see love affairs taking place, one admiring another from afar, another two flirting, and the playfulness that arises out of sexual tensions between those attracted to each other. The asylum, on the other hand, perhaps shows love taken to the extremes; the madness that comes from, and partly explains, carnal desires; and unrequited love. As such, the last poem might be intended to link up with the asylum painting—perhaps we see the "destroyed" ones in the asylum?

The juxtaposition provided on these three folios seems intended to trigger conversations, and they could serve as the starting point of an entertaining moralizing exercise (see plates 35, 37, 45). Selim Kuru reminds us that many Ottoman literary works with sexual content also had a comic element that does not get recognized in modern scholarship.[85] The exaggerated features on some of the faces here, namely, the masks of the entertainers and the faces of the asylum inmates, also seem intended to poke fun at these figures. Kuru reminds us that sexual anecdotes were usually shared as jokes in sixteenth-century Ottoman literature and were "included in circulating literature and widely commented upon." From the mid-sixteenth century onward, such sexual and humorous literature was relegated to private reading rather than enjoyment in social gatherings.[86] The humorous aspects of the three folios are likewise not explicit; the sexual jokes are couched in the disguise of the inappropriate, lest anyone should feel uncomfortable about sharing them. But for those who dare, they are there to be enjoyed. Couching the sex and the humor within a potentially moralizing exercise also allows the

album compiler and those enjoying it to hide from potential criticism. The viewers of the album are hereby allowed a glimpse of the scandalous, which they might well enjoy, but the juxtapositions also give them the excuse to disguise their pleasure in a moralizing exercise where they would be lauding the virtues of one kind of entertainment over another, all within the comparative framework that gives shape to the album.

Although focusing on the late-medieval period in Europe, Valentin Groebner also reminds us that many sexual jokes revolved around the nose, and that there was an understood although unspoken link perceived between the nose and the sexual organs, especially of men. Thus facial features, sex, and humor appear intimately connected in Groebner's reading of the late-medieval context. He also suggests these links continue into the present moment.[87] The features of the asylum inmates also forge this link for the early modern Ottoman context. Likewise, the juxtaposition between the exaggerated features and the refined ones on these pages also evoke class distinctions, with the large noses reserved for the lower classes, as can be identified from their clothes, too. The fun then involves sex, socioeconomic class, and physiognomy. The physiognomic aspect also extends to other images from the album, suggesting they too might be seen in an entertainment context (see plates 23, 31 [see detail on page 110], 53, 55, which contain other figures with exaggerated faces).

Representations of entertainments and outings of the lower social classes (the mercantile and military urban middle classes) that we find here are almost nonexistent in Ottoman art prior to this point. In addition to being correlated with the urban changes discussed above, their appearance might well be linked with the new literature being produced at this time, love tales that also have new homo- and heterosexual balances.[88] It is quite possible that what we see are illustrations to some of these tales, which also, of course, had the double role of both entertaining and giving moral lessons.

Whether they relate to literature or "real life," these images are visual remnants of what we know from other sources: namely, that after the middle of the sixteenth century, many more Sufi lodges, mosques, bathhouses, public fountains, and, of course, coffeehouses were built than ever before.[89] Istanbul's social life was as vibrant as it could be, with public controversies and debates about the role of coffee and tobacco, various items of faith, Sufism, and the role of women. Perhaps the images we see here comment on these debates?

The Sultan and the City

Kalender's choice to incorporate urban imagery in the album is undoubtedly also linked with the interests of his patron. These drawings and paintings were, after all, gifts given to the sultan, deemed worthy of being kept by him, and incorporated into the album by his order. The young sultan had a particular love for the city of Istanbul, as we have seen in his poetry analyzed in chapter 1. Ahmed also liked to go hunting to see various parts of his country, and he liked to talk with his subjects as he did so. Safi tells us he also liked to execute his daily prayers with a community, as opposed to isolated in the palace, and that he sought opportunities to pray in various mosques around town. These, of course, were also opportunities to see his people. The emphasis that Safi lays on these accounts is quite unusual. Even more extraordinary are the numerous anecdotes recounted by

Safi of the sultan going out of the palace in disguise, wandering the city, and talking to his subjects.[90] These appearances in disguise are interpreted by Safi as being proof that the sultan is both omnipresent and omniscient.[91] Omniscience is also made possible, of course, by images such as those in the album that give the sultan a view onto what his subjects are doing. In the early days of his reign, Ahmed often teamed up with Derviş Pasha, the chief gardener and his companion, to inspect markets and streets and to mete out punishments to any of his subjects who were disobeying rules.[92]

An apt example concerns a day when the sultan happened to be enjoying the seaside along the Bosporus and noticed some illicit courting among two men in a rowboat. The sultanic boat not being at his disposal right then, he hailed a public one and went after the lovers himself, and after they were apprehended, he forbade with an official decree not only the carrying of lovers by oarsmen, but the riding together of men and women in public boats at the same time.[93] This seems to be quite in the same spirit as that which is behind the painting of the janissaries apprehending the amorous couple on folio 20b of the *Album of the World Emperor* (see plate 40).

If the image of a ruler in disguise is a trope, it was not a very common one in Ottoman visual accounts until this time. Instead, more common were images of rulers being approached by villagers as they hunt in the countryside, with the villagers asking for direct justice. In the early seventeenth century, however, such pictures gave way to those of the ruler mingling in the city in disguise. This new trope was repeated for Ahmed's deputies, too, and was preferred by authors of the early seventeenth century.[94] This suggests a further heightening of direct contact between rulers and the urban contexts just outside of their palaces. The sedentarization of the Ottoman rulers who gave up campaigning increased their chances for interaction with the urban populace.[95] Such interaction perhaps also became more necessary as a response to social unrest and rebellions of the period, as well.[96]

That Ahmed is interested in people such as those represented in the album, and not simply in artworks, is signaled by Kalender in his preface with his use of the words "seduced," "astonished," and "excited" (*firīfte, alüfte,* and *āşüfte*) when characterizing the effects of the images in the album on its viewers. The word *alüfte* was used in the nineteenth century to refer to a class of misguided or loose women. An eighteenth-century album containing Levni's depictions of seductive men and women includes an inscription describing one such professional woman as one of the *āşüfte*s of Bursa.[97] The ongoing and active use of these two terms raises the possibility that the preface is not simply referring to *art* as seductive, astonishing, and exciting, but also to the *people* represented in the paintings.

Urban expansion and increased social activity, in addition to being a source of fascination, also inspired anxiety. Both the new institutions like coffeehouses and the emergent social groups, especially the "city boys," are described in positive and negative terms by Ottoman social commentators.[98] There was an increased need to police the new groups and their activities, and Ahmed I was keenly interested in controlling urban life.[99] Indeed, as detailed in chapter 1, the note he sent to the deputy grand vizier upon claiming the throne was concerned primarily with keeping order in the city. Not surprisingly, Ahmed imposed a curfew on the city's populace as soon as he came to the throne in 1603.[100] He banned coffeehouses with an imperial decree,[101] and also banned wine, in

1613–14.[102] These bans constitute legal symbols of public order and social discipline intended to counter the crisis surrounding the empire, and they were accompanied by the reissuing of decrees regarding the clothing of non-Muslims, which had rarely been enforced previously.[103] This might very well be related to the clear interest in costume that is demonstrated by the album pages under examination here.

Such interventions resonate with the image depicting janissaries apprehending a couple in the countryside for immoral behavior (see plate 40). The man being restrained by two janissaries on the left is clearly ashamed of the compromising situation in which he was caught—he covers his mouth with two hands. The woman is pleading with the other two soldiers, not as appalled by having been caught as her male companion. Who are these people? Husband and wife? A prostitute and a client? It is hard to tell. The poetry on the facing page offers some clues, but nothing precise; it talks of the fire of love and the drunkenness from practicing it. But it also has another element—the word *ḥafiẓ* is repeated at the end of each line of one of the two poems. In addition to being the name of the renowned Persian poet Hafiz of Shiraz (1326–89), *ḥafiẓ* also means "guardian, keeper, preserver, governor," or "one who has memorized the Qur'an." The word *ḥafiẓ* resonates with the soldiers who have just caught the amorous couple, potentially saving the woman from receiving a blow to her reputation, and also protecting the order of society.

This painting visually captures the state's attempt to regulate the interactions of young men and women in the public sphere, in parks and markets, as part of its efforts to impose order on the newly enlarged population of the city. There was a perceived connection between prostitutes and newcomers to Istanbul, and the city witnessed increasingly municipalized forms of prostitution, which meant that women became "objects of widespread erotic interest to the extent that demanded the attention of the authorities."[104]

The genre scenes discussed here, as well as those of picnickers and lovers in the countryside, can all be read in two different registers (see plates 27, 31, 55). These images depict Istanbul both as a heavenly abode and as a city of sinners. In doing so, they call to mind the *Miftāḥ-ı cifrü'l-cāmiʿ* and its multilayered depiction of the city. Sinners are depicted in the *Miftāḥ* illustrated for Ahmed and his father in scenes very similar to the picnic scenes in the album.[105] According to the author of the *Miftāḥ*, the final sign of the apocalypse will be a warm wind that will kill all the Muslims. Only sinners will remain, and the apocalypse will be upon them. Illustrating the warm wind in both copies of the *Miftāḥ* are images of people feasting in the countryside, enjoying the mixed company of lovers, and music and wine, or engaging in inappropriate acts (see figs. 14, 47). Yet the *Miftāḥ* also presents a positive image of Istanbul, the city whose conquest is desired. Echoing the contradictory images of the city in that manuscript, the depictions of the city in the *Album of the World Emperor*—and indeed Ahmed's own relationship to the city—reflect both its negative and positive aspects.

While this album was being prepared for him, Ahmed was busy helping to lay the foundations of the mosque that would carry his name. The Sultan Ahmed Mosque filled a special place in this dynamic city. A great public piazza was created between it and the Hagia Sophia. Although the area had existed as an empty space before, and was used for festivities such as the imperial circumcision ceremonies in 1582, the building of the mosque helped to further define this vast area.[106] The new square, known as At Meydanı, which had

been made more attractive by the mosque courtyard, was, in the words of the French traveler Grelot, "the largest piazza belonging to the city of Constantinople"[107] and would meet the demands of public space that rose with increased participation in public life.

It is possible, therefore, to understand the single figure studies in this context too: as images of the inhabitants of the city that the sultan helped to enliven by his mosque project and its public piazza, the city that was the pride and joy of his empire, and the city that he liked to wander through, when he could. It was also the city upon which he wanted to impose order. The album, in a way, is a visual manifestation of the sultan's bringing order to the city, by organizing its vast varieties of people into uniform frames. Just as the European books examined in the beginning of this chapter used costumes to order and make sense of the expanding world around them, so the urban types in the *Album of the World Emperor*, contained by their frames and presented in neat rows and columns, can be understood as a means to impose order on the city.

The social portrait of Istanbul that emerges in this album does not only demonstrate the presence of diverse populations in the city. The ethnic and economic variety, and the large size of the population also attests to Sultan Ahmed's justice. "A state," Âli writes, "has two treasures, one its silver and gold, the other its subjects. The latter must be won and kept by justice, and is the more important, for without it the monetary treasure will pass to another."[108] By documenting for us the vast varieties of subjects that the sultan rules over—subjects that include foreigners and bolster Ahmed's claim to be the "World Emperor"—the album also presents us with a picture of Ahmed as a just ruler.[109] For here is the human treasure, its mere presence proving the ruler's legitimacy. The intimations of control we get from the album also point to the just government of Sultan Ahmed, doing his best to protect his subjects.

The concepts of just rule and a virtuous city are drawn close together in works of morals that were translated into Ottoman Turkish for Ahmed. Of particular significance is Kashifi's *Akhlāq-i Muḥsinī*, translated for him by Hocazade Abdülaziz as *Aḫlāḳ-i Sulṭān Aḥmedi*. Kashifi's work was in turn a modernization of Nasir al-Din Tusi's *Akhlāq-i Nāṣirī*, wherein civil society is classified into the virtuous city and the unrighteous city. Both authors presented the ideal city as composed of men of different sects and social groups, in their proper places. And the ruler, the philosopher king, would oversee these people as they strove to achieve perfection.[110]

In an article on Indo-Persian *shahrashub* (the Persian name given to şehrengiz) poetry, Sunil Sharma convincingly shows that the Mughal contemporaries of the Ottomans were writing their city thrillers not so much to describe actual Mughal cities, but to praise them as places where "the seven climes of the world have come together and people of every country reside." Sharma argues that the variety of professions mentioned by the poet were intended to convey a sense of the dynamic and complex structure of Mughal urban society.[111] The depiction of varieties of people from all over the globe to suggest a world-encompassing empire and by extension, world domination, is not unique to the Ottoman or Mughal empires, of course. It has parallels in the European practice of depicting people in various costumes in early modern maps suggesting world domination.[112] The variety here not only points to a vibrant urban context, but through

it, to the wider empire that is represented in microcosm in the city. The visual celebration of Istanbul in this album, with its representatives from the seven climes (or at least diverse enough to intimate all-encompassing variety), and its new urbanites attesting to its growth, crystallizes the Ottoman equivalent of this widespread Perso-Islamic early modern phenomenon.

The image cycle of the *Album of the World Emperor*, with its references to the past, with the portraits of the Ottoman dynasty as well as the ancestors of the Ottomans, also underlines the greatness of the Ottoman dynasty. As we know from Talikizade's words cited at the beginning of this chapter, the Ottomans very much saw the varieties of people and lands under their control as a sign of their greatness. Hence the multiple images pointing to the presence of Syrians, Georgians, Iranians, Africans, Armenians, Greeks, and Franks among the people of the album also signal the greatness of the empire and lay claim to world rule.

These images can also be interpreted within the economy of the occult. The world-encompassing empire, under Ahmed's control, supports the expectation that one faith and one empire will prevail before the coming of the apocalypse. According to the Ottoman view, of course, that one faith was Islam and the one victorious empire would be the Ottoman Empire. While the single figures might point to variety and world rule, the narrative scenes with picnics, wine drinking, and other urban entertainment moments might be viewed as one of the signs of the apocalypse itself. The calligraphic peacock discussed in chapter 4, where Ahmed is referred to as the champion of earth and time, also reinforces such a suggestion. An apocalyptic reading connects the contents of the album with each other and also with the larger preoccupations of the Ottoman court of the early seventeenth century. Viewed in this way, the various categories of the album's images fall into a certain relationship with each other. In this context, the images of urban populations, beyond attesting to Ahmed's justice as a ruler, contribute to his presentation as the Mahdi, an image strengthened by the European prints in the album examined in the following pages.

European Prints
from the Album

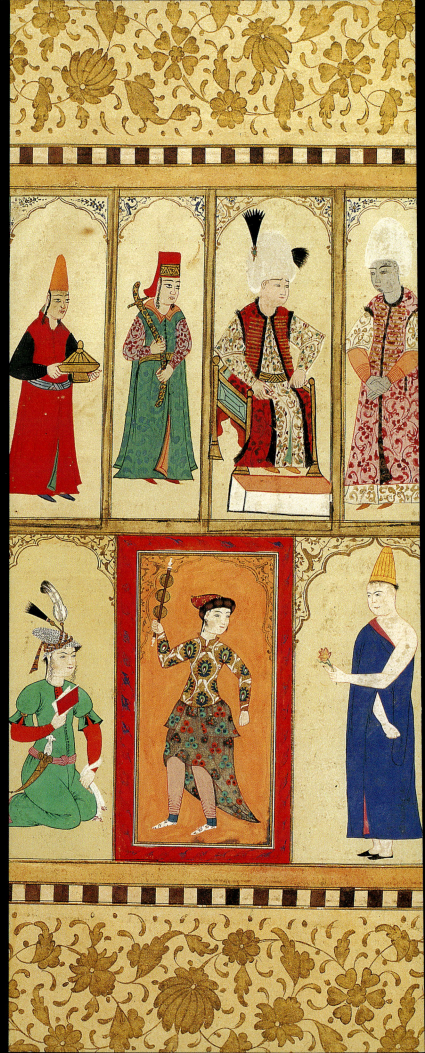

The Department of Islamic Art in the Metropolitan Museum of Art in New York City owns an album known as the Bellini Album. The Venetian artist Gentile Bellini (d. 1507), who traveled to the court of the Ottoman sultan Mehmed II and painted his portrait in oil on canvas, was believed to be the artist of one of the works previously in the album, hence its name. As David Roxburgh has shown, the Bellini Album was most likely put together by the Swedish dealer-collector of Islamic art, F. R. Martin in the early years of the twentieth century.[1] Martin owned numerous works of art from the Topkapı Palace collections and compiled the Bellini Album from pages belonging to different albums. Six of its folios clearly originate from the court of Ahmed I, and they form the focus of this chapter.

Of these six folios, one has illumination on both sides (fig. 41; all others are reproduced at the end of this volume as plates 65–74), and one has an Ottoman calligraphic work on one side and a Persian painting on the other. The other four folios contain Christological prints from varied European cities such as Antwerp, Rome, and Paris, including a number of crucifixions, a scene not easily incorporated into the Islamic understanding of Christ. Given the history of the Bellini Album's concoction by Martin, one might assume that he inserted these prints into pages with Ottoman borders and removed the Ottoman or Persian artworks that were originally pasted on the same folios. Surely such scenes had no place at the court of an Ottoman ruler who is known for his devoutness, who, as Tijana Krstić tells us, was greatly upset at the sight of a flag, carried by the retinue of the Habsburg ambassador entering Istanbul, because it was decorated with Christ on the cross.[2]

Giving such credit to Martin, however, ignores the long history of Ottoman artists' and patrons' engagement with western European art, even at moments when the Ottomans *seem* to have turned their backs on European visual culture.[3] It also ignores what Palmira Brummett refers to as the Ottomans' "familiarity in the context of rivalry" with European rulers, materials, and cultures, and it undervalues the "juxtaposition of alterity and attraction" that characterized Ottoman-European interactions of the early modern period.[4] The visual evidence clearly indicates that these prints were at Ahmed's court and were used by Kalender and other Ottoman artists as they worked on various projects. What is perhaps ironic, and certainly fascinating for art historians, is that the Christian devotional imagery in this album was used to create Ottoman artworks with a decidedly Islamic worldview, as I demonstrate in the following pages.[5] In this chapter I seek to understand whether these prints could have been in the *Album of the World Emperor*, and if they were, what role they played, and how they contributed to the multiple meanings of the album. After an analysis of the prints, their display, possible routes of arrival at the Ottoman palace, and their relationship with Ottoman painting, the last section of this chapter examines their role in the *Album of the World Emperor*.

The *Album of the World Emperor* was made during a period of religious tension in the empire. Ottoman authorities were pushing their confessional agenda by turning churches into mosques, and claiming land from non-Muslims, as for the construction of Safiye Sultan's mosque.[6] A number of new Christian groups, including Jesuit and other missionaries and large numbers of Moriscos (converted Spanish Muslims) who had been expelled from Spain arrived in Istanbul during Ahmed I's reign, and Ahmed was also in

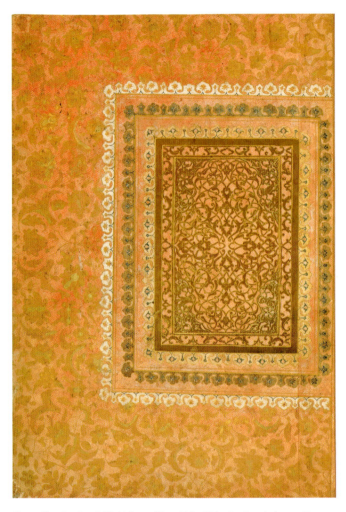

Fig. 41. Illumination. Bellini Album, fol. 1v. Folio: Kalender. Istanbul, 1612. The
Metropolitan Museum of Art, New York. Louis V. Bell Fund, 1967 (67.266.7.1v).

conversations with different Christian European powers about renewing or granting
"capitulations" (trading privileges), which meant that increasing numbers of merchants
and diplomats from western Europe were in the city. Wars with the Habsburgs were also
ongoing. Both religious and political authorities of the period made concerted efforts to
redefine the place of non-Muslim minorities in the Ottoman Empire in accordance with
the norms and regulations of the shariah.[7] Thus Christianity and Christians were in
public and courtly daily discourse. The prints find their place in the context of the
Christian-Islamic rivalry that underlay apocalyptic scenarios, especially when we con-
sider the importance of religion in the fashioning of imperial identity and the centrality
of the messianic dimensions of that identity.[8]

Furthermore, considered in the context of manuscript production at Ahmed's
court, it makes perfect sense for these prints to have been used and appreciated. As we
saw in chapter 2, of the few illustrated works produced during Ahmed's reign, a signifi-
cant proportion are concerned with the occult, an ongoing preoccupation at the Ottoman
court. The commissioning of the *Miftāḥ-ı cifrü'l-cāmi'* and the *Fālnāme* are manifesta-
tions of this interest. The specific early modern Ottoman understanding of the occult

had great respect for the traditions of the Old and New Testaments, and for Jesus in particular.[9] Moreover, Jesus had a central and very specific role to play in the Ottoman vision of the apocalypse.[10] As a result, his image is incorporated into both the *Fālnāme* and the *Miftāḥ-ı cifrü'l-cāmi'*. While the *Fālnāme* includes an image of the Virgin Mary and the Christ child, for which compositional models abound, the *Miftāḥ* actually features images of Christ for which there are no compositional or iconographic precedents in Ottoman art. For these, I am arguing, the artists turned to European prints. Those prints were later kept at the Topkapı workshop, and eventually chosen by Kalender to be included in the *Album of the World Emperor*.

The Christian imagery extracted from the *Album of the World Emperor* brings the album contents into alignment with an apocalyptic reading, in which the images of earlier rulers point to the place of the Ottomans in universal history; the many garden scenes remind us of the empire as paradise on earth, with the garden of state referenced through the floral Ottoman visual idiom;[11] the urban scenes stand in for the city that would be the backdrop to many of the events of the apocalypse; the varied single figures point to the just rule of Ahmed; and the images of Christ represent one of the events before the apocalypse: the return of Jesus (see figs. 8, 13). As seen in previous chapters, a new caliphal role was devised for the Ottoman sultan in the political writings around Ahmed's court. Ahmed's image of piety and his emulation of the Prophet Muhammad are also aligned with the assumption of a messianic role. The Mahdi, after all, would be a world emperor who ruled with perfect justice.

Codicological Considerations

Currently the *Album of the World Emperor* does not contain any European artworks; it was purged of Western content at some indeterminate point. However, their current absence does not preclude the possibility that originally the prints in New York were in the album. Albums were understood to be organic compilations; the process of addition and subtraction was ongoing and was part of the nature of an album.[12] Thus it is quite feasible that the removal of these pages, too, was by the very hand that put them there in the first place. Or if they were removed later on, this was not considered an unusual occurrence in the life history of an album. In this section, I examine the codicological affinities between the Istanbul and New York pages to see if they once belonged together.

Perhaps the most distinctive feature of the Bellini folios is the checkerboard patterning one sees on all except for folio 1 (cf. fig. 41 with plates 65–74). The pattern is one of Kalender's hallmarks, present in both the *Album of the World Emperor* and the calligraphy album H 2171 (fig. 42). The sizes of the New York pages, at 45.4 by 32.1 cm, are just a little smaller than the Istanbul ones, with the *Album of the World Emperor* pages measuring 47.5 by 33.5 cm, and the calligraphy album pages 48.8 by 34 cm. The difference can easily be explained by the cropping of the blank spaces in the margins of the Istanbul pages, which have been excised from the New York ones, where the design goes all the way to the edge. The folios in New York were bound with folios from other Istanbul albums, and the cropping must have been necessary to ensure that all the folios in the newly created album were of the same size.

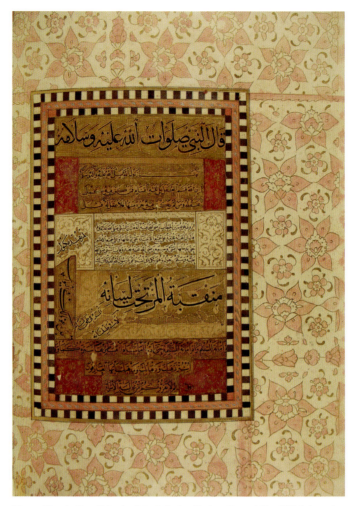

Fig. 42. Illumination. Kalender. Istanbul, 1612. Topkapı Sarayı Müzesi Kütüphanesi, Istanbul. H 2171, fol. 44b.

The margins of all the Bellini folios are closely related to Ahmed's calligraphy album. The margin illumination on plate 72, for example, finds exact counterparts in H 2171, folios 25a, 45b, 53b, and 66a. The delicate floral spirals of plates 65 and 68 are identical to those of H 2171 folio 27b. Plate 69 has matching illumination to H 2171 folios 9a, 29b, and 44b (see fig. 42). Margins of plate 71 match those of folio 38b in H 2171. The marbled margins of plates 67 and 74 also have siblings (if not identical twins) in the H 2171 album. The examples could be expanded, but suffice it to say that the marginal illumination of the Bellini Album pages is of the same style and quality as Kalender's work.

The illumination covering folio 1v (see fig. 41) of the Bellini Album finds several counterparts in H 2171: folios 14a, 14b, 15a, and 15b have overall designs very close to those of the Bellini folio (see fig. 35). Indeed, the composition seems to have been executed as part of a series, and the Bellini page clearly belongs to the same collection as the Istanbul folios, providing variations on the same composition with subtle changes of color and detail. The vertically oriented cartouches subtly created in the central part of the page (the "text block"), with the use of different vegetal designs and background colors, are accompanied by brackets in the corners that are reminiscent of book

bindings. The three rows of crenellated borders in New York are repeated in Istanbul as two rows. The color schemes of subdued creams, rose-pink, and beiges, highlighted by silver and gold, are shared across all the pages. Folio 1 of the Bellini Album was most likely extracted from H 2171, and it was either between the current folios 13 and 14 (in which case it would be upside down, but given its symmetrical design, it is quite possible that its current orientation is reversed) or 15 and 16.

The calligraphy album H 2171 was rebound at the Ottoman court in the nineteenth century. Along with a number of other manuscripts of relatively large size, this too was sent to the Yıldız Palace library for rebinding. It seems plausible that a number of pages were removed when it was being rebound. Its order may have changed as well. There are also a number of folios in H 2171 (34b, 42a, 51b, 52b, 61a, 64b, 68b, 69b) from which elements seem to have been removed, and at times replaced with other artworks. When they were replaced, the illumination or the paper joinery was clearly done by someone other than Kalender (probably at a later time), and the quality of the work is jarringly inferior to Kalender's meticulously executed compositions. The ease with which these clumsy replacements are noticed only throws into relief the similarity in quality and workmanship between the Bellini folios and the Istanbul pages in their original form.

While the margins of some Bellini folios might be closer to those currently in H 2171, they are still in keeping with the aesthetics of *Album of the World Emperor* and could just as easily have belonged in it. After all, the margins of *Album of the World Emperor* are simply different variations on similar floral themes. Although it still retains an early modern binding, it too was repaired in the nineteenth century, if not before, and currently some of its folios are loose from the binding. Images in other Western collections that seem to have come out of this album prove that it also lost some other folios over time.[13]

Furthermore, H 2171 is clearly a calligraphy album, whereas *Album of the World Emperor* is a mixed collection that privileges the figural image. It makes sense that the Bellini folios would have been juxtaposed with Kalender's other compositions that emphasize visual relationships in a connoisseurial way. The overall aesthetic of the Bellini pages is much more in keeping with the pages of the *Album of the World Emperor*. The composition of plates 69, 70, and 72, with their juxtaposition of similar or repeating images, continues the same aesthetic demonstrated in Kalender's idiosyncratic arrangement of folios in the *Album of the World Emperor*. The multiple elements Kalender collected on the pages of the *Album of the World Emperor* distinguish this album from his other work as well as from other albums. The crowded, overwhelming compositions of the *Album of the World Emperor*'s folios, as discussed in chapter 3, reflect the comparative approach of connoisseurs of the arts and poetry at the Ottoman court. Similarly, the Bellini folios shown in plates 69, 70, and 72 bring together prints that are visually close to each other. The crucifixion scenes pasted next to each other on plate 70, for example, one colored and one not, one slightly smaller than the other, elicit a similar comparison. Likewise, the three images that make up the upper row relate to each other compositionally, with a central element surrounded by roundels. The images of the saints in plate 72 provoke a similar comparative viewing, as do the compositions of the Salvator Mundi and St. Anthony prints next to them: both feature a haloed man, hands opened to the sides. The presentation of the prints is in keeping with the rest of the album. As such

they suggest that the connoisseurial tendencies of Ahmed and Kalender expanded beyond the geographic borders of the Ottoman Empire and beyond the temporal borders of the early seventeenth century.

The arrangement of the images on the Bellini folios, where the blank spaces are filled in with strips of illuminated papers, is also consistent with the treatment of such spaces in the *Album of the World Emperor* pages. Another visual characteristic that links the two is the use on some folios of a single, central image that is then enlarged with Kalender's meticulous illumination and paper joinery to create a composition that fills the entirety of the pages (cf. plates 65 and 18). The extra borders and rulings that enlarge the center of the pages, the illumination and paper joinery, and the refined margins and invisible seams on the folios of both albums are clearly the work of the same hand. Thus codicologically, stylistically, and compositionally, the Bellini folios 1, 2, 3, 4, 5, and 8 unmistakably evidence Kalender's high-quality workmanship. Except for the first folio, which clearly came out of H 2171, the others continue the aesthetic themes and visual tactics evident in the *Album of the World Emperor*.

Content

There has been no study, to my knowledge, of the contents of these pages, aside from the basic information provided in the catalog of the 1961 Sotheby's sale from which the Metropolitan bought the Bellini Album, which is repeated on the museum's website.[14] My research on the prints has revealed the following information:[15]

> 2r: A Jesuit print of a heart circumscribing an image of Jesus superimposed onto a tree, surrounded by the words: *Ego sum vitis, vos palmites* (I am the vine, you are the branches [John 15:5]) (see plate 65). Underneath Jesus are four Jesuit figures, including Ignatius of Loyola, Francis Xavier, and Stanislaus Koskta. The print also features the Jesuit motto, *Ad Majorem/Maiorem Dei Gloriam*, and *IHS*, the Jesuit emblem used consistently after the sixteenth century. The image is dedicated: "To the most Illustrious and Reverend Lord Johannes Andreas Prochnik, Bishop of Kamieniec and Perpetual Administrator of the Abbey of Sieciechów, Most Excellent Senator of the Kingdom of Poland." The Polish Johannes Andrea Prochniki (1553–1633) was bishop of Kamienec-Podolsk (Kamyanets-Podilsky, today in Ukraine) in 1607 and Latin archbishop of Leopoli (today Lviv, Ukraine) from 1614 to 1633. The print was produced when he was bishop of Kamieniec and also had the title of administrator of a Polish abbey. Given that he also claimed the nobility title of "senator," he was probably not a Jesuit himself (Jesuits had to leave honors behind), but a supporter.[16] His titles in the inscription suggest the image must have been produced around 1607 and before 1614.
>
> 2v: Mercurius (see plate 66): Mercury is depicted in a chariot pulled by two ravens above a landscape with cities and market scenes; the engraved Latin text reads, *M. de Vos figuravit*. Marten de Vos (1531–1603) was a successful Antwerp painter and printmaker. This image of Mercury comes from his series of the Seven Planets. Another version of this print is dated 1585;[17] this one must have been produced around the same time.
>
> 3r: An engraving of the archangel Michael (see plate 67) by Giovanni Orlandi, an

engraver, publisher, and print dealer active between 1590 and 1640 in Rome and Naples. A book of portraits by Orlandi and Giacomo Franco, published in Rome in 1599, includes portraits of Ottoman rulers and officers as well as those of Hungary, Transylvania, Russia, and Ethiopia, providing a link, however weak, between him and the Ottoman context.[18] It appears that this depiction of the archangel is based on a painting by Marten de Vos or its many print versions popularized by Sadeler and Wierix, both Antwerp printmakers. De Vos's painting is unusual for the fact that the archangel is de-militarized: Michael does not hold a sword but rather has one arm raised with his hand open, and the other is holding a martyr's palm. It seems the Antwerp artists chose this version to replicate for its international popularity, and the iconography seems to have spread across the globe in the late sixteenth and early seventeenth centuries, from Peru to Asia.[19] The print from the *Album of the World Emperor* attests to the success of the print among connoisseurs.

3v: An engraving of the Annunciation by Cornelis Cort (see plate 68), active in Antwerp until 1565 and later in Italy (Venice, Rome, and Florence). He worked for Titian for a while, and he counted the Medici among his patrons. An identical print of the Annunciation in London is dated to 1577. According to Nadine Orenstein, this seems to be "the copy published by Johannes Sadeler which is lacking Sadeler's publisher's address in the bottom left. Either it dates before the address was added or the address was taken out in a later state or the address has been rubbed out in this impression."[20]

4r: A group of seven small engravings of the images of Christian saints (including Blasius and Veronica), an Ecce Homo scene (see plate 69). Thomas de Leu, a French printer of Flemish origin (1560–1612), signed the St. Basil print. The three images printed in red ink, Mary, Jesus, and Anne (*Salvs generis humani*) and St. Veronica are signed *I Laurus f* (*Iacobus Laurus fecit*). Two indicate Rome as place of production.[21] The Jesus Child with the instruments of the passion, inscribed *In laboribus a inventute mea* is also signed *Roma Jacobus Laurus*. Iacomo/Jacobus Laurus (Giacomo Lauro) was active from the late 1580s to the 1610s.[22]

4v: A group of six small engravings, including the Joyful Mysteries, the Lamb of God, and two crucifixion scenes (see plate 70). There are no signatures here, but the *Crucifixion* is by Christoph Greuter, active in Augsburg from 1600 to 1633.[23] The vertical black-and-white pattern pasted on the bottom of the folio, according to Femke Speelberg, is a textile pattern close to several patterns that are copied frequently in books published in Germany and Venice between circa 1525 and 1550.[24]

5r: An image of the Virgin and Child, print by Georg Wyns, after a painting by Jan Gossart (1478–1532), also known as Mabuse (see plate 71). Inscribed at bottom left: *Ioan. Mabuse invent.*[25] The publisher for this print was, according to Nadine Orenstein, Petrus Firens, who is also the engraver of an image on the other side of this folio.

5v: Six devotional prints (see plate 72), including Jesus as Salvator Mundi (signed *I. Laurus f.*) and Christ with a crown of thorns, inscribed with *Respice me, me conde animo, me pectore serua*, lines from a poem on the passion of Christ attributed to Lactantius, a Byzantine historian and poet from the era of Constantine the Great.[26] The print is signed *Petrus Firens fecit et excud.*[27] An image of the ascension of Christ is signed *C. de Mallery, ex*. According to Nadine Orenstein, Carel de Mallery was born in Antwerp 1571 and was active there until circa 1635.[28] The portraits of saints Apollonia

and Cecilia are printed in red ink and are not signed. According to Jamie Gabbarelli, these are in "a rather common format for images of saints in this period [and] . . . probably engraved around 1600. Cecilia and Apollonia were two locally important saints in Rome at the time. While they are unsigned and we cannot know who engraved them, the style is similar to that of Philippe Thomassin, one of the most prominent engravers in Rome between 1585 and 1620."[29] And finally, an image of St. Anthony Abbot is signed *I. Laurus f.*

All the prints on the Bellini folios date from the late sixteenth or early seventeenth centuries, and they come from a variety of western European urban centers—Rome being the most frequent place of origin. The dates of productivity for some of the artists or printers admittedly extend into the 1630s, but since the prints are not dated, it is equally possible that these prints are from the earlier careers of these publishers or artists. So far, nothing rules out the possibility of these prints being in Istanbul in the 1610s. There are three questions I would like to answer about these prints: how did they get to Istanbul, how do they relate to artistic production at the court of Ahmed I, and finally, what role did they play in the *Album of the World Emperor*, if indeed, as I think, they were included in it.

Routes

One easy way for artworks from Europe to reach the Ottoman palace was as gifts given during the granting or renewal of trading capitulations—and the reign of Ahmed I is particularly rich with such treaties. Trading capitulations for the English and the French were renewed early in his reign: the French in 1604 and the English in 1606. In 1610, the sultan finally decided to grant favor to the Dutch and allow them to trade under their own flag in Syria and in other parts of his empire.[30] The Spanish were given trading privileges close to the end of Ahmed's reign.[31] All four of these capitulation agreements (French, English, Dutch, and Spanish) would have provided ample opportunity for gift exchange, as numerous elaborate gifts were customarily given to the sultan and to high-ranking court officials during the ceremonies surrounding the signing of such agreements.[32] In the introduction to the album of Ahmed I, Kalender writes that the works of art in the album were given to the sultan as gifts or as requests for his generosity; it is thus not impossible that some of these prints were gifted during such an occasion, but their religious content renders this less likely.[33]

Granting trading privileges to some nations of course disadvantaged others by increasing competition. The Venetians, the French, and the English tried very hard to block the treaty with the Dutch, for example. Various Ottoman courtiers were for or against the treaty, and all tried to influence the sultan's opinion.[34] Upon his arrival in Istanbul in 1612, Cornelis Haga was received by the commander of the navy, Halil Pasha, and established in a house in Galata at the location of the current Dutch Consulate in Istanbul. While the Dutch envoy hopefully awaited an audience with the sultan, the present English, French, and Venetian ambassadors were working to discredit him, so as not to face more trade competition and lose commissions. The French, and especially the Venetians, tried to convince the Ottoman officials with whom they were close, that the

Dutch were simply rebellious subjects and vassals of the king of Spain and should not be viewed as an independent nation. They claimed that concluding a treaty with the Dutch would not be fitting to the sultan's dignity and that it would also put him in great difficulty with the Spanish. Indeed, these complaints were written up in a letter presented to the sultan by Hacı Mustafa Agha, who seems to have been a supporter of the French and Venetian cause.[35] The sultan still decided to receive the Dutch envoy, however, thanks to Halil Pasha's sustained efforts, and with the support of the shaikh al-Islam Sadeddinzade Mehmed Efendi and other members of the imperial council.[36] Given the heated negotiations taking place in Istanbul, it is quite feasible that many presents changed hands prior to the signing of the treaty. Haga came equipped with nine chests of gifts, and these did include prints, books, and maps. But the prints mentioned in the Dutch sources do not include any with religious subject matter, and at any rate, the Bellini prints are mostly Catholic, not Protestant.[37]

It is equally possible that others involved in these negotiations may have given prints as gifts. Against the treaty were Hacı Mustafa Agha and the grand vizier Nasuh Pasha. Haga's detractors also included the Netherlandish merchants already resident in Istanbul, especially the Roman Catholic Gisbrechti brothers. These jewelers and goldsmiths to the Ottoman palace, who had lived in Istanbul since 1602, wanted to be the ambassadors themselves.[38] Given the close patronage relationship between Mustafa Agha and Kalender, it is not too far-fetched to surmise that a gift from the anti-Dutch camp, given to Mustafa Agha, might have found its way into Kalender's hands.

It is also important to consider that these prints may not necessarily have been gifts, or may not have come to the palace from overseas, but rather from within Istanbul.[39] There was a considerable community of Christians living in or traveling through Istanbul in the sixteenth and seventeenth centuries, and some of these prints may simply have been bought on the streets of the city. The trade agreements of Ahmed's reign increased both the flow of goods and the number of Europeans in the empire.[40] By the end of the sixteenth century, and certainly by the 1610s, prints were not the rare commodity that they had been earlier. Marten de Vos, Cornelis Cort, Giovanni Orlandi, and Georg Wyns, the identified printmakers represented in the Bellini pages, were all successful printers whose works were widely available in Europe and beyond.[41]

European print collections of the Renaissance were organized in just the same way as the prints on these folios and the other artworks in the *Album of the World Emperor* seem to be: by subject matter and scale.[42] Thus the arrangement of saints' portraits in plate 69, the devotional prints in plate 72, or the colored prints in plate 70 accord perfectly with the way prints would have been kept in albums in their original, western European context. Peter Parshall refers to Renaissance print collections as "pictorial reference works most often shelved in libraries."[43] This, too, accords with the way these prints (and at times, other materials in albums from the Islamic world) were understood. The juxtaposition of earthly and religious topics as seen in this album is also common in European print collections, where genre scenes were often presented along with religious subjects.[44] I will return to this point when I discuss the intersection between these prints and artistic production in the late-sixteenth-century Ottoman court. Here, suffice it to note that this similarity of organization and use suggests cognate functions in the

Ottoman and the western European worlds. Perhaps the Ottoman viewers of the prints had seen them in their original contexts of print collections? Or the prints had come from European print collectors who also ordered their prints by topic and size.[45]

The smaller images from the album have a much more personal, devotional nature and are not of the highest quality: it is quite unlikely that they were diplomatic gifts. The image of St. Anthony Abbot (see plate 72), for example, might easily be related to the congregation of the church of St. Anthony the Abbot in Galata.[46] The history of another Galata church, San Benedetto, might explain the Jesuit print in plate 65. A Jesuit mission had appeared there as of 1609, and soon after, the Jesuits began to be supported by the French crown.[47] The missionary connection, evident from the Jesuit image in plate 65, is an important route to bear in mind when considering how and why these prints would have appeared in the art market or the streets of Istanbul. Such images might have been collected by Kalender or other Ottoman courtiers, as their contents (the lives of some of the saints) relate to the geography of the Ottoman Empire, and their themes relate to topics of interest to the Ottoman court in the early seventeenth century.

And finally, the reign of Ahmed I was also witness to two important developments with regard to the Christians resident in Istanbul. One is the arrival of Moriscos in Istanbul after their expulsion from Spain, and the other is the Carazo affair—the discussion about levying special taxes on embassy personnel.[48] The arrival of the Moriscos seems to have wreaked a good amount of havoc in the relations between the Ottoman court and its non-Muslim subjects residing in Galata, as the Moriscos were settled there.[49] The Carazo affair, too, shows the high-stakes nature of the relations between Muslims and Christians, and thus their symbolic importance for Ahmed and his courtiers. The discussion about levying taxes appears to have highlighted a rift between the ruler and his chief religious officer, and in the end Ahmed came down on the side of common practice rather than religious law and did not impose the taxes as his chief religious officer requested.[50] But the tense circumstances might well be connected to the growing "confessionalization" of the empire and the age.[51] These concerns also form the foundations of the anxiety about the millennium and the competition between not only empires but faiths—for one faith was supposed to triumph before the end of the world.

Intersections with Ottoman Art

The Christological images would have been appreciated at the court of Ahmed I in a number of ways. They would have served as representations of timely subjects, used as models for other artworks, and would have been enjoyed on an aesthetic level. Their subject matter would have resonances in the Sufism-infused atmosphere of Ahmed's court. Jesus in particular was considered a "perfect man," a model human being, especially in the writings of Ibn ʿArabi, whose thinking was popular in Ahmed's court, followed, among others, by Ahmed's beloved Sufi shaikh Aziz Mahmud Hüdai.[52] The notion of the "perfect man" had come to pervade the ideal image of the Ottoman ruler, as discussed in chapter 1. The Christological prints could serve the purpose of modeling a certain kind of behavior for Sufi devotees, including the sultan. The Christian saints, too, could provide models of behavior.[53]

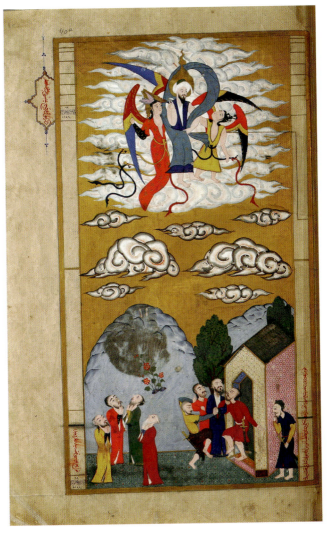

Fig. 43. Ascension of Christ. *Zübdetü't-tevārīḫ*, by Lokman. Istanbul, 1583. Türk ve Islam Eserleri Müzesi, Istanbul. 1973, fol. 40a.

In an album where images are interpreted to bring wisdom when gazed on with scrutiny, the Veronica veil (see plate 69) and its potential as visual commentary on image making might also have particular resonance. The Veronica veil was believed to bear the image of Christ's face, made not by man but when it was placed on his face by St. Veronica to wipe off his sweat and blood. It was a central example in the medieval discourse on images.[54] If considered in juxtaposition with the image of Saʿdi in the *Fālnāme* (see fig. 23) where idolatry is the issue in question, the Veronica veil does point to a concern with, or an ongoing conversation about, images and idolatry. Given Kalender's words in the preface about works of art inspiring people in dark or difficult times, it is not at all difficult to find space for these images in the album. However, the prints played an even more specific role in artistic production at the Ottoman court of the late sixteenth and early seventeenth centuries.

A number of the Bellini prints appear to have served as models for Ottoman paintings, both during the reign of Ahmed I and earlier. The earliest surviving image of Jesus Christ in an imperial Ottoman manuscript, the ascension scene in the 1583 *Zübdetü't-tevārīḫ*, is a case in point (fig. 43). This universal history presents Ottoman rule as divinely ordained and

suggests that the Ottomans are the last dynasty to rule before the end of the world. Murad III is presented in the book as the heir of Prophet Muhammad.[55] As part of its account of universal history with a particular focus on prophets, the *Zübdetü't-tevārīḫ* includes an image of Jesus as he ascends to heaven. This image is extremely close to the ascension scene included on folio 5v of the Bellini Album (see plate 72). Details adapted from the print include the triangular top of the tomb from which Jesus is ascending, the clouds surrounding his body, and the surprise that scatters those watching him to either side. Churches in late-sixteenth-century Ottoman painting were often depicted with triangular roofs, and this image must have thus appeared familiar, or at least struck a chord with the artists.[56] The flowing cloth behind Jesus has been rather more solidly incorporated into the Ottoman version of the image as a blue sash framing Jesus's head. The overall composition, with its vertical arrangement and division into two parts is clearly inspired by the print.

Certainly other images of Jesus would have been available to Ottoman artists. The *Compendium of Chronicles*, the thirteenth-century universal history written by the Ilkhanid vizier Rashid al Din, would have been an obvious model for the *Zübdet*, as it too is a universal history that included stories from the Old and New Testaments, and there were illustrated copies of it at the Topkapı. Indeed, I suspect that it did serve as a conceptual model to Lokman as he was composing his work. However, the *Compendium* only included two scenes from the Jesus story: the Annunciation, and the Seven Sleepers.[57] These would have been of no use in trying to picture the ascension of Jesus.

The many *Qiṣaṣ al-ʾAnbiyāʾ* (Stories of the prophets) manuscripts still housed in the Topkapı collections also include images of Jesus. Popular throughout Islamic history, these tales of Old and New Testament figures were copied, with illustrations, in the late sixteenth century. Many copies now in the Topkapı were prepared in Baghdad near the turn of the century.[58] The *Qiṣaṣ* manuscripts usually illustrated the Annunciation, the Nativity, baby Jesus speaking right after his birth to defend his mother's honor, the "miracle of the table" (or multiplication of fishes and loaves), and the execution of Jesus's substitute, which is the common Islamic account (or denial of) the Crucifixion.[59] No actual ascension is depicted in the *Qiṣaṣ* manuscripts. Rather, what it portrays is simply a man who is being hung on the gallows.[60] After a lengthy description of Jesus's birth and various miracles, al-Kisai's version of the *Qiṣaṣ* simply states: "The people who believed in him remained, and Jesus stayed among them until God raised him up to Himself."[61] This reflects very closely what the Qur'an says about Jesus, that "God raised him up to Him" (4:156–57).[62] According to the author of another popular version of the *Qiṣaṣ al-ʾAnbiyāʾ*, Dayduzami, Jesus was "seated in a carriage of air, and the angels carried him. No one saw this ascension."[63] That this was an ascension nobody saw is significant here, as it tells us that what is being portrayed in the *Zübdetü't-tevārīḫ* is not based on the text (or, of course, the image) of the *Qiṣaṣ al-ʾAnbiyāʾ*, because there are clearly people in the image who are witnessing the ascension and are biting their fingers in amazement at what they see. For this image, the artists clearly went to a source outside the Islamic tradition.[64]

The Bellini print and the *Zübdetü't-tevārīḫ* painting are very different from each other in terms of style, but the composition and the iconography, those informative parts of an artwork that allow us to identify the scene as that of Christ ascending to heaven, have been carefully and practically adapted from the print. The two were not

displayed together. The point was not to emulate another artwork and juxtapose the original and the copy, but instead to practically gather visual information from an authoritative source.[65] The *Zübdetü't-tevārīḫ* is an entirely different project, but the compositional dependence of the ascension image on the print from the Bellini Album shows us that the print was indeed in Istanbul, as early as 1583.[66]

Surely Ottoman artists wandering the mosques of Istanbul would have seen mosaic images of Christ as well, notably in the Hagia Sophia and the Chora Church.[67] But I favor the Bellini print as a model for the *Zübdetü't-tevārīḫ* rather than mosaics or frescoes in a Byzantine church, because the artists of the Perso-Islamic world had long been in the habit of using models on paper, foreign or local. Starting as early as the fourteenth century, if we are to judge by the compositions in the *Compendium of Chronicles*, this had meant looking at Christian models as well.[68] Designs on paper (and, admittedly, textiles) were instrumental in spreading styles across Asia during the thirteenth and fourteenth centuries.[69] Works on paper were the most common sources of inspiration for later paintings, as is made abundantly clear by looking at the works collected in Timurid albums.[70] Furthermore, we also know that in the workshop hierarchies of the Islamic world, artists working on paper were the most esteemed, especially if they were calligraphers.[71] Turning to models on paper would have been the obvious thing to do.

And finally, this was not the first time Ottoman artists had turned to European prints to gather information for paintings they wanted to produce. The Ottomans continued to appreciate, and buy or receive as gifts, European works of art in various media, even after the mid-sixteenth century, when the court seemed less receptive to foreign visual idioms. The effects of this continuing appreciation on the visual arts *produced* in Istanbul is most evident when one looks for *not* stylistic affinities *but instead* shared conceptual underpinnings, as in the coming together of vita and portrait in the Ottoman imperial portrait book, the *Şemāʿilnāme* (see fig. 9), and one of its models, Paolo Giovio's *Elogia* (fig. 44)—a well-known case.[72] In that instance, Ottoman artists had incorporated specific facial features from European images of Ottoman rulers into their own Ottomanized depictions of the sultans. However, the finished Ottoman paintings, despite their close relationship with the European originals (a relationship that the author of the book advertised boldly in his introduction), visually deny that dependence on the foreign source material, because the imperial portraits were serving Ottoman ends and were created in a visual idiom that was appropriate to their intended purpose and audience. Similarly here, the artists of the *Zübdetü't-tevārīḫ* clearly benefited from this print, but the final product does not attempt to emulate it. It was created for a different end. To reiterate what may have become an obvious point by now: Ottoman artists of the book, and their artistic ancestors, had long been in the habit of looking at earlier images on paper, both in and outside of their own traditions, as they created works anew. The fiercely intervisual (to borrow a term from Michael Camille[73]) nature of Ottoman painting meant that the use of a European print to design an image of Jesus for an Ottoman universal history was simply par for the course.

The *Zübdetü't-tevārīḫ* image is the earliest instance that I could find of Ottoman artists using prints that were later incorporated into the Bellini Album. There were also manuscripts created at the court of Ahmed I that lacked such compositional precedents, such as the *Miftāḥ-ı cifrü'l-cāmiʿ*. According to the Ottoman and Islamic beliefs about

Fig. 44. Sultan Süleyman. *Elogia virorum bellica virtute illustrium*, by Paolo Giovio. Basel, 1575. Houghton Library, Harvard University, Cambridge, Massachusetts. flC5.G4395.B575v.

the apocalypse as outlined in the *Miftāḥ*, the coming of Jesus is one of the signs of the apocalypse (see figs. 8, 13). Jesus will descend onto a minaret to the east of Damascus (some sources interpret this as the easternmost minaret of the Great Mosque in Damascus). He will appear after the arrival of the Antichrist, which is envisioned as a very ugly creature, and will kill the Antichrist and lead the Muslim armies in victory. He will rule for forty years, and be buried in Medina.[74] Jesus is different from the Mahdi that will also appear.[75] Incidentally, Bistami's writing in the *Miftāḥ* makes it quite clear that he was familiar with the gospels, and the emphasis on Jesus in his account of the apocalypse is but one manifestation of this.[76] Images of Jesus in Ahmed's copy of the *Miftāḥ-ı cifrü'l-cāmiʿ* show him descending to earth, killing the Antichrist, and conversing with the Seven Sleepers.[77]

The descent to earth is the most unusual composition in the context of Ottoman art, since there are quite a few precedents for images of political or military leaders hunting, fighting, or conversing with others. The conversation with the Seven Sleepers, for example, simply shows Jesus, a haloed man, seated in front of a cave, talking with another group of seated men. This image replicates a basic "audience" scene, examples of which abound in Ottoman art. Similarly, the slaying of the Antichrist is a basic battle scene, with Jesus and his followers neatly organized behind a hill at the right of the image, swords raised, ready for action. The Antichrist is depicted as a man with a dark face, riding on horseback. Jesus's long lance has pierced him in the back, and the end of the lance is still in Jesus's hand. Two monsters, like those in the *Shāhnāma* , accompany the Antichrist and his army. This is, in other words, a battle scene with a few flourishes, probably modeled on one of myriad examples to be found in Ottoman painting.

Not so the image of Jesus descending onto a minaret to the east of Damascus; there were no "local" models available for this composition, as discussed above for the 1583 ascension scene. Again, artists must have turned to non-Ottoman examples. Ahmed's manuscript of the *Miftāḥ* depicts Jesus's descent in an Ottomanized composition (see fig. 13). Here we have an Ottoman-style mosque, with round domes and an arcade in front, but shown from a rather strange perspective, with its minaret rising up the center of the image. Date palms in the background help to locate the image in the Arab lands.[78] Standing on top of the central minaret, however, supported by angels holding his two outstretched arms, is Jesus himself. His body is depicted in a frontal pose, but his head is turned to the side in a more traditional three-quarters view. This odd depiction recalls the Jesus in the Bellini Album Jesuit print (see plate 65), as well as having resonances with the Anthony Abbot in plate 72.

In the scene of Jesus's descent in the earlier copy of the *Miftāḥ* (see fig. 8), we see Jesus in a full-frontal pose, with his hands open to the sides similar to a Salvator Mundi pose, not so unlike what we see on folio 5v (see plate 72) of the Bellini Album, though this print is not as close to the Ottoman miniature as is the ascension example in the *Zübdet*. However, the full-frontal view, especially the face looking straight out at the viewer, is a rather unusual pose for a human being in an Ottoman miniature, and it would not be at all surprising to find that this painting, too, is based on foreign precedents, perhaps even the Salvador Mundi image and the Jesuit print from the Bellini Album (see plates 65, 72).

The artists of Ahmed's copy of the *Miftāḥ-ı cifrü'l-cāmiʿ* updated and improved on the earlier copy made for Mehmed III.[79] Jesus's descent, for example, was changed to include a mosque and trees, an earthly context, in order to give specificity. Although Jesus's body remains frontal, the full-frontal face we see in Mehmed III's copy was deemed inappropriate and replaced with a three-quarters view. This last change suggests again that the first version of the image is based on something outside of the Islamic tradition, a foreign visual model that was eventually rejected.

In addition to their use during the production of the *Miftāḥ* manuscripts, the prints in the Bellini Album resonate with another project from Ahmed's court, the *Fālnāme*. The *Fālnāme* Mary and Child image (see fig. 22) has a composition very similar to that of the Bellini print in plate 71. As with the ascension image in the *Zübdet*, the *Fālnāme* Virgin and Child draws on informational points of the Georg Wyns print. In this case, the Virgin's red dress and blue veil, her exposed and awkwardly located breast, and the presence of fruit in both images suggest a relationship. The tresses of hair that come down next to her ear have also been noticed, though straightened, by the Ottoman interpreter of the image. The halos of the two holy figures are repeated in the Ottoman image. And although the Ottoman haloes are of the flaming kind, which was the local preference, Mary's halo still retains its circular overall shape. The visual connections here are much stronger than to those of, for instance, the image of the Virgin and Child in the apse of the Hagia Sophia, or to those of the Virgin and Child to be found in the Safavid Shah Tahmasp album, also in Istanbul.[80] This is not to say that the Georg Wyns print was necessarily the only model, as the *Fālnāme* image also retains allusions to another Virgin and Child image type, where the child offers fruit to his mother.[81] The two images share strong affinities all the same, suggesting that the print was in Ottoman collections, and enhancing the probability that

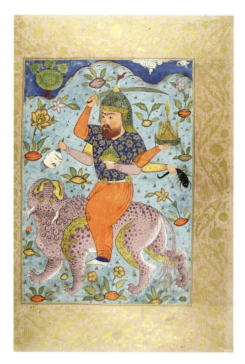

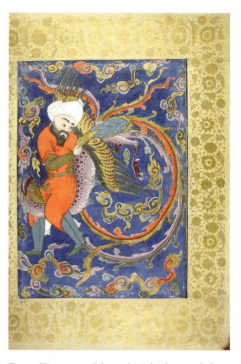

Fig. 45. Mars. *Fālnāme*, by Kalender. Istanbul, 1614–16. Topkapı Sarayı Müzesi Kütüphanesi, Istanbul. H 1703, fol. 30b.

Fig. 46. Hippocrates. *Fālnāme*, by Kalender. Istanbul, 1614–16. Topkapı Sarayı Müzesi Kütüphanesi, Istanbul. H 1703, fol. 38b.

the rest of the Bellini prints were also in Istanbul by the early seventeenth century and could have been incorporated into an album for the sultan.

We might also compare the image of Mercury riding his chariot across the sky (see plate 66) to two images in the *Fālnāme*. One is the image of Mars, and the other is Hippocrates (figs. 45, 46). In particular, the lack of a background for the Hippocrates image and the bend of his body (though reversed) seem related to the print. While neither Ottoman image is obviously based on the image of Mercury, it would have been a relevant example. It is also quite possible that the full series of the Seven Planets of Marten de Vos's prints were available at the palace and that Kalender chose this example to incorporate into the album for aesthetic reasons. One of de Vos's Seven Planets, too, is Mars.

Most important, whether they ultimately formed the basis of Ottoman images or not, such prints were clearly of interest to the Ottoman court with its intense focus on prophecy and the occult (which would also include astrology), interests that were of course shared by their western European contemporaries. The speed with which the telescope came to the Ottoman and Safavid empires after its invention, owing to intense exchange in scientific instruments, is further proof of these shared interests. Sonja Brentjes points to the many travelers who brought such instruments with them from Europe.[82] This strengthens my assertions about the availability of prints, but also points to astronomy/astrology as a shared area of interest (as is also attested by the observatory in Galata established and torn down during the reign of Murad III), not unrelated to the collection of astrological prints and even apocalyptic ones.[83]

The different prints in the Bellini pages were collected because they related to the concerns of the Ottoman court. Whether they were expressly collected to serve as visual

models for the Ottomans' own projects is impossible to ascertain. But they were used as such models once already in Ottoman hands. In addition to the *Zübdetü't-tevārīḫ* and the *Miftāḥ-ı cifrü'l-cāmiʿ*, there were other manuscripts created at the end of the sixteenth and the beginning of the seventeenth centuries that dealt with the signs of the apocalypse, the stories of the prophets, and with the wonders of creation.

Although the Safavid and Mughal courts did produce works of art in which they imitated European prints and incorporated the iconography of Jesus and the Virgin Mary, until now, the history of Ottoman painting was thought to lack any such examples. If I am right about the prints in New York and their use in Istanbul, then we need to rethink our understanding of the Ottoman interest in European religious iconography. It is important to note that while Mughals and Safavids adopted select stylistic characteristics of European images, the Ottomans did not budge from their own visual idiom but simply appropriated iconography and compositional aspects. These are precisely the parts that carry information and help viewers to identify the scene, which were the primary concerns of the Ottoman artists. As these examples show, engagement with a foreign visual tradition does not always entail adopting aspects of that foreign style.[84] In these cases, the prints were not so much useful as aesthetic objects but rather as carriers of information.[85] That Ottoman artists had such foreign artworks, looked at them, appreciated them, used them, but still chose to paint in the "house style" is further proof of the deliberation of that house style and points also to a certain self-confidence on the part of these artists. Their eventual inclusion in an Ottoman album, however, does suggest that they were of interest as works of art, too. In other words, their aesthetic properties were indeed appreciated, just not copied.

There is, nevertheless, one example in the album of Ahmed I that seems to incorporate a European landscape print in its upper part (see the top half of plate 46). It is painted over, with attention to atmospheric perspective. The lower part of the image is likely Ottoman. This scene contains, then, the vestiges of European materials in the Istanbul portion of the album. As such, it increases the likelihood that other prints too were once a part of this album. If the New York prints were indeed included in the *Album of the World Emperor*, this means that European and Ottoman images were juxtaposed in a single artwork, albeit on a much grander scale than the example I just described. While this is certainly an aesthetic gesture different from using European artworks to create Ottoman ones, it actually has considerable precedent within the visual universe of Kalender and Ahmed, in the older albums kept in the Topkapı treasury, especially H 2153, in which Ahmed's handwriting is to be found.[86] There is one image on folio 58b, which shows Jesus being lowered from the cross, and a number of other European prints with classically derived themes. Ahmed and Kalender must have thought of them as models when deciding what kinds of materials to include in the *Album of the World Emperor*.

The Role of the Prints in the *Album of the World Emperor*

Like most albums, the *Album of the World Emperor* is open to a number of different readings. The Christological images, if they were indeed incorporated here, allow one such variant reading to come to the fore. With the prints, this album becomes a collection of the signs of the apocalypse, a looser version of the *Miftāḥ-ı cifrü'l-cāmiʿ*. Created at a

time when Ottoman (and more generally Islamic) artists and intellectuals were increasingly interested in compilations, perhaps the *Album of the World Emperor* was a "modernized" version of the *Miftāḥ?* Alternatively, just as many European print collections were meant to accompany books of relevant materials, perhaps one of the functions of this album was to be a companion volume to the various apocalyptical works in circulation at Ahmed's court.[87] One could read related texts, gaze at the album's images, and ponder the horrors around the corner. At the very least, the album is a collection of images of contemporary concern, and we know that one of the interests of early-seventeenth-century Ottoman intellectuals and courtiers was the occult. It contains numerous images that are related to apocalyptic books.

It has recently been pointed out that some Safavid album prefaces, notably that by Dust Muhammad, display clear lettrist occult tendencies.[88] I have already discussed how Kalender based his preface on the Safavid examples at hand. We also know that occult tendencies, as explored through the *Miftāḥ* and the *Fālnāme*, were very much at the center of courtly discourse during the reign of Ahmed I. Although the emphasis of the preface of B 408 is not on the pen and the writing of creation, as it is in the preface of the Dust Muhammad album (and that of H 2171), the description of the creation of Adam on the page of existence echoes a similar worldview. Moreover, Kalender's references to the "people of the heart," "those with acute perception and sagacious people of insight," and his evocation of the contemplative gaze, all of which I discussed in chapter 3, can also be understood as references to those elite circles who were aware of lettrist or occult practices.[89] His reference to "infelicitous times" and recommendation that the browsing of the album might "console the felicitous person and troubled heart of the mighty sovereign" also lend themselves to such an interpretation.[90] Thus the audience and viewing contexts of the album lend credence to the possibility of an apocalyptic reading of the images in the album, as I am about to suggest.

If the prints were indeed in the album, they would refer to one of the signs of the apocalypse, of course, the return of Jesus. The image of Michael the archangel triumphing over the devil might be read as Jesus's victory over Dajjal. The Mercury and Annunciation scenes would also easily fall under the category of the occult. Turning to the Istanbul folios, it is possible to interpret the genre scenes and the single-figure studies discussed in chapter 5 as closely connected to the sultan's personal interests and preoccupations, while being linked with literary currents found both in the album and outside of it. Similarly, portraits of Ottoman rulers had been an important dynastic project since the reign of Murad III. Yet these types of images also illustrate the signs of the apocalypse in the *Miftāḥ-ı cifrü'l-cāmi*ʿ manuscripts.

While the *Miftāḥ* does not actually relate Ottoman history, both illustrated versions from this period incorporate a collective portrait of the Ottoman house, where the rulers are pictured next to each other under the arches of an architectural frame. In fact in the copy from Ahmed's reign, this scene is spread over two pages, analogous to the full set of Ottoman imperial portraits in the album of Ahmed I, spread over two folios (see fig. 18). By incorporating the dynastic portrait series, the *Miftāḥ*'s visual program emphasizes a cyclical historical perspective, connecting the Ottomans to the Mahdi, and their dynasty with the end times.[91]

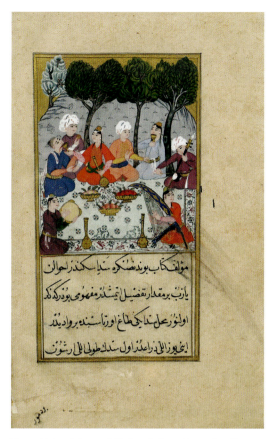

Fig. 47. Tribe of sinners. *Miftāḥ-ı cifrü'l-cāmi'*, translated by
Şerifi. Istanbul, ca. 1600. Topkapı Sarayı Müzesi Kütüphanesi,
Istanbul. B 373, fol. 243b.

Similarities between the *Miftāḥ* and the album do not end with the dynastic series.
Mehmed II as conqueror of Istanbul gets special treatment in the *Miftāḥ*, as the conquest
of the city is supposed to be one of the signs of the apocalypse. Likewise, the *Album of the
World Emperor* includes a full-page portrait of this ruler (see plate 30). The second figure
to receive so much individual attention is Selim I, and we also find him on the pages of
Ahmed's album, singled out with an entire composition of courtiers created around him
(see plate 21). In both works then, the imperial portrait series is enhanced by added por-
traits of select rulers, as befitting their individual contributions to the events that pave
the way to the apocalypse. The serial portraits of Ottoman rulers included in the album
(see plates 13, 63, 64) can also be interpreted in this same vein. Hence the long history of
the house of Osman could also offer clues as to its fate in the future, and Ahmed could
imagine himself as the Mahdi, or his prefiguration.

The many images of young men and women populating the album offer a social
landscape of Istanbul. Since the city was supposed to be the backdrop to many events
announcing the apocalypse, it is possible its inhabitants were pictured as an alternative
way to visualize the city. They might also, perhaps more pointedly, be viewed in the
same category as those images in the *Miftāḥ* that illustrate the sinners of the earth (see
fig. 14).[92] For instance, the *Miftāḥ* image illustrating a sinning tribe (fig. 47) is reminiscent
of the image from the album depicting the janissaries apprehending the couple in the

countryside (see plate 40). The images of inappropriate behaviors, such as the picnics in mixed company, the insane asylum scene, the apprehended lovers, or the drunken revelry certainly seem to point to moral commotion, one of the signs of the end times.

It is important to remember at this juncture that the New York pages contain an unmistakably Ottoman work of art, that is, the calligraphic peacock image (see plate 73). The wording of this calligraphic specimen also helps to link the various European prints together, to the peacock image, and indeed to the rest of the *Album of the World Emperor*. Here the view presented is clearly a cyclical one, where Ahmed (the unnamed Ottoman sultan who is being praised by the calligraphy) is the embodiment of *Shāhnāma* heroes like Dara and Faridun, as well as being the champion of earth and time. Additionally, the reference to the family of Osman accords well with the incorporation of the sultanic portraits, both as a series and additional individual ones, into the rest of the album. Reminders of the day of judgment (and hence the end of the world, the signs of the apocalypse, which include the return of Jesus) might form an oblique reference to the Christological prints, or at least explain their presence. The apocalyptic references of the peacock inscription strengthens my reading of the B 408 images as having such undertones, as well. The other side of the peacock folio contains a Persian painting of a biblical scene, *Yusuf Freed from the Well* (see plate 74), which also brings the history of prophets into the album, as well as Sufi undertones, given the popularity of this subject among the works of Persian and Ottoman poets with Sufi tendencies.

Considered individually or in discrete groupings, the images in the *Album of the World Emperor* appear, if perhaps idiosyncratic, still within the same categories of images one finds in other Ottoman and Persianate albums of the late sixteenth and early seventeenth centuries. In discussing this particular album, one can certainly emphasize the increasing interest in genre scenes, the prevalence of urban types, and the connection with the costume albums prepared for European visitors around this time. One can equally highlight how the album attests to the refined tastes of its owner and its maker, and links them to revered precedents from the Timurid Empire. And while all of these accord with our image of the Ottoman court and the increasingly lively urban context of Istanbul, they do not account for the pious and anxious character of the sultan that we also know from histories of the time and discussed in chapter 1. When put in the company of the Christological images excised from the album, the different groups of urban images, picnic scenes, imperial portraiture, and historical paintings do fall into an understandable relationship with each other, providing a religious and eschatological reading of the images, based on the presence of manuscripts such as *Miftāḥ-ı cifrü'l-cāmi'* and the *Fālnāme* at Ahmed's court. Coupled with Ahmed's pious tendencies and his desire to model himself on the behavior of the Prophet, it is feasible that the album was meant to praise him as the Mahdi, the redeemer, also named after the Prophet Muhammad, and hence in some sense a second coming of the Prophet. This interpretation is also predicated on late-sixteenth-century Ottoman uses of the *Miftāḥ* text, which had come to supplant dynastic histories at the end of the sixteenth century, hence the inclusion of the images of past and Ottoman rulers in the album. The European prints were quite appropriate for use in such an eschatological context. As such, they are incorporated into an existing program of meaning, and their foreign visual characteristics, clearly seductive to the album maker,

might even enhance their powers as images. Given the respect that the prophetic sciences appear to have held for a wide variety of traditions, these images might even have been understood as proof of the veracity of the occult teachings practiced at Ahmed's court.

The *Album of the World Emperor* provides rich documentation of the early-seventeenth-century Ottoman court and urban context. I do not mean to suggest that it is exclusively a collection of images of the signs of the apocalypse. That would be denying the significance of all the poetry that is also included in the album and forcing a single, unidirectional narrative onto the album genre that so clearly resists such monolithic definitions and interpretations. On the contrary, what I am suggesting here with the signs of the apocalypse is simply one way in which to understand some of the images in the album and their thematic interrelation. The fact that even after the removal of the prints, the album continued to be a prized possession, and can still be appreciated as a complex work of art demonstrating the aesthetic and social concerns of the court of Ahmed I also points to the multiplicities of meaning contained by the album. It could continue to function as a different aesthetic whole without the prints.

Its aesthetic qualities are keys to some of the other lessons to be derived from this album that are explored in this book. The multiplicity of styles and the search for fresh models in evidence here brings the album in tune with contemporary literature, architecture, and other creative fields. The juxtaposition of a quest for the new with reverence for the old—evident in the parallels between this album and earlier examples in imperial collections—connects the album to broader early modern trends. The album's structure and contents are also clues to the productive process, reminding us of the notion of genre (was this the moment, perhaps, when a general consensus of "what an album should be" was reached?) and of the comparative gaze that brings to life both the relationships between the individual objects pasted into the album and the connections between the album and its precedents. Certainly the description in the preface of Kalender's curating and artistry, which we as viewers are asked to witness and appreciate on every folio, are suggestive of the importance of process. Albums from the Islamic world are often repositories of the creative endeavors of the workshop that created them. The *Album of the World Emperor* is no exception; it too preserves traces of the productive process. The images—both those still in its pages in Istanbul and those on the New York folios—are equally vestiges of the creative process that produced the *Fālnāme* and the *Miftāḥ-ı cifrü'l-cāmiʿ*. Simultaneously, this album is a site of comparison between different calligraphic and pictorial artistic traditions. Examples from the Ottoman, Persian, and Mughal contexts grace its pages, pointing to the fluidity of the larger Perso-Islamic visual tradition of which the Ottomans were a part. The European prints provide a case of comparison, linear artworks for a tradition that so prized the calligraphic line.[93] Rather than functioning as an obvious competitive framing, however, these diverse artworks add to the claim the album makes for Ahmed I: that he is the "World Emperor." They attest to the vastness of his artistic dominion, as do the images of different types of people.

The prints demonstrate that Ottoman artists could easily turn to foreign works of art to fulfill internal needs—and this was neither the first nor the last time. In this case, the use of religious imagery from Christian contexts to create an Islamic visualization of

the signs of the apocalypse, in an age where these faiths were becoming more and more politicized against each other, is a fascinating example of cross-cultural interaction. The prints were valued for the information they bore, but their function changed entirely in the new context in which they were used.[94] What makes this dependence on the European prints even more interesting is the belief in both contexts that one of their faiths would triumph against the other before the end of time. Christian images here help to demonstrate that the Islamic tradition is superior, because they are contained within the Ottoman structure of the album that makes claims to world rule for Ahmed. In other words, the very use of European images to create the apocalyptic reading in itself points to the superiority of the Ottoman tradition in the eyes of the album makers.

By bringing together works of art from places as diverse as Rome, Paris, Antwerp, Karbala, and Isfahan, this album produced for an Ottoman ruler who had just negotiated a trade treaty with the Dutch States General embodies a number of themes that relate to early modern globalization. The mobility of prints and their central role in cultural exchange between Europe and the Islamic world is perhaps foremost among these. Equally important, however, is the appreciation in early-seventeenth-century Istanbul of the works of art created in these rather different contexts, and the ability of Ottoman album makers to creatively re-purpose and therefore give new meaning to such divergent works of art. The juxtapositions exemplified by the *Album of the World Emperor* point to a potential comparison of different artistic traditions as well as the creation of a hybrid aesthetic at the Ottoman court that benefited greatly from the presence of transcultural, or perhaps, trans-imperial, artists, merchants, and patrons. In turn, the Ottoman context is simply one example of the closely connected cultural geographies of early modern metropolitan centers in western Europe and the Islamic world.

Notes

INTRODUCTION. THE ALBUM OF THE WORLD EMPEROR

1. Kalender, *Muraḳḳaʿ-ı Pādişāh-ı Cihān Sulṭān Aḥmed Ḫān* (*Album of the World Emperor Sultan Ahmed Khan*), fol. 1b. For an overview of the album and a full translation and transcription of its preface, see Bağcı, "Presenting *Vaṣṣāl* Kalender's Works, esp. 263–69; Fetvacı, "The Album of Ahmed I"; and Ünver, "L'album d'Ahmed Ier." The title is translated by Thackston in "Appendix II C: Translation of the Preface to the Ahmed I Album, B 408 (fols. 1b–4b)," in Bağcı, "Presenting *Vaṣṣāl* Kalender's Works," 305.

2. Safavid album prefaces allude to such a relationship between albums and the world, as discussed by Roxburgh, *Prefacing the Image*, 108–9.

3. For a linguistic analysis of sixteenth-century Ottoman poetry and its implications, see Andrews, "Literary Art of the Golden Age," esp. 360. For Safavid examples of albums understood as microcosms, see Roxburgh, *Prefacing the Image*, 108–9.

4. For Roxburgh's field-changing observations, see Roxburgh, *Prefacing the Image*; and Roxburgh, *The Persian Album, 1400–1600*. Bağcı, "Presenting *Vaṣṣāl* Kalender's Works"; and Ünver, "L'album d'Ahmed Ier," do provide brief overall descriptions of the album's contents.

5. Thackston, "Appendix II C," in Bağcı, "Presenting *Vaṣṣāl* Kalender's Works," 305–6.

6. For the development of an Ottoman visual idiom, see Necipoğlu, "A Ḳānūn for the State, a Canon for the Arts"; Necipoğlu, "L'idée de décor dans les régimes de visualité islamiques"; Necipoğlu, "Early Modern Floral"; Necipoğlu, *The Age of Sinan*; and Fetvacı, *Picturing History at the Ottoman Court*.

7. Unfortunately, the area of Ottoman-Mughal political and cultural interaction is vastly understudied. No study has been undertaken of the Mughal materials in the Topkapı collections, which have not been systematically cataloged either. A few works that highlight links are Casale, *The Ottoman Age of Exploration*; and Özbaran, *Ottoman Expansion towards the Indian Ocean in the Sixteenth Century*. Milstein, "From South India to the Ottoman Empire," points to the prevalence of Indians in Baghdadi paintings from the turn of the century. I have also examined Lokman's *Shāhinshāhnāma* of 1601 concerning Mehmed III's Hotin campaign, which must have been given to the Mughal court as a gift, as it contains the seal of a Mughal princess, and is currently in the Khoda Bakhsh Library in Patna (Persian ms. 265).

8. Koch, "The Mughal Emperor as Solomon, Majnun, and Orpheus, or the Album as a Think Tank."

9. For the importance of mobility, see Shalem, "Histories of Belonging and George Kubler's Prime Object"; and Hoffman, "Pathways of Portability." For objects in motion in the early modern world, see Rizvi, "Introduction: Affect, Emotion, and Subjectivity in the Early Modern Period," esp. 12–16; Bleichmar and Martin, "Objects in Motion in the Early Modern World"; and Farago, "On the Peripatetic Life of Objects in the Era of Globalization."

10. Shaw, "The Islam in Islamic Art History," points to the importance of such networks for influencing the form and content of Islamic art, alongside the movement of objects (12). Soucek, "Persian Artists in Mughal India," traces such networks in the context of Mughal and Safavid art.

11. Limiting myself to the early modern period and keeping the focus on the Ottomans, I would like to point to the following works as select (though not comprehensive) examples: Artan, "Objects of Consumption"; Roberts, *Printing a Mediterranean World*; Necipoğlu, "Süleyman the Magnificent and the Representation of Power in the Context of Ottoman-Hapsburg-Papal Rivalry"; Necipoğlu, "Word and Image; Raby, "Opening Gambits"; Raby, "From Europe to Istanbul"; Meyer zur Capellen and Bağcı, "The Age of Magnificence"; Fetvacı, "From Print to Trace"; Carboni, *Venice and the Islamic World, 828–1797*; Campbell and Chong, *Bellini and the East*; Howard, *Venice and the East*; Harper, *The Turk and Islam in the Western Eye 1450–1750*; and Saurma-Jeltsch and Eisenbeiss, *The Power of Things and the Flow of Cultural Transformations*. Outside the field of art history, see Goffman, *The Ottoman Empire and Early Modern Europe*; Aksan and Goffman, *The Early Modern Ottomans*; Faroqhi, *The Ottoman Empire and the World around It*; Kafadar, "The Ottomans and Europe, 1450–1600." See the following essays for further bibliography: O'Connell, "The Italian Renaissance in the Mediterranean, or, Between East and West"; Mikhail and Philliou, "The Ottoman Empire and the Imperial Turn." See also Subrahmanyam, *Explorations in Connected History*; Subrahmanyam, "Connected Histories"; and Subrahmanyam, "A Tale of Three Empires."

12. Farhad and Simpson, "Safavid Arts and Diplomacy in the Age of the Renaissance and Reformation"; Denny, "Carpets, Textiles and Trade in the Early Modern Islamic World"; Tajudeen, "Trade, Politics and Sufi Synthesis in the Formation of Southeast Asian Islamic Architecture"; and Cummins and Feliciano, "Mudejar Americano." See also note 26 for further bibliography on Mughal and Safavid interactions with western European art.

13. For the Ottoman engagements with European art in the fifteenth century, see Necipoğlu, "Persianate Images between Europe and China"; Necipoğlu, "Visual Cosmopolitanism and Creative Translation"; Necipoğlu, "Preface: Sources, Themes, and Cultural Implications of Sinan's Autobiographies," vii–xvi; Raby, "Opening Gambits"; Raby, "1 Portrait of Mehmed II," 80; and Raby, "2 Mehmed Smelling a Rose," 82. The European side of this exchange has become a topic of scholarly interest recently, as demonstrated by such works as Fraser, *Mediterranean Encounters*; and Roberts, *Istanbul Exchanges*; both treat later periods and take as their focus European artists. Kaufmann and North, *Mediating Netherlandish Art and Material Culture*, includes a few articles by specialists of Islamic art; however, the Dutch East India Company still remains at the heart of this book's inquiry.

14. On Ottoman viewers' engagement with the contents of the imperial treasury, see Uluç, "The Perusal of the Topkapı Albums."

15. Necipoğlu, "Word and Image"; and Fetvacı, "From Print to Trace."

16. For the court of Mehmed II, see Kafescioğlu, *Constantinopolis/Istanbul*; and Necipoğlu, "Visual Cosmopolitanism."

17. Hamadeh, *The City's Pleasures.*

18. During the last quarter of the sixteenth century, we already have evidence of a broadening patronage base for illustrated manuscripts, and there is evidence of production in places such as Aleppo and elsewhere in the eastern reaches of the empire, as demonstrated by such projects as Mustafa Âli's first illustrated *Nuṣretnāme* (British Library Add. 22011) and Asafi's *Şecāʿatnāme* (Istanbul University Rare Book Library, T 6043). Manuscript patrons included military figures like Asafi, household servants like the eunuchs, and also other courtiers. They had access to artists working for the imperial studio and others outside of it. For details, see Fetvacı, *Picturing History*, 59–98. The social changes have been explored by Andrews and Kalpaklı, *The Age of Beloveds*; and Kafadar, "How Dark Is the History of the Night, How Black the Story of Coffee, How Bitter the Tale of Love."

19. Fetvacı, "Love in the Album of Ahmed I"; Fetvacı, "Enriched Narratives and Empowered Images in Seventeenth Century Ottoman Manuscripts"; and Değirmenci, "Osmanlı Tasvir Sanatında Görselin 'Okunması'"; Taner, "'Caught in a Whirlwind,'" also examines such changes, esp. 74–113.

20. Fetvacı, "Enriched Narratives."

21. Mahir, "A Group of 17th Century Paintings Used for Picture Recitation." See also Değirmenci, "Sözleri Dinlensin, Tasviri İzlensin"; and Değirmenci, "An Illustrated Mecmua."

22. For developments in Ottoman literature at this time, see Aynur, "Ottoman Literature"; Babacan, *Klasik Türk Şiirinin Son Baharı, Sebk-i Hindi (Hint Üslubu)*; Aynur, Çakır, and Koncu, *Sözde ve Anlamda Farklılaşma*; and Andrews, Black, and Kalpaklı, *Ottoman Lyric Poetry: An Anthology*, 22–23.

23. A lot of recent scholarship has focused on these changes in the political, economic, and social realms. Some examples include Tezcan, *The Second Ottoman Empire*, esp. 10, 227–38; Faroqhi, "Crisis and Change, 1590–1699"; Kafadar, "How Dark"; Kafadar, "Janissaries and Other Riffraff of Ottoman Istanbul"; Piterberg, *An Ottoman Tragedy*; Sariyannis, "Mobs, Scamps, and Rebels in Seventeenth Century Istanbul"; Faroqhi, *Travel and Artisans in the Ottoman Empire.*

24. Tezcan, *The Second Ottoman Empire*, 10, 17, 227–38; Kafadar, "Janissaries and Other Riffraff"; Kunt, *The Sultan's Servants*; Raymond, *The Great Arab Cities in the 16th–18th Centuries.*

25. Andrews and Kalpaklı, *Age of Beloveds*; and Aynur, "Ottoman Literature," write of the city as source of subject matter for poets in this period, but the issue is greater than that, as is captured by Kafadar, "How Dark."

26. Welch, *Artists for the Shah*; Farhad, "Safavid Single Page Painting 1629–1666"; Babaie, *Isfahan and Its Palaces*; Babaie, Babayan, Baghdiaz-McCabe, and Farhad, *Slaves of the Shah*; Koch, *Mughal Art and Imperial Ideology*; Beach, "The Mughal Painter Abu'l Hasan and Some English Sources for His Style"; Bailey, *Art on the Jesuit Missions in Asia and Latin America, 1542–1773*; Bailey, *The Jesuits and the Grand Mogul.*

27. Kafadar, "Sohbete Çelebi, Çelebiye mecmûa . . ."; Little et al., *Alternative Dreams.*

28. Kafadar, "Sohbete Çelebi, Çelebiye mecmûa" See also Buzov, "Osmanlı'da karışık içerikli mecmûalar"; and Değirmenci, "Osmanlı tasvir Sanatında Görselin 'Okunması.'" 29. Roxburgh, "The Aesthetics of Aggregation," considers the connection between albums and anthologies in a much earlier moment in the Perso-Islamic world, during which the earliest known albums were made.

29. Kafadar, "Self and Others"; Fetvacı, "Ottoman Author Portraits in the Early-Modern Period."

30. See, for example, Terzioğlu, "Where ʿilm-i-ḥāl Meets Catechism," esp. 79–82; Şahin, "The Ottoman Empire in the Long Sixteenth Century." Goffman, *The Ottoman Empire*, aims to view the history of the Ottoman empire as an integral part of European history. Aksan and Goffman, *The Early Modern Ottomans*; and Bentley, "Early Modern Europe and the Early Modern World," provide a history of the term and consider its ongoing usefulness. David Porter, *Comparative Early Modernities, 1100–1800*, provides a new analysis.

31. Fletcher, "Integrative History."

32. Bentley, "Early Modern Europe," 19–27.

33. For criticism of the early modern, see Jack A. Goldstone, "The Problem of the 'Early Modern' World"; Fodor, *The Unbearable Weight of Empire*; and Mikhail and Philliou, "The Ottoman Empire and the Imperial Turn."

34. In this way, what I am proposing is a model very different from the "pluritopic model" proposed by Hoffmann, "Pathways of Portability," for the medieval Mediterranean.

35. Le Chevalier, *Voyage de la Propontide et du Pont Euxin*, 298.

36. Le Chevalier, *Voyage de la Propontide et du Pont Euxin*, 298.

37. TSMK ms. no. B 408, folio 1b. Transliterated by Thackston, "Appendix II B: Transliteration of the Preface to the Ahmed I Album, B 408 (fols. 1b–4b)," in Bağcı, "Presenting *Vaṣṣāl Kalender's Works*," 303, as: Muraḳḳaʿ-ı Pādişāh-ı Cihān Sulṭān Aḥmed Ḫān (Ḫallada 'llahu mulkahu wa-abbada salṭanatahu ilā yawmi 'l-ḥaşri wa'l-mīzān. Āmīn.)

38. Rüstem, "The Spectacle of Legitimacy," summarizes how Ahmed is perceived by historians. Farhad with Bağcı, *Falnama: The Book of Omens*, is the only study that examines Ahmed's artistic patronage in the context of his piety.

39. Çıpa, *The Making of Selim*, 214; Fleischer, "Ancient Wisdom and New Sciences"; Fleischer, "The Lawgiver as Messiah"; Fleischer, "Mahdi and Millennium"; Fleischer, "Seer to the Sultan"; Fleischer, "Shadows of Shadows"; Barbara Flemming, "Ṣāḥib-ḳırān und Mahdi"; Şahin, "Constantinople and the End Time."

40. Melvin-Koushki, "Early Modern Islamicate Empire" (quotation on 355); Melvin-Koushki, "Astrology, Lettrism, Geomancy"; Melvin-Koushki and Gardiner, "Islamicate Occultism: New Perspectives"; Moin, *Millennial Sovereign*; and Çıpa, *Making of Selim*. See also Gruber, "Signs of the Hour."

41. Brady, "Confessionalization."

42. Krstić, *Contested Conversions*; and Terzioğlu, "How to Conceptualize Ottoman Sunnitization."

43. Flood, "From Prophet to Postmodernism?"; Shalem, "What Do We Mean When We Say 'Islamic Art'?"; Shaw, "The Islam in Islamic Art History"; and Ahmed, *What Is Islam?*.

44. Wright, "An Introduction to the Albums of Jahangir and Shah Jahan," 41.

45. Roxburgh, *Persian Album*, viii.

46. Roxburgh, *Persian Album*, viii and passim.

47. Botchkareva, "Representational Realism in Cross-Cultural Perspective."

48. Koch, "The Mughal Emperor as Solomon"; Wright, "An Introduction to the Albums of Jahangir and Shah Jahan"; Botchkareva, "Representational Realism"; Rice, "Cosmic Sympathies and Painting at Akbar's Court"; Rice, "Lines of Perception"; and Gonella, Weis, and Rauch, *The Diez Albums*. Four albums from the Topkapı collections have intrigued scholars since the early 1980s, collectively known as the Saray Albums. These include two Timurid albums and two late-fifteenth- / early-sixteenth-century albums associated with Turkman Tabriz, but most recently attributed to the Ottoman context by Necipoğlu, "Persianate Images between Europe and China." The first issue of the journal *Islamic Art* (1981) was dedicated to the contents of these four albums. Earlier scholarship on albums includes work by Milo Cleveland Beach, Stuart Cary Welch, Ernst Grube, and Filiz Çağman. Çağman, "The Earliest Known Ottoman 'Murakka' Kept in Istanbul University Library."

49. Uluç, "The Perusal of the Topkapı Albums," 121–62.

50. The developments in the late sixteenth century are made evident by Mustafa Âli's words in the *Menakıb-ı Hünerveran* (*Epic Deeds of Artists*) about collectors: Akın-Kıvanç, *Mustafa ʿÂli's "Epic Deeds of Artists,"* 92–112. See chapter 3 of the present study for details.

51. Very little scholarship exists on eighteenth-century Ottoman albums, which constitute a significant group in the Topkapı Library collection. See Atbaş, "Topkapı Sarayı Müzesi Kütüphanesi'ndeki H. 2155 numaralı Murakka"; and Atbaş, "Dağılmış bir Safevi Murakkasının."

52. Mahir, "XVI. Yüzyıl Osmanlı Nakkaşhanesinde Murakka Yapımcılığı," 402.

53. Necipoğlu, "Persianate Images between Europe and China."

54. Çağman, "The Earliest Known Ottoman 'Murakka'"; Atıl, *The Age of Sultan Süleyman the Magnificent*, 97–109; and Bağcı, Çağman, Renda, and Tanındı, *Ottoman Painting*, 224–28.

55. Froom, "Adorned like a Rose"; Mahir, "XVI. Yüzyıl Osmanlı nakkaşhanesinde murakka yapımcılığı"; Mahir, "Sultan III. Mehmed İçin Hazırlanmış Bir Albüm"; and Fetvacı, "The Album of Mehmed III."

56. An excellent analysis on the nature of literary gatherings and their role in intellectual and social exchange in the Ottoman Empire, especially in its Arab provinces, is provided by Pfeifer, "Encounter after the Conquest." See also Ali, *Arabic Literary Salons in the Islamic Middle Ages*; Brookshaw, "Palaces, Pavilions and Pleasure-Gardens"; Subtelny, "Scenes from the Literary Life of Tīmūrid Herāt"; and İpekten, *Divan Edebiyatında Edebi Muhitler*.

57. An idea made clear by Roxburgh, *Persian Album*, 310–11.

58. Necipoğlu, "The Suburban Landscape of Sixteenth-Century Istanbul as a Mirror of Classical Ottoman Garden Culture," describes imperial as well as non-royal gardens in early modern Istanbul as informal sites of leisure activities. One such imperial garden was the Üsküdar palace, to which Ahmed I added his own garden pavilion (35–36). This must have been one of the places he enjoyed such gatherings. See also Ertuğ, "Entertaining the Sultan," esp. 133.

59. Artan, "Arts and Architecture," describes the pavilion.

60. Artan, "Ahmed I's Hunting Parties," 98.

61. Artan, "Ahmed I's Hunting Parties," 98; Çuhadar, *Mustafa Sâfî'nin Zübdetü't- tevârîh'i*, fol. 151b.

62. Pfeifer, "Encounter after the Conquest," 229. Mustafa Âli writes in *Tables of Delicacies* that his book "became quite well known at gatherings of all educated people, grandees who are persons of refinement, eloquent persons, and poets" (Brookes, trans., *The Ottoman Gentleman of the Sixteenth Century: Mustafa Âli's* Mevāʾidüʾn-Nefāis fī kavāʾidiʾl-mecālis; *"Tables of Delicacies concerning the Rules of Social Gatherings,"* 4).

63. See Pfeiffer, "Encounter after the Conquest," for the idea of majālis as performance. See also Sternberg, *Status Interaction during the Reign of Louis XIV*, for an analysis of everyday courtly encounters such as the literary gathering and their importance in determining social hierarchies at court.

64. See Farhad, "Safavid Single-Page Painting"; and Babaie, "The Sound of the Image / The Image of the Sound."

CHAPTER ONE. SULTAN AHMED I

1. Translated in Tezcan, *Second Ottoman Empire*, 72–73. The original is in Beyzade, *Hasan Beyzâde Târîhi*, 3:800: "Sen ki Kasım Paşa'sın, babam Allāh emri ile gitti ve ben tahta cülûs eyledüm. Şehri onat gözleyesin. Bir fesâd olursa, senün başını keserüm." See also Börekçi, "Factions and Favorites at the Courts of Sultan Ahmed I (r. 1603–1617) and His Immediate Predecessors," 78.

2. For comparison with other Ottoman accessions, see Vatin and Veinstein, *Le Sérail ébranlé*; and Ertuğ, *XVI. Yüzyıl Osmanlı Devletinde Cülûs ve Cenaze Törenleri*.

3. Vatin and Veinstein, *Le Sérail ébranlé*.

4. Ahmed's emulation of Süleyman was first suggested by Avcıoğlu, "Ahmed I and the Allegories of Tyranny in the Frontispiece of George Sandy's *Relation of a Journey*," esp. 218–20.

5. Mantran, "Aḥmad I"; Faroqhi, "Crisis and Change"; also summarized in Tezcan, *Second Ottoman Empire*, who depends on the classic studies by Kütükoğlu, *Osmanlı-Iran Siyâsî Münâsebetleri (1578–1612)*, and Griswold, *The Great Anatolian Rebellion 1000–1020/1591–1611*. For the Istanbul rebellions, see Kafadar, "Janissaries and Other Rifraff."

6. Mantran, "Aḥmad I."

7. Dressler, "Inventing Orthodoxy"; for the conflict, see also Walsh, "The Historiography of Ottoman-Safavid Relations in the Sixteenth and Seventeenth Centuries."

8. Mantran, "Aḥmad I."

9. Babaie, *Isfahan and Its Palaces*; Babayan, *Mystics, Monarchs and Messiahs*; Welch, *Artists for the Shah*; and Babaie et al., *Slaves of the Shah*.

10. Babaie, *Isfahan and Its Palaces*, 5–7, 95–99.

11. Rizvi, "The Suggestive Portrait of Shah ʿAbbas."

12. El-Rouayheb, *Islamic Intellectual History in the Seventeenth Century*, 27.

13. Griswold, *The Great Anatolian Rebellion*; Cook, *Population Pressure in Rural Anatolia 1450–1600*; Barkan, "Price Revolution in the Sixteenth Century"; and Faroqhi, "Crisis and Change," 433–73.

14. Murphey, "Rhetoric versus Realism in Early Seventeenth-Century Ottoman Historical Writing," 161.

15. With the exception of Mehmed II's first brief reign in 1444–48,

as noted in Börekçi, "Factions and Favorites," 12–13; and Tezcan, "The Question of Regency in Ottoman Dynasty."

16. Börekçi, "Factions and Favorites," 89–91, discusses this air of doom and gloom at the beginning of Ahmed's reign at great length.

17. Börekçi, "Factions and Favorites," 142; and Varlık, *Plague and Empire in the Early Modern Mediterranean World.*

18. These new power dynamics have historically been presented as signs of decline and moving away from an idealized militarized empire. Current scholarship, however, views them as necessary and conscious adjustments and negotiations. Fleischer, *Bureaucrat and Intellectual in the Ottoman Empire;* Tezcan, *The Second Ottoman Empire;* Börekçi, "Factions and Favorites"; and Fetvacı, *Picturing History,* 43–46, 149–88.

19. Börekçi, "Factions and Favorites," 12–13; and Tezcan, "Question of Regency."

20. Börekçi, "Factions and Favorites," 138, 199–234; and Tezcan, *Second Ottoman Empire,* 104. For the career of Hacı Mustafa Agha, see Hathaway, *The Chief Eunuch of the Ottoman Imperial Harem,* 88–97; and Değirmenci, *İktidar Oyunları ve Kitaplar: II. Osman Döneminde değişen güç simgeleri,* 59–83.

21. Börekçi, "Factions and Favorites," 145.

22. Burian, *The Report of Lello,* 64, 65, 71 (Turkish translation, 21, 22, 28).

23. Murphey, "Rhetoric versus Realism."

24. Bosscha Erdbrink, *At the Threshold of Felicity,* 4.

25. Krstić, *Contested Conversions;* Cooper, "The Eastern Churches and the Reformation in the Sixteenth and Seventeenth Centuries"; Frazee, *Catholics and Sultans;* Hering, *Ökumenisches Patriarchat und Europäische Politik, 1620–1638;* and Cafagna, "A Diplomatic Chessboard." I am grateful to Tom Papademetriou for these references.

26. Şahin, "Staging an Empire"; and Necipoğlu, *Architecture, Ceremonial and Power,* 30.

27. Nutku, "17. Yüzyılda Saray Kumaşları."

28. Börekçi, "Factions and Favorites," 240.

29. Nutku, "17. Yüzyılda Saray Kumaşları."

30. Rüstem, "The Spectacle of Legitimacy," 253.

31. Kafadar, "Janissaries and Other Riffraff," examines these rebellions and what they divulge about the urban makeup of Istanbul.

32. Kayaalp, *Sultan Ahmed Divanının Tahlili,* 218 (fol. 12a of Millet Library, Ali Emiri, Manzum no. 53): Edirne şehri gibi gerçi şehr-i bî bedel olmaz / Yine ammâ bu dünyâda Sitânbul'a bedel olmaz / Egerçi ḫûb olur ğâyetde ayvası anuñ ammâ / Sitânbul'uñ şulu şeftâlüsi gibi güzel olmaz."

33. Börekçi, "Factions and Favorites," 208–9.

34. Murphey, "The Historian Mustafa Safi's Version of the Kingly Virtues as Presented in His Extended Preface to Volume One of the *Zübdet'ül Tevarih,* or Annals of Sultan Ahmed, 1012–1023 A.H. /1603–1614 A.D.," 77.

35. Artan, "Ahmed I's Hunting Parties"; and Artan, "A Book of Kings Produced and Presented as a Treatise on Hunting."

36. Yılmaz, *Caliphate Redefined,* 145–80; Imber, "The Ottoman Dynastic Myth"; and Flemming, "The Political Genealogies in the Sixteenth Century."

37. Necipoğlu, *Architecture, Ceremonial and Power,* 133–41; Necipoğlu, "Word and Image"; and Necipoğlu, "Dynastic Imprints on the Cityscape."

38. Fetvacı, "From Print to Trace"; Hagen, "Legitimacy and World Order"; and Kafadar, "The Myth of the Golden Age."

39. Yılmaz, *Caliphate Redefined,* 10–14.

40. Kafadar, "The Myth of the Golden Age."

41. Avcıoğlu, "Ahmed I and the Allegories of Tyranny," 219. The issuing of the new law code is also mentioned by Hammer-Purgstall, *Histoire de l'Empire Ottoman,* 2:359. For a comparison of these two *Kanunname*s, see Akgündüz, *Osmanlı Kanunnameleri ve Hukuki Tahlilleri,* 9:25–27, and 4:455ff. According to Mantran, "Ahmad I," the law code "designed to establish an authoritative code of the administrative and commercial regulations of the empire, hitherto not co-ordinated."

42. Barozzi and Berchet, *Le relazioni degli stati europei tette al Senato dagli ambasciatori Veneti nel secolo decimosettimo,* 1:290; Rycaut, *The Turkish History with Sir Paul Rycaut's Continuation,* 2:837.

43. Murphey, "The Historian Mustafa Safi's Version of the Kingly Virtues."

44. Evliya Çelebi, *Seyahatname,* 2:83–85. Likewise, according to Beyzade, *Hasan Beyzâde Târîhi,* 3:848–50, Sunullah Efendi asked Ahmed to pay money out of the income from Egypt for campaigns, and Ahmed retorted by saying that was his "pocket money." When the mufti replied by saying that is what Süleyman had done, however, Ahmed responded with, "You do not understand what I am saying, that time and this time are different."

45. Çuhadar, *Mustafa Sâfî,* 1:171.

46. Fetvacı, "From Print to Trace," 258–59; and Necipoğlu, "Word and Image," 34–35.

47. Fleischer, "Ancient Wisdom and New Sciences"; Fleischer, "Lawgiver as Messiah"; Fleischer, "Mahdi and Millennium"; Melvin-Koushki, "Early Modern Islamicate Empire"; Moin, *The Millennial Sovereign;* and Çıpa, *The Making of Selim.*

48. Börekçi, "Factions and Favorites," paints such a picture. Rüstem, "The Spectacle of Legitimacy," 253–344, begins with Ahmed's piety; and Avcıoğlu, "Ahmed I and the Allegories of Tyranny," also explores this image. Tezcan, *Second Ottoman Empire,* 70, begins the reevaluation I take up here by stating that Ahmed worked to create a pious image.

49. Murphey, "The Historian Mustafa Safi's Version of the Kingly Virtues," 72–79; and Rüstem, "The Spectacle of Legitimacy," 285, citing the lengthy discussion of Ahmed's piety in Çuhadar, *Mustafa Sâfî,* I:lxx and 24–26.

50. Çuhadar, *Mustafa Sâfî,* 1:46–55.

51. Çuhadar, *Mustafa Sâfî,* 1:37–46.

52. Çuhadar, *Mustafa Sâfî,* 1:109–24, 2:207–9, 217–18; and Crane, ed., *Risâle-i Miʿmâriyye,* 11, 75.

53. As pointed out by Rüstem, "Spectacle of Legitimacy," 285.

54. Çuhadar, *Mustafa Sâfî,* 1:75–81, 127–28, 248–49.

55. Murphey, "The Historian Mustafa Safi's Version of the Kingly Virtues," 76.

56. Terzioglu, "How to Conceptualize Ottoman Sunnitization"; and Tezcan, *Second Ottoman Empire,* 36–43.

57. Necipoğlu, *Age of Sinan,* passim.

58. Fetvacı, *Picturing History,* 164–85, 267–82; Necipoğlu, *Age of Sinan,* 20–70; Şahin, *Empire and Power in the Reign of Süleyman,* 157–213; Tezcan, *The Second Ottoman Empire,* 128–29, 227–38;

Fleischer, "Ancient Wisdom and New Sciences"; Fleischer, "Mahdi and Millennium"; Fleischer, *Bureaucrat and Intellectual*, 253–72; and Çıpa, *Making of Selim*, 210–50.

59. Woodhead, *Taʿlīḳīzāde's Şehnāme-i Hümāyūn*, fols. 5r–10v; and Necipoğlu, *Age of Sinan*, 30–32.

60. Necipoğlu, "Early Modern Floral"; Necipoğlu, *Age of Sinan*, 30–34, 55–56, 455–65; and Şahin, *Empire and Power*, 157–213.

61. Krstić, *Contested Conversions*, 7–16.

62. Çıpa, *Making of Selim*, 238ff. ; Şahin, "Constantinople and the End Time."

63. Fleischer, "Mahdi and Millennium," 42–54; Fleischer, "The Lawgiver as Messiah"; Flemming, "Ṣāḥib-ḳırān und Mahdī"; Necipoğlu, "The Dome of the Rock as Palimpsest"; and Şahin, *Empire and Power*, 187–93.

64. Necipoğlu, "Dome of the Rock as Palimpsest," 57–73.

65. Yılmaz, *Caliphate Redefined*, 181–217.

66. Fetvacı, *Picturing History*, 43, 96. For the *Siyer-i Nebī*, see Zeren Tanındı, *Siyer-i Nebi*. In her discussion of the role of dreams among the Ottoman intelligentsia of the late sixteenth and early seventeenth centuries, Niyazioğlu, *Dreams and Lives in Ottoman Istanbul*, touches upon the significance of the approach of the millennium and the anxiety this seems to have induced.

67. Curry, *The Transformation of Muslim Mystical Thought in the Ottoman Empire*.

68. Terzioğlu, "How to Conceptualize Ottoman Sunnitization," 319. For a history of the Halvetis, see Clayer, *Mystiques, état et société*, 70–90; and Curry, *The Transformation of Muslim Mystical Thought*, esp. 51, 76–77.

69. Arnaldez, "al-Insān al-Kāmil."

70. See Fleischer, "Shadows of Shadows," 57, for Ibn ʿArabi as the patron saint of the Ottomans. For Nevʿi Efendi, see Sefercioğlu, "Nevʿī." For the concept of the "perfect man" as developed by Ibn ʿArabi, see Chodkiewicz, *Seal of the Saints*, 70–73.

71. Yılmaz, *Caliphate Redefined*, 200–217.

72. Fetvacı, *Picturing History*, 173–74, 267–82; Eryılmaz, "The Shehnamecis of Sultan Süleyman"; and Yılmaz, *Caliphate Redefined*, 200–206.

73. Necipoğlu, *Age of Sinan*, 263–64.

74. Gündoğdu, "Padişah-Tarikat Şeyhi Münasebetleri Açısından Azîz Mahmud Hüdâyî ve çağdaşı Abdülmecîd-i Sivâsî"; Kayaalp, *Sultan Ahmed Divaninin tahlili*, 74–79, is only one of the myriad places where these anecdotes are recounted.

75. Evliya Çelebi, *Seyahatname*, 2:83–85; and Yılmazer, *Topçular Kâtibi ʿAbdülkâdir (Kadrî) Efendi Tarihi*, 1:654.

76. Rüstem, "Spectacle of Legitimacy."

77. Arı, "Istanbul'da corps Diplomatique ve Azîz Mahmud Hüdâyî"; and Kemal, "Azîz Mahmud Hüdâyî Hazretleri ve Döneminin Siyasal ortamına Etkisi."

78. Kayaalp, *Sultan Ahmed Divanının Tahlili*, 74–79.

79. Gündoğdu, "Padişah-Tarikat Şeyhi Münasebetleri."

80. Terzioğlu, "Sufi and Dissident in the Ottoman Empire," 251, quoting from Nazmī Mehmed, *Hediyyetü'l-Iḫvan*, SYEK, Hacı Mahmut 2413, ff. 57a–91b.

81. Zilfi, "The Kadizadelis"; and Şeyhī Meḥmed, *Vekayiʿ ül-füzelā*, 3:62–65.

82. Yılmazer, *Topçular Kâtibi ʿAbdülkâdir (Kadrî) Efendi Tarihi*,

1:654; and for the *Maṣnavī* exegesis, see Gündoğdu, "Padişah-Tarikat Şeyhi Münasebetleri," 27.

83. Terzioğlu, "Sufi and Dissident in the Ottoman Empire," 226; and Şeyhī Meḥmed, *Vekayiʿ ül-füzelā*, 3:62–65.

84. Zilfi, "The Kadizadelis;" Zilfi, *The Politics of Piety*; Kafadar, "Janissaries and Other Riffraff," 119–21; and Terzioğlu, "How to Conceptualize," 319.

85. Kafescioğlu, *Constantinopolis/Istanbul*, 45–51, for the legends and shrine of Ayyub al-Ansari. Necipoğlu, "Dynastic Imprints," 23–25.

86. Necipoğlu, "Dynastic Imprints," 25; Hasluck, *Christianity and Islam under the Sultans by the Late F. W. Hasluck*, 2:608; and D'Ohsson, *Oriental Antiquities and General View of the Othoman Customs, Laws, and Ceremonies*, 1:305.

87. Hasluck, *Christianity and Islam*, 2:609, writes that Gerlach describes Murad III going to Eyüb but does not mention girding. Selaniki, *Tarih-i Selaniki*, 1:42–43, describes Selim II visiting the tomb of Ayyub al-Ansari as well as his ancestors' tombs in Istanbul but makes no mention of girding. Sandys, *Sandys Travels*, 29, writes of the mufti. See also Kafadar, "Eyüp'te Kılıç Kuşanma törenleri," 50–62.

88. Necipoğlu, "Dynastic Imprints."

89. Yılmazer, *Topçular Kâtibi ʿAbdülkâdir*, 1:374, describes Ahmed's sword-girding ceremony, as does Çuhadar, *Mustafa Sâfî*, 1:15–16.

90. Kafadar, "Eyüp," 57. See also White, "Fetva Diplomacy."

91. Çuhadar, *Mustafa Sâfî*, 1:15–16 ("bir şemşir-i kudret nişan"); Evliya Çelebi, *Seyahatname*, 1:98; and Hammer-Purgstall, *Des Osmanischen Reichs Staatsverfassung und Staatsverwaltung, dargestellt aus den Quellen seiner Grundgesetze*, 1:484.

92. Hasluck, *Christianity and Islam*, 609–10. Kafadar, "Eyüp," 57–58, reminds us that other swords are mentioned too, at other accessions: the swords of Umar or Uthman, for example, or that of Selim I.

93. Fetvacı, *Picturing History*, 169–71.

94. Kayaalp, *Sultan Ahmed Divanının Tahlili*, 85; and in greater detail, Bağcı, "The Falnama of Ahmed I," 74. Evliya Çelebi, *Seyahatname*, 10:161–63.

95. I am grateful to one of the anonymous reviewers for Princeton University Press who helpfully pointed out that repairs to the Kaʿba were usually handled by administrators from Egypt and that the Sultan Ahmed Mosque had been opened soon after the suppression of a rebellion in Cairo, further enhancing the significance of Qaytbay's appearance. For an analysis of the role of dream narratives in seventeenth-century Istanbul, see Niyazioğlu, *Dreams and Lives in Ottoman Istanbul*. See Çıpa, *Making of Selim*, 217–30, for a discussion of the role of dream interpretation in legitimating Selim I and for an overview of the special authority of dreams in Ottoman political discourse. For the significance of dreams for Murad III, see Felek, *Kitābü'l-Menāmāt*; and Felek, "(Re)creating Image and Identity."

96. Kayaalp, *Sultan Ahmed Divanının Tahlili*, 85; and Çuhadar, *Mustafa Sâfî*, 2:221.

97. Kayaalp, *Sultan Ahmed Divanının Tahlili*, 85–86; and Atasoy, "Hırka-i Saadet," 17:374–77.

98. Atasoy, "Hırka-i Saadet."

99. Thackston "Appendix I C: Translation of the Preface to the Calligraphy Album, H 2171 (fols. 17b–23b)," 294.

100. Rüstem, "The Spectacle of Legitimacy," 270ff. The source is

currently titled "Tarih-i Bina-yı Cami-i Sultan Ahmed-i Evvel" (see 340).

101. Fetvacı, "Music, Light, and Flowers"; and Crane, *Risāle-i Miʿmāriyye*, 49, 73, 74.

102. For a facsimile, transcription, and translation of this preface, see Thackston, "Appendix I B: Transliteration of the Preface to the Calligraphy Album, H 2171 (fols. 17b–23b)"; and Thackston, "Appendix I C," 290–95, esp. 294. Bağcı identifies the author on 321.

103. Fetvacı, "Music, Light, and Flowers."

104. Endowment deed of the Sultan Ahmed Mosque, Topkapı Palace Library EH 3036, fols. 67v–68r, cited in Necipoğlu, *Age of Sinan*, 516; and Rüstem, "Spectacle of Legitimacy," 268.

105. Çuhadar, *Mustafa Sâfî*, 1:104–9.

106. Zilfi, "The Kadizadelis"; Selaniki, *Tarih-i Selaniki*, 2:826.

107. Arbela lay to the southeast of Mosul, in Upper Mesopotamia. Grunebaum, *Muhammedan Festivals*, 72–76. Page 77 also mentions that in Egypt the *Mevlūd* ceremonies would be accompanied by "dhikr-meetings."

108. The *Mevlūd* ceremonies were first celebrated here in the twelfth century according to Knappert, "Mawlid."

109. Shoshan, *Popular Culture in Medieval Cairo*, 17, 68, 69.

110. Necipoğlu, "The Life of an Imperial Monument," esp. 210–19.

111. For deciphering the contents of this page, I am indebted to Shahab Ahmed.

112. Roxburgh, "'The Eye Is Favored for Seeing the Writing's Form,'" esp. 279–80. Roxburgh discusses the notion of a "trace" and the idea that "writing recorded, by way of a footprint-like impression, the moral make-up of the calligrapher."

113. Roxburgh, *Persian Album*, 74. Akın-Kıvanç, *Mustafa ʿÂli's "Epic Deeds of Artists,"* 124, describes how Âli emphasizes the moral qualities of the artists he writes about.

114. Bağcı, "Presenting *Vaṣṣāl* Kalender's Works," 264.

115. Murphey, *Exploring Ottoman Sovereignty*, 77–97, carefully points to how the title "sultan" was used only sporadically before 1453.

116. For Ottoman sultanic titulature, see Murphey, *Exploring Ottoman Sovereignty*, 77–97. The title "imam" does feature in descriptions of Süleyman by Ebussuud, for which see Çıpa, *Making of Selim*, 234. See also Imber, "Süleymân as Caliph of the Muslims." But Imber, in "Ideals and Legitimation in Early Ottoman History," writes that Ebussuud did not formulate a definitive theory of the Ottoman caliphate and argues that the idea of the caliphate did not survive Ebussuud. See also Karateke, "Legitimizing the Ottoman Sultanate." I owe these references and this discussion of the caliphate to Çıpa, *Making of Selim*, 233–38.

117. Babaie, *Isfahan and Its Palaces*, 95–99.

118. Yılmaz, *Caliphate Redefined*, 196–99.

119. Howard, "Genre and Myth in the Ottoman Advice for Kings Literature"; Howard, "Ottoman Historiography and the Literature of 'Decline' of the Sixteenth and Seventeenth Centuries"; and Kafadar, "The Myth of the Golden Age," 37–48.

120. For an overview of translation from Persian to Ottoman and the consideration of some of the issues this raises, see Hagen, "Translations and Translators in a Multilingual Society."

121. Fleischer, *Bureaucrat and Intellectual*, 71, 141, 186. For the earlier (sixteenth-century) manifestation of this, see Fetvacı, *Picturing History*, 27–28, 49–55, 251. The *Dīvān* of Sultan Husayn

(TSMK EH 1636) and the many illustrated *Dīvāns* of Nevai from the sixteenth century housed in the Topkapı are cases in point.

122. For an illustrated version of the original, see Lamm and Zetterstéen, *The Story of Jamāl and Jalāl*.

123. Börekçi, "Factions and Favorites," 102–4, summarizes the events related in *Tercüme-i Celāl ü Cemāl*, TSMK, H. 1304, fols. 160a–160b; SYEK, Hamidiye 1068, fols. 2b–3b and 225a–b; and Çuhadar, *Mustafa Sâfî*, 2:114.

124. Kavruk, *Eski Türk edebiyatinda mensûr hikâyeler*, 29, also tells us that *Ḳaṣāṣ-ı Celāl u Cemāl* was translated by Safi for Ahmed I. Its surviving manuscripts are in the Süleymaniye Library Catalog, Izmir KTB 1583 (dated Istanbul AH 1065), and TSMK, Revan 1304/2.

125. Börekçi, "Factions and Favorites," 105n65. See also Hüseyin Altınpay, "Hocazâde Abdülaziz Efendi Ahlâk-ı Muhsini Tercümesi." Altınpay gives the date, on 74, as Rejeb 1021 (August–September 1612). He also notes (79) that between 1550 and 1575, four other translations of this work into Ottoman Turkish had been done.

126. Subtelny, "A Late Medieval Persian Summa on Ethics," esp. 612n63 for a list of libraries. (I am grateful to Mika Natif for this reference.) One copy in Istanbul, dated to the reign of Süleyman, was meant to have illustrations in it (Hacı Selim Aga, no. 745, dated AH 944/1537–38 CE). Golombek, "Early Illustrated Manuscripts of Kashifi's Akhlāq-i Muḥsinī," 615n1.

127. Analyzed in Howard, "Genre and Myth."

128. Kayaalp, *Sultan Ahmed Divanının Tahlili*, 96. Börekçi, "Factions and Favorites," 106n67, provides the manuscript number: İÜK, T. 3537.

129. Gündoğdu, "Sivasi, Abdülmecid," TDVIA, no. 255.

130. TSMK, Bağdat 348; and Tezcan, *Second Ottoman Empire*, 127. For the notion of "enjoining good and forbidding evil," see Cook, *Commanding Right and Forbidding Wrong in Islamic Thought*.

131. I am extremely grateful to Maurits van den Boogert for sharing this information with me. He discussed this manuscript, Leiden Cod. Or. 1286(1), in June 2016 at the "Ottomans and Entertainment" conference, University of Cambridge. See Schmidt and Rijksuniversiteit te Leiden, *Catalogue of Turkish Manuscripts in the Library of Leiden University and Other Collections in the Netherlands*, 1:582–86.

132. Karatay, *Topkapı Sarayı Müzesi Kütüphanesi Türkçe yazmalar kataloğu*, 1:193. See also Elçin, "Kitâbî, Mensur Realist Istanbul Hikâyeleri."

133. Değirmenci, *Iktidar Oyunları*, 102–10.

134. Değirmenci, *Iktidar Oyunları*, 103, 107.

135. Değirmenci, *Iktidar Oyunları*, 25, 89.

136. For an illustrated version of Cenani's tales, *Cevāhirü'l-ġarāʿib ve Tercemetü'l-baḥrü'l-acāʿib*, see Bağcı et al., *Osmanlı Resim Sanatı*, 187, fig. 151.

137. Değirmenci, *Iktidar Oyunları*, 148.

138. Roxburgh, "Baysunghur's Library."

139. Çuhadar, *Mustafa Sâfî*, 1:8: "Bahtî'nin maʿnâsı seʿâdet-i tâli' u baht ve mübârekî-i serîr-i saltanat u tahta delâlet itdüği gibi lafz u 'ibâreti târîh-i cülûs-ı hümâyûn-ı seʿâdet-makrûnları vâkı' olmışdur."

140. Danişmend, *İzahlı Osmanlı Tarihi Kronolojisi*, 3:230; and Börekçi, "Factions and Favorites," 97–98n46.

141. Translation from Börekçi, "Factions and Favorites," 98; original in Kayaalp, *Sultan Ahmed Divanının Tahlili*, 199: "Çü ben

Bahtî'ye virdün hâtırumda yoğ-iken devlet / Sana ısmarladum yâ Rab umûrum cümle ahvâlüm." *Devlet* means "sovereignty" here, but it also has a secondary meaning of "good fortune," and the poem evokes both readings.

142. Kayaalp, *Sultan Ahmed Divanının Tahlili*, 203–4 (*Dīvān*, fols. 3b–4a).

143. Kayaalp, *Sultan Ahmed Divanının Tahlili*, 199–200 (*Dīvān*, fols. 1b–2a); 212 (*Dīvān*, fol. 8b).

144. Kayaalp, *Sultan Ahmed Divanının Tahlili*, 209–12 (*Dīvān*, fols. 6b–8a).

145. Kayaalp, *Sultan Ahmed Divanının Tahlili*, 207 (*Dīvān*, fol. 5b).

146. Kayaalp, *Sultan Ahmed Divanının Tahlili*, 207 (*Dīvān*, fol. 6a): "Baḫtiyâ bendesi ol Ḥażret-i Mevlânâ'nuñ/Taḫt-ı ma'nîde odur pâdişehi devrânuñ."

147. Tanman, "Hacet Penceresi," *TDVIA*.

148. Kayaalp, *Sultan Ahmed Divanının Tahlili*, 219 (*Dīvān* fol. 12b); 219–20 (*Dīvān*, fol. 13a).

149. The *tahmis* is on fols. 14b–15a of the *Dīvān* (Kayaalp, *Sultan Ahmed Divanının Tahlili*, 223).

150. Babacan, *Klasik Türk Şiirinin Son Baharı*, 106–7.

151. Açıkgöz, "Riyâzî," *TDVIA*.

152. Çuhadar, *Mustafa Sâfî*, 1:51–52.

153. B 408 folio 6a (see plate 11). Araf 173–77, from *The Qur'an: English Meanings*:

Or [lest] you say, "It was only that our fathers associated [others in worship] with Allah before, and we were but descendants after them. Then would You destroy us for what the falsifiers have done?"
And thus do We [explain in] detail the verses, and perhaps they will return.
And recite to them, [O Muhammad], the news of him to whom we gave [knowledge of] Our signs, but he detached himself from them; so Satan pursued him, and he became of the deviators.
And if We had willed, we could have elevated him thereby, but he adhered [instead] to the earth and followed his own desire. So his example is like that of the dog: if you chase him, he pants, or if you leave him, he [still] pants. That is the example of the people who denied Our signs. So relate the stories that perhaps they will give thought.
How evil an example [is that of] the people who denied Our signs and used to wrong themselves.

154. Baqara 1–5, from *The Qur'an: English Meanings*:

ALM
This is the Book about which there is no doubt, a guidance for those conscious of Allah—
Who believe in the unseen, establish prayer, and spend out of what We have provided for them,
And who believe in what has been revealed to you, [O Muhammad], and what was revealed before you, and of the Hereafter they are certain [in faith].
Those are upon [right] guidance from their Lord, and it is those who are the successful.

CHAPTER TWO. SULTAN AHMED'S ARTISTIC PATRONAGE

1. Fetvacı, "Music, Light, and Flowers," 222. It is tempting to recite again the damning words of Goodwin, *A History of Ottoman Architecture*, 342–46, esp. 344: "The mosque is a marriage of other men's ideas in most but not all particulars, and where it is not inspired by previous masterpieces it is often ungainly or monotonous since the dominant ideas were size and splendor."

2. Necipoğlu, *Age of Sinan*, 514–18; and Rüstem, "Spectacle of Legitimacy" detail the story of the building of the Sultan Ahmed Mosque and touch on many of the same points that I make here. Avcıoğlu, "Ahmed I and the Allegories of Tyranny," was the first to consider the competition between Ahmed, Safiye, and Süleyman's mosques.

3. Avcıoğlu, "Ahmed I and the Allegories of Tyranny," 219–20; Necioğlu, *Age of Sinan*, 515; and Rüstem, "Spectacle of Legitimacy," 253–56.

4. Gelibolulu Mustafa Âli, *Mustafa Âli's Counsel for the Sultans of 1581*, 54, 146: "As long as the glorious sultans, the Alexander-like kings, have not enriched themselves with the spoils of the Holy War and have not become owners of lands through gains of campaigns of the Faith, it is not appropriate that they undertake to build soup kitchens for the poor and hospitals or to repair libraries and higher medreses or, in general, to construct establishments of charity, and it is seriously not right to spend and waste the means of the public treasury on unnecessary projects. For, the Divine Laws do not permit the building of charitable establishments with the means of the public treasury, neither do they allow the foundation of mosques and medreses that are not needed." Also cited in Necipoğlu, "The Süleymaniye Complex in Istanbul"; and Rüstem, "Spectacle of Legitimacy."

5. Grelot, *A Late Voyage to Constantinople*, 212.

6. Çuhadar, *Mustafa Sâfî*, 1:47–55.

7. Crane, *Risâle-i Mīmāriyye*, 67.

8. Necipoğlu, *Age of Sinan*, passim.

9. The relationship between the Valide Sultan Mosque and the Sultan Ahmed Mosque was first explored by Thys-Şenocak, "The Yeni Valide Complex at Eminönü."

10. The Venetian *bailo* Simone Contarini states that Ahmed had his mosque built partially to show his "disdain" for the "queen mother" and that he had "denied the one she had begun on the sea that to this day remains incomplete." Simone Contarini, "Relazione del N. U. Simon Contarini Cav. Ritornato Bailo di Constantinopoli, l'anno 1612," 181.

11. Mantran, "Ahmad I"; Tezcan, *The Second Ottoman Empire*, 70; and Hammer-Purgstall, *Histoire de l'Empire Ottoman*, 2:313. Lello also confirms this (Burian, *Report of Lello*, 19, 62), but says it was due to Ali Pasha's influence. Thys-Şenocak, "The Yeni Valide Complex in Eminönü, Istanbul (1597–1665)," 29.

12. Thys-Şenocak, "The Yeni Valide Mosque Complex," 18, 40–47; Goodwin, *History of Ottoman Architecture*, 340–42.

13. Yılmazer, *Topçular Kâtibi 'Abdülkâdir*, 1:561: "Lâkin tekrâr At Meydânı cânibleri şenlikli vâsi' yerler olmağın . . ."

14. Necipoğlu, *Age of Sinan*, 514–16; and Rüstem, "Spectacle of Legitimacy," 255, also point out Ahmed's attention to the legal purchase of the land. As is noted by Thys-Şenocak, the *Esasiyye Kaside* of the *Risale-i Mimariyye*, in the chapter describing the construction of the Sultan Ahmed complex pits Ahmed's act of patronage against Safiye's in an effort to praise his justice and piety. Crane, *Risale-i Mimariyye*, 66.

15. Necipoğlu, "The Life of an Imperial Monument," 210–12.

16. Necipoğlu, "Challenging the Past," 172–77.

17. Khoury, "Between Two Mosques"; and Khoury, *Ideologies and Inscriptions*.

18. Cantemir, *Osmanlı İmparatorluğu Tarihi*, 3:148, 322. Cited in Necipoğlu, "Challenging the Past," 180n43.

19. Necipoğlu, "Dome of the Rock as Palimpsest"; and Oleg Grabar, *The Shape of the Holy*, 52–54.

20. Also noticed by Avcıoğlu, "Ahmed I and the Allegories of Tyranny," 219–21.

21. For his career, see Crane, *Risale-i Mimariyye*.

22. Necipoğlu, "Challenging the Past," esp. 173.

23. Necipoğlu, "The Süleymaniye Complex in Istanbul," 107–11. The foundation inscription of the Sultan Ahmed Mosque was read by Nuha N. Khoury and discussed in a lecture ("Between Two Mosques") where she considered the relationship between the inscriptions on Shah ʿAbbas's mosque in Isfahan and the Sultan Ahmed Mosque. See also Khoury, *Ideologies and Inscriptions*.

24. Erzen, *Mimar Sinan Dönemi Cami Cepheleri*, 15, 51–61.

25. Evliya Çelebi, *Seyahatname*, 1:87; and Naima, *Tarih-i Naima*, 2:156, both praise the Sultan Ahmed as unequalled in its elegance. Naima writes: "Bir câmiʿi zîbâ binâ buyurmuşlardur ki levh-i zeminde misli mersūm olunmamışdur." The choice of the word *zîbâ*, meaning "elegant, ornamented" points to the notion that the ornamentation was considered an element of its beauty and a quality to be praised. The "baroque" nature of the Sultan Ahmed and its appreciation by contemporaries is also mentioned in Necipoğlu, "Challenging the Past."

26. This is obvious from the long search for the perfect location related by Safi in Çuhadar, *Mustafa Sâfî*, 1:47–55; and the Esâsiyye and Bahâriyye Kasides in the *Risâle-i Mîmâriyye*, which also emphasizes the decoration and the location.

27. For analyses of the multisensory aspects of Ottoman mosques, see Ergin, "The Fragrance of the Divine"; and Ergin, "The Soundscape of Sixteenth-Century Istanbul Mosques."

28. Crane, *Risâle-i Mîmâriyye*, 74, 67.

29. Tezcan, *Second Ottoman Empire*, 28, 120, based on Pietro della Valle and Gontaut-Biron, argues that later in his reign, Ahmed "became preoccupied with courtly pleasures and played an important role in the move of the dynasty to residences at the Bosporus, which led to further residential developments alongside the Bosporus and brought the Asian and European sides of this waterway closer to each other."

30. Artan, "Arts and Architecture," 454; and Çığ et al., *The Topkapı Palace Museum, Architecture*, 34.

31. The *Vaḳāʿi-i ʿAlī Pâşâ* was described in the mistake-laden Seçkin, "17. Yüzyılın Önemli Minyatürlü Yazması: Vekayi-i ʿAli Paşa"; as well as a facsimile and commentary by Soner Demirsoy that slightly amends the page order to reflect the ordering that Demirsoy believes to be correct (Demirsoy, *Kelâmî-i rûmî Vekayiʿ-i Ali Paşa*). Both manuscripts are discussed in Bağcı et al., *Osmanlı Resim Sanatı*, 209, 212–13. Değirmenci, *İktidar Oyunları*, 153–71, also analyzes the *Dîvân*, and I have done so both in "Enriched Narratives" and in *Picturing History*, 249–58.

32. Tanındı, "Portraits of Ottoman Courtiers in the Dîwâns of Bâkî and Nâdirî," dates this copy to the reign of Ahmed I because of the images in it. Later copies of the *Dîvân* include poems praising

Osman II as well, suggesting that it was extended later on. Değirmenci, *İktidar Oyunları*, 152.

33. Fetvacı, "Enriched Narratives," describes other such examples, 252–54. See also Tanındı, "Portraits of Ottoman Courtiers," for an analysis of the image.

34. Tanındı, "Portraits of Ottoman Courtiers."

35. Shortle, "Illustrated *Divans* of Hafiz."

36. Değirmenci, *İktidar Oyunları*, 147–48.

37. Kayaalp, *Sultan Ahmed Divanının Tahlili*, 47. The manuscript is in the Süleymaniye Library, ms no. Fatih 564.

38. Fetvacı, "Enriched Narratives,"; and Demirsoy, *Vekayi-i Ali Paşa*, xviii–xxiv.

39. Similarly, the *Şehname* of Mehmed III (TSMK H 1609) also has paintings produced separately from the text, as mentioned in Bağcı et al., *Osmanlı Resim Sanatı*, 180.

40. Fetvacı, "Enriched Narratives," 248–52.

41. Fetvacı, "Enriched Narratives," 248–49.

42. Değirmenci, *İktidar Oyunları*, 245.

43. Artan, "A Book of Kings."

44. Artan, "Book of Kings," 302–3.

45. Artan, "Book of Kings," 306–7, describes this part of the book under the title "A Counsel for Princes," but she also shows that other sections of the book are full of advice for a ruler and that hunting is used as a metaphor for statecraft.

46. Artan, "Book of Kings," 310.

47. Artan, "Book of Kings," 314: ". . . while it is normal for luxury, pleasure, and even various kinds of lust to be commonly associated with royal hunting parties, there is much more to hunting than these self-indulgent aspects."

48. Murphey, "The Historian Mustafa Safi's Version of the Kingly Virtues," 74.

49. Murphey, "The Historian Mustafa Safi's Version of the Kingly Virtues," 80–85. Safi's concern is to show that Ahmed is already fit to rule, of course, so the discussion of the hunt serves him as demonstration of the sultan's skills.

50. Artan, "Book of Kings," 321. She also argues for a Mevlevi association for the artists of the manuscript. For the Turkish *Shāhnāmas*, see Serpil Bağcı, "From Translated Word to Translated Image."

51. All this information comes from Bağcı et al., *Osmanlı Resim Sanatı*, 209–10nn3, 4. The copy with portraits only is IUL T 5970 (Kangal, *Sultan's Portrait*, 302–3). The copy with narrative illustrations is in the Musée Jacquemart-André, Paris, ms. no. D. 262. For the Jacquemart-André manuscript, see Halbout du Tanney, "Un chef-d'oeuvre de la peinture Ottomane La Couronne des Chroniques au musée Jacquemart-André."

52. Bağcı et al., *Osmanlı Resim Sanatı*, 210n6 lists fols. 6b, 7b, 8a, 28b.

53. Bağcı et al., *Osmanlı Resim Sanatı*, 210n5, also note an illustrated copy of Sadeddin's *Selimname* dated to the early seventeenth century. Paris BNF, Suppl Turc 524.

54. Börekçi, "Factions and Favorites," 225.

55. Tezcan, *Second Ottoman Empire*, 71.

56. Sadeddin, *Tâcü't-tevârîḫ*, fols. 1b–3a.

57. The illustrated *Miftāḥ-ı cifrü'l-câmiʿ* manuscripts are thoroughly described by Yaman, "Osmanlı Resim Sanatında

Kıyamet Alametleri." The manuscript is also considered by Bağcı et al., *Osmanlı Resim Sanatı*, 194–98; Fleischer, "Ancient Wisdom and New Sciences," 231–43; and Fetvacı, *Picturing History*, 245–49. For apocalyptical images in Shi'i Islam (including in works of Kashifi, which were popular at the Timurid and the Ottoman courts), see Amanat, *Apocalyptic Islam and Iranian Shi'ism*. Bistami was "a noted Arabic stylist and authority on exegesis and Prophetic Tradition, . . . a Hanafi by legal rite, a member of the Syrian Bistamiyyah Sufi order, and an important cultivator and disseminator of 'the science of letters and divine names' (*ilm al-huruf wa'l-asma*)" (Fleischer, "Ancient Wisdom and New Sciences," 232).

58. Fleischer, "Ancient Wisdom and New Sciences," 232.

59. Bağcı, "Beast of the Earth," 203.

60. Fleischer, "The Lawgiver as Messiah."

61. Fleischer, "Ancient Wisdom and New Sciences," 232, 235. For an exploration of the occult, astrology, and prophecy at late medieval and early modern Persianate courts, see Melvin-Koushki, "Astrology, Lettrism, Geomancy"; and Melvin-Koushki and Gardiner, *Islamicate Occultism*. Moin, *Millennial Sovereign*, considers this topic for the Mughal context.

62. TSMK ms. no. B 373. Fleischer, "Mahdi and Millennium," 54n47.

63. IÜK ms. no. T 6624. Earlier manifestations include Sultan Süleyman's court "seer," Haydar; the creation of an image of Süleyman as the Mahdi by the use of Bistami's text; and also Süleyman's renovations to the Dome of the Rock. The first two are discussed by Fleischer, "Ancient Wisdom and New Sciences"; Fleischer, "Lawgiver as Messiah,"; and Fleischer, "Seer to the Sultan;" and the last by Necipoğlu, "The Dome of the Rock as Palimpsest."

64. Fleischer, "Ancient Wisdom and New Sciences," 231–43.

65. Fleischer, "Secretaries' Dreams," esp. 79.

66. El-Rouayheb, *Islamic Intellectual History in the Seventeenth Century*, 14–26.

67. Felek, *Kitābü'l-Menāmāt*; and Felek, "(Re)creating Image and Identity," 263.

68. Bibliothèque nationale de France, Paris, Ms. Supplement turc 242; Pierpont Morgan Library M. 788; and the Süleymaniye Library 1060. See Barbara Schmitz, *Islamic and Indian Manuscripts and Paintings in The Pierpont Morgan Library*, 71–84, esp. 71, where Schmitz suggests the book may have belonged to Ahmed I's daughter Ayşe Sultan as well as Murad's daughter Ayşe Sultan; Suudi Mehmed Efendi, *The Book of Felicity*; Farhad with Bağcı, *Falnama*, 217; and Bağcı et al., *Osmanlı Resim Sanatı*, 190–92.

69. Fetvacı, "From Print to Trace."

70. Fetvacı, *Picturing History*, 164–75.

71. Bağcı, "The Falnama of Ahmed I (TSM H. 1703)," esp. 73.

72. Bağcı "The Falnama of Ahmed I" brings them up on 74–75, and gives specifics in n. 37. One copy is in Istanbul (Suleymaniye Library, Hafid Efendi 139). See Yıldız, *Orta Osmanlıca Dönemine Ait bir Dil Yadigârı, Ahvâl-i Kıyâmet*. Another copy is in Berlin (Preuss-sischen Staatsbibliotek, MS. Or. Oct. 1596); see Stchoukine, Flemming, et al., *Illuminierte Islamische Handschriften*, 229–37, no. 85, plates 12, 53–54. Bağcı also lists some detached folios and postulates they may have been for a royal copy prepared for Mehmed III or Ahmed I. Bağcı et al., *Osmanlı Resim Sanatı*, 197–98,

write that the Süleymaniye and Berlin copies are by the same artist as Ahmed's *Miftāḥ* and point to a serial mode of production.

73. Bağcı and Farhad, *Falnama*, 214, cat. no. 66.

74. Fleischer "Lawgiver as Messiah."

75. See Fetvacı, *Picturing History*, 245–49, for a discussion of the image of Mehmed III as Mahdi.

76. Fleischer, "Ancient Wisdom and New Sciences," 243.

77. Yaman, "Osmanlı Resim Sanatında Kıyamet Alametleri," 19–52.

78. IÜK T 6624, fol. 163a, also noted in Yaman, "Osmanlı Resim Sanatında Kıyamet Alametleri," 103, my translation.

79. Çuhadar, *Mustafa Sâfî*, 1:171.

80. Bağcı, "Presenting *Vaṣṣāl* Kalender's Works"; and Bağcı, "The Falnama of Ahmed I." Farhad with Bağcı, *Falnama*, point out that three other surviving examples, mostly of smaller size, also date to around this time. Their study of this manuscript is exemplary and has guided my interpretations.

81. Bağcı and Farhad, "The Art of Bibliomancy." Bağcı, "The Falnama of Ahmed I," 68, dates the manuscript based on Kalender's referring to himself in the preface as pasha, a title he received in 1614. He died in 1616.

82. TSMK ms. A5; Farhad with Bağcı, *Falnama*, 90, cat. no. 9. They point to another example by Şeyh Hamdullah, TSMK ms. no. EH 71.

83. Bağcı and Farhad, "Art of Bibliomancy," 22. A sixteenth-century illustrated copy is in the British Library (Or. 1114); see Titley, *Miniatures from Turkish Manuscripts*, 47, no. 37. Hüseyin, *Rāznāme*.

84. Farhad with Bağcı, *Falnama*, 178, cat. no. 50. Other calendars with astrological functions were prepared for Mehmed II and other rulers. See Fleischer, "Ancient Wisdom and New Sciences," 235; Fleischer, "Seer to the Sultan"; and Fleischer, "Shadows of Shadows."

85. Evliya Çelebi, *Seyahatname*, 1:330–32.

86. The image-text relationship is discussed in Farhad and Bağcı, "The Falnama in the Sixteenth and Seventeenth Centuries," esp. 30, and the phrase *fal didan* (seeing the augury) used in the Dresden *Falnama* is provided as evidence of the importance of the visual, suggesting that seeing the *fāl* is as important as reading it.

87. For a full list of topics, see Farhad with Bağcı, *Falnama*.

88. Bağcı, "Falnama of Ahmed I," 72.

89. All these connections are made in Farhad with Bağcı, *Falnama*, 204, 207, 210.

90. Bağcı, "Falnama of Ahmed I," 70, also points this out.

91. H 2153, fols. 123b and 150a, and H 2154, fol. 34a contain the three copies of the Chinese grooms. Ahmed's notation is on folio 87b of TSMK H 2153. See Çağman, "On the Contents of the Four Istanbul Albums H 2152, 2153, 2154 and 2160." Çağman does not give the date for this inscription, but it is easily legible on the folio.

92. Anecdote recounted in Çuhadar, *Mustafa Sâfî*, 1:36, but also in Bağcı, "The Falnama of Ahmed I," 75.

93. For further details, see Fetvacı, "Enriched Narratives," 246; and Artan, "Arts and Architecture," 411–12.

94. Bağcı, "Beast of the Earth," 203.

CHAPTER THREE. KALENDER AND THE ALBUM

An earlier version of chapter 3 appeared, in much different form, as "The Gaze in the Album of Ahmed I," *Muqarnas: An Annual on Islamic Art and Architecture* 32 (2015): 135–54.

1. Serpil Bağcı has published on Kalender's life in two different occasions: Bağcı, "The Falnama of Ahmed I," and "Presenting *Vaṣṣāl* Kalender's Works." See also Artan, "Arts and Architecture."

2. Yılmazer, *Topçular Kâtibi ʿAbdülkādir (Kadrî) Efendi Tarihi*, 1:593, 609, also 546, 551, 557, 561, 562, 593, 604, 609, 611n, 629, 647.

3. Bağcı, "Presenting *Vaṣṣāl* Kalender's Works," 256; and Yılmazer, *Topçular Kâtibi ʿAbdülkādir*, 1:647.

4. Çuhadar, *Mustafa Sâfî*, 1:54.

5. Translation by Yorgos Dedes, in Bağcı, "The Falnama of Ahmed I," 68. The original is in Âli, *Menāḳıb-ı hünerverān*, 76–77; and Akın-Kıvanç, *Mustafa ʿÂli's "Epic Deeds of Artists,"* 422n18.

6. Also mentioned by Bağcı, "Presenting *Vaṣṣāl* Kalender's Works," 267.

7. Thackston, "Appendix II C, Translation of the Preface," 306.

8. Thackston, "Appendix II C, Translation of the Preface" 306.

9. Fetvacı, "Enriched Narratives." The same was true of Safavid courtiers, and it built on Timurid-era practices.

10. Kalender, *Album of the World Emperor Sultan Ahmed Khan*, TSMK, B 408, fol. 2b, as transliterated and translated by Thackston in "Appendix II B and II C," 303 and 305–6: ". . . dāyimā cevāhir-i ʿirfān-ı ʿavārif ü leʾālī ü maʿānī vü maʿārif birle ḳalb-i laṭīfleri memlū olmağıla ol dürer-i ġurer-i ṣanāyiʿ ü bedāyiʿi sarāy-ı bī-ʿayb u serāperde-i lāreybde olan enfüs-i nefāyis-i maḳālāt ve aḥsen-i maḥāsin-i muṣavverāt benāt-ı nükāta ḥilye-i ḥulel-i elfāẓ u ebṣārla zīver ü zīb verüp zīnet-i dilfirīb ile ḳulūb-ı cihānbānı firīfte ve ṭabʿ-ı ehl-i dilānı alüfte vü āşüfte itmişlerdür."

11. These are my translations of these three specific terms, which Thackston has chosen to convey contextually and not individually. He writes "mussed" for what I am translating as "astonished and excited."

12. Kalender, *Album of the World Emperor*, TSMK, B 408, fol. 2b (Thackston, "Appendix II B" [transcription] and "Appendix II C" [translation], in Bağcı, "Presenting *Vaṣṣāl* Kalender's Works," 303 [transcription] and 305 [translation]): ". . . taḥṣīl-i sermāye-i ʿilm-i ḥikmet ve sebeb-i tekmīl pīrāye-i ʿayn-ı ʿibret olduğundan māʿadā ol zāt-ı ferhunde-sumāt-ı pādişāh-ı ʿālī-derecāta mūcib-i tenşīṭ-i ḫāṭır-ı ḫaṭīr u müstevcib-i taṭyīb-i żamīr-i münīr ve ḳalb-i müstenīr olmaḳ."

13. Necipoğlu, "The Scrutinizing Gaze in the Aesthetics of Islamic Visual Cultures." The "scrutinizing gaze" was first discussed in Necipoğlu, *The Topkapı Scroll*, esp. 204–6. See also Necipoğlu, "L'idée de décor," 10–23.

14. Necipoğlu, *Topkapı Scroll*, 204; Robinson, *In Praise of Song*; Grabar, *The Alhambra*; Dickie, "The Alhambra: Some Reflections Prompted by a Recent Study by Oleg Grabar."

15. Shalem, "The Idol (Sanam) or the Man without a Soul," esp. 64–65.

16. Kalender, *Album of the World Emperor*, TSMK, B 408, fols. 3a–3b (Thackston, "Appendix II B" [transcription] and "Appendix II C" [translation], in Bağcı, "Presenting *Vaṣṣāl* Kalender's Works," 304): ". . . her birisinin biri birisine münāsebeti ile tertīb olunup . . ." and ". . . muḳaṭṭaʿāt u taṣvīrāt evrāḳını biri birisine münāsebeti ile envāʿ-ı reng-āmīz kâğıdlara vaṣl edüp muraḳḳaʿ etmeği."

17. Kalender, *Album of the World Emperor*, TSMK, B 408, fol. 4a (Thackston, "Appendix II B," in Bağcı, "Presenting *Vaṣṣāl* Kalender's Works," 304): ". . . rengāreng olan naḳş-ı būḳalemūnī ebrī vü sulṭānī vü aḥmedābādī vü devletābādī vü ḫıṭāyī vü ʿadilşāhī vü ḥarīrī vü

semerḳandī evrāḳtur ve eger şanʿat-ı vaṣṣālīde her bir ḳıṭʿanuñ kenārlarına fereskūrī alaca ḳumāş ṭarzında ikişer ü üçer ḳāt ḫurde evrāḳtur ḫurdebīnān u ḫurdedān ehl-i ʿirfāna ḫafī vü pūşīde değildür her birisine imʿān-ı naẓarla iltifāt müteʿalliḳ olsa inşāʾllāhu teʿālā çār gūşeleri vü muḳābelesi cemʿan biri birisine eger renginde vü eger cirminde vü ṭūl-ı ʿarżında muvāfıḳ u muṭābıḳ vāḳiʿ olmıştur."

18. Kalender, *Album of the World Emperor*, TSMK B 408, fols. 3a–3b (Thackston, "Appendix II B," 304 [transliteration] and Thackston, "Appendix II C," 306 [translation], in Bağcı, "Presenting *Vaṣṣāl* Kalender's Works"). This is my translation; Thackston translates the phrase as "each with some conformity to the others."

19. The series contains mistakes, which I discussed in "The Gaze in the Album of Ahmed I," esp. 143–44. The mistakes become more obvious when one compares this series with others.

20. Necipoğlu, "Word and Image."

21. Fetvacı, "From Print to Trace."

22. For a detailed discussion of such comparative judgment, see Roxburgh, "'The Eye Is Favored for Seeing the Writing's Form,'" 275–98; and Roxburgh, *Persian Album*, 85–87.

23. See also Fetvacı, "Love in the Album of Ahmed I."

24. For example, folios 9b, 11b, 12b (see plates 18, 22, 24).

25. Botchkareva, "Representational Realism," 26–31, in general about albums being ordered into sections and emphasizing aesthetic considerations over narrative or historical discourses.

26. Roxburgh, *Persian Album*, esp. 137–44.

27. I am grateful to Sara Nur Yıldız for helping me identify these names. She has found all of these names in the chronicle of Bayati Mahmudoğlu Hasan, *Câm-ı cem āyīn*. For Bayati, see Woods, *The Aqquyunlu*, 177–79.

28. Sinemoğlu, "On Yedinci Yüzyılın İlk Çeğreğine Tarihlenen bir Osmanlı Kıyafet Albümü," describes the album, BM 1928.-3-23-046, but does not mention the Ottoman inscriptions above the images. Similarly, another album in the British Museum (1974,0617,0.13) prepared by Peter Mundy, an English traveler who was in Istanbul in 1618, contains paintings by Ottoman artists of the sultan, his court, military, and various ethnic and social types.

29. And, "17. Yüzyıl Türk Çarşı Ressamları"; and Mahir, "A Group of 17th Century Paintings Used for Picture Recitation." An updated version of And's theory is asserted by Değirmenci, "Görselin Okunması," who sees these images as popular, bazaar imagery, and explains their simpler aesthetics as a consequence of their "commercial" nature. As is proven by a comparison with the style of the other manuscripts produced for Ahmed, this simpler style was clearly a choice that accorded with the sultan's tastes.

30. On Nakşi, see Esin Atıl, "Ahmed Nakşi, an Eclectic Painter of the Early Seventeenth Century"; and Ünver, *Ressam Nakşi*.

31. Atıl, "Ahmed Nakşi, an Eclectic Painter," makes this quite clear with its title.

32. Artan, "A Book of Kings," 320. Hafiz Ahmed Pasha's *Shāhnāma* is in the New York Public Library, Spencer Collection, ms. no. 1. Gottheil, "The Shahnameh in Turkish"; Atıl, "The Art of the Book," 214–15, 217, fig. 112; Schmitz, *Islamic Manuscripts in the New York Public Library*, 254–65, figs. 261–84, and plates xx–xxii; and Değirmenci, *İktidar Oyunları*, 96–99.

33. I am basing this on the numbers provided in Meriç, *Türk Nakış*

San'atı Tarihi Araştırmaları. Documents on pages 7–13 show a surge in numbers in the reign of Murad III, where the members of the corps of imperial painter designers (*cemāʿāt-i nakkaşān-ı ḫaṣṣa*) surge from 39 to 124 in 1596; the numbers then go down to 63 in 1605–6, which is still significantly larger than the mid-sixteenth-century figures.

34. Akın-Kıvanç, *Mutafa Âli's "Epic Deeds of Artists,"* 33.

35. Akın-Kıvanç, *Mutafa Âli's "Epic Deeds of Artists,"* 165, 235–37.

36. Babaie, "The Sound of the Image / The Image of the Sound," 149–50.

37. Fetvacı, *Picturing History*, 5, 83–94.

38. Farhad, "Safavid Single Page Painting"; and Taner, " 'Caught in a Whirlwind,' " 74–113.

39. British Library, Or. 4129 and Or. 2709. For Or. 4129, see Meredith-Owens, *Turkish Miniatures*, 28 and pl. 21; Titley, *Miniatures from Turkish Manuscripts*, pl. 17. For Or. 2709, see Titley, *Persian Miniature Painting and Its Influence on the Art of Turkey and India*, 151–57 and pl. 29. For the Chester Beatty Library ms no. T. 439, see Minorsky, *The Chester Beatty Library*.

40. "Hoca Hafız'in şagirdi Şirazi Mirzazadedir." Bağcı, "Presenting *Vaṣṣāl* Kalender's Works," 264–66, points to the Safavid figures on fols. 8b, 18b, and 27b, matching one of them (on 8b) with Qazvini work from ca. 1587 and the other two (18b, 27b) with T 439.

41. Identified by Taner, " 'Caught in a Whirlwind,' " 115.

42. *Kevorkian Flautist*, current whereabouts not known, formerly in the Hagop Kevorkian Collection (Sotheby's Islamic and Indian Art Oriental Miniatures and Manuscripts, October 15, 1994, lot 46), and Sotheby's sale catalog for April 7, 1975, lot 30.

43. Folios 12a, 14b, 16b, 18b, 20a, 21a, 23b, 24b, 25a, 25b, 26a, 27b, 28a. Bağcı, "Presenting *Vaṣṣāl* Kalender's Works," 264–65, points to a number of these images.

44. Taner, " 'Caught in a Whirlwind,' " 105.

45. See for example Fetvacı, "From Print to Trace." The portraits in the *Şemaʿilnāme* book of sultanic portraits were probably inspired by illustrated copies of Giovio's work. While the introduction to the Ottoman text candidly discusses the use of Frankish models, the style of the portraits is unabashedly Ottoman; the deliberately flattened and abstracted portraits do not admit any connection to Renaissance painting or printing.

46. Roxburgh, *Persian Album*; and Roxburgh, *Prefacing the Image*. Aynur, "Ottoman Literature," 3:502: "to be skilled in versification was part of the identity of a member of the Ottoman elite." Similarly, concerning Ottoman lyric poetry, Andrews, "Literary Art of the Golden Age," 355, comments on "the inescapable and uncompromising intertextuality of this particular poetic tradition, its tendency to base its logic and meaning on access to a common fund of information unavailable to outsiders." He also describes a "presupposition that the audience of poetry will have an encyclopedic familiarity with the tropes of the tradition and the lore that accompanies them" (356).

47. Necipoğlu, "Scrutinizing Gaze," 29–30.

48. Değirmenci, "Osmanlı Tasvir Sanatında Görselin 'Okunması,' " suggests the importance of oral literature to understanding album production of the seventeenth century; Kavruk, *Eski Türk edebiyatında mensûr hikâyeler*, 70.

49. Andrews, *Poetry's Voice, Society's Song*, 158–59.

50. Kafadar, "Sohbete Çelebi"; and Buzov, "Osmanlı'da karışık içerikli mecmûalar," 38. For a precedent for the parallels between anthologies and albums, see Roxburgh, "The Aesthetics of Aggregation."

51. Kafadar, "Sohbete Çelebi."

52. Necipoğlu, "Challenging the Past," 176.

53. Feldman, "Imitatio in Ottoman Poetry," esp. 42.

54. Andrews, "Starting over Again."

55. Köksal, *Sana Benzer Güzel Olmaz*, 70.

56. Köksal, *Sana Benzer Güzel Olmaz*, 70. The collection is in the Topkapı Palace Library, Ms. B 406.

57. Köksal, *Sana Benzer Güzel Olmaz*, 70.

58. Feldman, "Imitatio in Ottoman Poetry," 43.

59. Aynur, "Ottoman Literature," 483, 496.

60. According to İpekten, *Karamanlı Nizâmî Divanı*, 27, because naẓīre collections include poems that have a wide variety of relationships to earlier poems, our definition of naẓīre must also be kept loose.

61. For Tıflî Hikayeleri, see Sayers, *Tıflî Hikâyeleri*. For the city thrillers, see Levend, *Türk Edebiyatında Şehrengizler ve Şehrengizlerde Istanbul*; and Stewart-Robinson, "A Neglected Ottoman Poem: The Şehrengiz." Aynur, "Ottoman Literature," 490, also mentions works known as *biladiyye* that begin to be written in the seventeenth century, which discuss the poet's own relationship with his city or town.

62. Aynur, "Ottoman Literature," 496.

63. Kavruk, *Eski Türk edebiyatında mensûr hikâyeler*, 70. Among these he counts the stories composed by Cenani for Murad III.

64. On the *sebk-i hindî*, see Rypka, *History of Iranian Literature*; Babacan, *Klasik Türk Şiirinin Son Baharı*; Andrews, Black, and Kalpaklı, *Ottoman Lyric Poetry*, 22–23; and Aynur, "Ottoman Literature," 482.

65. Babacan, *Klasik Türk Şiirinin Son Baharı*, 106–20. See also the various essays in Aynur, Çakır, and Koncu, *Sözde ve Anlamda Farklılaşma*.

66. For an overview of its contents and formation, as well as an analysis of the circulation of books from the treasury, see Fetvacı, *Picturing History*, 27–37.

67. Çağman and Tanındı, transl. Rogers, *The Topkapı Saray Museum*, 11–14; for the Tahmasp album in the Ottoman context, see Arcak, "Gifts in Motion," 119, 131.

68. For the text of Kalender's preface, see the appendixes by Thackston in Bağcı, "Presenting *Vaṣṣāl* Kalender's Works." For other Persian album prefaces, see Thackston, *Album Prefaces and Other Documents on the History of Calligraphers and Painters*. For a groundbreaking analysis of Persian album prefaces and the concepts of art history that they embody, see Roxburgh, *Prefacing the Image*.

69. Tezcan, "The Multiple Faces of the One"; but also Pedersen, *The Arabic Book*.

70. Roxburgh, *Prefacing the Image*, 83–121.

71. Cenderecizade copies a preface by Khwaja Abdullah Marwarid for an album for the Timurid courtier Mir Ali Sher in the late fifteenth century, which in turn was incorporated into a Safavid album in the sixteenth century. See Thackston, *Album Prefaces*, 22–23, 30–31. To complicate matters further, the album that now contains Marwarid's preface includes calligraphic specimens dated as late as 1580. Froom, "Adorned Like a Rose," suggests the preface

in H 2156 is based on but does not copy Marwarid's. In either case, Cenderecizade is mimicking a Persian album preface.

72. Roxburgh, *Persian Album*, 193.

73. Thackston, "Appendix II C," in Bağcı, "Presenting *Vaṣṣāl* Kalender's Works," 305.

74. Thackston, "Appendix II C," in Bağcı, "Presenting *Vaṣṣāl* Kalender's Works," 306.

75. Roxburgh, *Persian Album*, 196.

76. Roxburgh, *Persian Album*, 197.

77. Thackston, "Appendix II C," in Bağcı, "Presenting *Vaṣṣāl* Kalender's Works," 306.

78. Roxburgh, *Persian Album*, 193, 251n10 ("naẓar-i arbāb-i baṣīr va baṣīrat").

79. Thackston, "Appendix II C," in Bağcı, "Presenting *Vaṣṣāl* Kalender's Works," 306.

80. Thackston, "Appendix II C," in Bağcı, "Presenting *Vaṣṣāl* Kalender's Works," 305. Another Sufi link is the mirror metaphor used by Kalender. Roxburgh, *Prefacing the Image*, 181–89; and Soucek, "Nizami on Painters and Painting," esp. 12–15.

81. Roxburgh, *Persian Album*, 24.

82. Necipoğlu, "Persianate Images between Europe and China."

83. Necipoğlu, "Persianate Images between Europe and China," 532–33.

84. Roxburgh, "Images on the Fringe"; and O'Kane, "Siyah Qalam."

85. Çağman, "On the Contents of the Four Istanbul Albums," 34.

86. Also mentioned in Bağcı, "The Poet Sa'di Dressed as a Monk," 148.

87. Roxburgh, *Persian Album*, 295–304, and Roxburgh, *Prefacing the Image*, 174–98.

88. In particular, folio 20a contains such examples.

89. Raby, "Opening Gambits," 70.

90. Necipoğlu, "Visual Cosmopolitanism and Creative Translation."

91. Raby, "Bust Portrait of Mehmed II," 91, cat. no. 8.

92. The Bellini *Scribe* is the Isabella Stewart Gardner Museum's P15e8. See Chong, "Seated Scribe, 1479–81," 122, cat. no. 32.

93. A similar point is made by Botchkareva, "Representational Realism," 32–33. The seven modes of painting are discussed by Roxburgh, *Persian Album*, 300; Necipoğlu "Early Modern Floral"; and Porter, "From the 'Theory of the Two Qalams' to the 'Seven Principles of Painting.'"

94. Necipoğlu, "Persianate Images between Europe and China," 589–91.

95. Botchkareva, "Representational Realism," claims a similar message in the illuminations of the St. Petersburg album.

96. Âli, *Künhül Ahbar*, 1:16, translated and cited in Fleischer, *Bureaucrat and Intellectual*, 254; and also used by Kafadar, "A Rome of One's Own," 12.

97. Roxburgh, *Persian Album*, 183.

98. Botchkareva, "Representational Realism," 23.

99. Botchkareva, "Representational Realism," 22–29.

CHAPTER FOUR. CALLIGRAPHY IN THE ALBUM

1. Blair, *Islamic Calligraphy*, 427–49. See also the Freer-Sackler Galleries website produced in connection with a past exhibition, *Nastaliq: The Genius of Persian Calligraphy*, http://www.asia.si.edu/explore/nastaliq.

2. Tabbaa, "The Transformation of Arabic Writing: Part 1, Qur'ānic Calligraphy"; Tabbaa, "The Transformation of Arabic Writing: Part 2, The Public Text"; Tabbaa, "Canonicity and Control"; and Bierman, *Writing Signs*, 60–132. See also Messick, *The Calligraphic State*; and Irvin C. Schick, "The Revival of *Kūfī* Script during the Reign of Abdülhamid II."

3. Blair, *Islamic Calligraphy*; and Freer-Sackler Galleries, *Nastaliq*.

4. Thackston, "Calligraphy in the Albums."

5. Subrahmanyam, *Explorations in Connected History*. For a distinction between global history and connected imperial history, see Potter and Saha, "Global History, Imperial History, and Connected Histories of Empire."

6. I am grateful to Irvin Cemil Schick for helping me navigate the scholarship on Ottoman calligraphy.

7. Muhittin Serin, *Hattat Şeyh Hamdullah*.

8. Çağman and Aksoy, *Osmanlı Sanatında Hat*; and Derman, "Kanuni Devrinde Yazı San'atımız."

9. Çağman, *Ahmed Karahisârî Mushaf-ı Şerîfî Tıpkıbasımı*; and Çağman, "The Ahmed Karahisari Qur'an in the Topkapi Palace Museum Library in Istanbul."

10. James, *Qur'āns of the Mamlūks*; and Blair, "The Religious Art of the Ilkhanids."

11. Necipoğlu, *The Age of Sinan*, 104, 198, 208, 216, 242, 252, 426; and Necipoğlu, "Qur'anic Inscriptions on Sinan's Imperial Mosques."

12. Schick, "I. Mahmud Döneminde Hat San'atı" details the developments of nastaʿlīq (which the Ottomans confusingly called *talik* [*taʿlīq*]) in the eighteenth century. I am grateful to Irvin Schick for sharing his unpublished work with me. Serin, *Hat San'atımız*, 66–68, writes that talik was used as the semi-official script of the *ulema* class after the conquest of Constantinople, but that the Turkish (read Ottoman) style of nastaʿlīq/talik did not develop until the late eighteenth century. See also Blair, *Islamic Calligraphy*, 512–13; and Alparslan, *Ünlü Türk Hattatları*, 24. Rado, *Türk Hattatları*, 92, 96, repeats the same account of Ottomanization in the eighteenth century by followers of Imad.

13. For a brief description of the calligraphy album's contents and date, see Bağcı, "Presenting *Vaṣṣāl* Kalender's Works," 255–313, esp. 259–63, and for facsimile, transliteration, and translation of the preface, 277–95.

14. Thackston, "Appendix I C," in Bağcı, "Presenting *Vaṣṣāl* Kalender's Works," 295.

15. As suggested in Bağcı, "Presenting *Vaṣṣāl* Kalender's Works," 259–60.

16. The only exceptions are fol. 5b with Ahmed's writing of hadith; folio 6a with selections from the Araf and Baqara suras, hadith, and a saying by ʿAli (both discussed in chapter 1); a calligraphic peacock since severed from the album, and two samples of administrative writing on folio 20a (all three discussed further down).

17. Mahir, "XVI. Yüzyıl Osmanlı Nakkaşhanesinde Murakka Yapımcılığı," 401–17.

18. Çağman and Tanındı, "Remarks on Some Manuscripts from the Topkapı Palace Treasury in the Context of Ottoman-Safavid Relations"; and Uluç, *Turkman Governors, Shiraz Artisans and Ottoman Collectors*.

19. For this album (Istanbul University Library, F 1426), see Atıl, *The Age of Sultan Süleyman*, 104–7, nos. 49a–f; and Çağman, "The Earliest Known Ottoman 'Murakka,'" 225–26.

20. Froom, "Adorned like a Rose." Only two calligraphic samples by Ottoman calligraphers were included in the album of Murad III, and Froom argues that one of these (by Fahri on folio 40b) is a later addition, even though Fahri does appear to have been active in the 1570s. The calligraphy by Mehmed Tahir is from the mid-sixteenth century, and Froom considers it part of the original album.

21. Froom, "Adorned like a Rose."

22. Mahir, "Sultan III. Mehmed İçin Hazırlanmış Bir Albüm"; and Fetvacı, "The Album of Mehmed III."

23. Necipoğlu, "Early Modern Floral," 136, where she suggests that the Safavid articulation of artistic theory as "the seven modes of design" so soon after the signing of the Amasya treaty between the Ottomans and Safavids was not a coincidence.

24. Serin, *Hat San'atımız*, 68, gives the "genealogy" of Ottoman nastaʿlīq/talik beginning with the Safavid calligrapher Imad of Isfahan, then lists Derviş Abdi-i Mevlevi as the next link in the chain. Like Mustafa Âli, whose work will be examined below, twentieth-century historians of calligraphy also do not seem to separate the two realms when it comes to training and collecting.

25. Bağcı, "Presenting *Vaṣṣāl* Kalender's Works" (translation and transcription by Wheeler Thackston), 306 (B 408, fols. 2b–3a).

26. Irvin Schick kindly pointed out in personal correspondence that the fact that later Ottoman nastaʿlīq/talik masters were referred to as "Imad-ı Rum," using the name of the Isfahani nastaʿlīq master of the early seventeenth century together with the geographic indicator of Rum suggests the persistence of this attitude. At the same time, he thinks that nastaʿlīq/talik is presented as "Persian" in the eighteenth-century biographical treatise of Müstakimzade.

27. Soucek, "ʿAlī Heravī"; Bayani, *Aḥvāl ve asār-i khūsh-nuvisān*, 492–516, 659–61; and Minorsky, *Calligraphers and Painters*, 126–31, 134–35.

28. See Minorsky, *Calligraphers and Painters*, 135–38, for Shah Mahmud Nishapuri's biography.

29. I found one reference in a Christie's sale catalog where a qiṭaʿ signed by Nur ʿAli is assumed to be Safavid, and he is said to be active ca. 1560, but no references are provided. The fact that he is writing in nastaʿlīq, a script so closely associated with Persian culture, must be what led the auction house specialists to claim he was Safavid. Christie's Sale 5495: Indian and Islamic Works of Art, April 16, 2010, London, South Kensington.

30. Koç, *Müstakimzade, Tuhfe-i Hattâtîn*, 630; and Huart, *Les calligraphes et les miniaturistes de l'Orient musulman*, 228, 263. Nur ʿAli's teacher Mahmud Shihabi was a rival of Malik Daylami, one of the Safavid calligraphers included in the album, and he was married to the daughter of Mir ʿAli.

31. Bayani, *Aḥvāl ve asār-i khūsh-nuvisān*, 3:950 also describes Nur ʿAli in the same terms; his account seems modeled on Müstakimzade. In addition, he mentions two albums, one with two qiṭaʿ by him (signed Faqir Nur ʿAli) in the Library of the Treasury of Endowments (which must be the current collection of the Museum of Turkish and Islamic Art), and the other with one qiṭaʿ by him (signed Nur ʿAli) in the Istanbul University Library.

32. Koç, *Müstakimzade*, 630.

33. Akın-Kıvanç, *Mustafa Âli's "Epic Deeds of Artists,"* appendix A: Artistic Lineage, 441. According to Âli, Nishapuri's teacher Abdi of Nishapur was trained by Sultan Ali of Mashhad, who was trained by Mawlana Azhar, who was trained by Mawlana Jafar of Tabriz, who was trained by Monla Abdullah (the son of Mir ʿAli), who was trained by Mir ʿAli Tabrizi. In a private conversation, Abolala Soudavar has raised the possibility that the calligraphies in this album might be sixteenth- or early-seventeenth-century forgeries, given that there was a vibrant market for the calligraphers named in the preface. See Soudavar, "Forgeries." Two examples by Mir ʿAli are on fol. 21b; Muhammad Mashhadi is also represented with two examples, on fols. 10a and 20a, but 20a is signed just Muhammad. Malik Daylami is on fol. 13b. Mir Sayyid Ahmed signed a qiṭaʿ on fol. 17b.

34. Bağcı, "Presenting *Vaṣṣāl* Kalender's Works," 263, identifies the text.

35. Müstakimzade writes of two Recebs that might be the same as this Derviş Receb-i Rumi. The first one, known as Receb Dede (Koç, *Müstakimzade*, 187), was from Konya and belonged to the Mevlevi order. He completed a Qur'an in 1019 (1610–11). We know nothing else about him, but his period of activity is contemporaneous with the album at hand, and his Mevlevi affiliation also matches. The second Receb is listed as Receb Revânî (of Yerevan, Koç, *Müstakimzade*, 187). His artistic genealogy goes back to Şeyh Hamdullah. He taught calligraphy at the Galata Palace, and died in 1551. This second Receb is also listed by Huart, *Les calligraphes*, 123. Given that he was trained by Hamdullah, it is unlikely that nastaʿlīq was a script he specialized in.

36. Değirmenci, *İktidar Oyunları*, 96–97, 102ff. One is Derviş Hasan Meddah, a storyteller who entered palace service during the reign of Murad III. The other is Derviş Abdi Efendi, the calligrapher who copied out the *Shāhnāma* prepared for Ahmed's grand vizier Hafız Ahmed Pasha in a Mevlevi shrine. Çağman and Tanındı, "Illustration and the Art of the Book in the Sufi Orders of the Ottoman Empire," esp. 512n44, note that Abdi studied nastaʿlīq in Isfahan under Mir Imad. See also Derman, "Derviş Abdi-i Mevlevi," 190–91; and Serin, *Hat San'atımız*, 68. Çağman and Tanındı, "Illustration and the Art of the Book in the Sufi Orders," 512n41, also mention Cevri Ibrahim, who was a scribe in the imperial chancery (he wrote the three-volume illustrated Turkish translation of the *Shāhnāma* for Osman II) and a Mawlawi poet and a master of nastaʿlīq script. After his retirement, Cevri Ibrahim copied manuscripts for the Ottoman elite, including two *Maṣnavīs* of Rumi for different Ottoman bureaucrat-officers in the 1640s, and one in 1618–20. The earlier one is in the SYEK, Halet Efendi no. 174. Halet Efendi was a Mawlawi statesman himself, according to Çağman and Tanındı, note 39, and the two later ones are in the Topkapı, M 505 and A 1354. See also Ayan, "Cevri Ibrahim Çelebi."

37. Akın-Kıvanç, *Mustafa Âli's "Epic Deeds of Artists,"* 199–200.

38. Çağman and Tanındı, "Illustration and the Art of the Book in the Sufi Orders of the Ottoman Empire" compare the support of shrines by the Ottomans and Safavids. They also suggest that lion images, chained and unchained, had a certain significance for Mawlawi Sufis. What exactly that significance was, however, is unclear. The lion images on folio 21a might well be connected to Sufi tendencies. The lions are also visually connected to such imagery found easily in Safavid albums. The "Lion of God" is a term often used for ʿAli, the prophet's cousin.

39. As Çağman and Tanındı, "Illustration and the Art of the Book in the Sufi Orders," point out, Mawlawis were active in manuscript

production in Baghdad at the turn of the century, and fifteenth- and sixteenth-century examples of manuscripts produced in Sufi shrines or by calligraphers adopting cognomens reflecting their affiliations with specific Sufi orders abound. Baghdad is an interesting location, as this was where the borders between the Ottoman and Safavid cultural worlds became rather porous as the city changed hands. See Taner, "'Caught in a Whirlwind,'" 112ff., for information on manuscript production in Baghdad around the turn of the century and the number of Mevlevi works sponsored there, probably at Mevlevi and Bektashi centers. On 119, Taner names Nusayra Dede and Abd al-baqi al-Mawlawi as calligraphers working in shrines in Baghdad.

40. For the production of artworks in Baghdad, see Taner, "'Caught in a Whirlwind,'"; Milstein, *Miniature Painting in Ottoman Baghdad*; and Bağcı et al., *Osmanlı Resim Sanatı*, 246–57. Roxburgh, *Prefacing the Image*, 29–30, writes of a preface author Qutb al-Din Muhammad, but this figure died in 1562–63, and Roxburgh concludes this cannot be the same person that Âli encounters in Baghdad in 1585–86.

41. See Roxburgh, *Prefacing the Image*, 34–35, on Mir Sayyid Ahmed as a preface author.

42. Akın-Kıvanç, *Mustafa Âli's "Epic Deeds of Artists,"* 246–47, 377: Maqsūd ʿAlī-i Türk.

43. Akın-Kıvanç, *Mustafa Âli's "Epic Deeds of Artists,"* 380n11. Koç, *Müstakimzade*, 667, reports that Tirmizi studied with Imad and died after the year AH 1000.

44. Akın-Kıvanç, *Mustafa Âli's "Epic Deeds of Artists,"* 248.

45. Koç, *Müstakimzade*, lists three calligraphers by the name Sıdki: one died in AH 1183 (p. 475, Mustafa Sıdkî bin Sâlih), and the other (Ebu Bekir-i Sıdkî, p. 126) in AH 1173 (1759–60). The third one, Ahmed-i Sıdkî (p. 90) died in Temesvar in AH 1073 (1662–63) and is therefore very unlikely to be this Sıdki as well. I have yet to identify the Sıdki whose work is in the album.

46. Der medḥ-i Ḥażret-i Kedkhudā-yi muʿażżam-i mukarram/ Ḥaled ẓilāl eqbale gofte shod fī sene elf.

47. Floor, "Kadkoda"; and Orhonlu and Baer, "Ketkhudā."

48. Çağman, *Katʾı Cut Paper Works and Artists in the Ottoman World*, 154, based on Selaniki, *Tarih-i Selaniki*, 2:487. Çağman dedicates pp. 154–61 to Kalender and discusses the relationship between paper cutout and paper joinery; he demonstrates that on folios 29a, 29b–30a, 1b, and 73a, Kalender uses both techniques.

49. "rūshani-yi chashm-i del-i ehl- yaqīn"; "Inja che dʿuā konam tora bihter azīn."

50. "zāt-i ṣifāt-i to"; "Yar-i to nebī bād ve muayyen-i to Vali."

51. For a schematized representation of Âli's account, see Akın-Kıvanç, *Mustafa Âli's "Epic Deeds of Artists,"* 440–45.

52. In addition to those discussed here, Ahmed Karahisari, who was a participant in the formation of an Ottoman visual idiom in the second half of the sixteenth century, studied with the Safavid calligrapher Asadullah Kirmani.

53. For an exploration of this in the Mughal-Safavid context, see Soucek, "Persian Artists in Mughal India."

54. I am grateful to Simon Rettig and to Irvin Schick for looking at the two samples and helping me to compare them visually.

55. A full page from probably the same manuscript, with the same illumination and calligraphic style, is pasted on folio 20a.

56. Soudavar, "The Concepts of 'al-aqdamo aṣaḥḥ' and 'yaqin-e sābeq,' and the problem of Semi-Fakes"; and Soudavar, "Forgeries," also reminds us that the second signature was often cut out, and the copy was sold as if it were an original by the master calligrapher.

57. It is possible this might be read as "qiṭaʿ by," meaning the poetry is by Mevlevi-yi Rumi, but the poetry belongs to Hilali Chaghatai.

58. Roxburgh, "'The Eye Is Favored for Seeing the Writing's Form,'" 275–98.

59. I am grateful to Daniel Sheffield for helping me to track this down. Mir ʿAli's rendering of other lines by Hilali Chagataʾi are included in a Mughal album page in the Metropolitan Museum of Art, accession no. MMA 55.121.10.4r. See Ekhtiar et al., *Masterpieces from the Department of Islamic Art in the Metropolitan Museum of Art*, 360.

60. The link between calligraphy's form and content is explored fruitfully by Schick, "The Iconicity of Islamic Calligraphy in Turkey." For further discussion of the iconicity of script, see Hamburger, "The Iconicity of Script."

61. Arcak, "Gifts in Motion," 119, 131 (quoting from Mustafa ʿĀlī, *Cāmiʿuʾl-buhūr der Mecālis-i Sūr*), and 25, 172 (quoting from Lokman, *Shāhnāma-i al-i ʿOsmān*, BL Add. 7931).

62. Soudavar, "Forgeries."

63. The order of some of the folios appears to have been mixed up, probably during the nineteenth-century rebinding. Some folios are bound upside down. It is possible that there were openings with matching borders that were then disorganized in the nineteenth century, because there are repeating border designs throughout the album.

64. Bağcı, "Presenting *Vaṣṣāl* Kalender's Works," 261, writes that one side of the opening usually has taliq or nastaʿlīq, and the other side thuluth and naskh, but I do not find this to be consistently true throughout the album, though it is true of some openings.

65. For the Gulestan, see Değirmenci, *İktidar Oyunları*, 59.

66. Değirmenci, *İktidar Oyunları*, 78, also makes this suggestion.

67. Thackston, "Appendix I C," in Bağcı, "Presenting *Vaṣṣāl* Kalender's Works," 295.

68. Bağcı, "Presenting *Vaṣṣāl* Kalender's Works," 259–60.

69. Akın-Kıvanç, *Mustafa Âli's "Epic Deeds of Artists,"* 33.

70. Akın-Kıvanç, *Mustafa Âli's "Epic Deeds of Artists,"* 33–40.

71. Akın-Kıvanç, *Mustafa Âli's "Epic Deeds of Artists,"* 165.

72. Necipoğlu, "Early Modern Floral," 142. Similarly, as pointed out by Necipoğlu, mid-sixteenth-century Ottoman literary treatises praise an original local style, juxtaposing it with earlier poets who simply translated Persian poetry without creating a distinctive local style. Necipoğlu attributes the development of the Ottoman semi-naturalistic floral ornament to the same spirit of artistic innovation and imperial rivalry. The same division is evident in the organization of the Ottoman painting studio in the sixteenth century into two groups of artists, the Rumis and the Ajamis, a division that was eliminated by the end of the century. Necipoğlu, "Ḳānūn for the State," 205; but also Atıl, *Süleymanname*, 36, 118, 255–56.

73. Necipoğlu, "Early Modern Floral," 142.

74. Akın-Kıvanç, *Mustafa Âli's "Epic Deeds of Artists,"* 206.

75. Soucek, "Persian Artists in Mughal India," 167, states that "Mughal appreciation of Mir ʿAli's work appears to combine a genuine enthusiasm for his style with the view that he epitomizes the achievements of Timurid calligraphers."

76. See Thackston, "Calligraphy in the Albums," 153–56.

77. Akın-Kıvanç, *Mustafa Âli's "Epic Deeds of Artists,"* 206.

78. Akın-Kıvanç, *Mustafa Âli's "Epic Deeds of Artists,"* 206, translates *vaṣṣālī* as "book repair," but it is actually paper joinery, which is not only used in book repair but is an artform unto itself—the one in which Kalender specializes.

79. Akın-Kıvanç, *Mustafa Âli's "Epic Deeds of Artists,"* 206. In the original (Akın-Kıvanç 332, fol. 35b), Âli writes "*ibtidā-ʾi revāc-ı nastaʿlīq, . . .*" which can be translated as "the beginning of popularity of nastaʿlīq" and the rest of the arts he lists thereafter.

80. See Roxburgh, *Persian Album*, 37–83, for an analysis of Baysunghur's patronage, including his calligraphy album. Ibid., 81–83, also discusses the quotations from Âli that I analyze here and points to the importance of Baysunghur's reputation as a patron, which in turn must have led to the preservation of his calligraphy album in the Ottoman imperial collection.

81. My late friend Shahab Ahmad, who learned of the preface of the *Album of the World Emperor* during a talk I gave in 2011, also finds particular emphasis on the visual in the preface. We seem to have arrived at the same conclusion independently. See my "Album of Ahmed I," at 128–29, and Ahmad's *What Is Islam*, 54–56.

82. Kalender, *Album of the World Emperor Sultan Ahmed Khan*, TSMK, B 408, fol. 2b, as transliterated and translated by Thackston in "Appendix II B and II C," 303, 305–6, cited in chapter 3, note 11.

83. Kalender, *Album of the World Emperor Sultan Ahmed Khan*, TSMK, B 408, fol. 2b, as transliterated and translated by Thackston in "Appendix II B and II C," 303 and 305–6: taḥṣīl-i sermāye-i ʿilm-i ḥikmet ve sebeb-i tekmīl-i piraye-yi ʿayn-i ʿibret.

84. Roxburgh, *Persian Album*, 18–20, 188–96, 272–94; and Roxburgh, *Prefacing the Image*, 83–121, 181–89.

85. Roxburgh, *Prefacing the Image*, 184–85: "Integral to the Safavid culture was the understanding that by perception, forms were transferred (by intromission) to the artist's humor, which was thought to be a polished surface. In the act of perceiving, the image became impressed on the humor. In a second stage, the forms from both eyes were impressed on the composite sense, and in the third stage they were stored in the memory (*khiyāl*)."

86. Roxburgh, *Prefacing the Image*, 181–89; and Soucek, "Nizami on Painters and Painting," 12–15.

87. See, for example, Atanasiu, *De la fréquence des lettres et de son influence en calligraphie arabe*. I am grateful to Irvin Schick for the reference.

88. See Fetvacı, "Love in the Album of Ahmed I," for more examples of the relationship between the poetry and the paintings, especially as they relate to the theme of love.

89. Shab-i Qadr ast ve ṭay shud nāma-i hijr /Salām fī ḥattā maṭlaʿ al-fajr // Man az rindī na khvāham kard tavba/Walaw aadhatnī bīʾl-hajr waʾl ḥajar.

90. Andrews and Kalpaklı, *The Age of Beloveds*, 109. I am grateful to Walter Andrews for this suggestion.

91. Zahi sharmanda gulbarg-e tar az to / Halavat vām karda shakar az to / Mara har shab be-yād-e ru-ye khubat / Gul va lale damad dar bastar az to.

92. Andrews, *Poetry's Voice, Society's Song*; Andrews and Kalpaklı, *The Age of Beloveds*, 75–84, 107–12, 352–53. For imperial garden gatherings, see Inalcık, *Has-bağçede ʿayş-u tarab: nedîmler, şâirler, mutribler*, esp. 192–204.

93. Schick, "The Content of Form," esp. 183.

94. "Letter from Sultan-Husayn Mirza to the Calligrapher Sultan-Ali Mashhadi," in Thackston, *Album Prefaces*, 51.

95. Winter, "Text on/in Monuments," esp. 217.

96. See Schick, "The Content of Form," for a consideration of the relationship between form and content in Islamic calligraphy.

97. Metropolitan Museum of Art object files, translation and transcription by Annemarie Schimmel.

98. For peacocks and birds of paradise, see Claudia Swan, "Birds of Paradise for the Sultan."

99. Ettinghausen, "Arabic Epigraphy"; Tabbaa, "The Transformation of Arabic Writing: Part 1"; Bierman, *Writing Signs*; Schick, "The Revivial of Kūfī Script."

100. Both Serin, *Hat San'atımız*, 68; and Ünver, *Hekimbaşı ve talik üstadı Kâtip-zâde Mehmed Refiʿ Efendi*, 42–43, narrate the history of Ottoman talik this way, as does Rado, *Türk Hattatları*, 92, 96.

CHAPTER FIVE. THE CITY AND THE WORLD IN THE ALBUM

1. For an excellent discussion of these notions and their embodiment in the *ʿAjāʾib al Makhlūqāt* (Wonders of creation) manuscripts, see Berlekamp, *Wonder, Image, and Cosmos in Medieval Islam*. The *Wonders of Creation* text was translated into Ottoman Turkish in the late sixteenth century and was illustrated numerous times during the late sixteenth and early seventeenth centuries, as Berlekamp also points out (157–61). It would have been well known to Ahmed I, Kalender, and their courtly circle. The images of different professions one finds in the *Maṭāliʿ al-saʿāda wa manābiʿ al-siyāda* manuscripts prepared for the daughters of Murad III and discussed in chapter 2 are also a relevant comparison. Necipoğlu, "Scrutinizing Gaze," 33, also reminds us that according to al-Ghazali, "visual beauty could induce in those spiritually or intellectually inclined a contemplation of the wonders of creation."

2. As explained by Kafescioğlu, "Viewing, Walking, Mapping Istanbul, ca. 1580," while the Ottoman cartographic tradition has long attracted the attention of scholars (see, for example, Orbay, "Istanbul Viewed"; Ebel, "City Views, Imperial Visions"; Emiralioğlu, *Geographical Knowledge and Imperial Culture in the Early Modern Ottoman Empire*; Kafescioğlu, "Osmanlı şehir tahayyülünün görsel ve edebi izleri"; Rogers, "Itineraries and Town Views in Ottoman Histories"; and Bağcı et al., *Ottoman Painting*, 69–81), the representations of Istanbul in the context of urban and social history have received surprisingly little attention in the scholarship. See also Terzioğlu, "The Imperial Circumcision Festival of 1582."

3. Kagan, "Urbs and Civitas in Sixteenth- and Seventeenth-Century Spain," 75.

4. Kagan, "Urbs and Civitas," 77, is also quick to point out that describing the history of city views as a linear and progressive history, going from artistic to scientific, from paintings to maps, grossly oversimplifies things. City views in his understanding are

multifaceted, and the character of each view is shaped by the purpose for which it was made.

5. Nuti, "Mapping Places."

6. Woodhead, *Ta'līkīzāde's Şehnāme-i Hümāyūn*, 5r–10v; and Necipoğlu, *Age of Sinan*, 30–31.

7. Inalcik, "Istanbul," estimates the population inside the walls as between 350,000 and 400,000 in the sixteenth century. If we include Galata and areas immediately outside the walls, the number is greater.

8. Elliott, "Dress Codes in the Ottoman Empire," 116. Brentjes, "On the Relation between the Ottoman Empire and the West European Republic of Letters (17th–18th Centuries)," 122, notes that the number of travelers going to the Middle East for scholarly goals increased from the second half of the sixteenth century onward, suggesting the presence of ever-increasing numbers of foreigners in Istanbul and beyond.

9. Kafescioğlu, "Walking, Viewing, Mapping," 30–34; and Âlî, *Divan*, 1:309: "Dirin Istanbul'a ben ehl-i nazar deryâsı / Kesret-i nâsa nazar nev'-i beşer deryâsı."

10. Kafescioğlu, *Constantinopolis/Istanbul*, 171, 175. This attitude was also held by non-Ottoman celebrants of the conquest, such as the Karakoyunlu ruler who congratulated Mehmed in a letter.

11. Kafescioğlu, *Constantinopolis/Istanbul*, 173: "A number of Ottoman authors turned to a well-established apocalyptic tradition in Arabic literature that, from Abbasid times onward, saw the destruction of Constantinople as a sign of the approaching Day of Judgment. The city, in this version of its history, was built three times and destroyed three times. Its rulers were always driven by greed; oppression, cruelty, and intrigue [*zulm, fitne, fesād*] were the tools of their trade."

12. Kafescioğlu, *Constantinopolis/Istanbul*, 212, also discusses a 1537 map of Istanbul by Matrakçı Nasuh and demonstrates that it presents Istanbul through paradisal imagery.

13. Şahin, "Constantinople and the End Time."

14. Sims, "Hans Ludwig von Keufstein's Turkish Figures"; Ann Rosalind Jones, "Habits, Holdings, Heterologies"; Stichel, "Das Bremer Albumn und seine Stellung innerhalb der orientalischen Trachtenbücher"; Olian, "Sixteenth Century Costume Books"; Leslie Meral Schick, "Ottoman Costume Albums in a Cross-Cultural Context," 626; and Shesgreen, *Criers and Hawkers of London*.

15. Renda, "17. Yüzyıldan Bir Grup Kıyafet Albümü." Schick, "Ottoman Costume Albums," 628, suggests that the Ottomans easily adopted this genre because "it conformed to social practices and forms of representation established in the empire. Kynan-Wilson, "Pictorial Playfulness in Ottoman Costume Albums," claims there are two or three Ottoman-made costume books from the sixteenth century and many in the seventeenth. He believes, as does Metin And, that individual pages could be bought in Istanbul and combined as one wanted, because he has seen an album in London with twelve images of Bostancıs. Inal, "Tek Figürlerden Oluşan Osmanlı Albüm Resimleri," proposes that the Ottoman single figures are inspired by Safavid ones.

16. Schick, "Meraklı Avrupalılar İçin bir Başvuru Kaynağı," 87n15, based on Ahmed Refik, *Onuncu Asr-ı Hicride Istanbul Hayatı 1495–1591*, 47–48; Fleet and Boyar, *A Social History of Ottoman Istanbul*, 177; and Taner, "'Caught in a Whirlwind,'" 220.

17. Fleet and Boyar, *Social History*, 179; and Selaniki, *Tarih-i Selaniki*, 2:706.

18. Philips, "Ali Pasha and His Stuff"; and Zilfi, "Whose Laws?"

19. Elliott, "Dress Codes in the Ottoman Empire," 112–13.

20. Discussed in Fleet and Boyar, *Social History*, 175; and Gerlach, *Türkiye Günlüğü 1573–1576*, 2:624.

21. Brummett, "Mapping Trans-Imperial Ottoman Space," 36.

22. Sims, "Hans Ludwig von Keufstein," 23.

23. Ms. no. 206 Blankenburg, Herzog-August-Bibliothek, Wolfenbüttel. Szakály, *Szigetvári Csöbör Balázs török miniatúrái 1570*; see also Haase, "An Ottoman Costume Album in the Library of Wolfenbüttel, dated before 1579."

24. Della Valle, *The Journeys of Pietro Della Valle, The Pilgrim*, 14.

25. Schick, "Ottoman Costume Albums in a Cross-Cultural Context."

26. Sinemoğlu, "On Yedinci Yüzyılın Ilk Çeğreğine Tarihlenen bir Osmanlı Kıyafet Albümü," describes BM 1928.-3-23-046 but does not mention the Ottoman inscriptions above the images. Similarly, another album in the British Museum (1974,0617,0.13) prepared by Peter Mundy, an English traveler who was in Istanbul in 1618, contains paintings by Ottoman artists of the sultan, his court, military, and various ethnic and social types. For the Mundy album, see Kynan-Wilson, "'Painted by the Turcks Themselves.'"

27. Wilson, *The World in Venice*, demonstrates how costumes were the loci of alterity and were understood as the main marker of difference between people from different geographies.

28. For example, see the description of Sultan Husayn's courtiers in Lentz and Lowry, *Timur and the Princely Vision*, 257–59.

29. Brookes, *The Ottoman Gentleman of the Sixteenth Century*, 149–50. For a similar anecdote from Rumi about the importance of *kiyafet*, see Bağcı, "From Translated Word to Translated Image," 167–68.

30. Kuru, "Men Just Wanna Have Fun," suggests that Ottoman courtiers were engaged in a kind of ghazal game at court, where they would compete with each other via the ghazals they could compose and deliver in person. Brummett, "Mapping Trans-Imperial Ottoman Space," 36–37, also points to the presence of satire and wordplay in Murad IV's oversight of the empire.

31. Fols. 12a, 16a, 27a, 28a. Brummett, "Mapping Trans-Imperial Ottoman Space," 36–37, reminds us that Karagöz "typed its characters according to ethno-linguistic, communal and occupational identities."

32. Babaie, "The Sound of the Image"; Babaie et al., *Slaves of the Shah*, 114–20; Canby, *The Rebellious Reformer*; Farhad, "Safavid Single Page Painting"; and Welch, *Artists for the Shah*.

33. Andrews and Kalpaklı, *Age of Beloveds*, is just one example.

34. For an excellent analysis of three early modern capitals in the Islamic world, see Babaie and Kafescioğlu, "Istanbul, Isfahan and Delhi." Burke, "Representations of the Self from Petrarch to Descartes," 22, describes the sixteenth century as "an age of urbanization," and greater urbanization as one of the reasons behind the increase in autobiographical writing at this time. See Sharma, "The City of Beauties in the Indo-Persian Poetic Landscape," as proof of literature on the urban context.

35. Kafescioğlu, "Walking, Viewing, Mapping," 30.

36. Terzioğlu "The Imperial Circumcision Festival of 1582," 95,

suggests that the author of the *Sūrnāme* might have been inspired by şehrengiz.

37. *Arzu karda-ām ke cheshm-e to bāz*
Koshadam gah be shive gah be nāz
Mā kherīdim eger ferushad dust
Nīm nāzī be şad hezār niyāz
Jor o khvārī keshiden āz maḥbūb
Hoshter ast āz hezār nimat o nāz

38. Değirmenci, "Osmanlı Tasvir Sanatında Görselin 'Okunması,'" assumes such a common literary basis as she studies prose tales and mecmua contents from the seventeenth century in her quest to explain these figural types. This notion also of course has its basis in the works of Yarshater, "Some Common Characteristics of Persian Poetry and Art"; and Lentz and Lowry, *Timur and the Princely Vision*, 159–63, with their discussion of the literary basis of the Timurid imagination and painting. See also Welch, "Worldly and Other-worldly Love in Safavid Painting"; and Babaie, "The Sound of the Image," for Persian examples of the same link between poetry and album imagery.

39. See Sharma, "City of Beauties"; Aynur, "Ottoman Literature"; and Rizvi, "Between the Human and the Divine." See also Rizvi, "Introduction: Affect, Emotion, and Subjectivity in the Early Modern Period."

40. Kuru, "Naming the Beloved in Ottoman Turkish Gazel."

41. Levend, *Türk Edebiyatında Şehrengizler*, 16–17, suggests that Nesihi's şehrengiz is the first Ottoman example of the genre and dates to just before the author's death in 1512. Sharma, "The City of Beauties," 73–74 and Sharma, "'If There Is a Paradise on Earth, It Is Here,'" delineates the reference to the quotidian urban world in Persian lyric poetry written by elite as well as urban poets.

42. Bernardini, "The Masnavi-Shahrashubs as Town Panegyrics," 84. He also gives Western examples of town odes from the late sixteenth and seventeenth centuries and suggests this may have been a parallel development.

43. Halman, "Shāhrangīz"; and Stewart-Robinson, "A Neglected Ottoman Poem: The Şehrengiz," both point to the humorous nature of şehrengiz, which we also find in the images represented here. See also Karacasu, "Türk Edebiyatında Şehrengîzler."

44. Stewart-Robinson, "A Neglected Ottoman Poem: The Şehrengiz," 206; Sharma, "City of Beauties"; and Losensky, "Poetics and Eros in Early Modern Persia."

45. Stewart-Robinson, "A Neglected Ottoman Poem: The Şehrengiz," 206.

46. The Indo-Persian sphere referred to this kind of poetry as *shahr ʾāshūb*.

47. A concept that may not need a reference anymore, but all the same: Roland Barthes, "The Reality Effect," 141–48. Sayers, *Tıflî Hikâyeleri*, 77–81. Değirmenci, "Osmanlı Tasvir Sanatında," brings up the possibility that the spaces depicted are not necessarily real physical spaces, but imagined ones.

48. Sayers, *Tıflî Hikâyeleri*, 81, emphasizes names, description of everyday objects, concerns, and individual characteristics as contributing to the reality effect. See also Sharma, "Representations of Social Groups in Mughal Art and Literature," esp. 17.

49. Mikhail, "The Heart's Desire," 167, discusses the coffee server

boys as male beloveds, quoting from Brookes, *The Ottoman Gentleman* (ʿAlī: Mevāʾidüʾn-Nefāis), 97: "Beautiful servant girls and boys are usually mentioned . . . as a pair, like the houris and male servants in paradise." Andrews and Kalpaklı, *Age of Beloveds*, 178, also emphasizes that "the (elite) male imagination made no practical distinction between boys and girls/women."

50. Levend, *Türk Edebiyatında Şehrengizler*, 126–27.

51. This is made all the more evident when one regards other albums from the period. For example, British Library Or. 2709, which can be dated on stylistic grounds to the same period as this album, is annotated with names just like those one finds in Azizi's şehrengiz. For specifics, see Değirmenci, "Osmanlı Tasvir Sanatında Görselin 'Okunması,'" 40–41.

52. Değirmenci, "Osmanlı Tasvir Sanatında Görselin 'Okunması,'" 43. However, if we take our cue from Palmira Brummett and imagine that Ottoman women could and did have a public presence in the city, then we do not need to assume the only visible women are prostitutes. Surely there is enough variety here for some to just be imagined beloveds, based on actual beloveds. See Brummett, "The 'What if?' of the Ottoman Female."

53. The two figures on the left can be viewed as the *rakib*, the "rival," for which see Andrews, *Poetry's Voice, Society's Song*, 162.

54. Boyar and Fleet, *Social History of Istanbul*, 105–6n180.

55. Kafadar, "Janissaries and Other Riffraff"; Piterberg, *An Ottoman Tragedy*; Tezcan, *Second Ottoman Empire*; Çuhadar, *Mustafa Sâfî*, 2:44–45.

56. Kafadar, "How Dark," 244.

57. Kafadar, "How Dark," 244; Hattox, *Coffee and Coffeehouses*.

58. Mikhail, "The Heart's Desire," 135–36; Andrews and Kalpaklı, *Age of Beloveds*, 70–71, describe them in similar terms.

59. For the architecture of a specific Ottoman coffeehouse in Aleppo, see Watenpaugh, *The Image of an Ottoman City*, 155–74, esp. 161–65; and David and Chauffert-Yvart, *Le Waqf d'Ipšīr Pāšā à Alep (1063/1653)*.

60. Watenpaugh, *The Image of an Ottoman City*, 163; and Mikhail, "The Heart's Desire," 151.

61. Kafadar, "How Dark," 255–56, also discusses the increased use of the night in this period, and the candle-burning scenes here are proof of that, too. Karagöz and meddah performances took place at night in coffeehouses.

62. See Brookes, *The Ottoman Gentleman* (ʿAlī: Mevāʾidüʾn-Nefāis), 131–33, for a description of wine and boza taverns.

63. According to Yılmaz, "Boş Vaktiniz var mı?," esp. 31–33.

64. Andrews and Kalpaklı, *The Age of Beloveds*, 69–73. Yılmaz, "Boş vaktiniz var mı?," 26–27, demonstrates that private spaces were used for smaller gatherings.

65. Andrews and Kalpaklı, *The Age of Beloveds*, 69–70.

66. Comparison with a coffeehouse image from the same time period in a similar album (mentioned in chapter 3, Chester Beatty Library T. 439), highlights the lack of specificity in these images. In the Dublin image, almost every single patron has a cup of coffee in his hands, and we see coffee being prepared and served. There is no mistaking the establishment they are in. The activities include reading, playing various games like backgammon, conversing, and listening to music. See Değirmenci, "Kahve Bahane, Kahvehane Şahane."

67. Andrews, *Poetry's Voice, Society's Song*, 160, on entertainers: "One such class [i.e., other actors than the friends who are

participating] of participants are those who function primarily as part of the entertainment—musicians, dancers, and at times, story tellers."

68. Brookes, *The Ottoman Gentleman* (*ʿAlī: Mevāʾidüʾn-Nefāis*), 129, cited in Mikhail, "The Heart's Desire," 148nn81–82.

69. Sariyannis, "Mobs, Scamps, and Rebels," 5. Sariyannis tracks how this term, which was used in a social sense referring to a group/demographic in the first half of the seventeenth century, becomes a moral term in the second half of the century.

70. Sariyannis, "Mobs, Scamps, and Rebels," 5.

71. Brookes, *The Ottoman Gentleman* (*ʿAlī: Mevāʾidüʾn-Nefāis*).

72. Sariyannis, "Mobs, Scamps, and Rebels."

73. Andrews, "Literary Art of the Golden Age," 359, explains the "pervasive allegory of an elegant entertainment for a circle of friends in a garden" that is to be found in many poems from the period.

74. See Andrews, *Poetry's Voice, Society's Song*, 143–74, for the garden party context and themes of ghazals. Andrews reminds us that ghazals were recited in such garden parties, but that they also talk of such garden parties, and so our knowledge of the parties comes from the ghazals collectively as well as from other sources. See also his discussion on those pages of ghazal as play (structured activity), a play (the script), and the play (a dramatic performance). Gardens also function as metaphors for the Ottoman state and as a safe sanctuary in Ottoman ghazals, as distinct from other Persian ghazals, according to Andrews (155–58), a microcosm of the empire. Necipoğlu, "Early Modern Floral," also reminds us that the floral aesthetics of the Ottoman visual idiom drew on the notion of the state as a garden. This might be brought to bear on the album's garden imagery.

75. Necipoğlu, "The Suburban Landscape"; and Necipoğlu, "Early Modern Floral."

76. Necipoğlu, "Suburban Landscape," refers to various public and private gardens in the sixteenth-century city.

77. Artan and Schick, "Ottomanizing Pornotopia," 160. But Sariyannis, "Prostitution in Ottoman Istanbul, Late Sixteenth–Early Eighteenth Century," suggests that *nigar* means "prostitute."

78. Kafadar, "How Dark," 244.

79. Kafadar, "How Dark," 245–46; and Kafadar, "Janissaries and other Riffraff."

80. Artan, "Forms and Forums of Expression," 386.

81. Andrews and Kalpaklı, *Age of Beloveds*, 72.

82. For details, see Kuru, "Sex in the Text," esp. 164.

83. I am grateful to Çiğdem Kafescioğlu for this suggestion. Bakhtin, *Rabelais and His World*.

84. Ghamīn bād ānke u shādat nakhvāhad / Kharāb an kas ke ābādat nakhvāhad / Hame bar kām-e dil firūzī-at bād / Ze Yazdān har che khvāhī rūzī-at bād.

85. Kuru, "Sex in the Text," 166.

86. Kuru, "Sex in the Text," 168.

87. Groebner, *Defaced*.

88. Kafadar, "How Dark," 263. One might be the stories in Nergisī's (d. 1635) *Khamse*, which according to Kavruk, *Eski Türk Edebiyatında Mansur Hikayeler*, 72, is full of original, "realist" love stories. Değirmenci, "Osmanlı Tasvir Sanatında Görselin 'Okunması,'"; and Değirmenci, "An Illustrated Mecmua," point to overlaps between popular literature and the visual arts.

89. Kafadar, "The Ottomans and Europe"; Kafadar, "Janissaries and Other Riffraff"; and Hattox, *Coffee and Coffeehouses*, 76–79. Matthee, "Exotic Substances," points to profound social changes in early modern Europe as one of the causes of the popularization of exotic substances and discusses the increasing separation of public and private life, and a resultant quest for "a private life that is on the basis of the freely chosen forms of social and political association. The emerging administrative, commercial and intellectual elites of Europe's secularizing urban centers engaged in new forms of social interaction, created new affiliations and frequented new gathering places, ranging from Masonic Lodges to scientific societies and literary salons."

90. Çuhadar, *Mustafa Sâfî*, 1:162–63. Murphey, "The Historian Mustafa Safi's Version of the Kingly Virtues," 83–85, discusses the section of Safi that is dedicated to the sultan's surprise appearances in public. Fleet and Boyar, *Social History of Istanbul*, 40, describes Ahmed as attuned to public outcries enough to execute his grand vizier Nasuh Pasha. Börekçi, "Factions and Favorites," 209, refers to a Venetian report in order to substantiate Ahmed's touring the city with Derviş Pasha, inspecting markets and streets, and punishing wrongdoers. But Boyar, "An Imagined Moral Community," 223, tells us that Selim II went out in disguise, too, and tried to locate prostitutes, as did Murad III. See also Gerlach, *Türkiye Günlüğü*, 600.

91. Murphey, "The Historian Mustafa Safi's Version of the Kingly Virtues," 84.

92. Börekçi, "Factions and Favorites," 99, 107–8, discusses Ahmed's eagerness to leave the palace.

93. Çuhadar, *Mustafa Sâfî*, 1:29–30.

94. Topçular Katibi Abdülkadir, *Tārīḥi āl-i Osmān*, Vienna National Library, ms. no. 1053, fols. 177b–180a, 189a–b.

95. By the time the end of the eighteenth century rolled around, there was a well-established tradition of the Ottoman ruler appearing in the city in disguise. This is attested by an image titled "grand seigneur en teptil ou incognito" in the BM Diez Album, "Costumes Turcs" 1974,0617,0.12.1, ca. 1790.

96. As argued by Kafescioğlu, "Sokağın, meydanın, şehirlilerin resmi."

97. Değirmenci, "Osmanlı Tasvir Sanatında Görselin 'Okunması.'" Fleet and Boyar, *Social History of Istanbul*, 207, write about the presence of women on the streets of Istanbul in the early modern period and show that there were public places for these women to go to. Terzioglu, "How to Conceptualize Ottoman Sunnitization," 321, refers to "the increased regulation of gender and sexual relations, and the attempts to control and contain everyday violence" at this time. See also Peirce, *Morality Tales*; Droor Zeevi, *Producing Desire*; Zilfi, *Women and Slavery in the Ottoman Empire*, esp. 45–95; and Semerdjian, *"Off the Straight Path."*

98. Mustafa Âli, for example, describes the different social classes who would gather there: "dervishes . . . intellectual circles who went there to talk and drink coffee, and . . . the poor who, having nowhere else to go on a limited budget, went there all the time. The janissaries and the *sipahis* were to be found there from morning to night, gossiping away in every corner, and there were those who played backgammon or chess or who gambled for money." Fleet and Boyar, *Social History of Istanbul*, 193; Sariyannis, "Mobs, Scamps, and Rebels."

99. Tezcan, *Second Ottoman Empire*, 125–26, refers to attempts to control smoking and other urban vices.

100. Fleet and Boyar, *Social History of Istanbul*, 106.

101. Fleet and Boyar, *Social History of Istanbul*, 190; Naima, *Tarih-i Naima*, 2:755–56. See also Matthee, "Exotic Substances," for a discussion of early modern instances of the banning of coffee, tobacco, and wine by many rulers. In the Ottoman case, Matthee points out that the banning of coffee and coffeehouses had a religious basis, as clerics were complaining that people congregated in coffeehouses rather than mosques, and tobacco had long been associated with dissent. He notes that "the articulation of prohibitive measures as a 'return to the true faith' tended to be intertwined with efforts to bolster the legitimacy of (new) rulers" (32).

102. Fleet and Boyar, *Social History of Istanbul*, 196.

103. Tezcan, *Second Ottoman Empire*, 66.

104. Sariyannis, "Prostitution," 50; and Andrews and Kalpaklı, *The Age of Beloveds*, 187–95. The authorities' warnings to boaters on the Bosphorus not to allow men and women to ride together (brought to scholarly attention years ago by Refik, *On altıncı Asırda Istanbul Hayatı, 1533–1591*, 41, no. 6), are also a reaction to public camaraderie between men and women.

105. Artan and Schick, "Ottomanizing Pornotopia," suggests as much for the many images of young men and women feasting in the countryside.

106. Abdülkadir, *Tarih-i āl-i Osmān*, fols. 308a–b ("Arslanḫane ve Naḳḳāsḫane ve ānbār yerleri ḳalḳub meydān olub").

107. Grelot, *A Late Voyage*, 210.

108. Fleischer, "Royal Authority, Dynastic Cyclism, and 'Ibn Khaldûnism' in Sixteenth-Century Ottoman Letters," 207. The notion of just rule is a central one for most premodern Islamic societies.

109. Terzioglu, "The Imperial Circumcision Festival," 88, suggests that the displays of exotic animals and performers from around the world at the 1582 celebration was one way in which the Ottomans hinted at their world dominion.

110. Alam, "Akhlaqi Norms and Mughal Governance," 72. I am grateful to Mika Natif for this reference.

111. Sharma, "City of Beauties," 75, 74.

112. See Brummett, *Mapping the Ottomans*, for many examples. I thank Thomas DaCosta Kaufmann for this suggestion.

CHAPTER SIX. EUROPEAN PRINTS FROM THE ALBUM

1. Roxburgh, "Disorderly Conduct?," 32–33.

2. Krstić, "Contesting Subjecthood and Sovereignty in Ottoman Galata in the Age of Confessionalization," 436.

3. Fetvacı, "From Print to Trace"; Necipoğlu, "Suleyman the Magnificent and the Representation of Power"; Necipoğlu, "Visual Cosmopolitanism and Creative Translation"; Raby, "Opening Gambits," 64–71, and cat. nos. 1–8 in Kangal, *The Sultan's Portrait*; Raby, "The Serenissima and the Sublime Port"; Raby, "Mehmed II's Greek Scriptorium"; Rodini, "The Sultan's True Face?"; Tezcan, "Law in China or Conquest in the Americas"; and Tezcan, "The Frank in the Ottoman Eye of 1583."

4. Brummett, "Mapping Trans-Imperial Ottoman Space," 32, 35.

5. I am inspired here by Fancy, "Theologies of Violence." Cultural interaction does not only happen despite religious differences; sometimes it happens because of them, he reminds us.

6. Thys-Şenocak, "The Yeni Valide Mosque Complex."

7. Terzioglu, "How to Conceptualize Ottoman Sunnitization," 321;

Krstić, *Contested Conversions*; and Tezcan, "Ethnicity, Race, Religion and Social Class: Ottoman Markers of Difference."

8. Rizvi, "The Suggestive Portrait of Shah ʿAbbas"; Moin, *Millennial Sovereign*; Melvin-Koushki, "Early Modern Islamicate Empire"; Melvin-Koushki, "Astrology, Lettrism, Geomancy"; Melvin-Koushki and Gardiner, *Islamicate Occultism*; Çıpa, *The Making of Selim*; Fleischer, "Ancient Wisdom and New Sciences"; Fleischer, "Mahdi and Millennium"; Fleischer, "The Lawgiver as Messiah"; Flemming, "Ṣāḥib-Ḳırān und Mahdī"; and Necipoğlu, "The Dome of the Rock as Palimpsest."

9. Fleischer, "Ancient Wisdom and New Sciences."

10. Yaman, "Osmanlı Resim Sanatında Kıyamet Alametleri."

11. Necipoğlu, "Early Modern Floral."

12. Roxburgh, *Persian Album*, 18 and passim.

13. Harvard Art Museums, 1985.277 and 1985.278 are a case in point. These are figural types just like those discussed in chapter 5. There is also a portrait of Selim II in the HAM collection (1985.217), likely from B 408.

14. Metropolitan Museum of Art, http://www.metmuseum.org/collection/the-collection-online/search/451978?pos=2&rpp=30&pg=1&ft=bellini+album.

15. I must here acknowledge the hard work of my research assistant Hyunjin Cho, who has discovered a lot of the information I provide here.

16. I am grateful to my colleague Eugenio Menegon for his help in deciphering and translating the Latin inscription and for sharing his deep knowledge of the Jesuit order with me.

17. At the University of Texas at Austin, Ransom Humanities Research Center.

18. I am grateful to Cristelle Baskins for the information and references on Orlandi. Orlandi seems also to have collaborated with Martino Rota, a Dalmatian printer. Orlandi's *Illustrium Virorum* includes the following: no. 38, Mehmet III; no. 39, Schiac Abbas; no. 40, Alhier sultan re di Tartari; no. 41, Sinan basha; no. 42, Aga Cap. Gianizeri; no. 43, Amurat Bassa; no. 44, Tartar Khan, killed 1596.

19. Porras, "St. Michael the Archangel," 187, calls Wierix's version of the image "strangely anti-militant" and argues that it was marketed to an international clientele of connoisseurs.

20. Nadine Orenstein, e-mail communication. I am grateful to Dr. Orenstein for sharing her expertise with me and helping me to identify some of these prints more confidently. She was kind enough to look over my identifications and offer corrections.

21. Jamie Gabbarelli has told me in private correspondence that he has seen "a set of prints printed in the same red ink dated 1599, printed on what appears to be 17th century paper. They were a set of Italian copies of Flemish prints, held in the Istituto Nazionale per la Grafica, in Rome (in volume 34. H. 24)."

22. I thank Nadine Orenstein again for this information.

23. I thank Nadine Orenstein for this identification.

24. For this I am grateful to Femke Speelberg and Nadine Orenstein of the Metropolitan Museum of Art.

25. According to Ainsworth, *Man, Myth, and Sensual Pleasures*, 426, the original painting was not by Mabuse but by an unknown artist. The print is dated to the late sixteenth or early seventeenth century.

26. I am grateful to Warren Woodfin for his help with identifying this line.

27. Petrus Firens died in 1638, according to Fleming, "Combining and Creating a Singular *Vita* of Ignatius of Loyola." See also Begheyn, "An Unknown Illustrated Life of Ignatius of Loyola by Petrus Firens (about 1609)." According to the Bibliothèque nationale de France website ("Pierre Firens I (1580?–1638)," http://data. bnf .fr/ark:/12148/cb12), Petrus (aka Pierre Firens I) was born in 1580 and died in 1638. He moved to Paris in the late sixteenth century and became "nationalized" in 1609. He worked as an engraver and printer. He has at least one collaboration with Maarten de Vos (d. 1603), on the images of the Passion of Christ.

28. I am grateful to Nadine Orenstein for so generously looking over my identifications and helping me to fill in the gaps.

29. I am grateful to Jamie Gabbarelli for sharing his thoughts with me.

30. Bosscha Erdbrink, *At the Threshold of Felicity*, 4.

31. Shakow, "Marks of Contagion," 319.

32. Shakow, "Marks of Contagion," 303. The English had been trying to secure such an agreement since the reign of Mehmed III with the famous organ that Queen Elizabeth sent to Mehmed as a gift. According to Dallam's report, Ahmed had the organ destroyed. The Venetians, of course had very long-standing trade relations with the Ottomans. Their gifts had been instrumental in the creation of the *Şemāʿilnāme*. For this manuscript, see Necipoğlu, "Word and Image"; and Fetvacı, "From Print to Trace." For a summary of Venetian-Ottoman gift exchange, see Raby, "The Serenissima and the Sublime Port."

33. Kalender, *Album of the World Emperor*, TPML, B 408, fols. 3a and b.

34. The chief eunuch, Hacı Mustafa Agha, Kalender's patron, was against the treaty, while Halil Pasha, Sadeddinzade Mehmed, the shaikh al-Islam, and others were in favor of it.

35. Bosscha Erdbrink, *At the Threshold of Felicity*, 5; and De Groot, "The Dutch Nation in Istanbul 1600–1985," esp. 31.

36. De Groot, "Dutch Nation," 31. Also supportive was the head of the privy chamber, the chief white eunuch, El Fakir Ahmed.

37. Swan, "Birds of Paradise," 54, describes the gifts presented by the Dutch to Sultan Ahmed: "Prints and maps and atlases and books, including eleven books by Calvin and the Atlas Mercator bound in red velvet as well as printed portraits of rulers on red satin in wooden frames."

38. De Groot, "Dutch Nation," 26–28.

39. For an overview of informal participants in diplomacy and of various go-betweens such as Jewish brokers, dragomans, and renegades in Istanbul and their role in everyday diplomacy, see Gürkan, "Mediating Boundaries."

40. Bevilacqua and Pfeiffer, "Turquerie," 78. They reference Van den Boogert, *The Capitulations and the Ottoman Legal System*, 7.

41. For example, Ethiopian church paintings from the 1610s are closely based on images printed in the Jesuit Jerome Nadal's *Evangelicae historiae imagines* of 1593. See Bosc-Tiessé, "The Use of Occidental Engravings in Ethiopian Painting in the Seventeenth and Eighteenth Centuries." Many European prints of Christian subject matter were available at the Mughal court at this time, as well.

42. See Parshall, "Antonio Lafreri's *Speculum Romanae Magnificentiae*," for a discussion of Renaissance print collections and their organizational principles.

43. Parshall, "Antonio Lafreri's *Speculum Romanae Magnificentiae*," 3.

44. Silver, *Peasant Scenes and Landscapes*, 53.

45. The publication in 1573 of a stock list of prints by Lafreri signals, as Parshall explains, the existence of a wide-ranging group of clientele, including tourists, amateurs, and humanists (Parshall, "Antonio Lafreri's *Speculum Romanae Magnificentiae*," 11). One of the subject areas in Lafreri's stock list is "Histories and devotional images from the Old and New Testaments by various painters and sculptors in two sizes" (Parshall, 12). I am not trying to suggest that the prints in the Bellini Album come from Lafreri's stocks but simply that these were very much the kinds of prints that were collected in the Renaissance and thus were available to a wide clientele, possibly including ones who had contacts at the Ottoman court.

46. For the location of this church, see Dursteler, *Venetians in Constantinople*, 25 (map).

47. Shakow, "Marks of Contagion," 345, with reference to Iorga, *Geschichte des osmanischen Reiches*, 3:399. For the history of the Jesuits in Istanbul, see Mun, "L'établissement des Jesuites a Constantinople sous le regne d'Achmet Ier." For the churches in Galata, see Dursteler, *Venetians in Constantinople*, 180–85; and Belin, *Histoire de la Latinité de Constatntinople*.

48. For both of these, see Shakow, "Marks of Contagion"; and Krstić, "Contesting Subjecthood."

49. Shakow, "Marks of Contagion"; and Krstić, "Contesting Subjecthood."

50. Shakow, "Marks of Contagion"; and Krstić, "Contesting Subjecthood."

51. Krstić, *Contested Conversions*; and Krstić, "Contesting Subjecthood."

52. Chodkiewicz, "La reception de la doctrine d'Ibn ʿArabī dans le Monde Ottoman."

53. Khalidi, *The Muslim Jesus*, provides selections from the works of many Muslim thinkers, including Ibn Arabi and al Ghazali (the quotations from al Ghazali form one of the longest sections in Khalidi's book, 164–87, that refer to Jesus).

54. Kessler and Wolf, *The Holy Face and the Paradox of Representation*.

55. See Fetvacı, *Picturing History*, 164–75.

56. See, for example, the cover of Krstić's *Contested Conversions*, where an image from a 1595 Ottoman copy of the ʿAjāʾib al Makhlūqāt juxtaposes a domed mosque with a triangular-roofed church.

57. Blair, *A Compendium of Chronicles*, 116.

58. Milstein, Rührdanz, and Schmitz, *Stories of the Prophets*, argue for Istanbul as the place of production, but stylistically these works are more similar to Ottoman manuscripts made in Baghdad.

59. Milstein et al., *Stories of the Prophets*, 155–60.

60. See Milstein et al., *Stories of the Prophets*, figs. 8, 62.

61. Thackston, *Tales of the Prophets*, 334.

62. Milstein et al., *Stories of the Prophets*, 159.

63. Milstein et al., *Stories of the Prophets*, 159.

64. Artan, "Arts and Architecture," 417, argues that many of the images in Kalender's *Fālnāme* depended on western European images.

65. Shalem, "Objects as Carriers of Real or Contrived Memories in a Cross-Cultural Context," points to the role of cross-cultural gifts as information carriers and reminds us how important it is to consider the information-bearing character of foreign objects.

66. Given the portability and multiplicity of prints, it is possible the *Zübdet* image is based on a copy or a similar print, but why postulate

another model that we cannot verify when we have a possible model still in existence and in Ottoman hands?

67. Necipoğlu, "The Life of an Imperial Monument." Ousterhout, "A Sixteenth Century Visitor to the Chora," shows that the mosaics and frescoes were in full view in the late sixteenth century.

68. Blair, *Compendium of Chronicles*, 46–54, discusses the potential Byzantine and western European models for the paintings in Rashid al Din's history.

69. Komaroff, "The Transmission and Dissemination of a New Visual Language."

70. Roxburgh, *Persian Album*, 85–147. Additionally, Adamova, "Repetition of Compositions in Manuscripts," reminds us that not only were earlier paintings commonly used as models in the Timurid context but that connoisseurship entailed recognizing such artistic debts.

71. The Timurid era "Arzadasht" [Petition], trans. Thackston, *Album Prefaces and Other Documents on the History of Calligraphers and Painters*, 43–46, provides ample evidence of this, as do the Ottoman wage registers that show the painter-designers were paid more than others. See Lentz and Lowry, *Timur and the Princely Vision*; Kazan, *XVI. Asırda Sarayın Sanatı Himayesi*, 137–86; Fetvacı, "Office of the Ottoman Court Historian"; and Çağman, "Behind the Ottoman Canon."

72. Fetvacı, "From Print to Trace."

73. Camille, *Mirror in Parchment*, 339, writes: "'Intervisuality' is the pictorial equivalent of what literary scholars call 'intertextuality.' It means not only that viewers seeing an image recollect others which are similar to it, and reconfigure its meaning in its new context according to its variance, but also that in the process of production one image often generates another by purely visual association. Once we accept this extra-textual and visual realm of meaning the possibilities of interpretation become less textually stratified and suggest a multiplicity of different available readings for different spectators."

74. Yaman, "Osmanlı Resim Sanatında Kıyamet Alametleri," 40–42.

75. Different interpretations of the Mahdi exist in Islamic history. According to one interpretation, Jesus was the Mahdi that the Prophet Muhammad spoke of. See Blichfeldt, *Early Mahdism*, 2. Blichfeldt also reminds us that the word "Mahdi" does not appear in the Qur'an (5–6).

76. Smith, "al-Bisṭāmī, ʿAbd al-Raḥmān"; and Fleischer, "Ancient Wisdom and New Sciences."

77. Yaman, "Osmanlı Resim Sanatında Kıyamet Alametleri," figs. 145, 147, 151.

78. Fetvacı, "Others and Other Geographies in the *Şehnāme-i Selīm Ḫān*."

79. The differences between the two *Miftāḥ* manuscripts are painstakingly highlighted by Yaman, "Osmanlı Resim Sanatında Kıyamet Alametleri."

80. İÜK F 1422. The manuscripts in the İÜK were brought here from the Yıldız Palace, and they were transferred to Yıldız from the Topkapı in the nineteenth century for conservation.

81. I am grateful to Christopher Jones for pointing this out.

82. Brentjes, "Astronomy a Temptation?"

83. The observatory is discussed by Necipoğlu, "Scrutinizing Gaze," 37–39, where she emphasizes the intellectual and scientific connections between the Ottoman Empire and western Europe; but also by El-Rouayheb, *Islamic Intellectual History*, 18–20.

84. An earlier parallel case is provided by Timurid reactions to Chinese Buddhist drawings, discussed in Roxburgh, "The Journal of Ghiyath al-Din Naqqash, Timurid Envoy to Khan Balïgh, and Chinese Art and Architecture." Roxburgh discusses two Timurid drawings that react to Chinese images of Buddhist lohans. In one case the artists chose to retain certain aspects of the Chinese drawing style, such as the animated, fluid brushstrokes; in the second example, the "expressive affect of the brushstrokes" is abandoned in favor of local graphic techniques.

85. It is also interesting to note that prints were indeed developed in Europe to do precisely that—to carry information. See Dackerman, *Prints and the Pursuit of Knowledge in Early Modern Europe*. A similar case might be the Timurid use of some Buddhist and Chinese materials, for which see Roxburgh, "The Journal of Ghiyath al-Din Naqqash."

86. Necipoğlu, "Persianate Images between Europe and China."

87. Parshall, "Antonio Lafreri's *Speculum Romanae Magnificentiae*," discusses Renaissance print collections as companions to other books.

88. Melvin-Koushki, "Of Islamic Grammatology," esp. 86–88.

89. According to Andrews, *Poetry's Voice, Society's Song*, 158–59: "In a poetic context, there are a number of terms in addition to *dostan* and *yaran* such as *ehl-i dil, erbab-ı dil* (people of the heart), *ehl-i batin* (people of the inner, esoteric interpretation), and *eshab-i keml/kemal* (people of perfection, completeness) that derive from the domain of the mystical-religious and designate the friends. In this use, the above terms can be taken to mean those who accept the rules of the emotional (mystical) interpretation and the party activity."

90. Thackston, "Appendix II C," 305–6, in Bağcı, "Presenting *Vaṣṣāl* Kalender's Works."

91. Fleischer, "Ancient Wisdom and New Sciences." Such a cyclical worldview was part and parcel of apocalyptic and millennial views in Middle Eastern religions in general and in Islam in particular. See Amanat, *Apocalyptical Islam*, 19–40. On 25–29, Amanat writes about the centrality of a cyclical vision to the coming of the messiah. Such vision is easily at work in the *Miftāḥ* and the *Album of the World Emperor*.

92. Artan and Schick, "Ottomanizing Pornotopia," also makes this suggestion. Artan similarly links the images of feasting found in Ahmed's *Tuhfetü'l-mülūk ve's-selātīn* to the *Miftāḥ-ı Cifrü'l-cami* in Artan, "A Book of Kings." See also Artan, "Ahmed I's Hunting Parties," which interprets the depictions of these feasts in the *Miftāḥ* as "real life scenes . . . fitted into a religious, legitimating framework" (121).

93. Rice, "The Brush and the Burin."

94. For the role of foreign objects as carriers of information, see Shalem, "Objects as Carriers of Real or Contrived Memories," where the author also touches on the fact that the function of objects traveling across cultural contexts also changed. See also Shalem, "Multivalent Paradigms of Interpretation and the Aura or Anima of the Object."

Bibliography

MANUSCRIPTS

Abdülkadir, Topçular Katibi. *Tārīḫ-i āl-i ʿOsmān*. National Library, Vienna. No. 1053.

Anonymous. *Endowment Deed of the Sultan Ahmed Mosque*, Istanbul. TSMK, Istanbul. E. H. 3036.

Anonymous. *Gencīne-i ʿAdālet*. TSMK, Istanbul. B 348.

Anonymous. *Habits of the Grand Signor's Court*. British Museum, London. 1928-3-23-046.

Anonymous. Naẓīre Collection. TSMK, Istanbul, B 406.

Anonymous. *Tuḥfetüʾl-mülūk veʾs-selāṭīn*. TSMK, Istanbul. H. 415.

Bistami, Abd ar Rahman. *Miftāḥ-ı cifrüʾl-cāmiʿ*. SYEK, Istanbul. 1060.

Kalender. *Fālnāme*. TSMK, Istanbul, H 1703.

———. *Muraḳḳaʿ-ı Pādişāh-ı Cihān Sulṭān Aḥmed Ḫān* [*Album of the World Emperor Sultan Ahmed Khan*]. TSMK, Istanbul. B 408.

Kelami. *Vaḳāʾiʿ-i ʿAlī Pāşā*. SYEK, Istanbul. Halet Efendi 612.

Kemaleddin Mehmed Efendi, Taşköprüzade. Preface to calligraphy album of Ahmed I by Kalender. TSMK, Istanbul. H 2171.

Lokman, Seyyid. *Şāhinşāhnāma*. 1601. Khoda Bakhsh Library, Patna. Persian ms. 265.

———. *Şāhnāma-i al-i ʿOsmān*. BL, London. Add. 7931.

———. *Zübdetüʾt-tevārīḫ*. Türk ve Islam Eserleri Müzesi, Istanbul. 1973.

Nadiri, Ganizade. *Dīvān*. TSMK, Istanbul. H. 889.

Sadeddin, Hoca, ibn Hasan Can. *Tācüʾt-tevārīḫ*. Musée Jacquemart-André, Paris. D262.

Şerifi, trans. *Miftāḥ-ı cifrüʾl-cāmiʿ*. TSMK, Istanbul. B 373.

———. *Miftāḥ-ı cifrüʾl-cāmiʿ*. IÜK, Istanbul. T 6624.

PUBLISHED SOURCES

Açıkgöz, Namık. "Riyâzî." In *TDVIA*.

Adamova, Ada. "Repetition of Compositions in Manuscripts: The Khamsa of Nizami in Leningrad." In *Timurid Art and Culture: Iran and Central Asia in the Fifteenth Century*, edited by Lisa Golombek and Maria Subtelny, 67–75. Leiden: Brill, 1992.

Ahmed, Shahab. *What Is Islam? The Importance of Being Islamic*. Princeton, NJ: Princeton University Press, 2016.

Ainsworth, Maryan Wynn. *Man, Myth, and Sensual Pleasures: Jan Gossart's Renaissance: The Complete Works*. New York: Metropolitan Museum of Art, 2010.

Akgündüz, Ahmed. *Osmanlı Kanunnameleri ve Hukuki Tahlilleri*. 9 vols. Istanbul: Osmanlı Araştırmaları Vakfı, 1990.

Akın-Kıvanç, Esra. *Mustafa ʿÂli's "Epic Deeds of Artists": A Critical Edition of the Earliest Ottoman Text about the Calligraphers and Painters of the Islamic World*. Leiden: Brill, 2011.

Aksan, Virginia, and Daniel Goffman, eds. *The Early Modern Ottomans*. Cambridge: Cambridge University Press, 2007.

Alam, Muzaffar. "Akhlaqi Norms and Mughal Governance." In *The Making of Indo-Persian Culture: Indian and French Studies*, edited by Muzaffar Alam, Françoise Nalini Delvoye, and Marc Gaborieau, 67–95. New Delhi: Manohar, 2000.

ʿĀlī, Mustafa. *Cāmiʿuʾl-buhūr der Mecālis-i Sūr*. Edited by Ali Öztekin. Ankara: Türk Tarih Kurumu, 1996.

———. *Divan*. Edited by İsmail Hakkı Aksoyak. Cambridge, MA: Department of Near Eastern Languages and Literatures, Harvard University, 2006.

———. *Künhül Ahbar*. 5 vols. Istanbul: Darüttıbaatil ʾâmire, 1861–69.

———. *Menāḳıb-ı hünerverān*. Edited by Ibnülemin Mahmud Kemal. Istanbul: Matbaa-i Amire, 1926.

———. *Mustafa Âli's Counsel for the Sultans of 1581*. Translated by Andreas Tietze. Vienna: Verlag der Oesterreichischen Akademie der Wissenschaften, 1979.

Ali, Samer. *Arabic Literary Salons in the Islamic Middle Ages*. Notre Dame, IN: University of Notre Dame Press, 2010.

Alparslan, Ali. *Ünlü Türk Hattatları*. Ankara: Kültür Bakanlığı, 1992.

Altınpay, Hüseyin. "Hocazâde Abdülaziz Efendi Ahlâk-ı Muhsini Tercümesi." MA thesis, Celal Bayar University, 2008.

Amanat, Abbas. *Apocalyptic Islam and Iranian Shi'ism*. London: I. B. Tauris, 2009.

And, Metin. "17. Yüzyıl Türk Çarşı Ressamları." *Tarih ve Toplum* 16 (1985): 40–44.

Andrews, Walter G. "Literary Art of the Golden Age." In *Süleyman the Second and His Time*, edited by Halil Inalcık and Cemal Kafadar, 353–68. Istanbul: Isis Press, 1993.

———. *Poetry's Voice, Society's Song: Ottoman Lyric Poetry*. Seattle: University of Washington Press, 1985.

———. "Starting over Again: Some Suggestions for Rethinking Ottoman Divan Poetry in the Context of Translation and Transmission." In *Translations: (Re)Shaping of Literature and Culture*, edited by Saliha Paker, 15–37. Istanbul: Boğaziçi University Press, 2002.

Andrews, Walter G., Najaat Black, and Mehmet Kalpaklı, eds. and trans. *Ottoman Lyric Poetry: An Anthology*. Austin: University of Texas Press, 1997.

Andrews, Walter G., and Mehmet Kalpaklı, *The Age of Beloveds: Love and the Beloved in Early-Modern Ottoman and European Culture and Society*. Durham, NC: Duke University Press, 2005.

Anonymous. "Tarih-i Bina-yı Cami-i Sultan Ahmed-i Evvel." Published in Rüstem, "The Spectacle of Legitimacy," 270ff.

Arcak, Sinem. "Gifts in Motion: Ottoman-Safavid Cultural Exchange, 1501–1618." PhD diss., University of Minnesota, 2012.

Arı, Bülent. "Istanbul'da corps Diplomatique ve Azîz Mahmud Hüdâyî." In *Azîz Mahmud Hüdâyî: Uluslararası sempozyum bildirileri, 20–22 Mayıs 2005*, edited by Hasan Kamil Yılmaz, 2:39–50. Istanbul: Üsküdar Belediyesi, 2008.

Arnaldez, R., "al-Insān al-Kāmil." In *EI2*. Accessed July 17, 2018, http://dx.doi.org.ezproxy.bu.edu/10.1163/1573-3912_islam_COM_0375.

Artan, Tülay. "Ahmed I's Hunting Parties: Feasting in Adversity, Enhancing the Ordinary." In *Starting with Food: Culinary*

Approaches to Ottoman History, edited by Amy Singer, 93–138. Princeton, NJ: Markus Wiener Publishers, 2011.

Artan, Tülay. "Arts and Architecture." In *The Cambridge History of Turkey*. Vol. 3, *The Later Ottoman Empire, 1603–1839*, edited by Suraiya N. Faroqhi, 408–81. Cambridge: Cambridge University Press, 2006.

———. "A Book of Kings Produced and Presented as a Treatise on Hunting." *Muqarnas* 25 (2008): 299–330.

———. "Forms and Forums of Expression: Istanbul and Beyond, 1600–1800." In *The Ottoman World*, edited by Christine Woodhead, 378–405. London: Routledge, 2011.

———. "Objects of Consumption: Mediterranean Interconnections of the Ottomans and Mamluks." In Flood and Necipoğlu, *A Companion to Islamic Art and Architecture*, 903–30.

Artan, Tülay, and Irvin C. Schick. "Ottomanizing Pornotopia: Changing Visual Codes in Eighteenth-Century Ottoman Erotic Miniatures." In *Eros and Sexuality in Islamic Art*, edited by Francesca Leoni and Mika Natif, 157–207. Farnham, UK: Ashgate, 2013.

Atanasiu, Vlad. *De la fréquence des lettres et de son influence en calligraphie arabe*. Paris: L'Harmattan, 1999.

Atasoy, Nurhan. "Hırka-i Saadet." In *TDVIA*.

Atbaş, Zeynep Çelik. "Dağılmış bir Safevi Murakkasının 18. Yüzyıla Ait bir Osmanlı Murakkasında Değerlendirilişi." In *Gelenek, Kimlik, Bireşim: Kültürel Kesişmeler ve Sanat: Günsel Renda'ya Armağan*, edited by Zeynep Yasa Yaman and Serpil Bağcı, 51–60. Ankara: Hacettepe Üniversitesi, 2011.

———. "Topkapı Sarayı Müzesi Kütüphanesi'ndeki H. 2155 numaralı Murakka." MA thesis, Istanbul Mimar Sinan University, 2003.

Atıl, Esin. *The Age of Sultan Süleyman the Magnificent*. Washington, DC: National Gallery of Art; New York: H. N. Abrams, 1987.

———. "Ahmed Nakşi, an Eclectic Painter of the Early Seventeenth Century." In *Fifth International Congress of Turkish Art*, edited by Geza Feher, 103–121. Budapest: Akadémiai Kiadó, 1978.

———. "The Art of the Book." In *Turkish Art*, edited by Esin Atıl., 137–238. Washington DC: Smithsonian Institution Press; New York: H. N. Abrams, 1980.

———. *Süleymanname: The Illustrated History of Süleyman the Magnificent*. Washington, DC: National Gallery of Art; New York: H. N. Abrams, 1986.

Avcıoğlu, Nebahat. "Ahmed I and the Allegories of Tyranny in the Frontispiece of George Sandy's *Relation of a Journey*." *Muqarnas* 18 (2001): 203–26.

Ayan, H. "Cevri Ibrahim Çelebi." In *TDVIA*.

Aynur, Hatice. "Ottoman Literature." In *The Cambridge History of Turkey*. Vol. 3, *The Later Ottoman Empire, 1603–1839*, edited by Suraiya Faroqhi, 481–520. Cambridge: Cambridge University Press, 2006.

Aynur, Hatice, Müjgan Çakır, and Hanife Koncu, eds. *Sözde ve Anlamda Farklılaşma: Sebk-i hindî 29 Nisan 2005 Bildiriler*. Istanbul: Türkuaz, 2006.

Babacan, İsrafil. *Klasik Türk Şiirinin Son Baharı, Sebk-i Hindi (Hint Üslubu)*. Ankara: Akçağ Yayınları, 2010.

Babaie, Sussan. *Isfahan and Its Palaces: Statecraft, Shi'ism, and the Architecture of Conviviality in Early Modern Iran*. Edinburgh: Edinburgh University Press, 2008.

———. "The Sound of the Image / The Image of the Sound: Narrativity in Persian Art of the Seventeenth Century." In *Islamic Art and Literature*, edited by Oleg Grabar and Cynthia Robinson, 143–62. Princeton, NJ: Markus Wiener Publishers, 2001.

Babaie, Sussan, Kathryn Babayan, Ina Baghdianz-McCabe, and Massumeh Farhad. *Slaves of the Shah: New Elites of Safavid Iran*. London: I. B. Tauris, 2004.

Babaie, Sussan, and Çiğdem Kafescioğlu. "Istanbul, Isfahan and Delhi: Imperial Designs and Urban Experiences in the Early Modern Era." In Flood and Necipoğlu, *A Companion to Islamic Art and Architecture*, 846–73.

Babayan, Kathryn. *Mystics, Monarchs, and Messiahs: Cultural Landscapes of Early Modern Iran*. Cambridge, MA: Harvard University Press, 2002.

Bağcı, Serpil. "Beast of the Earth." In *Falnama: The Book of Omens*, edited by Massumeh Farhad with Serpil Bağcı, 203. Washington, DC: Freer Gallery of Art and the Arthur M. Sackler Gallery, Smithsonian Institution, 2009.

———. "The Falnama of Ahmed I (TSM H. 1703)." In *Falnama: The Book of Omens*, edited by Massumeh Farhad with Serpil Bağcı, 68–75. Washington, DC: Freer Gallery of Art and the Arthur M. Sackler Gallery, Smithsonian Institution, 2009.

———. "From Translated Word to Translated Image." *Muqarnas* 17 (2000): 162–76.

———. "The Poet Sa'di Dressed as a Monk." In *Falnama: The Book of Omens*, edited by Massumeh Farhad with Serpil Bağcı, 148. Washington, DC: Freer Gallery of Art and the Arthur M. Sackler Gallery, Smithsonian Institution, 2009.

———. "Presenting *Vaṣṣāl* Kalender's Works: The Prefaces of Three Ottoman Albums." *Muqarnas* 30 (2013): 255–313.

Bağcı, Serpil, Filiz Çağman, Günsel Renda, and Zeren Tanındı. *Osmanlı Resim Sanatı*. Istanbul: T. C. Kültür ve Turizm Bakanlığı Yayınları, 2006.

———. *Ottoman Painting*. Ankara: Republic of Turkey, Ministry of Culture and Tourism, Publications: Banks Association of Turkey, 2010.

Bağcı, Serpil, and Massumeh Farhad. "The Art of Bibliomancy." In *Falnama: The Book of Omens*, edited by Massumeh Farhad with Serpil Bağcı, 20–25. Washington, DC: Freer Gallery of Art and the Arthur M. Sackler Gallery, Smithsonian Institution, 2009.

Bailey, Gauvin A. *Art on the Jesuit Missions in Asia and Latin America, 1542–1773*. Toronto: University of Toronto Press, 1999.

———. *The Jesuits and the Grand Mogul: Renaissance Art at the Imperial Court of India 1580–1630*. Washington, DC: Freer Gallery of Art and the Arthur M. Sackler Gallery, Smithsonian Institution, 1998.

Bakhtin, Mikhail. *Rabelais and His World*. Bloomington: Indiana University Press, 1984.

Barkan, Ömer Lütfi. "Price Revolution in the Sixteenth Century: A Turning Point in the Economic History of the Near East." *IJMES* 6 (1975): 8–15.

Barozzi, Nicolo, and Guglielmo Berchet, eds. *Le relazioni degli stati europei lette al Senato dagli ambasciatori Veneziani nel secolo decimosettimo: Turchia*. Vol. 1, part 1. Venice, 1871.

Barthes, Roland. "The Reality Effect." In Barthes, *The Rustle of*

Language. Translated by Richard Howard, 141–48. Oxford: Blackwell, 1986.

Bayani, Mahdi. *Aḥvāl ve asār-i khūsh-nuvisān*. Tehran: University of Tehran, 1966–69.

Beach, Milo Cleveland. "The Mughal Painter Abu'l Hasan and Some English Sources for His Style." *Journal of the Walters Art Gallery* 38 (1979): 6–33.

Begheyn, S. J., Paul. "An Unknown Illustrated Life of Ignatius of Loyola by Petrus Firens (about 1609)." *Archivum Historicum Societatis Iesu*, vol. 75, fasc. 149 (2006): 137–57.

Belin, Alphonse. *Histoire de la latinité de Constantinople*. Paris: Picard, 1894.

Bentley, Jerry H. "Early Modern Europe and the Early Modern World." In *Between the Middle Ages and Modernity: Individual and Community in the Early Modern World*, edited by Charles H. Parker and Jerry H. Bentley, 13–32. Lanham, MD: Rowman and Littlefield, 2007.

Berlekamp, Persis. *Wonder, Image, and Cosmos in Medieval Islam*. New Haven, CT: Yale University Press, 2011.

Bernardini, Michele. "The Masnavi-Shahrashubs as Town Panegyrics: An International Genre in Islamic Mashriq." In *Narrated Space in the Literature of the Islamic World*, edited by Roxanne Haag-Higuchi and Christian Szyska, 81–94. Wiesbaden: Harrassowitz, 2001.

Bevilacqua, Alexander, and Helen Pfeiffer. "Turquerie: Culture in Motion, 1650–1750." *Past & Present* 221 (November 2013): 75–118.

Beyzade, Hasan. *Hasan Beyzâde Târîhi*. 3 vols. Ankara: Türk Tarih Kurumu Basımevi, 2004.

Bibliothèque nationale de France. "Pierre Firens I (1580?–1638)." https://data.bnf.fr/en/12245483/pierre_firens.

Bierman, Irene A. *Writing Signs: The Fatimid Public Text*. Berkeley: University of California Press, 1998.

Blair, Sheila. *A Compendium of Chronicles*. New York: Nour Foundation, Azimuth Editions; Oxford: Oxford University Press, 1995.

———. *Islamic Calligraphy*. Edinburgh: Edinburgh University Press, 2006.

———. "The Religious Art of the Ilkhanids." In *The Legacy of Genghis Khan: Courtly Art and Culture in Western Asia, 1256–1353*, edited by Linda Komaroff and Stefano Carboni, 104–33. New York: Metropolitan Museum of Art; New Haven, CT: Yale University Press, 2002.

Bleichmar, Daniela, and Meredith Martin, eds. "Objects in Motion in the Early Modern World." Special issue, *Art History* 38, no. 4 (September 2015).

Blichfeldt, Jan-Olaf. *Early Mahdism: Politics and Religion in the Formative Period of Islam*. Leiden: Brill, 1985.

Börekçi, Günhan. "Factions and Favorites at the Courts of Sultan Ahmed I (r. 1603–1617) and His Immediate Predecessors." PhD diss., Ohio State University, 2010.

Bosc-Tiessé, Claire. "The Use of Occidental Engravings in Ethiopian Painting in the Seventeenth and Eighteenth Centuries." In *The Indigenous and the Foreign in Christian Ethiopian Art: On Portuguese-Ethiopian Contacts in the 16th–17th Centuries*, edited by Isabel Boavida and Manuel João Ramos, 83–102. Florence: Taylor and Francis, 2004.

Bosscha Erdbrink, G. R. *At the Threshold of Felicity: Ottoman-Dutch Relations during the Embassy of Cornelis Calkoen at the Sublime Porte, 1726–1744*. Ankara: Türk Tarih Kurumu Basımevi, 1975.

Botchkareva, Anastassiia. "Representational Realism in Cross-Cultural Perspective: Changing Visual Cultures in Mughal India and Safavid Iran, 1580–1750." PhD diss., Harvard University, 2014.

Boyar, Ebru. "An Imagined Moral Community: Ottoman Female Public Presence, Honour and Marginality." In *Ottoman Women in Public Space*, edited by Ebru Boyar and Kate Fleet, 187–229. Leiden: Brill, 2016.

Brady, Thomas A. "Confessionalization: The Career of a Concept." In *Confessionalization in Europe, 1555–1700: Essays in Honor and Memory of Bodo Nischan*, edited by John M. Headley, Hans J. Hillerbrand, and Anthony J. Papalas, 1–20. Aldershot, UK: Ashgate, 2004.

Brentjes, Sonja. "Astronomy a Temptation? On Early Modern Encounters across the Mediterranean Sea." In *Astronomy as a Model for the Sciences in Early Modern Times*, edited by M. Folkerts and A. Kühne, 15–45. Augsburg, DE: Erwin Rauner Verlag, 2006.

———. "On the Relation between Ottoman Empire and the West European Republic of Letters (17th–18th Centuries)." In *Proceedings of the International Congress on Learning and Education in the Ottoman World, Istanbul 12–15 April 1999* (Studies and Sources on Ottoman History Series, no. 6), edited by A. Çaksu, 121–48. Istanbul: Research Center for Islamic History, Art, and Culture, 2001.

Brookes, Douglas S., trans. and ed. *The Ottoman Gentleman of the Sixteenth Century: Mustafa Âli's "Mevāʾidü'n-Nefāis fī kavāʾidi'l-mecālis": "Tables of Delicacies concerning the Rules of Social Gatherings."* Cambridge, MA: Department of Near Eastern Languages and Civilizations, Harvard University, 2003.

Brookshaw, Dominic P. "Palaces, Pavilions and Pleasure-Gardens: The Context and Setting of the Medieval Majlis." *Middle Eastern Literatures* 6, no. 2 (2003): 199–223.

Brummett, Palmira. *Mapping the Ottomans: Sovereignty, Territory and Identity in the Early Modern Mediterranean*. New York: Cambridge University Press, 2015.

———. "Mapping Trans-Imperial Ottoman Space: Alterity and Attraction." In *Representing Imperial Rivalry in the Early Modern Mediterranean*, edited by Barbara Fuchs and Emily Weissbourd, 32–57. Toronto: University of Toronto Press in association with the UCLA Center for Seventeenth- and Eighteenth-Century Studies, 2015.

———. "The 'What if?' of the Ottoman Female: Authority, Ethnography, and Conversation." In *Ottoman Women in Public Space*, edited by Ebru Boyar and Kate Fleet, 18–47. Leiden: Brill, 2016.

Burian, Orhan, ed. *The Report of Lello: Third English Ambassador to the Sublime Porte / Babıâli nezdinde üçüncü İngiliz Elçisi Lello'nun muhtırası*. Ankara: Türk Tarih Kurumu Basımevi, 1952.

Burke, Peter. "Representations of the Self from Petrarch to Descartes." In *Rewriting the Self: Histories from the Middle Ages to the Present*, edited by Roy Porter, 17–28. London: Routledge, 2002.

Buzov, Snjezana. "Osmanlı'da karışık içerikli mecmûalar: Bir başka arşiv." In *Mecmûa: Osmanlı Edebiyatının kırkambarı*, edited by Hatice Aynur, Müjgân Çakır, Hanife Koncu, Selim S. Kuru, and Ali Emre Özyıldırım, 33–42. Istanbul: Turkuaz, 2012.

Cafagna, Ettore. "A Diplomatic Chessboard: Loukaris and the Western Diplomacies in Constantinople." In *Trame Controluce / Backlighting Plots*, edited by Viviana Nosilia and Marco Prandoni, 31–43. Florence: Firenze University Press, 2015.

Çağman, Filiz. *Ahmed Karahisarî Mushaf-ı Şerîfi Tıpkıbasımı*. Ankara: Kültür Bakanlığı, 2000.

———. "The Ahmed Karahisari Qur'an in the Topkapi Palace Museum Library in Istanbul." In *Persian Painting from the Mongols to the Qajars: Studies in Honor of Basil W. Robinson*, edited by Robert Hillenbrand, 57–74. London: I. B. Tauris, 2000.

———. "Behind the Ottoman Canon: The Workshops of the Imperial Palace." In *The Palace of Gold and Light: Treasures from the Topkapı, Istanbul*, 46–56. Washington, DC: Palace Arts Foundation, 2000.

———. "The Earliest Known Ottoman 'Murakka' Kept in Istanbul University Library." In *Seventh International Congress of Turkish Art*, edited by Tadesuz Majda, 75–78. Warsaw: Polish Scientific Publishers, 1990.

———. *Katʿı Cut Paper Works and Artists in the Ottoman World*. Istanbul: Aygaz, 2014.

———. "On the Contents of the Four Istanbul Albums H 2152, 2153, 2154 and 2160." *Islamic Art* 1 (1981): 31–36.

Çağman, Filiz, and Şule Aksoy. *Osmanlı Sanatında Hat*. Ankara: T. C. Kültür Bakanlığı, Anıtlar ve Müzeler Genel Müdürlüğü, 1998.

Çağman, Filiz, and Zeren Tanındı. "Illustration and the Art of the Book in the Sufi Orders of the Ottoman Empire." In *Sufism and Sufis in Ottoman Society: Sources-Doctrine-Rituals-Turuq-Architecture-Literature and Fine Arts-Modernism*, edited by Ahmet Yaşar Ocak, 501–27. Ankara: Turkish Historical Society, 2005.

———. "Remarks on Some Manuscripts from the Topkapı Palace Treasury in the Context of Ottoman-Safavid Relations." *Muqarnas* 13 (1996): 132–48.

———. *The Topkapı Saray Museum: The Albums and Illustrated Manuscripts*. Translated by Michael J. Rogers. Boston: Little, Brown, 1986.

Camille, Michael. *Mirror in Parchment: The Luttrell Psalter and the Making of Medieval England*. Chicago: University of Chicago Press, 1998.

Campbell, Caroline, and Alan Chong, eds. *Bellini and the East*. London: National Gallery; Boston: Isabella Stewart Gardner Museum, 2005.

Canby, Sheila. *The Rebellious Reformer: The Drawings and Paintings of Riza-yi Abbasi of Isfahan*. London: Azimuth Publishers, 1996.

Cantemir, Dimitri. *Osmanlı İmparatorluğu Tarihi*. Translated by Ö Çobanoğlu. 3 vols. Ankara: n.p., 1979.

Carboni, Stefano, ed. *Venice and the Islamic World, 828–1797*. New York: Metropolitan Museum of Art, 2007.

Casale, Giancarlo. *The Ottoman Age of Exploration*. Oxford: Oxford University Press, 2010.

Chodkiewicz, Michel. "La reception de la doctrine d'Ibn ʿArabī dans le monde Ottoman." In *Sufism and Sufis in Ottoman Society: Sources-Doctrine-Turuq-Architecture-Literature and Fine Arts-Modernism*, edited by Ahmet Yaşar Ocak, 97–120. Ankara: Turkish Historical Society, 2005.

———. *Seal of the Saints: Prophethood and Sainthood in the Doctrine of Ibn ʿArabi*. Cambridge: Islamic Texts Society, 1993.

Chong, Alan. "Seated Scribe, 1479–81." In *Bellini and the East*, edited by Caroline Campbell and Alan Chong, 122, cat. no. 32. London: National Gallery; Boston: Isabella Stewart Gardner Museum, 2005.

Christie's Sale 5495. Indian and Islamic Works of Art. April 16, 2010, London.

Çığ, Kemal, Sabahattin Batur, Cengiz Köseoğlu, and Michael Rogers. *The Topkapı Palace Museum, Architecture: the Harem and Other Buildings*. London: Thames and Hudson, 1988.

Çıpa, Erdem. *The Making of Selim: Succession, Legitimacy and Memory in the Early Modern Ottoman World*. Bloomington: Indiana University Press, 2017.

Clayer, Nathalie. *Mystiques, état et société: Les Halvetis dans l'aire balkanique de la fin du Xve siècle à nos jours*. Leiden: Brill, 1994.

Contarini, Simon. "Relazione del N. U. Simon Contarini Cav. Ritornato Bailo di Constantinopoli, l'anno 1612." In Barozzi and Berchet, *Le relazioni*, 125–254.

Cook, Michael. *Commanding Right and Forbidding Wrong in Islamic Thought*. Cambridge: Cambridge University Press, 2000.

———. *Population Pressure in Rural Anatolia 1450–1600*. London: Oxford University Press, 1972.

Cooper, D. J. C. "The Eastern Churches and the Reformation in the Sixteenth and Seventeenth Centuries." *Scottish Journal of Theology* 31 (1978): 417–33.

Crane, Howard, ed. *Risâle-i Miʿmâriyye: An Early Seventeenth Century Ottoman Treatise on Architecture*. Leiden: Brill, 1987.

Çuhadar, Ibrahim Hakkı, ed. *Mustafa Sâfî'nin Zübdetü't-tevârîh'i*. 2 vols. Ankara: Türk Tarih Kurumu, 2003.

Cummins, Thomas B. F., and Maria Judith Feliciano. "Mudejar Americano: Iberian Aesthetic Transmission in the New World." In Flood and Necipoğlu, *A Companion to Islamic Art and Architecture*, 1023–50.

Curry, John J. *The Transformation of Muslim Mystical Thought in the Ottoman Empire: The Rise of the Halveti Order, 1350–1650*. Edinburgh: Edinburgh University Press, 2010.

Dackerman, Susan. *Prints and the Pursuit of Knowledge in Early Modern Europe*. Cambridge, MA: Harvard Art Museums; New Haven, CT: Yale University Press, 2011.

Danişmend, Ismail Hami. *İzahlı Osmanlı Tarihi Kronolojisi*, 6 vols. Istanbul: Türkiye Yayınevi, 1947–71.

David, Jean-Claude, and Bruno Chauffert-Yvart. *Le Waqf d'Ipşîr Pâşâ à Alep (1063/1653): Étude d'urbanisme historique*. Damascus: Institut français de Damas, 1982.

Değirmenci, Tülün. *İktidar Oyunları ve Kitaplar: II. Osman Döneminde değişen güç simgeleri*. Istanbul: Kitap Yayınevi, 2012.

———. "An Illustrated Mecmua: The Commoner's Voice and the Iconography of the Court in Seventeenth-Century Ottoman Painting." *Ars Orientalis* 41 (2011): 186–218.

———. "Kahve Bahane, Kahvehane Şahane: Bir Osmanlı Kahvehanesinin 'Portresi.'" In *Bir taşım keyif: Türk kahvesinin 500 yıllık öyküsü*, edited by Ersu Pekin, 119–37. Ankara: Türk Kahvesi Kültürü ve Araştırmaları Derneği; T. C. Kültür ve Turizm Bakanlığı, 2015.

———. "Osmanlı Tasvir Sanatında Görselin 'Okunması': İmgenin Ardındaki Hikayeler (Şehir Oğlanları ve İstanbul'un Meşhur Kadınları) [Visual Reading or Reading with Images? Visuality and Orality in Ottoman Manuscript Culture (City Boys and Beautiful Women of Istanbul)]. *Journal of Ottoman Studies* 45 (2015): 25–55.

———. "Sözleri Dinlensin, Tasviri İzlensin: Tulūʿiʾnin *Paşanâme*'si ve 17. Yüzyıldan Eşkiya Hikayeleri." *Kebikeç* 33 (2012): 127–48.

De Groot, Alexander H. "The Dutch Nation in Istanbul 1600–1985: A Contribution to the Social History of Beyoğlu." In *The Netherlands and Turkey: Four Hundred Years of Political, Economical, Social and Cultural Relations; Selected Essays by Alexander de Groot*, 25–45. Istanbul: Isis, 2009.

Della Valle, Pietro. *The Journeys of Pietro Della Valle, the Pilgrim*. Translated, abridged, and introduced by George Bull. London: Folio Society, 1989.

Demirsoy, Soner, ed. *Kelâmî-i rûmî Vekayiʿ-i Ali Paşa: Yavuz Ali Paşa'nın Mısır valiliği (1601–1603)*. Istanbul: Çamlıca, 2012.

Denny, Walter. "Carpets, Textiles and Trade in the Early Modern Islamic World." In Flood and Necipoğlu, *A Companion to Islamic Art and Architecture*, 972–95.

Derman, Uğur. "Derviş Abdi-i Mevlevi." In *TDVIA*.

———. "Kanuni Devrinde Yazı San'atımız." In *Kanuni Armağanı*, 269–89. Ankara: Türk Tarih Kurumu Basımevi, 1970.

Dickie, James. "The Alhambra: Some Reflections Prompted by a Recent Study by Oleg Grabar." In *Studia Arabica et Islamica: Festschrift for Iḥsān ʿAbbās on His Sixtieth Birthday*, edited by Wadād al-Qāḍī, 127–49. Beirut: AUB Press, 1981.

D'Ohsson, Mouradgea. *Oriental Antiquities and General View of the Othoman Customs, Laws, and Ceremonies*. Philadelphia, 1788.

Dressler, Markus. "Inventing Orthodoxy: Competing Claims for Authority and Legitimacy in the Ottoman-Safavid Conflict." In *Legitimizing the Order: The Ottoman Rhetoric of State Power*, edited by Hakan Karateke and Maurus Reinkowski, 151–73. Leiden: Brill, 2005.

Dursteler, Eric. *Venetians in Constantinople: Nation, Identity, and Coexistence in the Early Modern Mediterranean*. Baltimore, MD: Johns Hopkins University Press, 2006.

Ebel, Kathryn A. "City Views, Imperial Visions: Cartography and the Visual Culture of Urban Space in the Ottoman Empire, 1453–1603." PhD diss., University of Texas at Austin, 2002.

Ekhtiar, Maryam D., Priscilla P. Soucek, Sheila R. Canby, and Navina Najat Haidar. *Masterpieces from the Department of Islamic Art in the Metropolitan Museum of Art*. New York: Metropolitan Museum of Art; New Haven, CT: Yale University Press, 2011.

Elçin, Şükrü. "Kitâbî, Mensur Realist Istanbul Hikâyeleri." In *Halk Edebiyatı Araştırmaları*, edited by Şükrü Elçin, 105–36. Ankara: Kültür Bakanlığı, 1977.

Elliott, Matthew. "Dress Codes in the Ottoman Empire: The Case of the Franks." In *Ottoman Costumes: From Textiles to Identity*, edited by Suraiya Faroqhi and Christoph K. Neumann, 103–23. Istanbul: Eren, 2004.

El-Rouayheb, Khaled. *Islamic Intellectual History in the Seventeenth Century: Scholarly Currents in the Ottoman Empire and the Maghreb*. Cambridge: Cambridge University Press, 2015.

Emiralioğlu, Mevhibe Pınar. *Geographical Knowledge and Imperial Culture in the Early Modern Ottoman Empire*. Farnham, UK: Ashgate, 2014.

Ergin, Nina. "The Fragrance of the Divine: Ottoman Incense Burners and Their Context," *Art Bulletin*, 96, no. 1 (2014): 70–97.

———. "The Soundscape of Sixteenth-Century Istanbul Mosques: Architecture and Qur'an Recital." *Journal of the Society of Architectural Historians* 67, no. 2 (June 2008): 204–21.

Ertuğ, Zeynep Tarım. "Entertaining the Sultan: *Meclis*, Festive Gatherings in the Ottoman Palace." In *Celebration, Entertainment and Theatre in the Ottoman World*, edited by Suraiya Faroqhi and Arzu Ozturkmen, 124–44. London: Seagull Books, 2014.

———. *XVI. Yüzyıl Osmanlı Devletinde Cülüs ve Cenaze Törenleri*. Ankara: Kültür ve Turizm Bakanlığı, 1999.

Eryılmaz, Fatma Sinem. "The Shehnamecis of Sultan Süleyman: ʿArif and Eflatun and Their Dynastic Projects." PhD diss., University of Chicago, 2010.

Erzen, Jale. *Mimar Sinan Dönemi Cami Cepheleri*. Ankara: ODTÜ Mimarlık Fakültesi Basım İşliği, 1981.

Ettinghausen, Richard. "Arabic Epigraphy: Communication or Symbolic Affirmation?" In *Near Eastern Numismatics, Iconography, Epigraphy and History: Studies in Honour of George C. Miles*, edited by Dickran K. Kouymjian, 297–319. Beirut: American University of Beirut, 1974.

Evliya Çelebi. *Seyahatname*. 10 vols. Edited and transcribed by Yücel Dağlı, Robert Dankoff, Orhan Şaik Gökyay, Seyit Ali Kahraman, Zekeriya Kurşun, and Ibrahim Sezgin. Istanbul: Yapı Kredi Yayınları, 1996–2007.

Fancy, Hussein. "Theologies of Violence: The Recruitment of Muslim Soldiers by the Crown of Aragon." *Past & Present* 221, no. 1 (2013): 39–73.

Farago, Claire. "On the Peripatetic Life of Objects in the Era of Globalization." In *Cultural Contact and the Making of European Art since the Age of Exploration*, edited by Mary D. Sheriff, 17–42. Chapel Hill: University of North Carolina Press, 2010.

Farhad, Massumeh. "Safavid Single Page Painting 1629–1666." PhD diss., Harvard University, 1987.

Farhad, Massumeh, and Serpil Bağcı. "The Falnama in the Sixteenth and Seventeenth Centuries." In *Falnama: The Book of Omens*, edited by Massumeh Farhad with Serpil Bağcı, 27–39. Washington, DC: Arthur M. Sackler Gallery, Smithsonian Institution, 2009.

Farhad, Massumeh, with Serpil Bağcı, eds. *Falnama: The Book of Omens*. Washington, DC: Arthur M. Sackler Gallery, Smithsonian Institution, 2009.

Farhad, Massumeh, and Marianna Shreve Simpson. "Safavid Arts and Diplomacy in the Age of the Renaissance and Reformation." In Flood and Necipoğlu, *A Companion to Islamic Art and Architecture*, 931–71.

Faroqhi, Suraiya. "Crisis and Change, 1590–1699." In *An Economic and Social History of the Ottoman Empire*. Vol. 2, 1600–1914, edited by Halil Inalcık and Donald Quataert, 411–636. Cambridge: Cambridge University Press, 1994.

———. *The Ottoman Empire and the World around It*. London: I. B. Tauris, 2008.

———. *Travel and Artisans in the Ottoman Empire: Employment and Mobility in the Early Modern Era*. London: I. B. Tauris, 2014.

Feldman, Walter. "Imitatio in Ottoman Poetry: Three Ghazals of the Mid-Seventeenth Century," *Turkish Studies Association Bulletin* 21, no. 2 (1997): 41–58.

Felek, Özgen, ed. *Kitābü'l-Menāmāt: Sultan III. Murad'ın Rüya Mektupları*. Istanbul: Tarih Vakfı Yurt Yayınları, 2014.

———. "(Re)creating Image and Identity: Dreams and Visions as a

Means of Murād III's Self-Fashioning." In *Dreams and Visions in Islamic Societies*, edited by Özgen Felek and Alexander Knysh, 249–71. Albany: State University of New York Press, 2012.

Fetvacı, Emine. "The Album of Ahmed I." *Ars Orientalis* 42 (2012): 127–38.

———. "The Album of Mehmed III: An Inquiry into Genre." In *Prof. Dr. Zeren Tanındı Armağanı: İslam Dünyasında Kitap Kültürü ve Sanatı*, edited by Serpil Bağcı and Aslıhan Erkmen. Forthcoming, 2019.

———. "Enriched Narratives and Empowered Images in Seventeenth Century Ottoman Manuscripts." *Ars Orientalis* 40 (2011): 243–67.

———. "From Print to Trace: An Ottoman Imperial Portrait Book and Its Western European Models." *Art Bulletin* 95, no. 2 (June 2013): 243–68.

———. "The Gaze in the Album of Ahmed I." *Muqarnas* 32 (2015): 135–54.

———. "Love in the Album of Ahmed I." *Journal of Turkish Studies* 34 (2010): 37–51.

———. "Music, Light, and Flowers: The Changing Aesthetics of Ottoman Architecture." *Journal of Turkish Studies* 32, no. 1 (Fall 2008): 221–40.

———. "The Office of the Ottoman Court Historian." In *Studies on Istanbul and Beyond,* edited by Robert G. Ousterhout, 7–21. Philadelphia: University of Pennsylvania Museum of Archaeology and Anthropology, 2007.

———. "Others and Other Geographies in the *Şehnāme-i Selīm Ḫān*." *Journal of Ottoman Studies* 40 (2012): 81–100.

———. "Ottoman Author Portraits in the Early-Modern Period." In *Affect, Emotion, and Subjectivity in Early Modern Islamic Empires: New Studies in Ottoman, Safavid, and Mughal Art and Culture,* edited by Kishwar Rizvi, 66–94. Leiden: Brill, 2017.

———. *Picturing History at the Ottoman Court*. Bloomington: Indiana University Press, 2013.

Fleet, Kate, and Ebru Boyar. *A Social History of Ottoman Istanbul*. Cambridge: Cambridge University Press, 2010.

Fleischer, Cornell H. "Ancient Wisdom and New Sciences: Prophecies at the Ottoman Court in the Fifteenth and Sixteenth Centuries." In *Falnama: The Book of Omens*, edited by Massumeh Farhad with Serpil Bağcı, 231–43. Washington, DC: Arthur M. Sackler Gallery, Smithsonian Institution, 2009.

———. *Bureaucrat and Intellectual in the Ottoman Empire: The Historian Mustafa Âli*. Princeton, NJ: Princeton University Press, 1986.

———. "The Lawgiver as Messiah: The Making of the Imperial Image in the Reign of Süleyman." In *Soliman le Magnifique et son temps*, edited by Gilles Veinstein, 159–77. Paris: Documentation Française, 1992.

———. "Mahdi and Millennium: Messianic Dimensions in the Development of Ottoman Imperial Ideology." In *The Great Ottoman-Turkish Civilization*. Vol. 3, *Philosophy, Science, and Institutions*, edited by Kemal Çiçek, 42–54. Ankara: Yeni Türkiye Yayınları, 2000.

———. "Royal Authority, Dynastic Cyclism, and 'Ibn Khaldûnism' in Sixteenth-Century Ottoman Letters." *Journal of Asian and African Studies* 18, nos. 3–4 (1983): 198–220.

———. "Secretaries' Dreams: Augury and Angst in Ottoman Scribal Service." In *Armağan: Festschrift für Andreas Tietze*, edited by Ingeborg Baldauf and Suraiya Faroqhi, with Rudolf Veselý, 77–88. Prague: Enigma Corporation, 1994.

———. "Seer to the Sultan: Haydar-ı Remmal and Sultan Süleyman." In *Cultural Horizons: A Festschrift in Honor of Talat S. Halman*, 2 vols., edited by Jayne L. Warner, 1:290–99. Syracuse, NY: Syracuse University Press, 2001.

———. "Shadows of Shadows: Prophecy in Politics in 1530s Istanbul." *International Journal of Turkish Studies* 13, nos. 1–2 (2007): 51–62.

Fleming, Alison. "Combining and Creating a Singular *Vita* of Ignatius of Loyola." In *Privater Buchbesitz in der Renaissance: Bild, Schrift und Layout*, edited by Angela Dressen and Susanne Gramatzki. *kunsttexte. de* (March 2014): 1–14. https://edoc.hu-berlin.de/bitstream/handle/18452/8327/-fleming.pdf.

Flemming, Barbara. "The Political Genealogies in the Sixteenth Century." *Journal of Ottoman Studies* 7–8 (1988): 198–220.

———. "Ṣāḥib-Ḳırān und Mahdī: Türkische Endzeitwartungen im ersten Jahrzehnt der Regierung Süleymāns." In *Between the Danube and the Caucasus*, edited by György Kara, 43–62. Budapest: Akadémiai Kiadó, 1987.

Fletcher, Joseph F. "Integrative History: Parallels and Interconnections in the Early Modern Period, 1500–1800." In Fletcher, *Studies on Chinese and Islamic Inner Asia*, edited by Beatrice Forbes Manz. Variorum Collected Studies. London: Routledge, 1995. Reprinted from *Journal of Turkish Studies* 9 (1985): 1–35.

Flood, Finbarr Barry. "From Prophet to Postmodernism? New World Orders and the End of Islamic Art." In *Making Art History: A Changing Discipline and Its Institutions*, edited by Elizabeth Mansfield, 31–53. London: Routledge, 2007.

Flood, Finbarr Barry, and Gülru Necipoğlu, eds. *A Companion to Islamic Art and Architecture*. Vol. 2, *From the Mongols to Modernism*. Hoboken, NJ: WileyBlackwell, 2017.

Floor, Willem. "Kadkoda." *Encyclopedia Iranica*, vol. 15, fasc. 3, 328–31.

Fodor, Pál. *The Unbearable Weight of Empire: The Ottomans in Central Europe—A Failed Attempt at Universal Monarchy (1390–1566)*. Budapest: Research Center for the Humanities, Hungarian Academy of Sciences, 2015.

Fraser, Elizabeth. *Mediterranean Encounters: Artists between Europe and the Ottoman Empire, 1774–1839*. State College, PA: Penn State University Press, 2017.

Frazee, Charles A. *Catholics and Sultans: The Church and the Ottoman Empire, 1453–1923*. London: Cambridge University Press, 1983.

Freer-Sackler, *Nasta'liq: The Genius of Persian Calligraphy*. http://www.asia.si.edu/explore/nastaliq.

Froom, Aimée. "Adorned like a Rose: The Sultan Murad III Album (Austrian National Library Cod. Mixt. 313) and the Persian Connection." *Artibus Asiae* 66, no. 2 (2006): 137–54.

Gerlach, Stephan. *Türkiye Günlüğü 1573–1576*. Translated by Türkis Noyan. 2 vols. Istanbul: Kitap Yayınevi, 2007.

Goffman, Daniel. *The Ottoman Empire and Early Modern Europe*. Cambridge: Cambridge University Press, 2002.

Goldstone, Jack A. "The Problem of the 'Early Modern' World." *Journal of the Economic and Social History of the Orient*, 41, no. 3 (1998): 249–84.

Golombek, Lisa. "Early Illustrated Manuscripts of Kashifi's Akhlāq-i Muḥsinī." *Iranian Studies* 36, no. 4 (December 2003): 615–43.

Gonella, Julia, Friederike Weis, and Christoph Rauch, eds. *The Diez Albums: Contexts and Contents*. Leiden: Brill, 2016.

Goodwin, Godfrey. *A History of Ottoman Architecture*. New York: Thames and Hudson, 1987.

Gottheil, R. "The Shahnameh in Turkish: An Illuminated Manuscript in the Spencer Collection." *Bulletin of the New York Public Library* 36, no. 8 (1936): 8–11.

Grabar, Oleg. *The Alhambra*. Cambridge, MA: Harvard University Press, 1987.

———. *The Shape of the Holy: Early Islamic Jerusalem*. Princeton, NJ: Princeton University Press, 1996.

Grelot, W. *A Late Voyage to Constantinople*. London, 1683.

Griswold, William J. *The Great Anatolian Rebellion 1000–1020/1591–1611*. Berlin: Klaus Schwarz Verlag, 1983.

Groebner, Valentin. *Defaced: The Visual Culture of Violence in the Late Middle Ages*. New York: Zone Books, 2004.

Gruber, Christiane J. "Signs of the Hour: Eschatological Imagery in Islamic Book Arts." *Ars Orientalis* 44 (2014): 40–60.

Grunebaum, G. E. von. *Muhammedan Festivals*. London: Curzon Press, 1976.

Gündoğdu, Cengiz. "Padişah-Tarikat Şeyhi Münasebetleri Açısından Azîz Mahmud Hüdâyî ve çağdaşı Abdülmecîd-i Sivâsî." In *Azîz Mahmud Hüdâyî Uluslararası Sempozyum Bildirileri*, edited by Hasan Kamil Yılmaz, 15–38. Istanbul: Üsküdar belediye Başkanlığı 2005.

———. "Sivasi, Abdülmecid." *TDVIA*.

Gürkan, Emrah Safa. "Mediating Boundaries: Mediterranean Go-Betweens and Cross-Confessional Diplomacy in Constantinople, 1560–1600." *Journal of Early Modern History* 19 (2015): 107–28.

Haase, Claus-Peter. "An Ottoman Costume Album in the Library of Wolfenbüttel, Dated before 1579." In *9th International Congress of Turkish Art: Contributions*, edited by Nurhan Atasoy, 3:225–28. Ankara: Kültür Bakanlığı, 1995.

Hagen, Gottfried. "Legitimacy and World Order." In *Legitimizing the Order: The Ottoman Rhetoric of State Power*, edited by Hakan Karateke and Muarus Reinkowski, 55–84. Leiden: Brill, 2005.

———. "Translations and Translators in a Multilingual Society: A Case Study of Persian-Ottoman Translations, Late 15th to Early 17th Century." *Eurasian Studies* 2, no. 1 (2003): 95–134.

Halbout du Tanney, Dominique. "Un chef-d'oeuvre de la peinture ottomane: *La Couronne des Chroniques* au musée Jacquemart-André." *Revue du Louvre et des Musées de France* 111 (1979): 1–12.

Halman, Talat S. "Shāhrangīz." *EI2*.

Hamadeh, Shirine. *The City's Pleasures: Istanbul in the Eighteenth Century*. Seattle: University of Washington Press, 2008.

Hamburger, Jeffrey F. "The Iconicity of Script." *Word & Image,* 27, no. 3 (2011): 249–61. DOI: 10.1080/02666286.2011.541118.

Hammer-Purgstall, Joseph von. *Des Osmanischen Reichs Staatsverfassung und Staatsverwaltung, dargestellt aus den Quellen seiner Grundgesetze*. Vienna: In der Camesinaschen Buchhandlung, 1815.

———. *Histoire de l'Empire Ottoman*, 3 vols. Paris: Béthun et Plon, 1844.

Harper, James G., ed. *The Turk and Islam in the Western Eye 1450–1750: Visual Imagery before Orientalism*. Aldershot, UK: Ashgate, 2011.

Hasluck, Margaret M., ed. *Christianity and Islam under the Sultans by the Late F. W. Hasluck*. Oxford: Clarendon Press, 1929.

Hathaway, Jane. *The Chief Eunuch of the Ottoman Imperial Harem: Head of the African Eunuchs at the Sultan's Court*. Cambridge: Cambridge University Press, 2018.

Hattox, Ralph. *Coffee and Coffeehouses: The Origins of a Social Beverage*. Seattle: University of Washington Press, 1985.

Hering, Gunnar. *Ökumenisches Patriarchat und Europäische Politik, 1620–1638*. Wiesbaden: F. Steiner, 1968.

Hoffman, Eva. "Pathways of Portability: Islamic and Christian Interchange from the Tenth to the Twelfth Century." *Art History* 24, no. 1 (2001): 17–50.

Howard, Deborah. *Venice and the East: The Impact of the Islamic World on Venetian Architecture, 1100–1500*. New Haven, CT: Yale University Press, 2000.

Howard, Douglas. "Genre and Myth in the Ottoman Advice for Kings Literature." In *The Early Modern Ottomans: Remapping the Empire*, edited by Virginia Aksan and Daniel Goffman, 137–66. Cambridge: Canbridge University Press, 2007.

———. "Ottoman Historiography and the Literature of 'Decline' of the Sixteenth and Seventeenth Centuries." *Journal of Asian History* 22, no. 1 (1988): 52–77.

Huart, Clément. *Les calligraphes et les miniaturistes de l'Orient musulman*. Paris: E. Leroux, 1908.

Hüseyin, Kefeli. *Rāznāme* (SYEK, Hekimoğlu Ali Paşa No. 539). Transcription and facsimile prepared by I. H. Solak. Cambridge, MA: Harvard University, 2004.

Imber, Colin. "Ideals and Legitimation in Early Ottoman History." In *Süleyman the Magnificent and His Age: The Ottoman Empire in the Early Modern World*, edited by Metin Kunt and Christine Woodhead, 138–53. London: Longman, 1995.

———. "The Ottoman Dynastic Myth." *Turcica* 19 (1987): 7–27.

———. "Süleymân as Caliph of the Muslims: Formulation of Ottoman Dynastic Ideology." In *Soliman le Magnifique et son temps*, edited by Gilles Veinstein, 179–84. Paris: Documentation Française, 1992.

Inal, Güner. "Tek Figürlerden Oluşan Osmanlı Albüm Resimleri." *Arkeoloji Sanat Tarihi Dergisi* (Izmir: Ege Üniversitesi Edebiyat Fakültesi Yayınları) 3 (1984): 83–96.

Inalcık, Halil. *Has-bağçede ʿayş-u tarab: nedîmler, şâirler, mutribler*. Istanbul: Türkiye İş Bankası, 2011.

———. "Istanbul." *EI2*.

Iorga, Nicola. *Geschichte des osmanischen Reiches*. Gotha, 1908–13. Reprint, Darmstadt: Wissenschaftliche Buchsgesellschaft, 1990.

İpekten, Haluk. *Divan Edebiyatinda Edebi Muhitler*. Istanbul: Milli Eğitim Bakanlığı 1996.

———. *Karamanlı Nizâmî Divanı*. Ankara: Atatürk Üniversitesi Yayınları, 1974.

James, David. *Qur'āns of the Mamlūks*. New York: Thames and Hudson, 1988.

Jones, Ann Rosalind. "Habits, Holdings, Heterologies: Populations in Print in a 1562 Costume Book." *Yale French Studies* 110 (2006): 92–121.

Kafadar, Cemal. "Eyüp'te Kılıç Kuşanma törenleri." In *Eyüp: Dün/ Bugün*, edited by Tülay Artan, 50–62. Istanbul: Tarih Vakfı Yurt Yayınları, 1994.

———. "How Dark Is the History of the Night, How Black the Story of Coffee, How Bitter the Tale of Love: The Changing Measure of Leisure and Pleasure in Early Modern Istanbul." In *Medieval and*

Early Modern Performance in the Eastern Mediterranean, edited by Arzu Öztürkmen and Evelyn Birge Vitz, 243–69. Turnhout: Brepols, 2014.

Kafadar, Cemal. "Janissaries and Other Riffraff of Ottoman Istanbul: Rebels without a Cause?" *International Journal of Turkish Studies* 13, nos. 1–2 (2007): 113–34.

———. "The Myth of the Golden Age: Ottoman Historical Consciousness in the Post-Süleymanic Era." In *Süleyman the Second and His Time*, edited by Halil İnalcık and Cemal Kafadar, 37–48. Istanbul: Isis Press, 1993.

———. "The Ottomans and Europe, 1450–1600." In *Handbook of European History, 1400–1600: Late Middle Ages, Renaissance, and Reformation*, edited by Thomas A. Brady, Heiko A. Oberman, and James D. Tracy, 2:589–636. Leiden: Brill, 1994.

———. "A Rome of One's Own: Reflections on Cultural Geography and Identity in the Lands of Rum." *Muqarnas* 24 (2007): 7–25.

———. "Self and Others: The Diary of a Dervish in Seventeenth-Century Istanbul and First-Person Narratives in Ottoman Literature." *Studia Islamica* 69 (1989): 121–50.

———. "Sohbete Çelebi, Çelebiye mecmûa . . ." In *Mecmûa: Osmanlı Edebiyatının kırkambarı*, edited by Hatice Aynur, Müjgân Çakır, Hanife Koncu, Selim S. Kuru, and Ali Emre Özyıldırım, 43–52. Istanbul: Turkuaz, 2012.

Kafescioğlu, Çiğdem. *Constantinopolis/Istanbul: Cultural Encounter, Imperial Vision, and the Construction of the Ottoman Capital*. University Park: Penn State University Press, 2009.

———. "Osmanlı şehir tahayyülünün görsel ve edebi izleri: Onaltıncı ve onyedinci yüzyıl menzilname ve seyahatnameler-inde şehir imgeleri." In *Kültürel Kesişmeler ve Sanat: Günsel Renda onuruna sempozyum bildirileri / Cultural Crossings and Art: Proceedings of a Symposium in Honour of Günsel Renda*, edited by Serpil Bağcı and Zeynep Yasa Yaman, 139–50. Ankara: Hacettepe Üniversitesi, 2011.

———. "Sokağın, meydanın, şehirlilerin resmi: Onaltıncı yüzyıl sonu İstanbul'unda mekan pratikleri ve görselliğin dönüşümü." Forthcoming.

———. "Viewing, Walking, Mapping Istanbul, ca. 1580." In "Littoral and Liminal Spaces: The Early Modern Mediterranean and Beyond," edited by Hannah Baader and Gerhard Wolf. Special issue, *Mitteilungen de Kunsthistorischen Institutes in Florenz* 56, no. 1 (2014): 17–35.

Kagan, Richard. "Urbs and Civitas in Sixteenth- and Seventeenth-Century Spain." In *Envisioning the City: Six Studies in Urban Cartography*, edited by David Buisseret, 75–108. Chicago: University of Chicago Press, 1998.

Kangal, Selmin, ed. *The Sultan's Portrait: Picturing the House of Osman*. Istanbul: İşbank, 2000.

Karacasu, Barış. "Türk Edebiyatında Şehrengîzler." *Türkiye Araştırmaları Literatür Dergisi* 5, no. 10 (2007): 259–313.

Karatay, Fehmi Edhem. *Topkapı Sarayı Müzesi Kütüphanesi Türkçe yazmalar kataloğu*, 2 vols. İstanbul: Topkapı Sarayı Müzesi, 1961.

Karateke, Hakan. "Legitimizing the Ottoman Sultanate: A Framework for Historical Analysis." In *Legitimizing the Order: The Ottoman Rhetoric of State Power*, edited by Hakan Karateke and Maurus Reinkowski, 13–52. Leiden: Brill, 2005.

Kaufmann, Thomas DaCosta, and Michael North. *Mediating Netherlandish Art and Material Culture in Asia*. Amsterdam: Amsterdam University Press, 2014.

Kavruk, Hasan. *Eski Türk edebiyatında mensûr hikâyeler*. Istanbul: Milli Eğitim Bakanlığı, 1998.

Kayaalp, Isa. *Sultan Ahmed Divanının Tahlili*. Istanbul: Kitabevi, 1999.

Kazan, Hilal. *XVI. Asırda Sarayın Sanat Himayesi*. Istanbul: Isar. 2010.

Kemal, Necmettin. "Azîz Mahmud Hüdâyî Hazretleri ve Döneminin Siyasal Ortamına Etkisi." In *Azîz Mahmud Hüdâyî Uluslararası Sempozyum Bildirileri*, edited by Hasan Kamil Yılmaz, 51–70. Istanbul: Üsküdar belediye Başkanlığı, 2005.

Kessler, Herbert and Gerhard Wolf, eds., *The Holy Face and the Paradox of Representation: Papers from a Colloquium Held at the Bibliotheca Hertziana, Rome, and the Villa Spelman, Florence, 1996*. Bologna: Nuova Alfa, 1998.

Khalidi, Tarif. *The Muslim Jesus: Sayings and Stories in Islamic Literature*. Cambridge, MA: Harvard University Press, 2001.

Khoury, Nuha N. "Between Two Mosques." Lecture. Aga Khan Program Lectures in Islamic Art and Architecture, Harvard University, 1999.

———. *Ideologies and Inscriptions: The Construction of Safavid Legitimacy*. Forthcoming.

Knappert, J. "Mawlid." *EI2*.

Koç, Mustafa, ed. *Müstakimzade, Tuhfe-i Hattâtîn*. Istanbul: Klasik Yayınları, 2014.

Koch, Ebba. *Mughal Art and Imperial Ideology: Collected Essays*. Delhi: Oxford University Press, 2001.

———. "The Mughal Emperor as Solomon, Majnun, and Orpheus, or the Album as a Think Tank." *Muqarnas* 27 (2010): 277–311.

Köksal, Fatih. *Sana Benzer Güzel Olmaz: Divan Şiirinde Nazire*. Ankara: Akçağ Yayınları, 2006.

Komaroff, Linda. "The Transmission and Dissemination of a New Visual Language." In *The Legacy of Genghis Khan: Courtly Art and Culture in Western Asia, 1256–1353*, edited by Linda Komaroff and Stefano Carboni, 168–95. New York: Metropolitan Museum of Art; New Haven, CT: Yale University Press, 2002.

Krstić, Tijana. *Contested Conversions to Islam: Narratives of Religious Change in the Early Modern Ottoman Empire*. Stanford, CA: Stanford University Press, 2011.

———. "Contesting Subjecthood and Sovereignty in Ottoman Galata in the Age of Confessionalization: The *Carazo* Affair, 1613–1617." *Oriente Moderno* 93 (2013): 422–53.

Kunt, Metin. *The Sultan's Servants: The Transformation of Ottoman Provincial Government, 1550–1650*. New York: Columbia University Press, 1983.

Kuru, Selim S. "Men Just Wanna Have Fun: Learned and Bureaucrats at Play with Words in Premodern Istanbul." Talk presented in the Skilliter Center Conference on Ottomans and Entertainment, University of Cambridge, June 2016.

———. "Naming the Beloved in Ottoman Turkish Gazel—The Case of Ishak Çelebi (d. 1537–8)." In *Ghazal as World Literature II: From Literary Genre to a Great tradition The Ottoman Gazel in Context*, edited by Angelika Neuwirth, Michael Hess, Judith Pfeiffer and Börte Sagaster, 163–73. Wurzbürg: Erlon Verlag Wurzbürg, 2006.

———. "Sex in the Text: Deli Birader's Dâfi'ü'l-gumûm ve

Râfi'ü'l-humûm and the Ottoman Literary Canon." *Middle Eastern Literatures* 10, no. 2 (2007): 157–74.

Kütükoğlu, Bekir. *Osmanlı-Iran Siyâsî Münâsebetleri (1578–1612)*, 2nd ed. Istanbul: Istanbul Fetih Cemiyeti, 1993.

Kynan-Wilson, William. " 'Painted by the Turcks Themselves': Reading Peter Mundy's Ottoman Costume Album in Context." In *The Mercantile Effect: Art and Exchange in the Islamicate World during the Seventeenth and Eighteenth Centuries*, edited by Sussan Babaie and Melanie Gibson, 39–50. London: Gingko Library, 2017.

———. "Pictorial Playfulness in Ottoman Costume Albums." Paper delivered at the Skilliter Center for Ottoman Studies, Cambridge, July 2016.

Lamm, Carl J., and Karl V. Zetterstéen. *The Story of Jamāl and Jalāl: An Illuminated Manuscript in the Library of Uppsala University*. Uppsala: Almqvist & Wiksells, 1948.

Le Chevalier, J. B. *Voyage de la Propontide et du Pont-Euxin*. Paris, 1800.

Lentz, Thomas W., and Glenn Lowry. *Timur and the Princely Vision: Persian Art and Culture in the Fifteenth Century*. Los Angeles: Los Angeles County Museum of Art; Washington, DC: Arthur M. Sackler Gallery, Smithsonian Institution, 1989.

Levend, Agâh Sırrı. *Türk Edebiyatında Şehrengizler ve Şehrengizlerde Istanbul*. Istanbul: Istanbul Fethi Derneği, 1958.

Little, Stephen, ed. *Alternative Dreams: 17th-Century Chinese Paintings from the Tsao Family Collection*. Los Angeles: Los Angeles County Museum of Art; Munich: DelMonico Books, 2016.

Losensky, Paul. "Poetics and Eros in Early Modern Persia: The Lovers' Confection and the Glorious Epistle by Muhtasham Kāshāni." *Iranian Studies* 42, no. 5 (2009): 745–64.

Mahir, Banu. "A Group of 17th Century Paintings Used for Picture Recitation." In *Turkish Art: 10th International Congress of Turkish Art, Geneva, 17–23 September 1995: Proceedings*, edited by François Déroche, Antoinette Harri, and Allison Ohta, 443–56. Geneva: Fondation Max van Berchem, 1999.

———. "Sultan III Mehmed İçin Hazırlanmış Bir Albüm; III. Mehmed Albümü." In *16. Yüzyıl Osmanlı Kültür ve Sanatı 11–12 Nisan 2001 Sempozyum Bildirileri*, 169–86. Istanbul: Sanat Tarihi Derneği, 2004.

———. "XVI. Yüzyıl Osmanlı Nakkaşhanesinde Murakka Yapımcılığı." In *Uluslararası Sanat Tarihi Sempozyumu, Prof. Dr. Gönül Öney'e Armağan, 10–13 Ekim 2001, Bildiriler*, edited by Rahmi Hseyin Önal, 401–17. Izmir: Ege Üniversitesi, Edebiyat Fakültesi, Sanat Tarihi Bölümü, 2002.

Mantran, R. "Aḥmad I." In *EI2*.

Matthee, Rudi. "Exotic Substances: The Introduction and Global Spread of Tobacco, Coffee, Tea, Cocoa, and Distilled Liquor, 16–18th Centuries." In *Drugs and Narcotics in History*, edited by Roy Porter and Mikulas Teich, 24–51. Cambridge: Cambridge University Press, 1995.

Melvin-Koushki, Matthew. "Astrology, Lettrism, Geomancy: The Occult-Scientific Methods of Post-Mongol Islamicate Imperialism." *Medieval History Journal* 19, no. 1 (2016): 142–50.

———. "Early Modern Islamicate Empire: New Forms of Religiopolitical Legitimacy." In *The Wiley-Blackwell History of Islam*, edited by Armando Salvatore, Roberto Tottoli, and Babak Rahimi, 353–75. Malden, MA: Wiley-Blackwell, 2017.

———. "Of Islamic Grammatology: Ibn Turka's Lettrist Metaphysics of Light." *Al-ʿUṣūr al-Wusṭā* 24 (2016): 42–113.

Melvin-Koushki, Matthew, and Noah Gardiner, eds. "Islamicate Occultism: New Perspectives." Special double issue, *Arabica* 64, nos. 3–4 (2017): 287–693.

Meredith-Owens, G. M. *Turkish Miniatures*. London: Trustees of the British Museum, 1963.

Meriç, Rıfkı Melûl. *Türk Nakış San'atı Tarihi Araştırmaları*. Ankara: Üniversitesi Ilahiyat Fakültesi, 1953.

Messick, Brinkley. *The Calligraphic State: Textual Domination and History in a Muslim Society*. Berkeley: University of California Press, 1993.

Meyer zur Capellen, Jürg, and Serpil Bağcı. "The Age of Magnificence." In *The Sultan's Portrait: Picturing the House of Osman*, edited by Selmin Kangal, 96–109. Istanbul: Iş Bankası, 2000.

Mikhail, Alan. "The Heart's Desire: Gender, Urban Space and the Ottoman Coffee Hosue." In *Ottoman Tulips, Ottoman Coffee: Leisure and Lifestyle in the Eighteenth Century*, edited by Dana Sajdi, 133–70. London: Tauris Academic Studies, 2007.

Mikhail, Alan, and Christine M. Philliou. "The Ottoman Empire and the Imperial Turn." *Comparative Studies in Society and History* 54 (2012): 721–45.

Milstein, Rachel. "From South India to the Ottoman Empire: Passages in 16th Century Miniature Painting." In *Ninth Congress of Turkish Art*, 497–506. Ankara: Ministry of Culture, 1995.

———. *Miniature Painting in Ottoman Baghdad*. Costa Mesa, CA: Mazda, 1990.

Milstein, Rachel, Karin Rührdanz, and Barbara Schmitz. *Stories of the Prophets: Illustrated Manuscripts of Qisas al-Anbiya*. Costa Mesa, CA: Mazda Publishers, 1999.

Minorsky, Vladimir P. *Calligraphers and Painters: A Treatise by Qāḍī Ahmad, Son of Mīr Munshī (circa A.H. 1015/A.D. 1606)*. Washington, DC: Freer Gallery of Art, 1959.

———. *The Chester Beatty Library: A Catalogue of the Turkish Manuscripts and Miniatures*. Dublin: Hodges, Figgis, 1958.

Moin, Azfar. *The Millennial Sovereign: Sacred Kingship and Sainthood in Islam*. New York: Columbia University Press, 2012.

Mun, Gabriel de. "L'établissement des Jesuites a Constantinople sous le regne d'Achmet Ier." *Revue des Questions Historiques* 74 (1903): 163–72.

Murphey, Rhoads. *Exploring Ottoman Sovereignty: Tradition, Image and Practice in the Ottoman Imperial Household, 1400–1800*. London: Continuum, 2008.

———. "The Historian Mustafa Safi's Version of the Kingly Virtues as Presented in His Extended Preface to Volume One of the *Zübdet'ül Tevarih*, or Annals of Sultan Ahmed, 1012–1023 A.H. /1603–1614 A.D." In Murphey, *Essays on Ottoman Historians and Historiography*, 69–86. Istanbul: Eren, 2009.

———. "Rhetoric versus Realism in Early Seventeenth-Century Ottoman Historical Writing: On the Creation and Purpose of Kuyucu Murad Pasha's Vaunted Reputation as Vanquisher of the Celalîs." In Murphey, *Essays on Ottoman Historians and Historiography*, 161–78. Istanbul: Eren, 2009.

Naima, Mustafa. *Tarih-i Naima*, 6 vols. Istanbul: Matbaa-yi Amire, 1864–66.

Necipoğlu, Gülru. *The Age of Sinan: Architectural Culture in the*

Ottoman Empire. London: Reaktion Books; Princeton, NJ: Princeton University Press, 2005.

Necipoğlu, Gülru. Architecture, Ceremonial and Power: The Topkapı Palace in the Fifteenth and Sixteenth Centuries. Cambridge, MA: Architectural History Foundation and MIT Press, 1991.

———. "Challenging the Past: Sinan and the Competitive Discourse of Early Modern Islamic Architecture." Muqarnas 10 (1993): 169–80.

———. "The Dome of the Rock as Palimpsest: 'Abd al-Malik's Grand Narrative and Sultan Süleyman's Glosses." Muqarnas 25 (2008): 17–105.

———. "Dynastic Imprints on the Cityscape: The Collective Message of Funerary Imperial Mosque Complexes in Istanbul." In Colloque internationale: Cimetières et traditions funéraires dans le monde islamique (Institut français d'études anatoliennes, Istanbul, September 28–30, 1991), edited by Jean-Louis Bacqué-Grammont, 23–36. Paris: Centre national de la recherche scientifique, 1996.

———. "Early Modern Floral: The Agency of Ornament in Ottoman and Safavid Visual Cultures." In Histories of Ornament: From Global to Local, edited by Gülru Necipoğlu and Alina Payne, 132–55. Princeton, NJ: Princeton University Press, 2016.

———. "A Ḳānūn for the State, a Canon for the Arts: Conceptualizing the Classical Synthesis of Ottoman Art and Architecture." In Soliman le Magnifique et son temps, edited by Gilles Veinstein, 195–216. Paris: Documentation Française, 1992.

———. "L'idée de décor dans les régimes de visualité islamiques." In Purs décors? Arts de l'Islam, regards du XIXe siècle: Collections des Arts Décoratifs, edited by Rémi Labrusse, 10–23. Exh. cat. Musée des arts décoratifs, Musée du Louvre. Paris: Arts décoratifs, Musée du Louvre, 2007.

———. "The Life of an Imperial Monument: Hagia Sophia after Byzantium." In Hagia Sophia: From the Age of Justinian to the Present, edited by Robert Mark and Ahmet Çakmak, 195–225. Cambridge: Cambridge University Press, 1992.

———. "Persianate Images between Europe and China: The 'Frankish Manner' in the Diez and Topkapı Albums, ca. 1350–1450." In The Diez Albums: Contexts and Contents, edited by Julia Gonella, Friederike Weiss, and Christoph Rauch, 531–91. Leiden: Brill, 2017.

———. "Preface: Sources, Themes, and Cultural Implications of Sinan's Autobiographies. " In Sinan's Autobiographies: A Critical Edition of Five Sixteenth-Century Texts. Critical edition and translation by Howard Crane and Esra Akin, edited with a preface by Gülru Necipoğlu, vii–xvi. Leiden: Brill, 2006.

———. "Qur'anic Inscriptions on Sinan's Imperial Mosques: A Comparison with Their Safavid and Mughal Counterparts." In Word of God, Art of Man: The Qur'an and Its Creative Expressions, edited by Fahmida Suleman, 69–104. Oxford: Oxford University Press, 2007.

———. "The Scrutinizing Gaze in the Aesthetics of Islamic Visual Cultures: Sight, Insight, and Desire." Muqarnas 32 (2015): 23–61.

———. "The Suburban Landscape of Sixteenth-Century Istanbul as a Mirror of Classical Ottoman Garden Culture." In Gardens in the Time of the Great Muslim Empires: Theory and Design. Edited by Attilio Petruccioli, 32–71. Leiden: Brill, 1997.

———. "The Süleymaniye Complex in Istanbul: An Interpretation." Muqarnas 3 (1985): 92–117.

———. "Suleyman the Magnificent and the Representation of

Power in the Context of Ottoman-Hapsburg-Papal Rivalry." Art Bulletin 71, no. 3 (September 1989): 401–27.

———. The Topkapı Scroll: Geometry and Ornament in Islamic Architecture. Santa Monica, CA: Getty Center for the History of Art and the Humanities, 1995.

———. "Visual Cosmopolitanism and Creative Translation: Artistic Conversations with Renaissance Italy in Mehmed II's Constantinople." Muqarnas 29 (2012): 1–81.

———. "Word and Image: The Serial Portraits of Ottoman Sultans in Comparative Perspective." In The Sultan's Portrait: Picturing the House of Osman, edited by Selmin Kangal, 22–61. Istanbul: İş Bankası, 2000.

Niyazioğlu, Aslı. Dreams and Lives in Ottoman Istanbul: A Seventeenth-Century Biographer's Perspective. Milton Park, UK: Routledge 2017.

Nuti, Lucia. "Mapping Places: Chorography and Vision in the Renaissance." In Mappings, edited by Denis Cosgrove, 90–108. London: Reaktion Books, 1999.

Nutku, Özdemir. "17. Yüzyılda Saray Kumaşları." Tarih ve Toplum 22 (1985): 44–49.

O'Connell, Monique. "The Italian Renaissance in the Mediterranean, or, Between East and West: A Review Article." California Italian Studies Journal 1, no. 1 (2010): 1–30.

O'Kane, Bernard. "Siyah Qalam: The Jalayirid Connections." Oriental Art 48, no. 2 (2003): 2–18.

Olian, Joanne. "Sixteenth Century Costume Books." Costume 3 (1977): 20–48.

Orbay, İffet. "Istanbul Viewed: The Representation of the City in Ottoman Maps of the Sixteenth and Seventeenth Centuries." PhD diss., Massachusetts Institute of Technology, 2001.

Orhonlu, Cengiz, and G. Baer, "Ketḫudā." In EI2.

Ousterhout, Robert. "A Sixteenth Century Visitor to the Chora." Dumbarton Oaks Papers 39 (1985): 117–24.

Özbaran, Salih. Ottoman Expansion towards the Indian Ocean in the Sixteenth Century. Istanbul: Bilgi University Press, 2009.

Parshall, Peter. "Antonio Lafreri's Speculum Romanae Magnificentiae." Print Quarterly 23, no. 2 (March 2006): 3–28.

Pedersen, Johannes. The Arabic Book. Princeton, NJ: Princeton University Press, 1984.

Peirce, Leslie P. Morality Tales: Law and Gender in the Ottoman Court of Aintab. Berkeley: University of California Press, 2003.

Pfeifer, Helen. "Encounter after the Conquest; Scholarly Gatherings in 16th-Century Ottoman Damascus." IJMES 47 (2015): 219–39.

Philips, Amanda. "Ali Pasha and His Stuff: An Ottoman Household in Istanbul and Van." In Living the Good Life in the Qing and Ottoman Empires, edited by Elif Akçetin and Suraiya Faroqhi, 90–112. Leiden: Brill, 2018.

Piterberg, Gabriel. An Ottoman Tragedy, History and Historiography at Play. Berkeley: University of California Press, 2003.

Porras, Stephanie. "St Michael the Archangel: Spiritual, Visual and Material Translations from Antwerp to Lima." In Prints in Translation, 1450–1750: Image, Materiality, Space, edited by Suzanne Karr Schmidt and Edward H. Wouk, 183–202. Abingdon, UK: Routledge, 2017.

Porter, David, ed. Comparative Early Modernities, 1100–1800. New York: Palgrave Macmillan, 2012.

Porter, Yves. "From the 'Theory of the Two Qalams' to the 'Seven Principles of Painting': Theory, Terminology, and Practice in Persian Classical Painting." *Muqarnas* 17 (2000): 109–18.

Potter, Simon J., and Jonathan Saha. "Global History, Imperial History, and Connected Histories of Empire." *Journal of Colonialism and Colonial History* 16, no. 1 (2015): https://muse.jhu.edu.

The Qurʾān: English Meanings. English revised and edited by Saḥeeḥ International. Jeddah: Abul-Qasim Publishing House, 1997; London: al-Muntada al-Islami, 2004.

Raby, Julian. "1 Portrait of Mehmed II." In *The Sultan's Portrait: Picturing the House of Osman*, edited by Selmin Kangal, 80. Istanbul: Türkiye İş Bankası, 2000.

———. "2 Mehmed Smelling a Rose." In *The Sultan's Portrait: Picturing the House of Osman*, edited by Selmin Kangal, 82. Istanbul: Türkiye İş Bankası, 2000.

———. "Bust Portrait of Mehmed II," In *The Sultan's Portrait: Picturing the House of Osman*, edited by Selmin Kangal, 91. Istanbul: Türkiye İş Bankası, 2000.

———. "From Europe to Istanbul." In *The Sultan's Portrait: Picturing the House of Osman*, edited by Selmin Kangal, 136–63. Istanbul: Türkiye İş Bankası, 2000.

———. "Mehmed II's Greek Scriptorium." *Dumbarton Oaks Papers* 37 (1983): 15–34.

———. "Opening Gambits." In *The Sultan's Portrait: Picturing the House of Osman*, edited by Selmin Kangal, 64–95. Istanbul: Türkiye İş Bankası, 2000.

———. "The Serenissima and the Sublime Port: Art in the Art of Diplomacy 1453–1600." In *Venice and the Islamic World, 828–1797*, edited by Stefano Carboni, 90–119. New York: Metropolitan Museum of Art; New Haven, CT: Yale University Press, 2007.

Rado, Şevket. *Türk Hattatları: XV. yüzyıldan günümüze kadar gelmiş ünlü hattatların hayatları ve yazılarından örnekler.* İstanbul: Yayın Matbaacılık Ticaret, 1983.

Raymond, André. *The Great Arab Cities in the 16th–18th Centuries: An Introduction.* New York: NYU Press, 1984.

Refik, Ahmet. *On altıncı Asırda Istanbul Hayatı, 1533–1591.* Istanbul: Devlet, 1935.

———. *Onuncu Asr-ı Hicride Istanbul Hayatı, 1495–1591.* Istanbul: Enderun Kitabevi, 1988.

Renda, Günsel. "17. Yüzyıldan Bir Grup Kıyafet Albümü." In *17. Yüzyıl Osmanlı Kültür ve Sanatı*, 153–78. Istanbul: Sanat Tarihi Derneği Yayınları, 1998.

Rice, Yael. "The Brush and the Burin: Mughal Encounters with European Engravings." In *Crossing Cultures: Conflict, Migration, and Convergence; The Proceedings of the 32nd International Congress of the History of Art*, edited by Jaynie Anderson, 305–10. Carlton, AU: Mienguyah Press, Melbourne University Publishing, 2009.

———. "Cosmic Sympathies and Painting at Akbar's Court." In *A Magic World: New Visions of Indian Painting*, edited by Molly Emma Aitken, 88–99. Mumbai: Marg, 2016.

———. "Lines of Perception: European Prints and the Mughal Kitābkhāna." In *Prints in Translation, 1450–1750: Image, Materiality, Space*, edited by Suzanne Karr Schmidt & Edward H. Wouk, 202–23. Abingdon, UK: Routledge, 2017.

Rizvi, Kishwar. "Between the Human and the Divine: The Majālis al-ushshāq and the Materiality of Love in Early Safavid Art." In *Ut pictura amor: The Reflexive Imagery of Love in Artistic Theory and Practice 1500–1700*, edited by Walter S. Melion, Joanna Woodall, and Michael Zell, 229–63. Boston: Brill, 2017.

———. "Introduction: Affect, Emotion, and Subjectivity in the Early Modern Period." In *Emotions and Subjectivity in the Early Modern World*, edited by Kishwar Rizvi, 1–20. Leiden: Brill, 2017.

———. "The Suggestive Portrait of Shah ʿAbbas: Prayer and Likeness in a Safavid Shahnama." *Art Bulletin* 94, no. 2 (2012): 226–50.

Roberts, Mary. *Istanbul Exchanges: Ottomans, Orientalists and Nineteenth-Century Visual Culture.* Berkeley: University of California Press, 2015.

Roberts, Sean. *Printing a Mediterranean World: Florence, Constantinople, and the Renaissance of Geography.* Cambridge, MA: Harvard University Press, 2013.

Robinson, Cynthia. *In Praise of Song: The Making of Courtly Culture in Al-Andalus and Provence, 1005–1134 A.D.* Leiden: Brill, 2002.

Rodini, Elizabeth. "The Sultan's True Face? Gentile Bellini, Mehmet II, and the Values of Verisimilitude." In *The Turk and Islam in the Western Eye, 1450–1750*, edited by James G. Harper, 21–40. Farnham, UK: Ashgate, 2011.

Rogers, J. Michael. "Itineraries and Town Views in Ottoman Histories." In *Cartography in the Traditional Islamic and South Asian Societies*, edited by J. B. Harley and David Woodward, 228–55. Chicago: University of Chicago Press, 1992.

Roxburgh, David J. "The Aesthetics of Aggregation: Persian Anthologies of the Fifteenth Century." In *Princeton Papers: Interdisciplinary Journal of Middle Eastern Studies* 8 (2001): 119–42.

———. "Baysunghur's Library: Questions Related to Its Chronology and Production." *Journal of Social Affairs (Shuun ijtimaiyah)* 18, no. 72 (2001): 11–41/300–330.

———. "Disorderly Conduct? F. R. Martin and the Bahram Mirza Album." *Muqarnas* 15 (1998): 32–57.

———. "'The Eye Is Favored for Seeing the Writing's Form': On the Sensual and the Sensuous in Islamic Calligraphy." *Muqarnas* 25 (2008): 275–98.

———. "Images on the Fringe: Muhammad Siyah Qalam and Responses by Turkman Artists" / "Saçaklardaki Tasvirler: Mehmed Siyah Kalem ve Türkmen Sanatçıların Cevapları." In *Ben Mehmed Siyah Kalem, Insanlar ve Cinler Ustası*, edited by Mine Haydaroğlu, 97–111. Istanbul: Yapı Kredi Kültür Yayıncılık, 2004.

———. "The Journal of Ghiyath al-Din Naqqash, Timurid Envoy to Khan Balïgh, and Chinese Art and Architecture." In *The Power of Things and the Flow of Cultural Transformations: Art and Culture between Europe and Asia*, edited by Lieselotte E. Saurma-Jeltsch and Anja Eisenbeiss, 90–113. Berlin: Deutscher Kunstverlag, 2010.

———. *The Persian Album 1400–1600: From Dispersal to Collection.* New Haven, CT: Yale University Press, 2005.

———. *Prefacing the Image: The Writing of Art History in Sixteenth-Century Iran.* Leiden: Brill, 2001.

Rüstem, Ünver. "The Spectacle of Legitimacy: the Dome Closing Ceremony of the Sultan Ahmed Mosque." *Muqarnas* 33 (2016): 253–344.

Rycaut, Sir Paul. *The Turkish History with Sir Paul Rycaut's Continuation.* 3 vols. London, 1687.

Rypka, Jan. *History of Iranian Literature.* Dordrecht: D. Reidel, 1968.

Şahin, Kaya. "Constantinople and the End Time: The Ottoman

Conquest as a Portent of the Last Hour." *Journal of Early Modern History* 14 (2010): 317–54.

Şahin, Kaya. *Empire and Power in the Reign of Süleyman: Narrating the Sixteenth-Century Ottoman World*. Cambridge: Cambridge University Press, 2013.

———. "The Ottoman Empire in the Long Sixteenth Century." *Renaissance Quarterly* 70 (2017): 220–34.

———. "Staging an Empire: An Ottoman Circumcision Ceremony as Cultural Performance." *American Historical Review* 123, no. 2 (April 2018): 463–92.

Sandys, George. *Sandys Travels: Containing an History of the Original and Present State of the Turkish Empire*. London : Printed for John Williams junior, 1673.

Sariyannis, Marinos. "Mobs, Scamps, and Rebels in Seventeenth Century Istanbul." *International Journal of Turkish Studies* 11, nos. 1–2 (2005): 1–15.

———. "Prostitution in Ottoman Istanbul, Late Sixteenth–Early Eighteenth Century." *Turcica* 40 (2008): 37–65.

Saurma-Jeltsch, Liselote E., and Anja Eisenbeiss, eds., *The Power of Things and the Flow of Cultural Transformations*. Berlin: Deutscher Kunstverlag, 2010.

Sayers, David Selim. *Tıflî Hikâyeleri*. Istanbul: Bilgi Üniversitesi Yayınları, 2013.

Schick, Irvin Cemil. "The Content of Form: Islamic Calligraphy between Text and Representation." In *Sign and Design: Script as Image in a Cross-Cultural Perspective*, edited by Jeffrey F. Hamburger and Brigitte Bedos-Rezak, 173–94. Washington, DC: Dumbarton Oaks; Cambridge, MA: Harvard University Press, 2016.

———. "The Iconicity of Islamic Calligraphy in Turkey." *RES: Anthropology and Aesthetics* 53/54 (2008): 211–24.

———. "I. Mahmud Döneminde Hat San'atı." Lecture delivered at the conference "Lâlenin ve Isyanin Gölgelediği Yıllar: I. Mahmud Dönemi 1730–1754." Mimar Sinan University, Istanbul, September 26–27, 2014.

———. "The Revival of *Kûfî* Script during the Reign of Abdülhamid II." In *Calligraphy and Architecture in the Muslim World*, edited by Irvin C. Schick and Muhammad Gharipour, 119–38. Edinburgh: Edinburgh University Press, 2013.

Schick, Leslie Meral. "Meraklı Avrupalılar İçin bir Başvuru Kaynağı: Osmanlı Kıyafet Albümleri." *Toplumsal Tarih* 116 (August 2003): 84–89.

———. "Ottoman Costume Albums in a Cross-Cultural Context." In *Turkish Art: 10th International Congress of Turkish Art, Geneva, 17–23 September 1995: Proceedings*, edited by François Déroche, Antoinette Harri, and Allison Ohta, 625–28. Geneva: Fondation Max Van Berchem, 1999.

Schmidt, Jan, and Rijksuniversiteit te Leiden. Bibliotheek. *Catalogue of Turkish Manuscripts in the Library of Leiden University and Other Collections in the Netherlands*. Islamic Manuscripts and Books, no. 3. Leiden: Legatum Warnerianum in Leiden University Library, 2000.

Schmitz, Barbara. *Islamic and Indian Manuscripts and Paintings in the Pierpont Morgan Library*. New York: Pierpont Morgan Library, 1997.

———. *Islamic Manuscripts in the New York Public Library*. New York: Oxford University Press, 1992.

Seçkin, Selçuk. "17. Yüzyılın Önemli Minyatürlü Yazması: Vekayi-i

'Ali Paşa." *Ankara Üniversitesi Osmanlı Tarihi Araştırma ve Uygulama Merkezi Dergisi* 21 (2009): 95–122.

Sefercioğlu, Nejat. "Nev'î," in *TDVIA*.

Selaniki, Mustafa Efendi. *Tarih-i Selaniki*. Edited by Mehmet Ipşirli. 2 vols. Istanbul: Edebiyat Fakültesi Basımevi, 1989.

Semerdjian, Elyse. *"Off the Straight Path": Illicit Sex, Law and Community in Ottoman Aleppo*. Syracuse, NY: Syracuse University Press, 2008.

Serin, Muhiddin. *Hat San'atımız*. Istanbul: Kubbealtı, 1981.

———. *Hattat Şeyh Hamdullah: Hayâtı, talebleri, eserleri*. Istanbul: Kubbealtı, 1992.

Şeyhî Meḥmed. *Vekayi' ül-füzelâ*. Facsimile with index, as vols. 3 and 4 of *Şakaik-i Nu'maniye ve Zeyilleri*, edited by Abdülkadir Özcan. Istanbul: Çağrı, 1989.

Shakow, Aaron. "Marks of Contagion: The Plague, the Bourse, the Word and the Law in the Early Modern Mediterranean, 1720–1762." PhD diss., Harvard University, 2009.

Shalem, Avinoam. "Histories of Belonging and George Kubler's Prime Object." *Getty Research Journal* 3 (2011): 1–14.

———. "The Idol (Sanam) or the Man without a Soul: A Short Note on a Unique Illustration in the Kalila wa Dimna Manuscript (cod. Arab. 625) in the Bavarian State Library in Munich." In *The Phenomenon of "Foreign" in Oriental Art*, edited by Annette Hagedorn, 61–70. Wiesbaden: Reichert Verlag, 2006.

———. "Multivalent Paradigms of Interpretation and the Aura or Anima of the Object." In *Islamic Art and the Museum: Approaches to Art and Archaeology of the Muslim World in the Twenty-First Century*, edited by Benoît Junod, Georges Khalil, Stefan Weber, and Gerhard Wolf, 101–15. London: Saqi Books, 2012.

———. "Objects as Carriers of Real or Contrived Memories in a Cross-Cultural Context." *Mitteilungen zur spatantiken Archaologie un byzantinischen Kunstgeschichte* 4 (2005): 101–19.

———. "What Do We Mean When We Say 'Islamic Art'? A Plea for a Critical Rewriting of the History of the Arts of Islam." *Journal of Art Historiography* 6 (2012): 1–18.

Sharma, Sunil. "The City of Beauties in the Indo-Persian Poetic Landscape." *Comparative Studies of South Asia, Africa and the Middle East* 24, no. 2 (2004): 73–81.

———. "'If There Is a Paradise on Earth, It Is Here': Urban Ethnography in Indo-Persian Poetic and Historical Texts." In *Forms of Knowledge in Early Modern Asia: Explorations in the Intellectual History of India and Tibet, 1500–1800*, edited by Sheldon Pollock, 240–56. Durham, NC: Duke University Press, 2011.

———. "Representations of Social Groups in Mughal Art and Literature: Ethnography or Trope?" In *Indo-Muslim Cultures in Transition*, edited by Alka Patel and Karen Leonard, 17–36. Leiden: Brill 2012.

Shaw, Wendy M. K. "The Islam in Islamic Art History: Secularism and Public Discourse," *Journal of Art Historiography* 6 (June 2012): 1–34.

Shesgreen, Sean. *Criers and Hawkers of London: Engravings and Drawings by Marcelus Laroon*. Stanford, CA: Stanford University Press, 1990.

Shortle, Margaret. "Illustrated *Divans* of Hafiz: Persian Aesthetics at the Intersection of *Ghazal* Literature, 1450–1550." PhD diss., Boston University, 2018.

Shoshan, Boaz. *Popular Culture in Medieval Cairo*. Cambridge: Cambridge University Press, 1993.

Silver, Larry. *Peasant Scenes and Landscapes: The Rise of Pictorial Genres in the Antwerp Art Market*. Philadelphia: University of Pennsylvania Press, 2012.

Simpson, Marianna Shreve, and Jerome Clinton. "Word and Image in Illustrated *Shahnama* Manuscripts: A Project Report." In *Shahnama Studies*, edited by Charles Melville, 219–37. Cambridge: Cambridge University Press, 2006.

Sims, Eleanor. "Hans Ludwig von Keufstein's Turkish Figures." In *At the Sublime Porte: Ambassadors to the Ottoman Empire (1550–1800)*, edited by Ernst J. Grube, 20–40. London: Hazlitt, Gooden & Fox, 1988.

Sinemoğlu, Nermin. "On Yedinci Yüzyılın İlk Çeğreğine Tarihlenen bir Osmanlı Kıyafet Albümü." In *Aslanapa Armağanı*, edited by Selçuk Mülayim, Zeki Sönmez, and Ara Altun, 169–82. Istanbul: Bağlam, 1996.

Smith, M. "al-Bisṭāmī, ʿAbd al-Raḥmān." In *EI2*.

Sotheby's Islamic and Indian Art Oriental Miniatures and Manuscripts. October 15, 1994, lot 46.

Sotheby's Sale Catalog. April 7, 1975, lot 30.

Soucek, Priscilla P. "ʿAlī Heravī." *Encyclopaedia Iranica*.

———. "Nizami on Painters and Painting." In *Islamic Art in the Metropolitan Museum of Art*, edited by Richard Ettinghausen, 9–34. New York: Metropolitan Museum of Art, 1972.

———. "Persian Artists in Mughal India: Influences and Transformations." *Muqarnas* 4 (1987): 166–81.

Soudavar, Abolala. "The Concepts of 'al-aqdamo aṣaḥḥ' and 'yaqin-e sābeq,' and the Problem of Semi-Fakes." *Studia Iranica* 28 (1999): 255–73.

———. "Forgeries: i. Introduction. " *Encyclopædia Iranica*, online edition, 2012. http://www.iranicaonline.org/articles/forgeries-i.

Stchoukine, Ivan, Barbara Flemming, et al. *Illuminierte Islamische Handschirften*. Wiesbaden: Franz Steiner Verlag, 1971.

Sternberg, Giora. *Status Interaction during the Reign of Louis XIV*. Oxford: Oxford University Press, 2014.

Stewart-Robinson, J. "A Neglected Ottoman Poem: The Şehrengiz." In *Studies in Near Eastern Culture and History: In Memory of Ernst T. Abdel-Massih*, edited by James A. Bellamy, 201–11. Ann Arbor: University of Michigan, Center for Near Eastern and North African Studies, 1990.

Stichel, Rudolf H. W. "Das Bremer Albumn und seine Stellung innerhalb der orientalischen Trachtenbücher." In *Das Kostumbuch des Lambert de Vos*, edited by Hans-Albrecht Koch, 31–54. Graz, DE: Akademische Druck- u. Verlagsanstalt, 1991.

Subrahmanyam, Sanjay. "Connected Histories: Notes towards a Reconfiguration of Early Modern Eurasia." *Modern Asian Studies* 31, no. 3 (1997): 735–62.

———. *Explorations in Connected History*. New Delhi: Oxford University Press, 2005.

———. "A Tale of Three Empires: Mughals, Ottomans and Habsburgs in a Comparative Context," *Common Knowledge* 12, no. 1 (2006): 66–92.

Subtelny, Maria. "A Late Medieval Persian Summa on Ethics: Kashifi's Akhlāq-i Muḥsinī." *Iranian Studies* 36, no. 4 (December 2003): 601–14.

———. "Scenes from the Literary Life of Tīmūrid Herāt." In *Logos islamicos: Studia islamica in honorem Georgii Michaelis Wickens*.

Papers in Medieval Studies, no. 6, edited by Roger Savory and Dionisius Agius, 137–55. Toronto: Pontifical Institute of Medieval Studies, 1984.

Suudi Mehmed Efendi. *The Book of Felicity*. Barcelona: M. Moleiro Editor, 2007.

Swan, Claudia. "Birds of Paradise for the Sultan: Early Seventeenth-Century Dutch-Turkish Encounters and the Uses of Wonder." *De Zeventiende Eeuw* 29, no. 1 (2013): 49–63.

Szakály, Ferenc. *Szigetvári Csöbör Balázs török miniatúrái 1570*. Budapest: Európa Könyvkiadó, 1983.

Tabbaa, Yasser. "Canonicity and Control: The Sociopolitical Underpinnings of Ibn Muqla's Reform." *Ars Orientalis* 29 (1999): 91–100.

———. "The Transformation of Arabic Writing: Part 1, Qurʾānic Calligraphy." *Ars Orientalis* 21 (1991): 119–48.

———. "The Transformation of Arabic Writing: Part 2, The Public Text." *Ars Orientalis* 24 (1994): 119–47.

Tajudeen, Imran bin. "Trade, Politcs and Sufi Synthesis in the Formation of Southeast Asian Islamic Architecture." In Flood and Necipoğlu, *A Companion to Islamic Art and Architecture*, 996–1022.

Taner, Melis. "'Caught in a Whirlwind': Painting in Baghdad in the Late Sixteenth–Early Seventeenth Centuries." PhD diss., Harvard University, 2016.

Tanındı, Zeren. "Portraits of Ottoman Courtiers in the Dîwâns of Bâkî and Nâdirî." *RES: Anthropology and Aesthetics* 43 (2003): 131–45.

———. *Siyer-i Nebi: Islam Tasvir Sanatında Hz. Muhammed'in Hayatı*. Istanbul: Hürriyet Vakfı Yayınları, 1984.

Tanman, Baha. "Hacet Penceresi." *TDVIA*.

Terzioğlu, Derin. "How to Conceptualize Ottoman Sunnitization: A Historiographical Discussion." *Turcica* 44 (2012–13): 301–38.

———. "The Imperial Circumcision Festival of 1582: An Interpretation." *Muqarnas* 12 (1995): 84–100.

———. "Sufi and Dissident in the Ottoman Empire: Niyaz-i Misri (1618–94)." PhD diss., Harvard University, 1999.

———. "Where *ʿIlm-i Ḥāl* Meets Catechism: Islamic Manuals of Religious Instruction in the Ottoman Empire in the Age of Confessionalization." *Past & Present* 220 (August 2013): 79–114.

Tezcan, Baki. "Ethnicity, Race, Religion and Social Class: Ottoman Markers of Difference." In *The Ottoman World*, edited by Christine Woodhead, 159–70. Milton Park, UK: Routledge, 2012.

———. "The Frank in the Ottoman Eye of 1583." In *The Turk and Islam in the Western Eye: Visual Imagery before Orientalism*, edited by James G. Harper, 267–96. Farnham, UK: Ashgate, 2011.

———. "Law in China or Conquest in the Americas: Competing Constructions of Political Space in the Early Modern Ottoman Empire." *Journal of World History*, 24, no. 1 (2013): 107–34.

———. "The Multiple Faces of the One: The Invocation Section of Ottoman Literary Introductions as a Locus for the Central Argument of the Text." *Middle Eastern Literatures* 12, no. 1 (2009): 27–41.

———. "The Question of Regency in Ottoman Dynasty: The Case of the Early Reign of Ahmed I." *Archivum Ottomanicum* 25 (2008): 185–98.

———. *The Second Ottoman Empire: Political and Social Transformation in the Early Modern World*. New York: Cambridge University Press, 2010.

Thackston, Wheeler M. *Album Prefaces and Other Documents on the History of Calligraphers and Painters*. Leiden: Brill, 2001.

———. "Appendix I B: Transliteration of the Preface to the

Calligraphy Album, H 2171 (fols. 17b–23b)," 290–95. In Serpil Bağcı, "Presenting *Vaṣṣāl* Kalender's Works: The Prefaces of Three Ottoman Albums," *Muqarnas* 30 (2013): 255–313.

Thackston, Wheeler M. "Appendix I C: Translation of the Preface to the Calligraphy Album, H 2171 (fols. 17b–23b)," 294. In Serpil Bağcı, "Presenting *Vaṣṣāl* Kalender's Works: The Prefaces of Three Ottoman Albums," *Muqarnas* 30 (2013): 255–313.

———. "Appendix II B: Transliteration of the Preface to the Ahmed I Album, B 408 (fols. 1b–4b)," 303–4. In Serpil Bağcı, "Presenting *Vaṣṣāl* Kalender's Works: The Prefaces of Three Ottoman Albums," *Muqarnas* 30 (2013): 255–313.

———. "Appendix II C: Translation of the Preface to the Ahmed I Album, B 408 (fols. 1b–4b)," 305–6. In Serpil Bağcı, "Presenting *Vaṣṣāl* Kalender's Works: The Prefaces of Three Ottoman Albums," *Muqarnas* 30 (2013): 255–313.

———. "Calligraphy in the Albums." In *Muraqqaʿ: Imperial Mughal Albums from the Chester Beatty Library, Dublin*, edited by Elaine Wright, 152–63. Alexandria, VA: Art Services International; Hanover, NH: distributed by University Press of New England, 2008.

———, ed. and trans. *Tales of the Prophets by Muhammad Ibn ʿAb Allāh al-Kisāʾi*. Chicago: Great Books of the Islamic World, 1997.

Thys-Şenocak, Lucienne. "The Yeni Valide Complex at Eminönü." *Muqarnas* 15 (1998): 58–70.

———. "The Yeni Valide Complex in Eminönü, Istanbul (1597–1665)." PhD diss., University of Pennsylvania, 1994.

Titley, Norah M. *Miniatures from Turkish Manuscripts: A Catalogue and Subject Index of Paintings in the British Library and British Museum*. London: British Library, 1981.

———. *Persian Miniature Painting and Its Influence on the Art of Turkey and India*. London: British Library, 1983.

Uluç, Lale. "The Perusal of the Topkapı Albums: A Story of Connoisseurship." In *The Diez Albums: Contexts and Contents*, edited by Julia Gonella, Friederike Weis, and Christoph Rauch, 121–62. Boston: Brill, 2016.

———. *Turkman Governors, Shiraz Artisans and Ottoman Collectors: Sixteenth Century Shiraz Manuscripts*. Istanbul: Türkiye Iş Bankası, 2006.

Ünver, Ahmed Süheyl. "L'album d'Ahmed Ier." *Annali dell'Istituto Universitario orientale di Napoli*, n.s., 13 (1963): 127–62.

———. *Hekimbaşı ve talik üstadı Kâtip-zâde Mehmed Refiʿ Efendi: Hayatı ve Eserleri*. Istanbul: Kemal Matbaası, 1950.

———. *Ressam Nakşi: Hayatı ve Eserleri*. Istanbul: Kemal Matbaası, 1949.

Van den Boogert, Maurits H. *The Capitulations and the Ottoman Legal System: Qadis, Consuls and Beratlıs in the Eighteenth Century*. Leiden: Brill, 2005.

Varlık, Nükhet. *Plague and Empire in the Early Modern Mediterranean World: The Ottoman Experience, 1347–1600*. New York: Cambridge University Press, 2015.

Vatin, Nicolas, and Gilles Veinstein. *Le sérail ébranlé: Essai sur les morts, depositions, et avènements des sultans ottomans XIVe–XIXe siècle*. Paris: Fayard, 2003.

Walsh, J. R. "The Historiography of Ottoman-Safavid Relations in the Sixteenth and Seventeenth Centuries." In *Historians of the Middle East*, edited by Bernard Lewis and P. M. Holt, 197–211. Oxford: Oxford University Press, 1962.

Watenpaugh, Heghnar Zeitlian. *The Image of an Ottoman City*. Leiden: Brill, 2004.

Welch, Anthony. *Artists for the Shah: Late Sixteenth Century Painting at the Imperial Court of Iran*. New Haven, CT: Yale University Press, 1976.

———. "Worldly and Otherworldly Love in Safavid Painting." In *Persian Painting from the Mongols to the Qajars*, edited by Robert Hillenbrand, 301–17. London: I. B. Tauris, 2000.

White, Joshua M. "Fetva Diplomacy: The Ottoman *Şeyhülislam* as Trans-Imperial Intermediary." *Journal of Early Modern History* 19, nos. 2–3 (2015): 199–221.

Wilson, Bronwen. *The World in Venice: Print, the City and Early Modernity*. Toronto: University of Toronto Press, 2005.

Winter, Irene J. "Text on/in Monuments: 'Lapidary Style' in the Ancient Near East." In *Sign and Design: Script as Image in a Cross-Cultural Perspective (300–1600 CE)*, edited by B. M. Bedos-Rezak and J. F. Hamburger, 197–218. Washington, DC: Dumbarton Oaks Research Library and Collection, 2016.

Woodhead, Christine, ed. *Taʿlikizâde's Şehnâme-i Hümāyūn: A History of the Ottoman Campaign into Hungary, 1593–94*. Berlin: Klaus Schwartz Verlag, 1983.

Woods, John E. *The Aqquyunlu: Clan, Confederation, Empire*. Salt Lake City: University of Utah Press, 1999.

Wright, Elaine. "An Introduction to the Albums of Jahangir and Shah Jahan," in *Muraqqaʿ: Imperial Mughal Albums from the Chester Beatty Library*, edited by Elaine Wright, 39–51. Alexandria, VA: Art Services International, 2008.

Yaman, Bahattin. "Osmanlı Resim Sanatında Kıyamet Alametleri: Tercüme-i Cifru'l-Câmi ve Tasvirli Nüshaları." PhD. diss., Hacettepe University, 2002.

Yarshater, Ehsan. "Some Common Characteristics of Persian Poetry and Art." *Studia Islamica* 16 (1962): 61–71.

Yıldız, Osman. *Orta Osmanlıca Dönemine Ait bir Dil Yadigârı, Ahvāl-i Kiyāmet*. Istanbul: Şûle Yayınları, 2002.

Yılmaz, Fikret. "Boş Vaktiniz var mı? veya 16: Yüzyılda Anadolu'da şarap, eğlence ve suç." *Tarih ve Toplum Yeni Yaklaşımlar* 1 (Spring 2005): 11–49.

Yılmaz, Hüseyin. *Caliphate Redefined: The Mystical Turn in Ottoman Political Thought*. Princeton, NJ: Princeton University Press, 2018.

Yılmazer, Ziya, ed. *Topçular Kâtibi ʿAbdülkâdir (Kadrî) Efendi Tarihi*. 2 vols. Ankara: Türk Tarih Kuyrumu Basımevi, 2003.

Zeevi, Droor. *Producing Desire: Changing Sexual Discourse in the Ottoman Middle East, 1500–1900*. Berkeley: University of California Press, 2006.

Zilfi, Madeline. "The Kadizadelis: Discordant Revivalism in Seventeenth-Century Istanbul." *Journal of Middle Eastern Studies*, 45, no. 4 (1986): 251–69.

———. *The Politics of Piety: The Ottoman Ulema in the Post-Classical Age, 1600–1800*. Minneapolis, MN: Bibliotheca Islamica, 1988.

———. "Whose Laws? Gendering the Ottoman Sumptuary Regime." In *Ottoman Costumes: From Textile to Identity*, edited by Suraiya Faroqhi and Christoph K. Neumann, 125–41. Istanbul: Eren, 2004.

———. *Women and Slavery in the Ottoman Empire*. Cambridge: Cambridge University Press, 2010.

Index

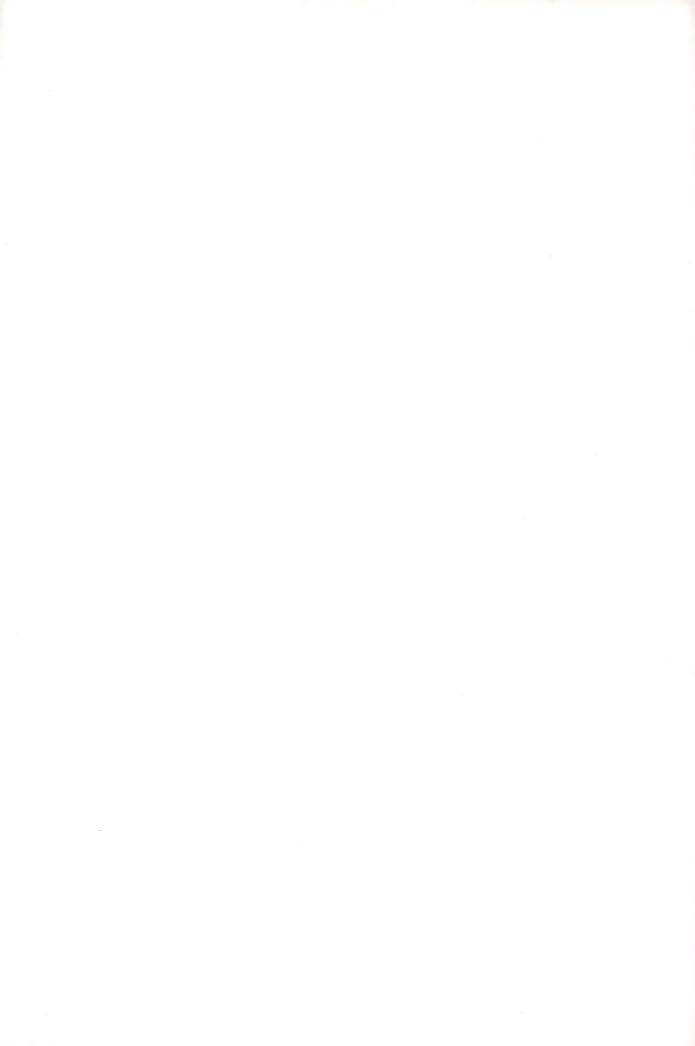

Photo Credits

Plates

The *Album of the World Emperor* is reproduced on the following pages, starting at the very end of the present volume. This replicates the orientation of Ottoman language books and albums and reproduces the current arrangement of the album folios. In order to examine the album in its natural order, go to the back of this book, and turn the pages from left to right. Plates 65–74 (which in terms of Western bookmaking immediately follow this explanation) will then be viewed last; these are the folios separated from the album and presently in the Metropolitan Museum of Art, New York.

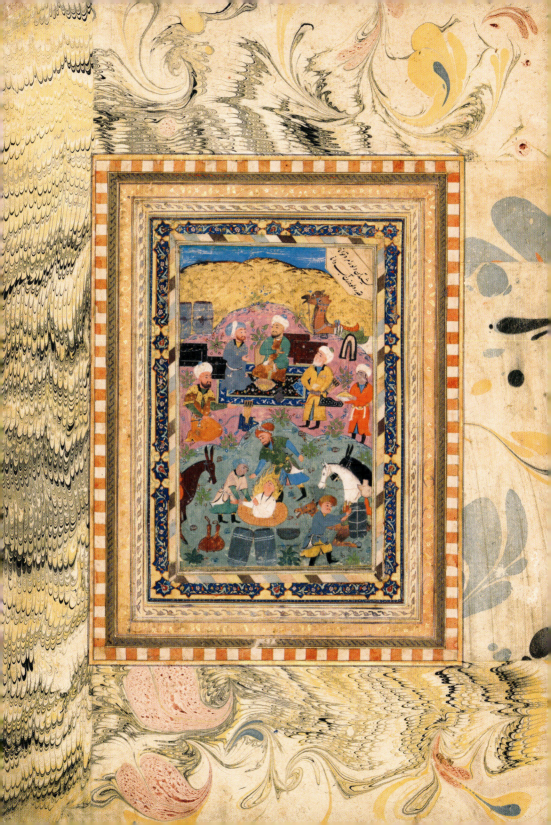

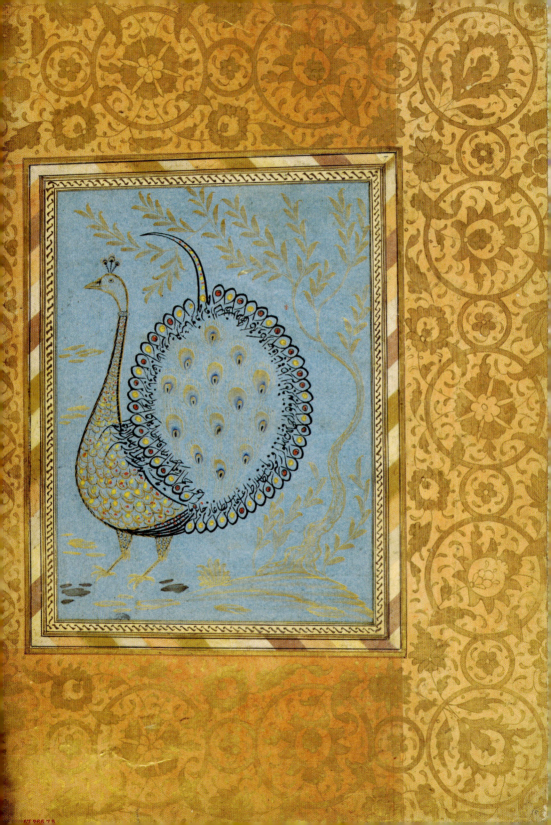

Respice me, me conde animo, me pectore serva.
Petrus Firens fecit et excud.

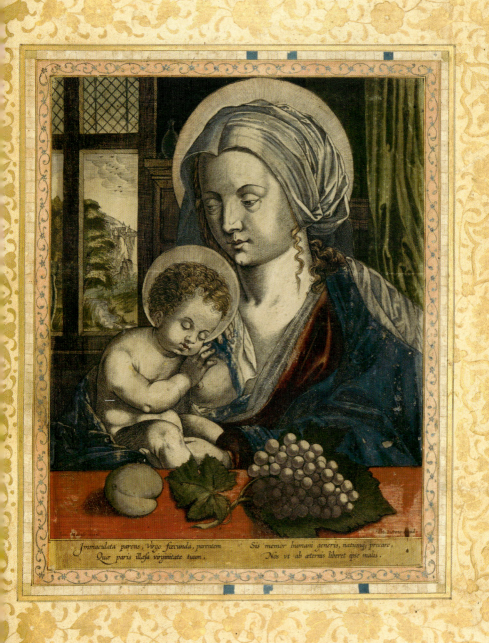

Immaculata parens, Virgo fœcunda, parentem
Quæ paris illæsa virginitate tuum,

Sis memor humani generis, naturamq; precare,
Nos vt ab æternis liberet ipse malis.

PLATE 68.

The Annunciation. Folio from the Bellini Album.

Cornelis Cort. Venice, Rome, or Florence, ca. 1577.

Metropolitan Museum of Art, New York. Louis V. Bell

Fund, 1967 (67.266.7.3v).

PLATE 67.

St. Michael the Archangel. Folio from the Bellini Album.
Giovanni Orlandi. Rome, ca. 1600. Metropolitan
Museum of Art, New York. Louis V. Bell Fund, 1967
(67.266.7.3r).

Istanbul Folios

Plates 1–64 replicate the present order of the *Album of the World Emperor*, Topkapı Palace Library ms. no. B 408. They begin at the back of this book, reflecting the customary page ordering of Ottoman language books, and they are accompanied by the album covers.

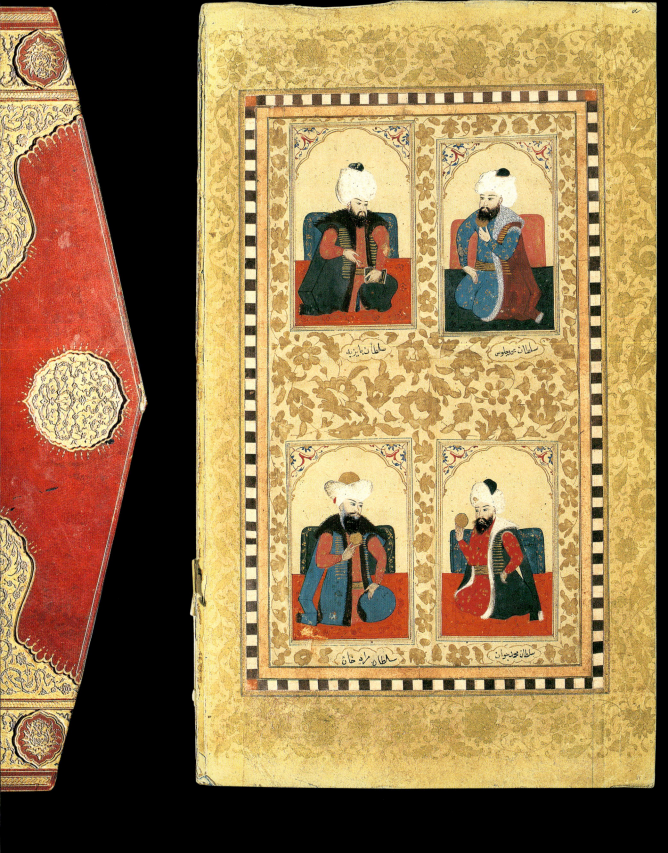

PLATE 64.
Album of the World Emperor, fol. 32b.

209

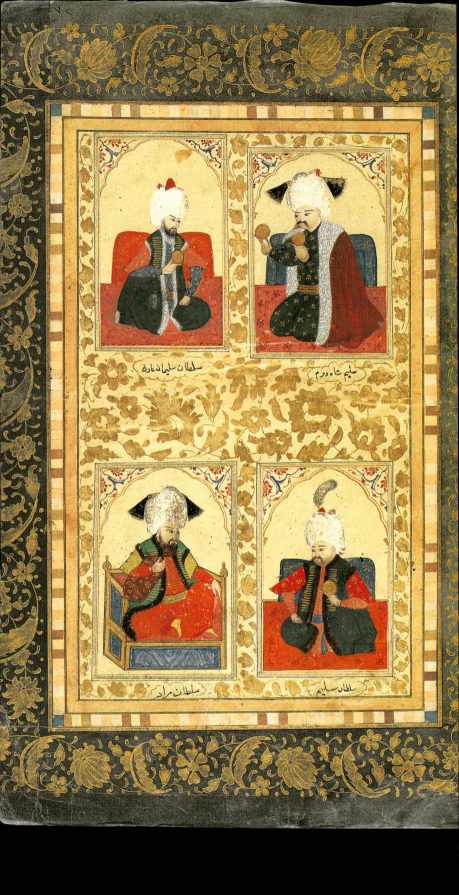

سلطان سليمان زاده سليم شاه دوم

سلطان مراد سلطان سليم

PLATE 63.

Album of the World Emperor, fol. 32a.

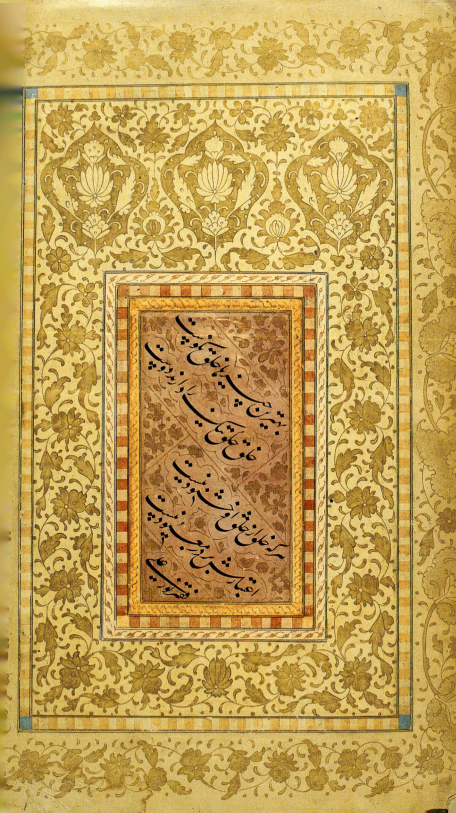

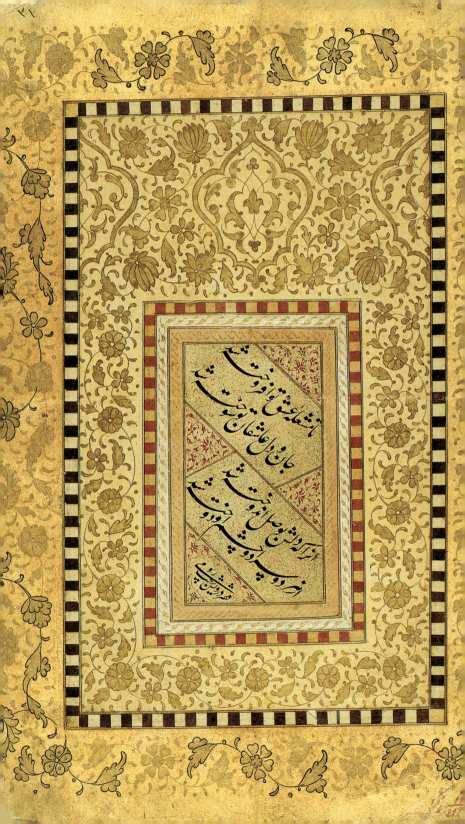

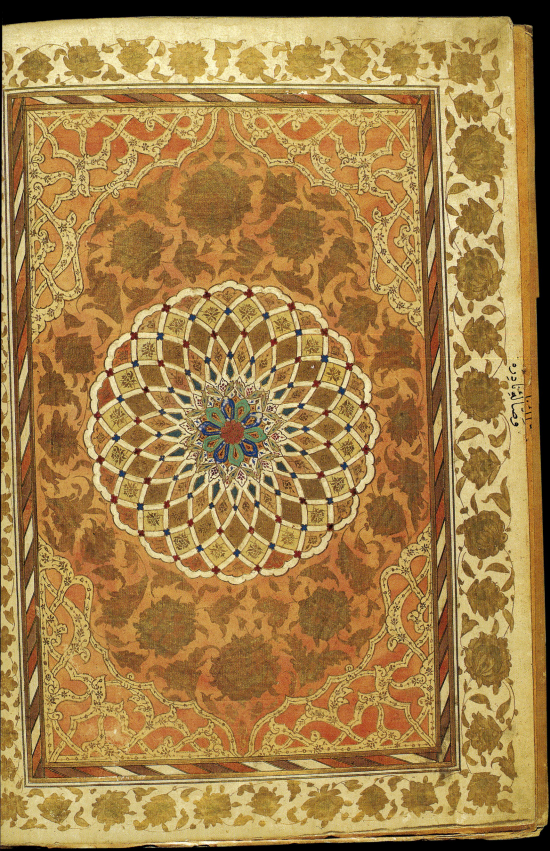

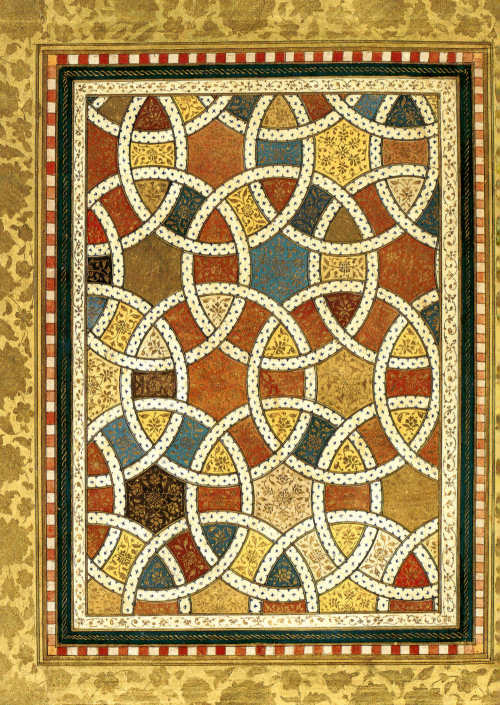

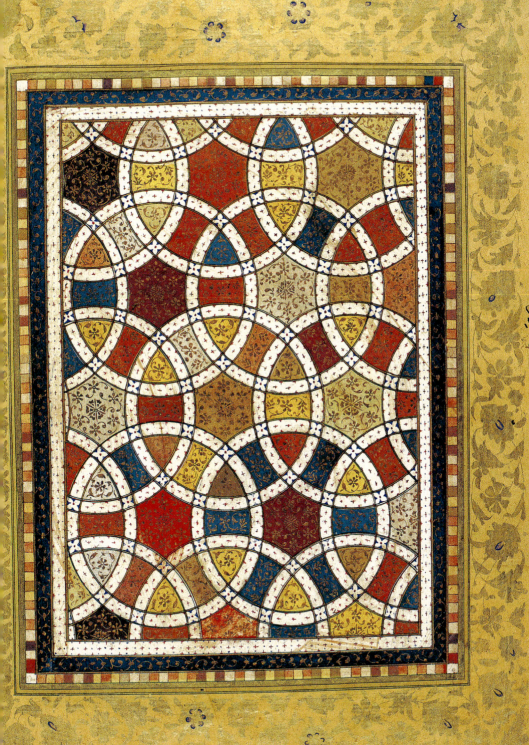

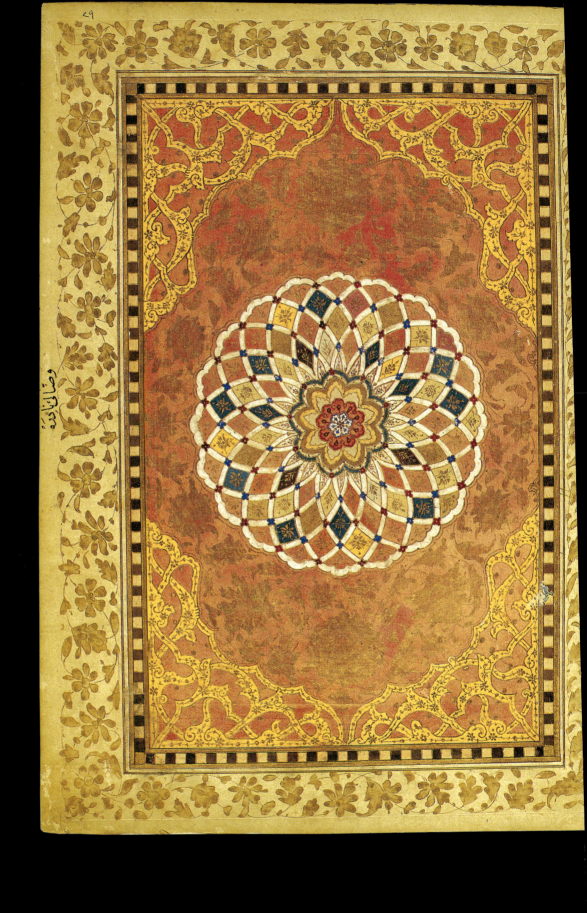

PLATE 57.

Album of the World Emperor, fol. 29a.

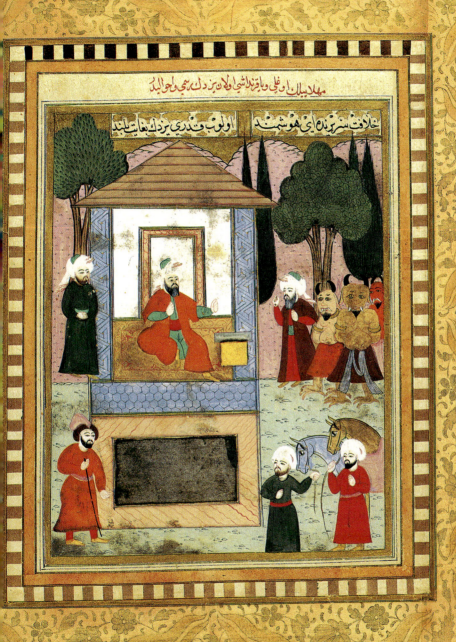

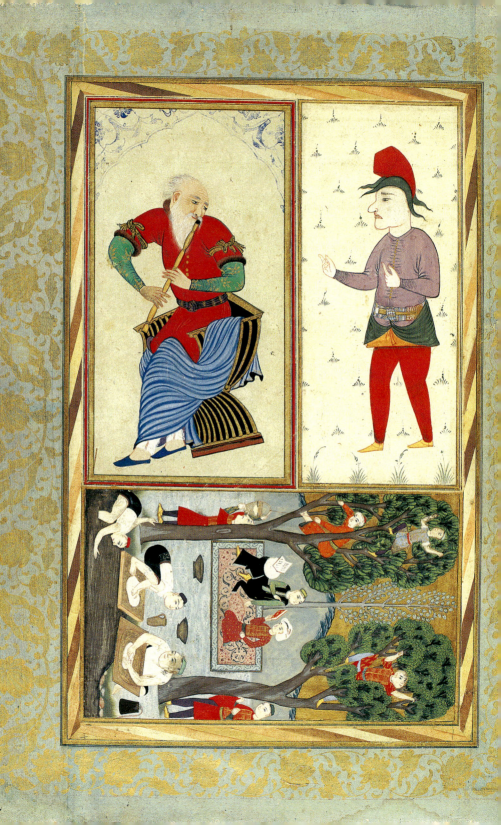

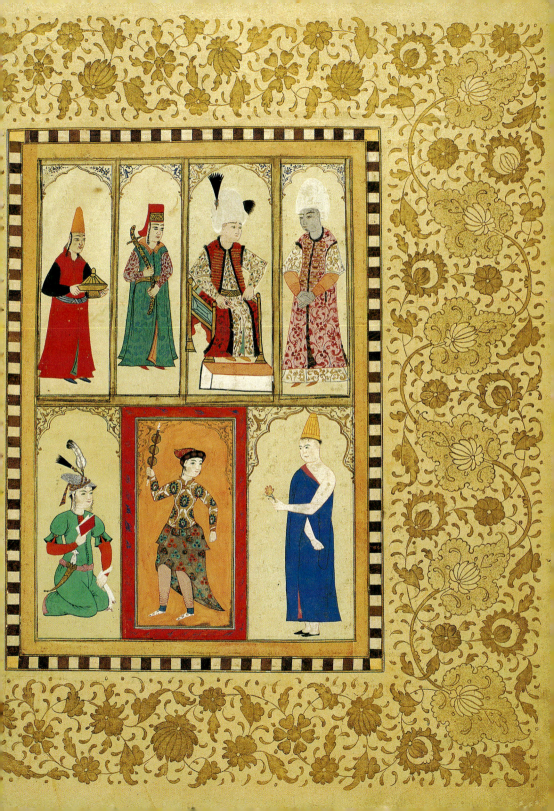

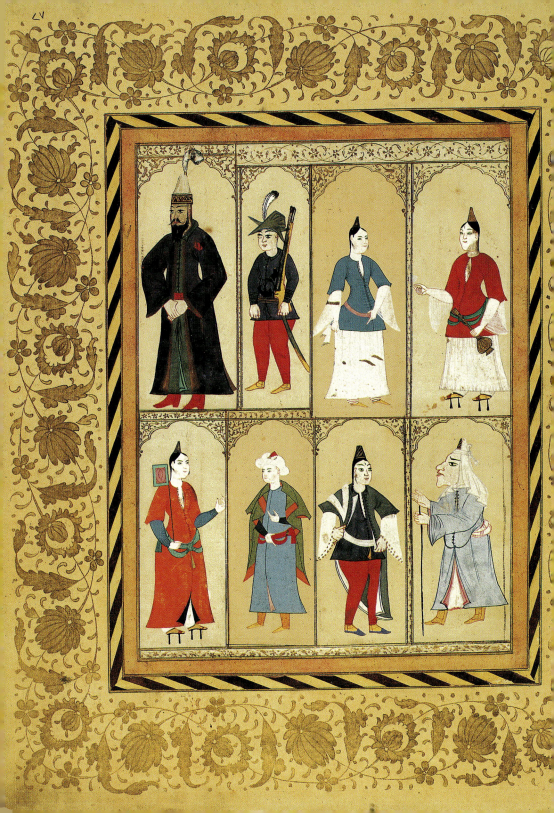

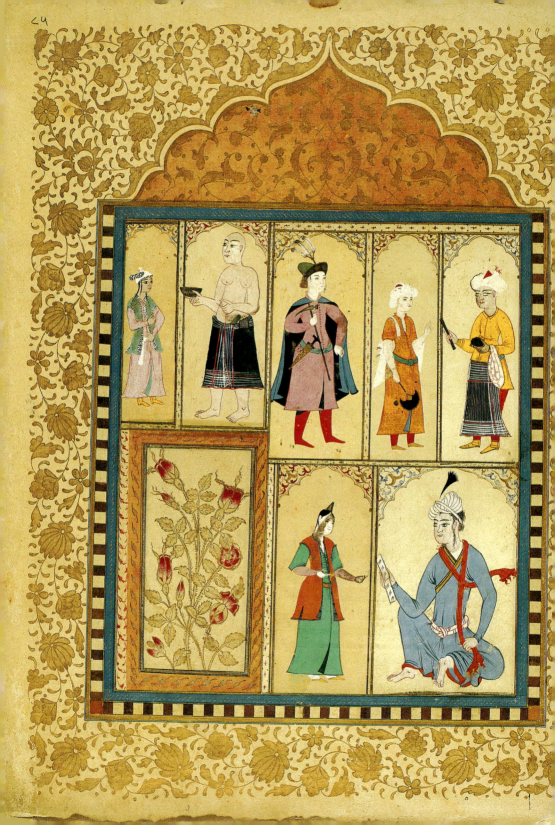

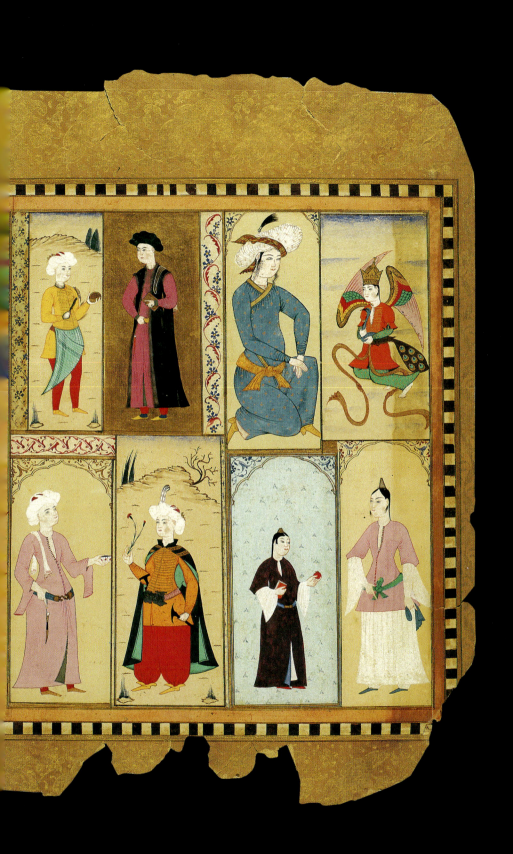

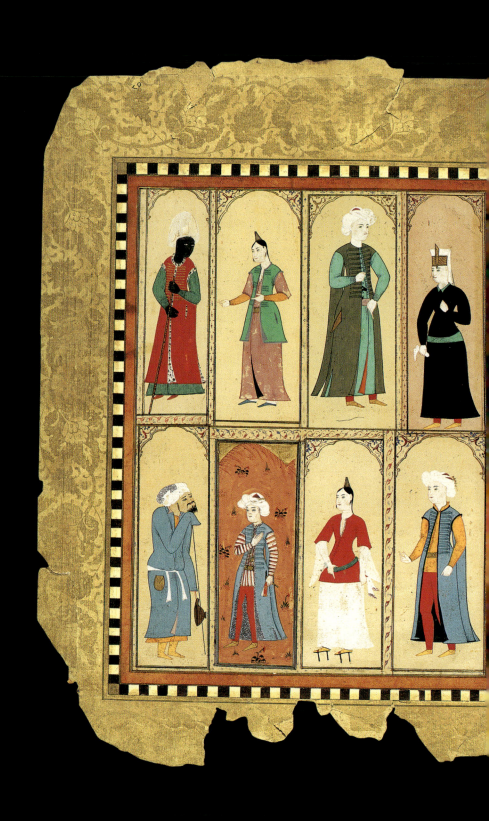

PLATE 49.
Album of the World Emperor, fol. 25a.

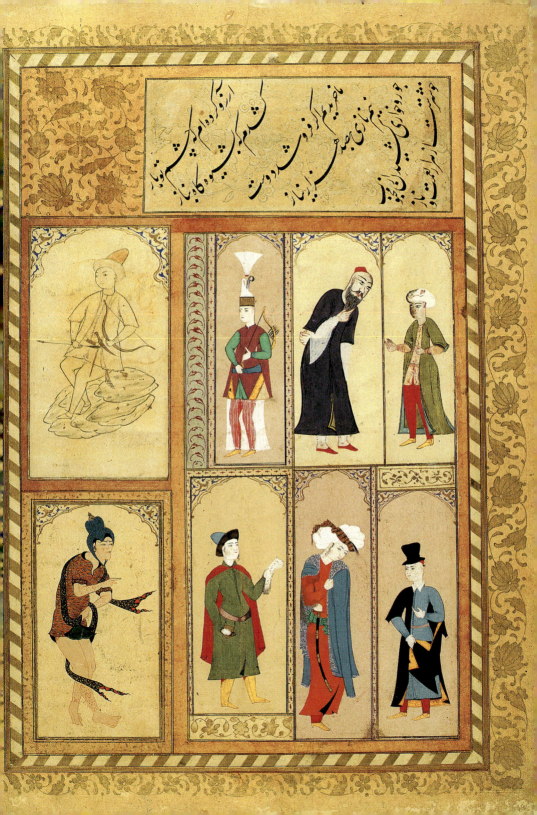

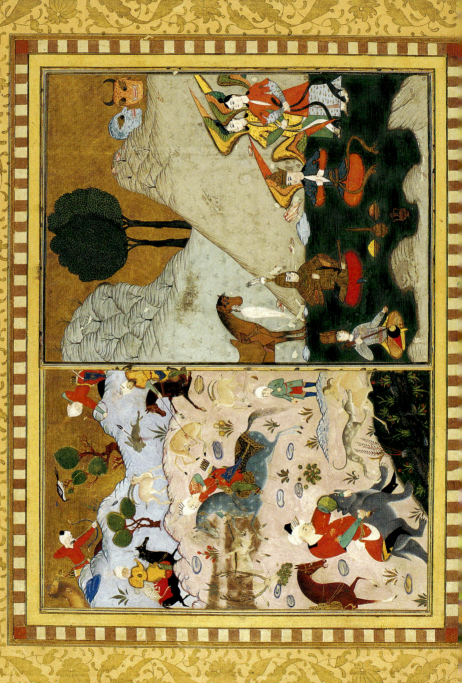

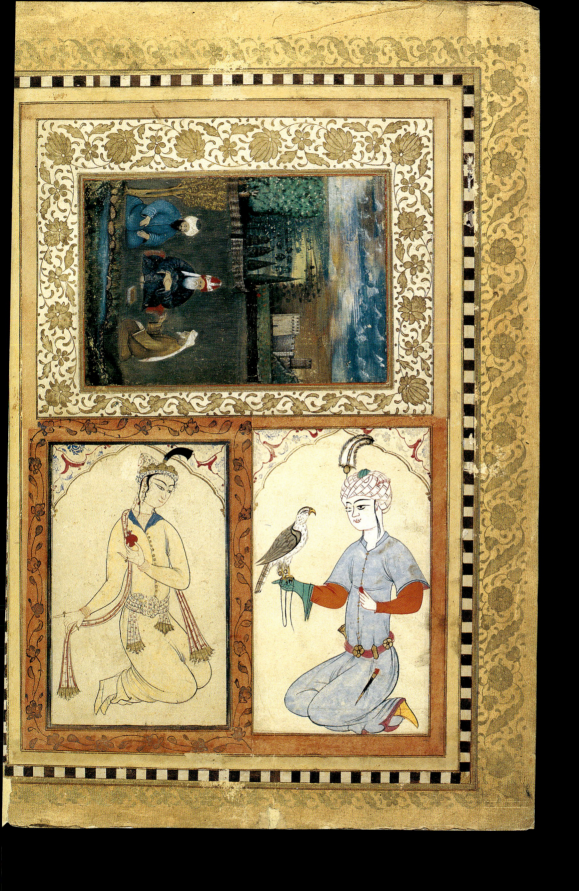

PLATE 46.
Album of the World Emperor, fol. 23b.

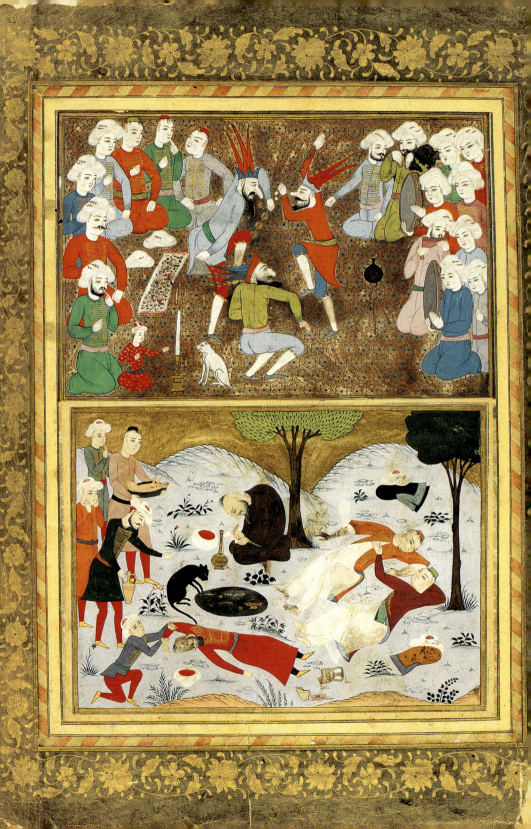

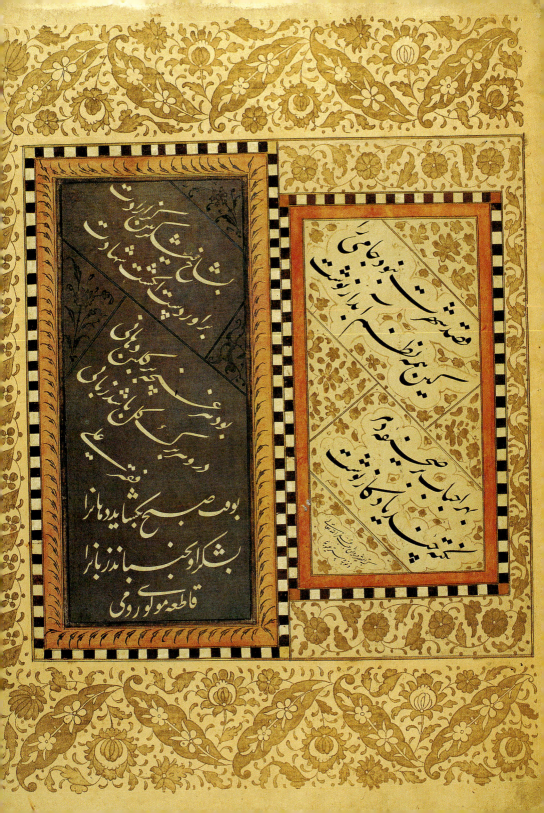

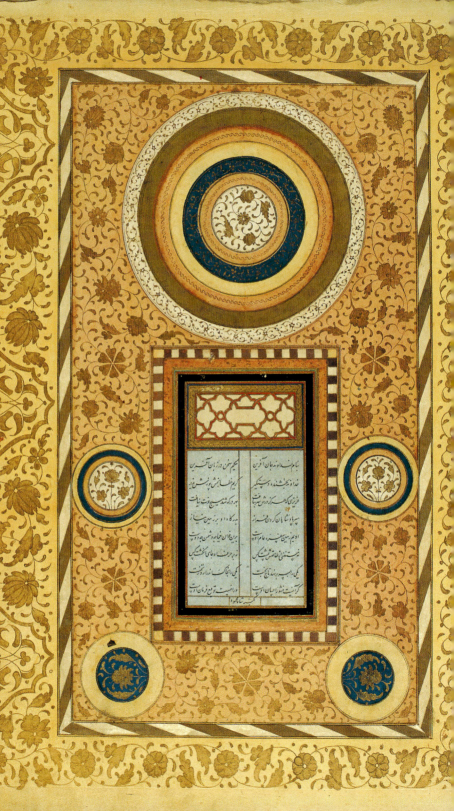

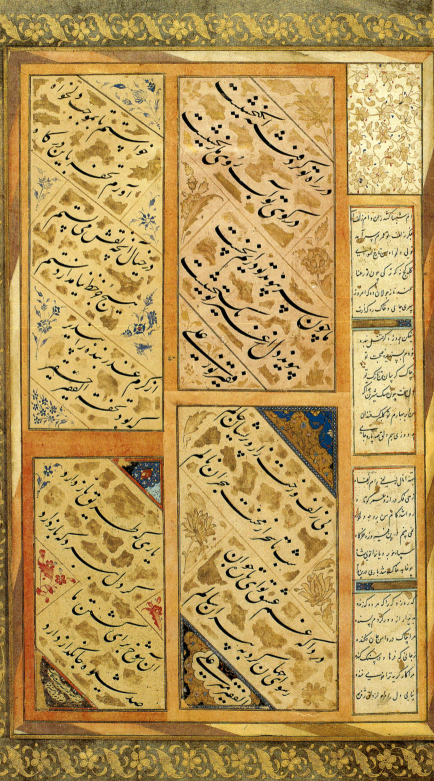

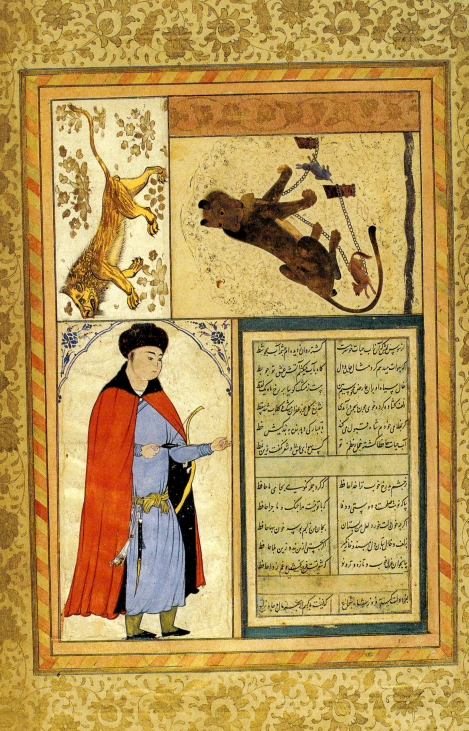

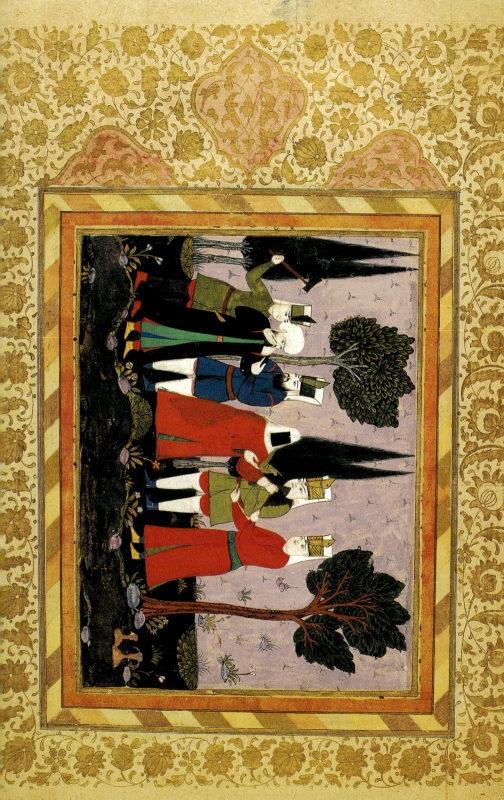

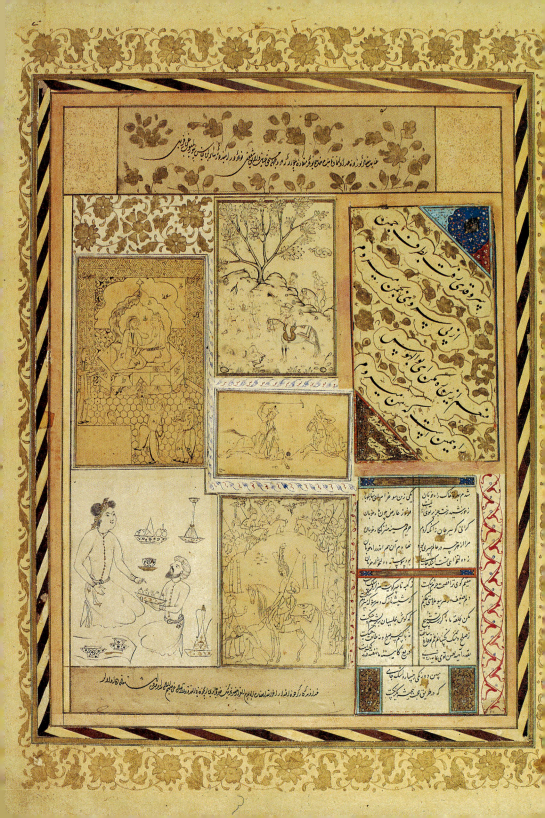

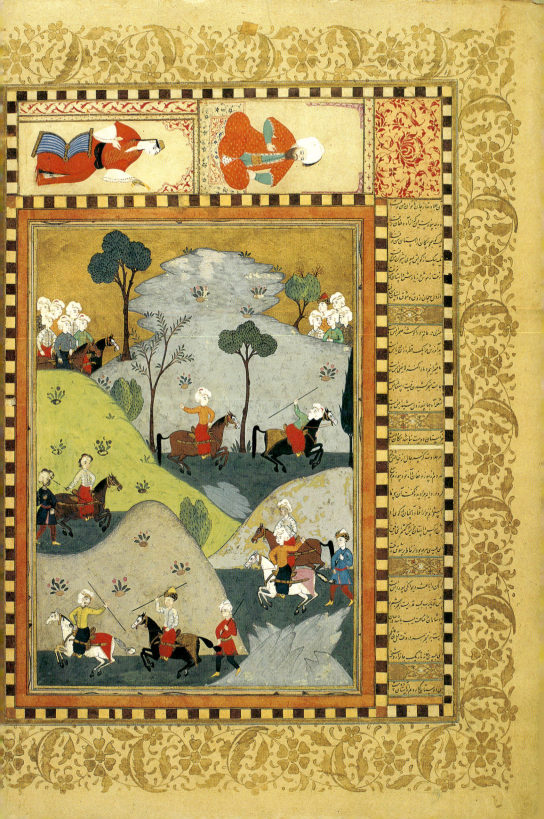

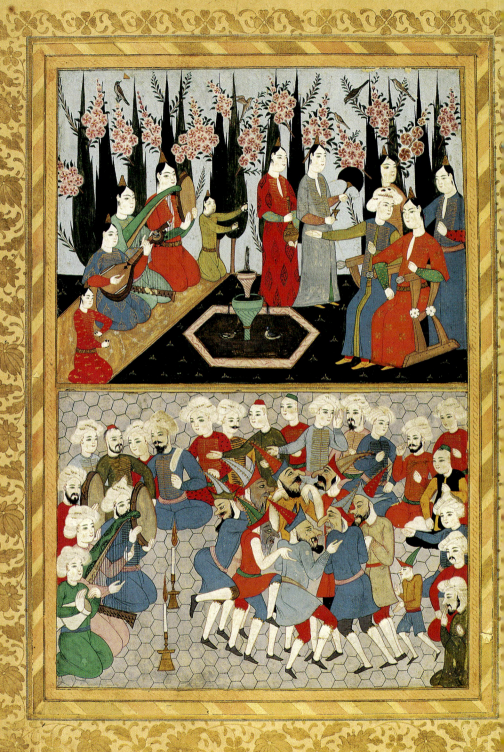

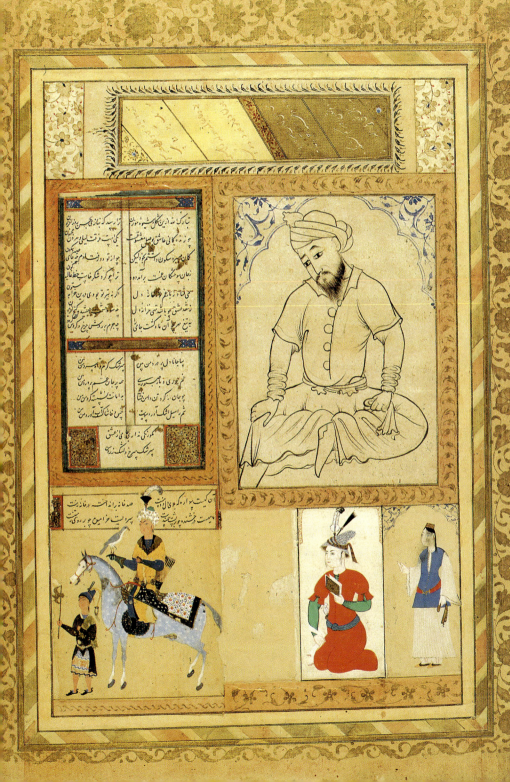

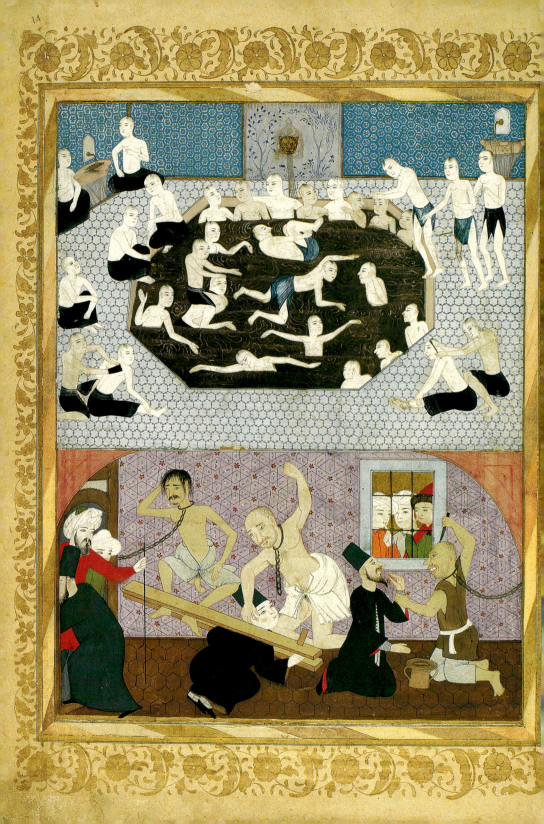

IV

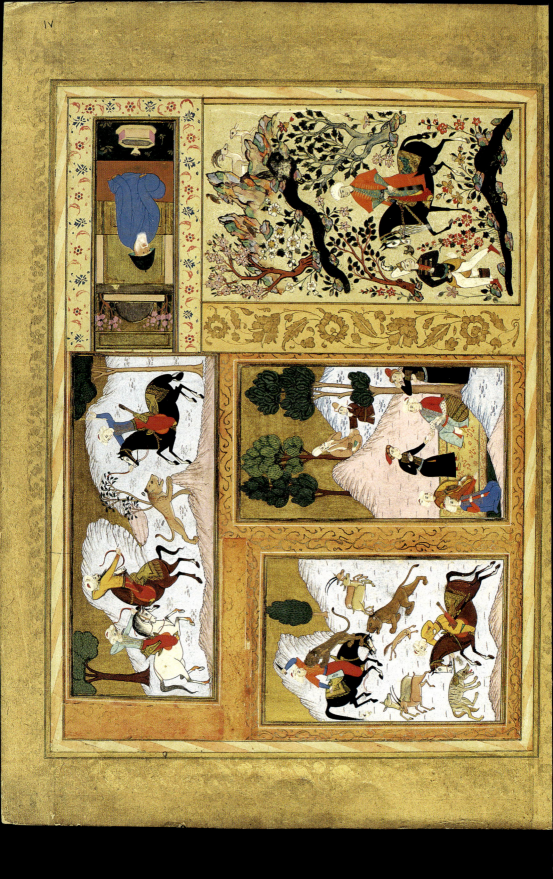

PLATE 33.
Album of the World Emperor, fol. 17a.

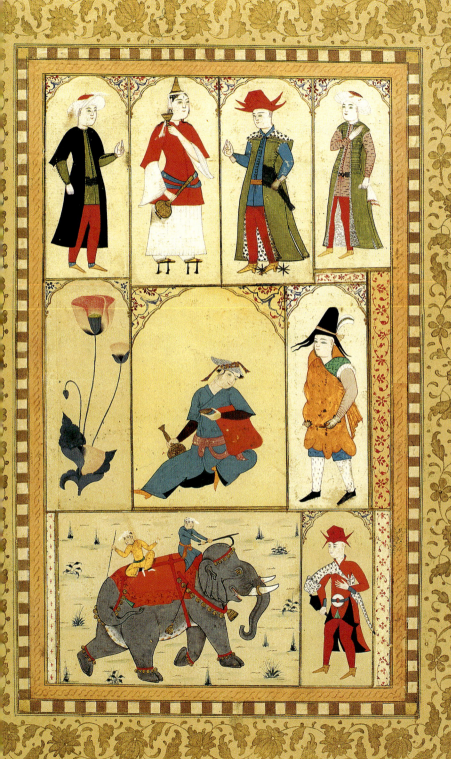

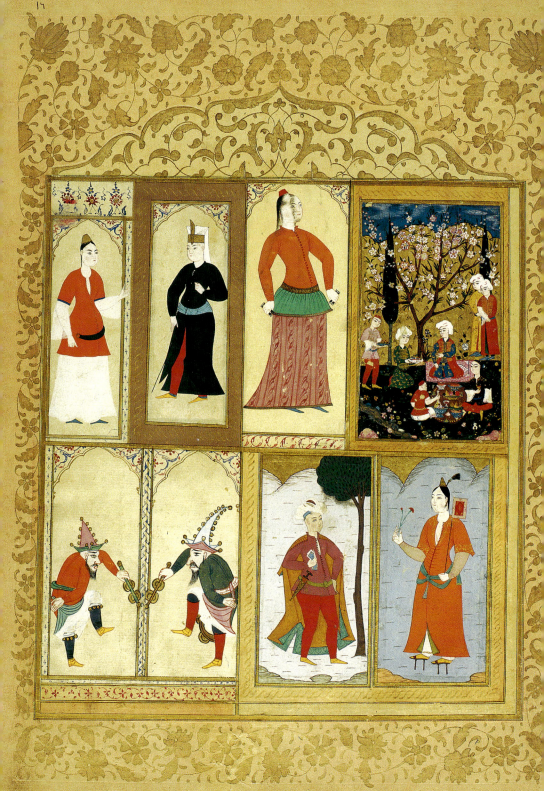

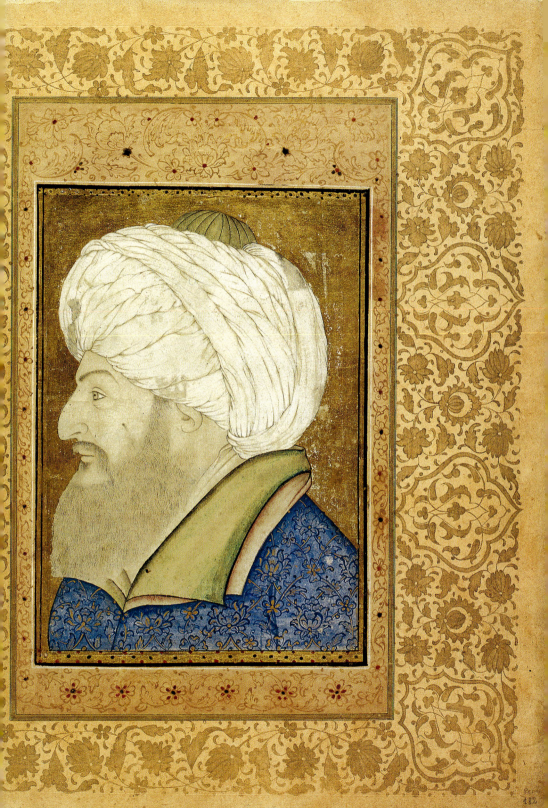

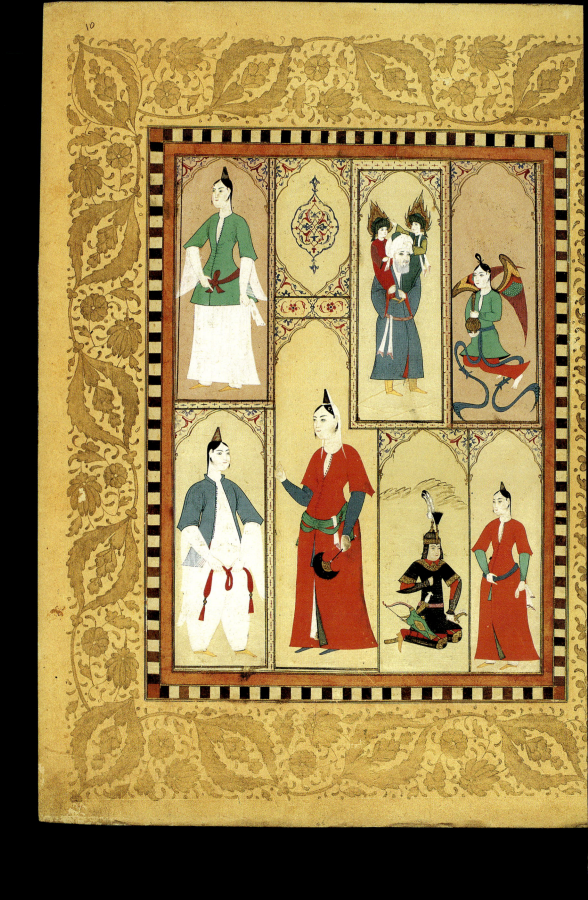

PLATE 29.

Album of the World Emperor, fol. 15a

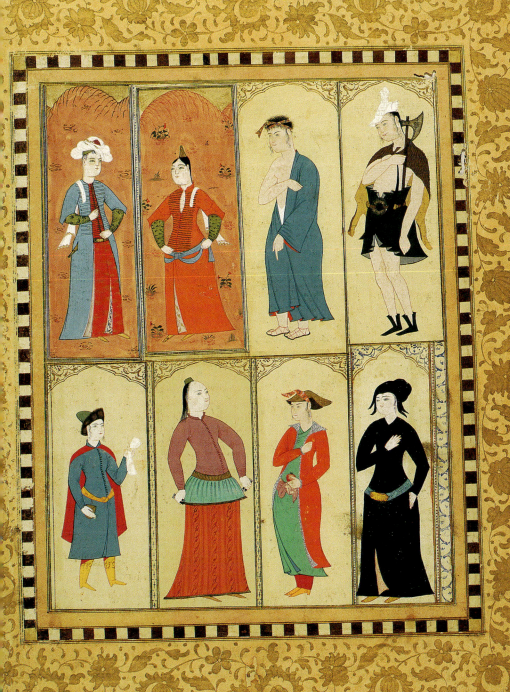

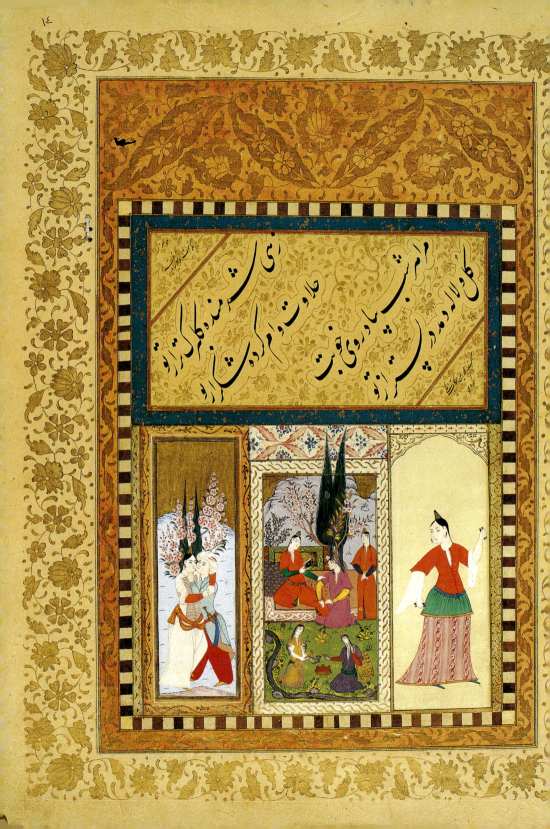

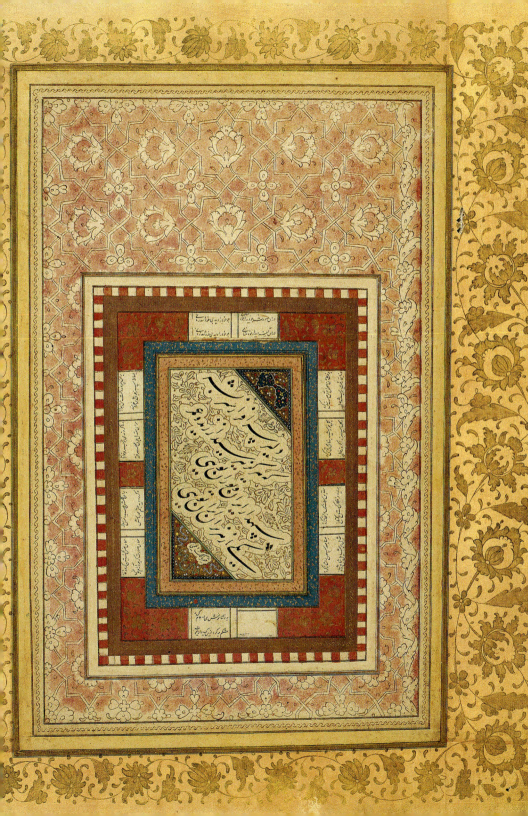

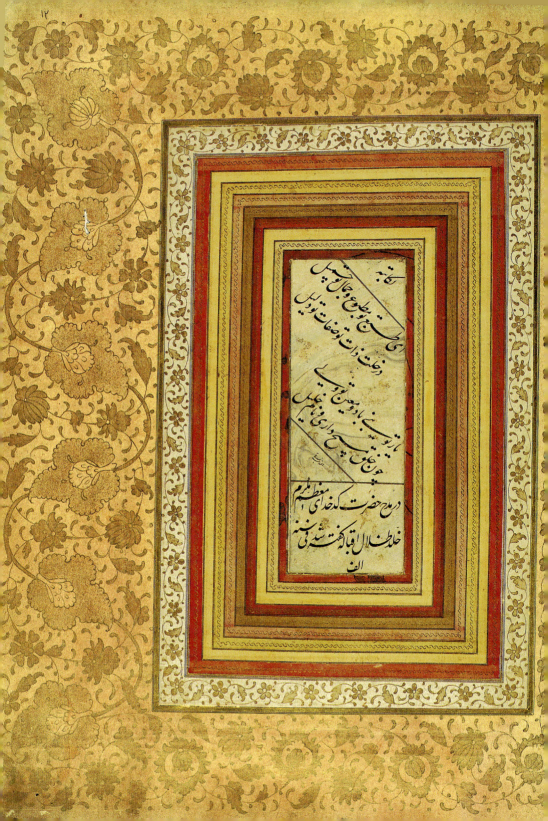

درمدح حضرت که خدای معظم اعظم

خلدطلال اقبال که گفته شده منی سنه

الف

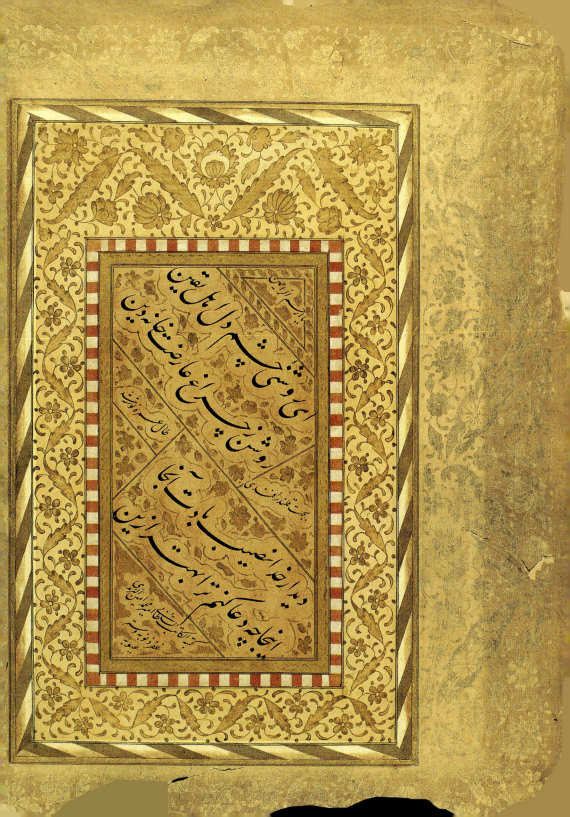

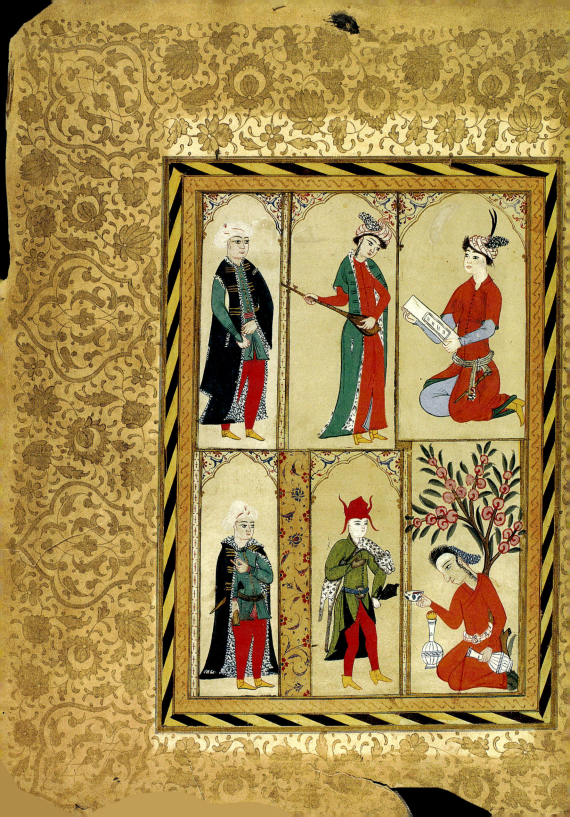

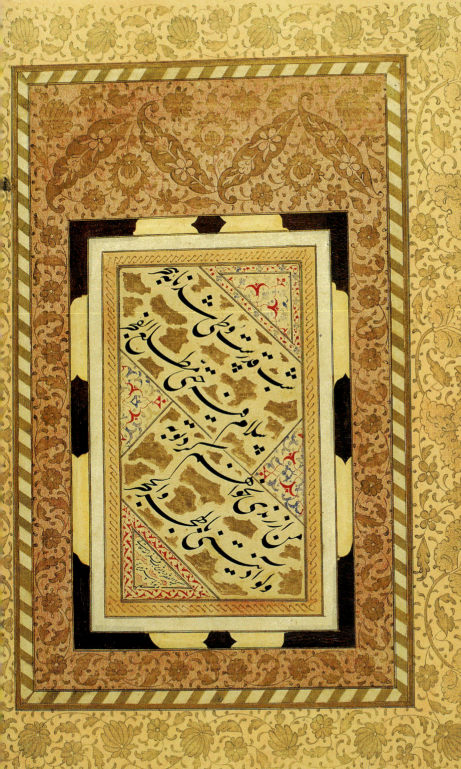

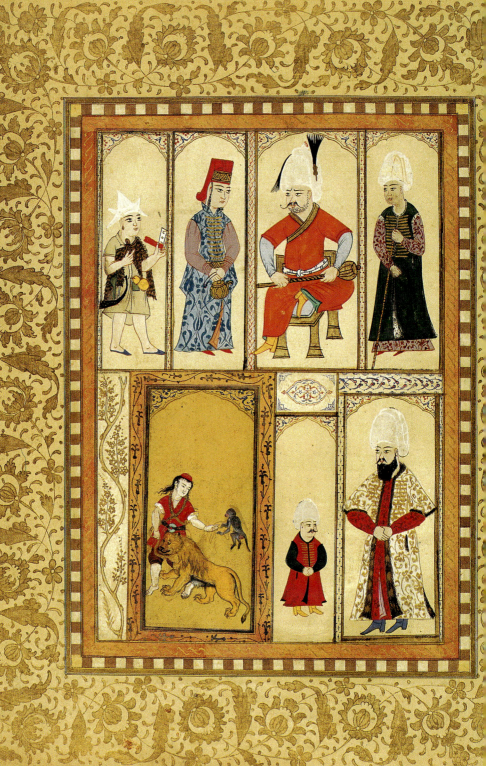

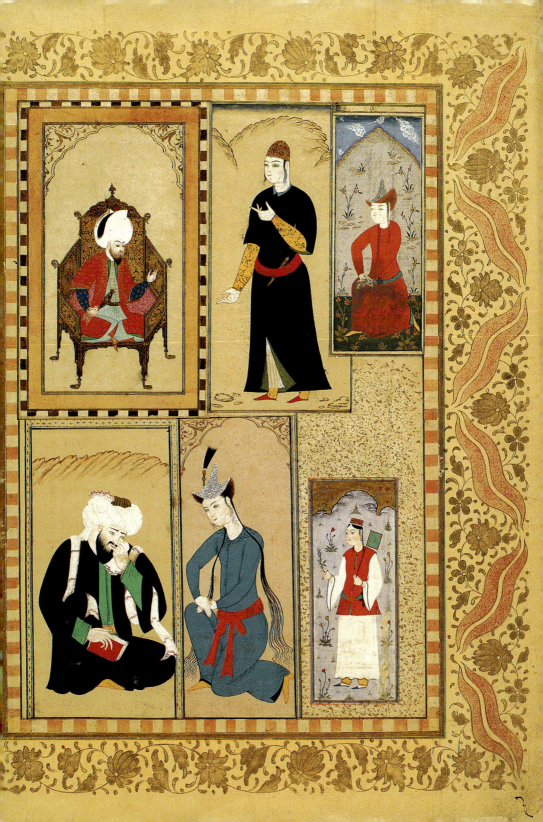

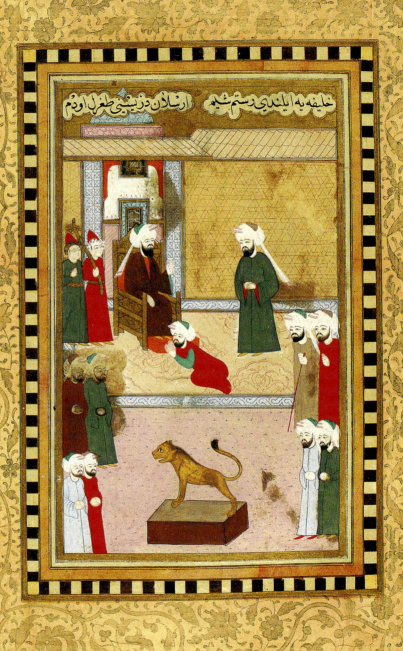

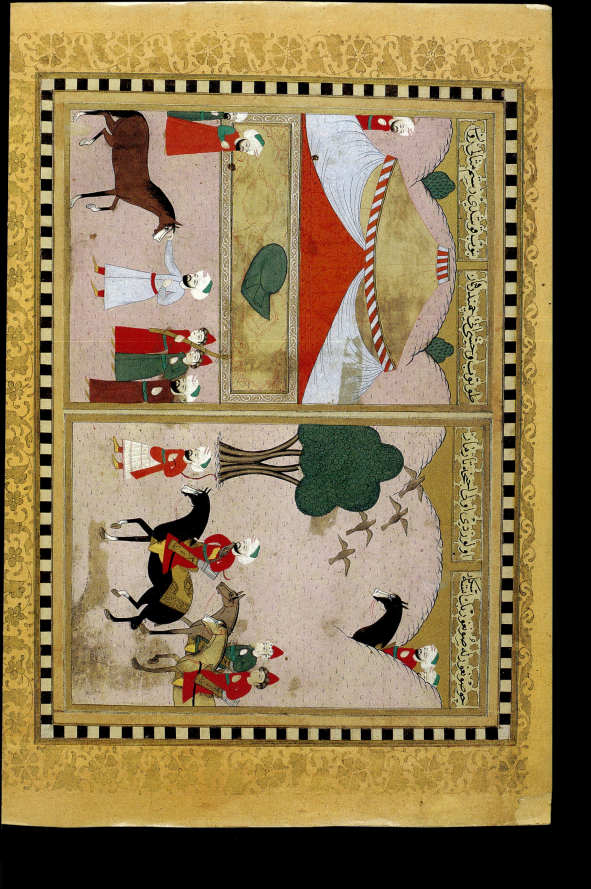

PLATE 14.
Album of the World Emperor, fol. 7b.

259

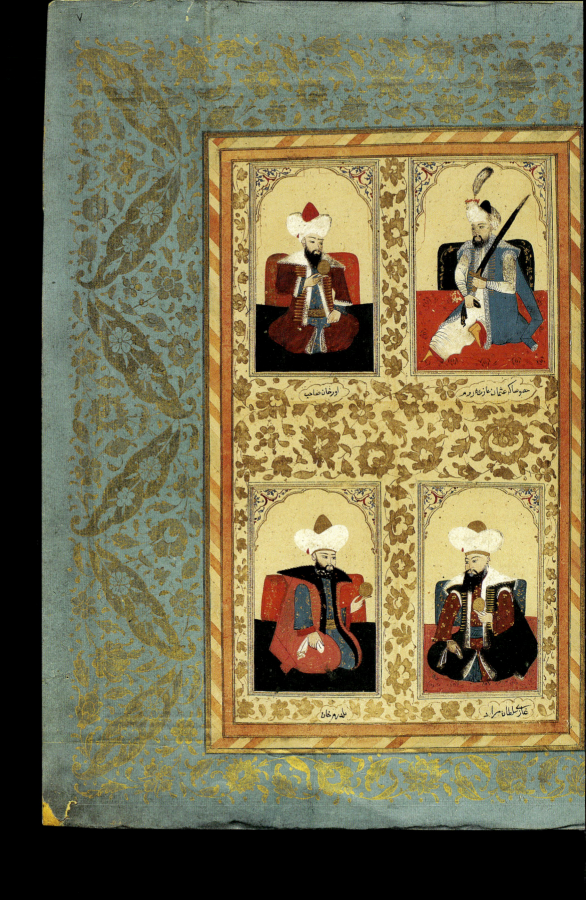

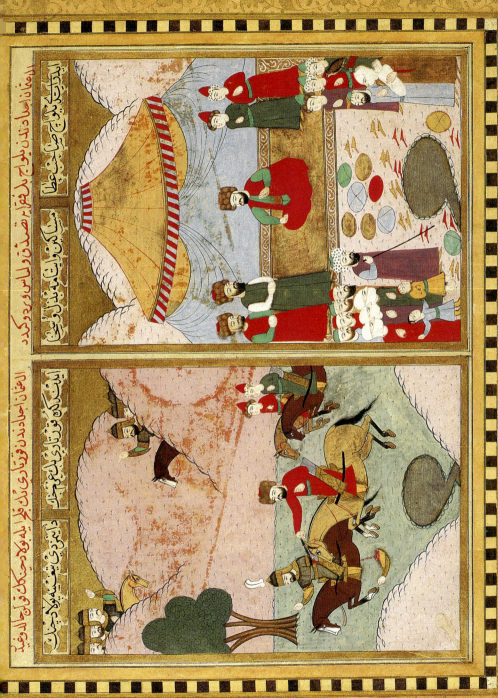

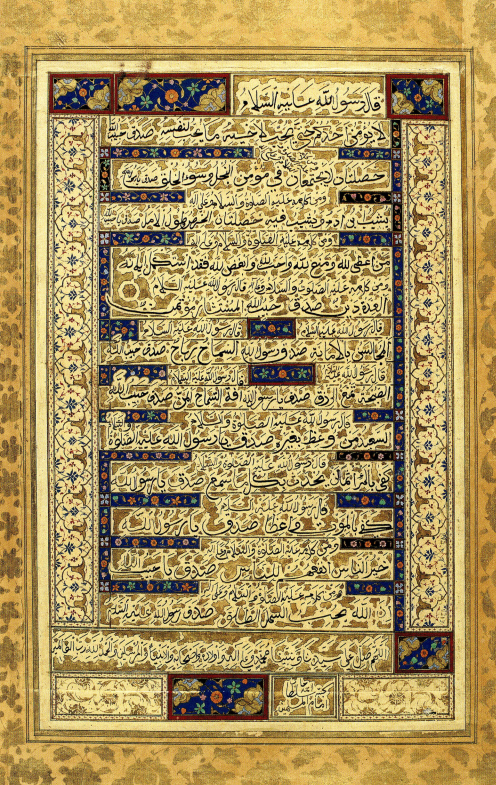

PLATE 10.

Album of the World Emperor, fol. 5b.

PLATE 9.
Album of the World Emperor, fol. 5a.

بويله پر عدل كستر ● رعيت پرور ● چوشنا برد ولت آساس

اهل نظر ● پادشاه دين پناه ● حضرتلرينك حضور شريفلرنده شكسته

وبسته اولان تصنعات مقبول شريفلري ● وبسنديده لطيفلري

اولوب ● كاهى نظرلرينه نظيرلرى متعلق اولدوغى مخصادر دولت عظمى

وسعادت كبرى ● اولغين فرمان سعادت عنوانلرى وزره هر بريسى بر لوينه

ترتيب وتكميل اولنشدر هميشه سلطان آفتاب عالمتاب

كردون نيلكون ● اوزره اشعه لمعات فايض الانوار برله نمايان وتابان

اولوب انوار ميمنت آثاررندن مفارق عامه مخلوقات مستنير ومستفيض

اولا ● پادشاه جمجاه وعالمپنا همك خيام واجب الاحترام ● وووجود مرجود

مسعود لرى وناد واطناب امتداد خلود برله الى يوم الموعود ● كشيده و

ممدد ● اولوب فرق فوقساى اقبال ابد اتصال ● وتارك ملك هماى

دولت بى اختيا لرى ● كوهر تاج ابتهاج برله مجلى اولوب ● شوكت

سلطنت عدالت نمونلرى روز بروز افزون ● واعداى دولتلرى شكسته

ومحزون ● اولوب ممالك اسلاميه ساير جماعتلرندن آسوده ● ووفق

علولرى سمند سعادتلرى التنده فرسوده اولا ● آمين بحرمة سيد المرسلين

رنكارنك اولان نقش بوقلمونى بارى وسلطانى واجد ابادى ودولت ابادى
وخطائى وعدلشاهى وحريرى وسمرقندى ورافقدر ● واكثر صنعت وصالـه
هرنى قطعه نك كنار لرينه فرسكورى لاجه قماش طرازنده ايكى شرواوجر
قات خرده او رافقدر خرده بنان ● وخرده دان اهل عرفانه ● خوى پشيد
دكلدرهر برينه امعان نظرله التفات متعلق اولسه انشاء الله تعالى جار
كوشه لرى ومقابله سى جميعا برى برينه اكرزنكنده واكرجرمنده وطول
عرضنده موافق ومطابق واقع اولمشدر ● سعادتلوشوكتلو ومرحمتلو
پادشاه جمجاه عظمت شعار حضرتلرندن مرجو ومتوقعدركه دائما بو قوللرنى
خدمت شريفلرى ايله تشريف بيورب نظر التفاتلرى يه مغتنم ايدوب
دلنواز لقدن خالى اولمه اره وبوكينه دير ينه بنده لرينك دخى بو روز كار روز كار
سريع الدوارده بودكلودقت واهتمام ايله مقدس صرف ايلدكده
مراد بوانه دكين يچه ارباب حيثيت واصحاب معارفله خلطه ايدوب
روز كار ديدين ● وكار ازموده ● استاد لره مقارن اولوب وبودكلو
زمانندن بروتحصيل ايلد وكم معرفت ● ايام سعادت شهريارى ● وهنكام
دولت تاجدارنده ● صنائع اولـيوب الحمد لله تعالى ولرسوله

أنواع رنك اميز كاغذلره وصل ايلوب مرقع اتمكى قديمدن بو كذركاه
پر عبرده وصالة نادره كار ۞ ومتعينان روزكار ۞ اولوب بوحقيرك
استادى محمد شريف بغداد يدن كو روب مقدما دنخى برا كى دفعه
جناب نعم المالكى ايجون بعضى جونكلر وكتابلر تأليف و ترتيب
و تصنيف و ترتيب ۞ اولندقدن شوكتلو وسعادتلو پادشاه جمهاه
حضرتلرينك كرم طبع پر همملر ندن مقبول شريف ۞ و پسنديده لطيفلرى
اولمش ايدى حق جل وعلا ۞ وجود پرجود نظرينى نظير لرين خطا ۞ و خطرارك
محفوظ ومصون ايدوب يوما فيوما عدل وداد ۞ وطاعت وعباد تلرين
زياد ۞ وممالك محروسه لرى رب العباد آباد ۞ ايدوب عمرو دولت
سرمدى ميسر ومقدر ايتمش اولا امين ۞ بحرمة سيد المرسلين
بنه بو دفعه دنخى جمله صور و خطوط اوراقنى بر كذروب بو عبد قليل
البضاعه جانبنه كوندرد كلرين دن همان جان ودلدن سمعا وطاعة
ديوب فرمان همايون سلطانى هرنه ايسه شرف رتبت اعلا ۞ وخلعت
شريفه لرى جان عزيزمه منت عظمى ۞ فرض ايدوب دائره امكانك
اولان صنايع نادرده ۞ و بدايع ناشنيده خرج وصرف ايدوب اكثر

واعجامنده مشهور ومتعارف اولوب هر بريسينك خط ونقش پر آثارى
مقام اعجازده اولان مير على ● وشاه محمود ونور على ● ودخى نيجه بونلر
مرتبه سنه واصل وناـل اولان خوش نويسان سلف ونقشندن نقاشى
وآثاردن مؤثرى مشاهده اولنان بهزاد وآرزنك ومانى مانندى نقاش
پيشين ● وانواع سعى وكوشش ايله علم مشكافات دقته قلى قرق يرآز
يازى آقوانى مذهبان متقدمين ● عمرين ومقدرين حج وصرف
ايدوب يازوب وجيزوب وجوده كتورد كلرى ى نظير ● وبى عديل
خط وتصوير لرردن ● بعضى تحف وهديه وارمغان ● وبعضى دخى
طلب رجاى انعام واحسان ● پادشاهى ايچون ويزد كلرى مقطعات
وآوراق بريه جمع اولوب هر بريسينك برى بريسينه مناسبتى ايله ترتيب
اولنوب برمذهب ومجلد ومكلف مرقع اولمسى عظمتلو وسعادتلو
پادشاه داد اورحضرتلرينك مراد شريفلرى اولوب وجد ذات سعادت
سماتلرنده بومقوله معارف جزئيه وكلى يه ● وتحف وتقارق هديه
قلعمه ميل شريفلرى اولغين ● وبو قوللرى دخى قديمدن بومقوله استاد
خطرلريله اولان مقطعات وتصويرات آوراقى برى بريسينه مناسبتى ايله

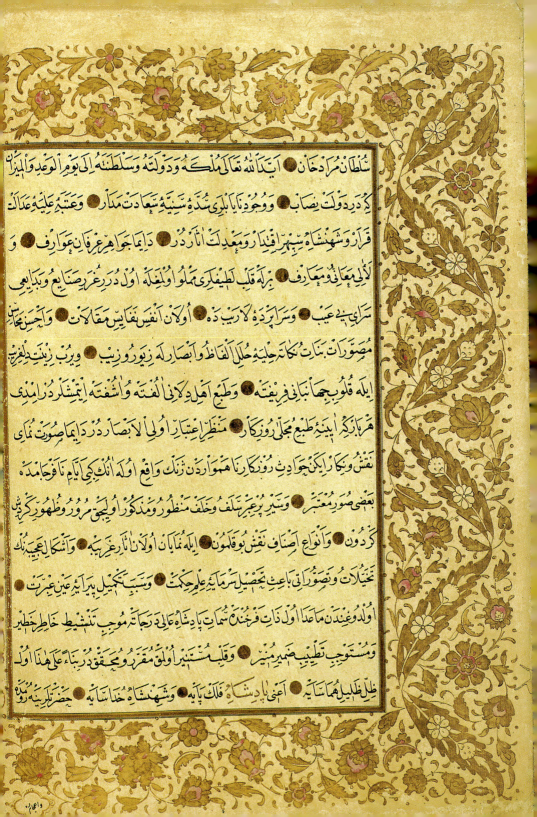

سلطان مراد خان ● ايد الله تعالى ملكه و دولته و سلطنته الى يوم الوعد و الميز

كرده دولت نصاب ● و وجود نايابلرى شده سنيه سعادت مدار ● و عتبه عليه عدالك

قرار و شهنشاه سپهر اقتدار و معدلت اثار در ● دايما جواهر عز قان عوارف ● و

لآلى معانى ذخائر معارف ● برله قلب لطيفلرى مملو اولغله اول درر غرر صنايع و بدايع

سرايى بى عيب ● و سرا پرده لا ريب ده ● اولان انفس نفايس مقالات ● و احسن

مصورات بنات نكات حليه حلل الفاظ و ابصاره له زيور و زيب ● و يروب زينت

ايله قلوب جهانبانى فريفته ● و طبع اهل دلانى لا نى الفته و اشفته ايتمش در امدى

هر بار كم اينه طبع مجلى روزگار ● منظر اعتبار اولى الابصار در ده ما صورت نماى

نقش و نگار ايكن حوادث روزگار نه همواره دن ژنك واقع اوله انك كبى ايام نافوجامده

بعضى صور معتبر ● و سير بو عبر سلف و خلف منظور و مذكور اوليچق مرور و ظهور

گردون ● و انواع اصناف نقش بوقلمون ● ايله نمايان اولان ازار غريبه ● و اشكال عجيبه نك

تخيلات و تصورانى باعث تحصيل سرمايه علم و حكمت ● و سبب تكميل پيرايه عين عبرت

اولدوغندن ماعدا اول ذات فرخنده سمات پادشاه عاليه رتبه نه موجب تنشيط خاطر خطير

و مستوجب تطييب ضمير منير ● و قلب مستنير اولق مقرر و محقق در بناء على هذا اول

ظل ظليل همايه ● اعنى پادشاه فلك پايه ● و شهنشاه خداسايه ● حضرتلرينه رمز

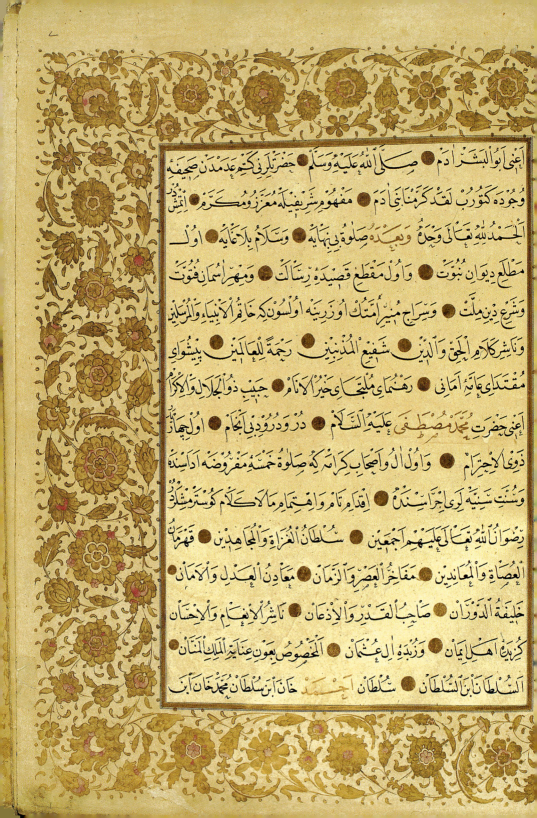

اعنی ابو البشر آدم ● صلی الله علیه و سلم ● حضرت لری بی کتم عدمدن صحیفه

وجوده کورب لقد کرمنا بنی آدم ● مفهوم شریفیله معزز و مکرم ● اتش

الحمد لله تعالی وحد ● و بعده صلوة بی نهایه ● و سلام بلا غایه ● اول

مطلع دیوان نبوت ● و اول مقطع قصیده رسالت ● و مهر اسمان قوت

و شرع دین ملت ● و سراج منیر امتك او زریه اولسونکه خاتم الانبیاء و المرسلین

و ناشر کلام الحق و الدین شفیع المذنبین ● رحمة للعالمین پیشوای

مقتدای عامه امانی ● رهنمای ملتجای خیر الانام ● حبیب ذوالجلال و الاکرام

اعنی حضرت محمد مصطفی علیه السلام ● درود رودی بی آنجام ● و اولی ها

ذوی الاحترام ● و اولاد و اصحاب کرامكه صلوة خمسه مفروضه آدا سنه

و سنت سنیه لری اجرا سنك ● اقدام تام و اهتمام ما لا کلام کو سترمشلر

رضوان الله تعالی علیهم اجمعین ● سلطان الغزاة و المجاهدین ● قهرمان

العصاة و المعاندین ● مفاخر العصر و الزمان ● معادن العدل و الامان

خلیفة الدوران ● صاحب القدر و الاذعان ● ناشر الانعام و الاحسان

کریم اهل ایمان ● و زبده ال عثمان ● المخصوص بعون عنایة الملك المنان

السلطان بن السلطان ● سلطان احمد خان ابن سلطان محمد خان ابن

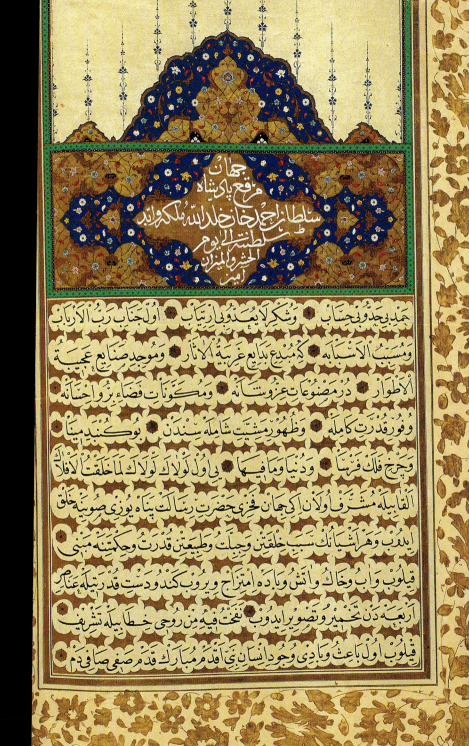

جهان
مرقع پادشاه
سلطان احمد خان خلد الله ملكه واید
سلطنته الی یوم
الحشر والميزان
آمین

حمدی بی حد و نی حساب ⁕ و شکری لا يعد لي وار ريابه ⁕ اول جناب رب الارباب
و مسبب الاسباب ⁕ كم مبدع بدايع غريبة الآثار ⁕ و موجد صنايع عجيبة
الاطوار ⁕ در مصنوعات عزروستانه ⁕ و مكونات فضاء بزوا حسانه
و فور قدرت كامله ⁕ و ظهور مشيت شامله سندن ⁕ بو كنبد مينا
و حرج فلك فرسا ⁕ و دنيا و ما فيها ⁕ بی اولد لولاك لولاك لما خلقت لافلاك
الفا بيله مشرف اولان اكی جهان نخری حضرت رسالت پناه يوزی صونه خلق
ايلوب و هرآشيانك سبب خلقتش وجلك وطبيعتن قدرت و حكمته مبنی
قلوب و آب و خاك و آتش و باده امتزاج ويروب كند و دست قدرتيله عناصر
اربعه دن تخمير و تصوير ايدوب نفخت فيه من روحی خطابيله تشريف
قلوب اول باعث و بادی وجود انسان ينی آدم مبارك قدم صفی في دم